The Egyptian Museum in Cairo

A Walk through the Alleys of Ancient Egypt

Text by Abeer el-Shahawy
Photographs by Farid Atiya
Published by Farid Atiya Press
© Farid Atiya Press

P.O. Box 75, 6th of October City, Giza, Cairo, Egypt
www.faridatiyapress.com, e-mail : atiya@link.net
First edition, 2005

Colour Separation by Farid Atiya Press
Printed and bound in Egypt by Farid Atiya Press

Dar al-Kuteb Registration 8092/2005
ISBN 977-17-2183-6

Previous page : Wood statue of Ka-aper, called Sheikh el-Balad, 5th Dynasty, reign of Userkaf 2513 - 2506 BC; Ground floor, room 42.
Pages 4 & 5. Two almost identical Ka statues of Tutankhamun; in page 4 he wears the *nemes* wig, in page 5 he wears the *khat* wig, 18th Dynasty, reign of Tutankhamun, 1356 - 1346 BC; Upper floor, gallery 45.

Preface

During my twenty years of experience in Egyptology, I have always felt overwhelmed during visits to the Egyptian Museum in Cairo. Walking through its halls is like a journey through ancient history, as one reaches back into the depths of the past. In fact, the museum collection is sufficiently large and varied to serve as both an introduction and summary of the 5,000 years of ancient Egyptian civilization and culture.

The visitor leaves behind the crowds at the entrance of the museum in Tahrir Square, situated in the heart of the modern, bustling city, and suddenly moves back to the pharaonic age. During his exploration of the museum's vast range of exhibits, he may catch a whiff of the ancient scent.

The statues and artefacts in the museum remain today as witnesses of the splendour that was Egypt. They reflect the glory of the great pharaohs and their times, of the wealthy noblemen and of the meticulous artists. Each statue has a special meaning and recalls a particular aspect of the ancient heritage. The statues reveal historical details, not only about their patrons, but also about the social, economic and political climate of the ancient land. The craftsmen transformed wood, stones and metals into statues that still live, silently attesting to the grandeur of the past.

Each piece is a reminder of a particular event, a certain environment and a specific phase and period in ancient history. Walking through the rooms and galleries of the Prehistoric Period, one can imagine the small and simple settlements and communities of that time, with its primitive, but steadily advancing societies. Moving to the Archaic Period, we explore the era when the first foundations of the impressive thirty centuries to come were laid. Glimpsing the Old Kingdom, we imagine the masons and workers cutting and transporting the stone for their god-like king; the architects supervising them, and the king himself filled with pride as he observed the progress in building his house of eternity, the pyramid. Proceeding to the Middle Kingdom, we can visualise the lake in Fayum and the agricultural projects in that verdant, fertile region. In the New Kingdom Period, one may imagine Thebes, the city of a thousand gates, with its vast temples, luxurious palaces, magnificent pharaohs and exquisite queens as well as the rich and powerful priests. Akhenaton, the philosopher king, is there, and so is Tutankhamen with his gorgeously wrought treasures of gold. Ramses with his chariots, battling for the empire, and building his colossal statues. Overlooking this pageant is the awesome necropolis on the West Bank of the Nile, guarding many legacies and secrets. Then in the Late Period, we see a return to archaism with an assimilation of the past, in an attempt to recreate the old glory and traditions.

The exhibits shown in this book are carefully chosen and photographed to reveal their beauty. They were selected according to either their historical importance or their artistic merit. Arranged in chronological order, the royal statues and artefacts are displayed first, followed by the private pieces.

The book aims, through detailed descriptions and comprehensive explanations, to identify the place and role of the selected pieces as part of the ancient Egyptian civilization

Abeer el Shahawy

Acknowledgements

First, and foremost a very special thanks to Dr. Zahi Hawas, for his encouragement and granting me the permission to make the photographs of this book.

I extend my gratitude to Dr. Wafaa Sadik, Director of the Egyptian Museum as well as the heads of the departments of the Egyptian Museum Hala Hassan, Mahmoud el-Halwagy, Salwa Abd el-Rahman, Adel Mahmoud, Ibrahim Abd el-Gawad, Zeinab Abd el-Aziz, Sayed Hassan and Somaya Abd el-Samiaa. They have all welcomed me in the Museum and have cheerfully aided my work at all stages, thus creating a friendly environment in which I could work.

For the German translation I am grateful to Mrs. Evelyn Posch, for the French translation Mrs. Dominique Krayenbuhl , for the Italian translation Mrs. Paola Maggiori, for the Spanish translation Mr. Yasser el-Helw and Monica Garcia-Viño and for the Japanese translation Mrs. Yoriko Mizuno.

Farid Atiya

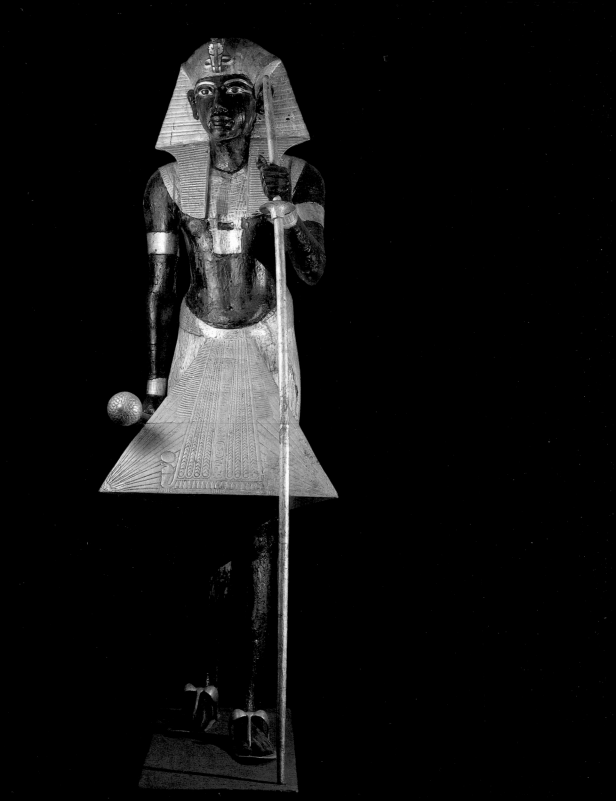

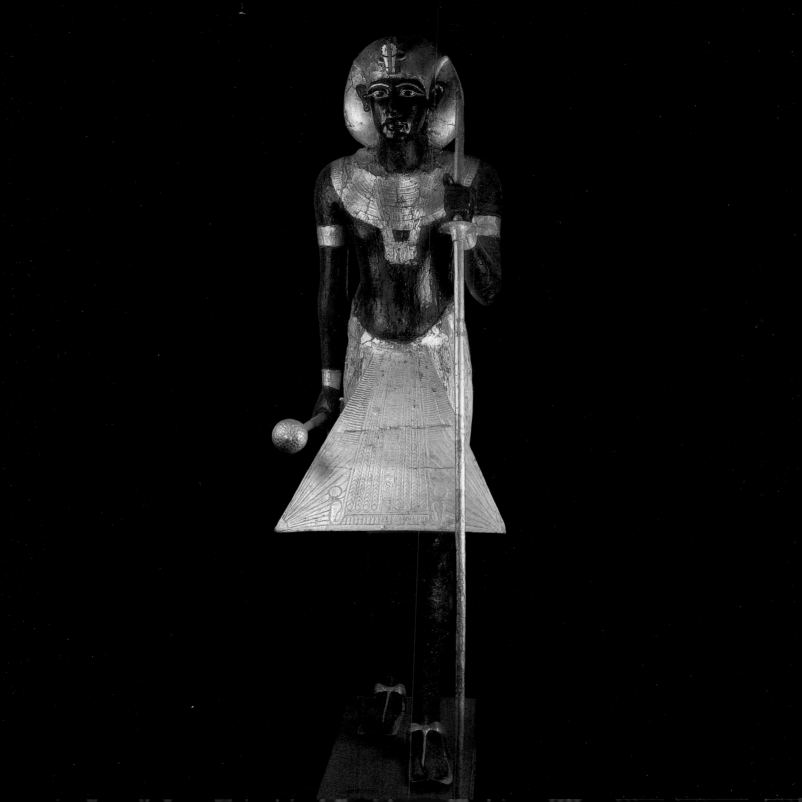

Table of Contents

The Predynastic Period

Egypt's Predynastic Period belongs to prehistory, or the story of human cultures before written records began. It spanned about twenty centuries, from about 5500 to 3100 BC. Although few monuments survive from this era, and those that remain cannot be compared to the glorious monuments of later periods, it forms an essential part of Egypt's past.

The first part is known as the Early Predynastic or Neolithic Period. At that time many small communities lived along the Nile. These groups differed from each other in some points but had many things in common. All these communities occupied the same region and a similar environment, and each interacted with and influenced the others.

There were many successive and coexistent civilisations during this Neolithic Period. Among them was the civilised community at Merimda Beni Salama in the southwest Delta. This particular civilisation marks the very beginning of the appearance of artefacts, as attested by clay pots, the terracotta bust of a woman wearing a collar and considered as a first step towards statuary, a model of a real papyrus boat which suggests navigation on the Nile, and a basalt cup thought to be among the earliest stone cups ever made.

Another Neolithic civilisation appeared in Fayum, approximately a hundred kilometres south-west of Cairo, where the land was extremely fertile and a large natural lake provided water for irrigation. Many objects have been identified from this site, including instruments for hunting and cultivation and utensils from daily life.

At Deir Tasa, near Assiut in Upper Egypt, pottery reached still higher standards. Cups fashioned in the form of lotus flowers have been found dating from this period. Other crafts were practised, as evidenced by an elongated reed basket containing the body of a child. This also suggests the beginning of burials in receptacles.

The second part of the Predynastic Period is called the Late Predynastic or Chalcolithic Period, and is distinguished by the introduction of copper smelting. Relics of this period have been found at al-Badari in Assiut, where jewellery and beads appear in the graves together with copper pins for linen clothing. Clay jars with fine surfaces were manufactured and decorated with designs of leaves and branches. The deceased were buried on a board, which is thought of as another step towards burial in coffins. The burial pits were lined with reeds, marking progress towards the mud-brick lining that appeared later. Findings from this period include jewellery made of shells and beads threaded on linen, ivory spoons with stylised handles, and seven female statues sculpted in ivory and clay. These pieces demonstrate excellent workmanship, a high artistic sense and a love of ornamentation.

The phase known as Naqada I corresponds to the centre of a civilisation located around Naqada near modern day Qena, sixty kilometres north of Luxor. Naqada was the cemetery of a city on the western side of the Nile called Nwbt, where the god Seth was the main deity. Naqada I is distinguished by white cross-lined pottery and jars decorated with animals, boats, hippopotami, and male and female dancers. Palettes for grinding made their appearance, and clay, terracotta and ivory statues were produced. The representation of the White Crown of the south on jars, and in other instances of the Red Crown of the north, suggests relations between the south and the north of the country, probably by means of navigation on the Nile.

The succeeding Naqada II phase is noted for trade with neighbouring countries. Obsidian was imported from Abyssinia, lapis lazuli from Mesopotamia. Byblos too was a familiar destination. Copper was widely used, and graves became richer in content and design. This phase is marked by great developments in painting and statuary. The use of the colour red for painting, together with motives consisting of spirals, people, animals and boats, were characteristic of this art. Copper and flint knives were shaped, and stone jars replaced pottery. Animal-shaped ivory combs appeared, and scenes were represented on cosmetic palettes, mace heads and knife handles. Indoor games included *senet*, stone marbles and a game played with pieces similar to those used in chess.

There were corresponding changes in burial practices. The burial pit was by now a room lined with bricks, which would eventually develop into a three-room tomb.

Other centres of civilisation during this phase included the northern sites of Helwan, Ain Shams and Maadi, which today border Cairo. Fewer relics were preserved in the north and the Delta because of its topography as a low swampland exposed to flooding.

During the phase referred to as Naqada III there were several attempts to unify the south and north, the so-called Upper and Lower

Egypt. The country passed through several stages before attaining its unification. The first was the unification of the north or Lower Egypt into two kingdoms: one in the East Delta and the other in the West Delta. The second episode was the unification of these two kingdoms into one, with its capital in Sais near San al-Haggar in the west of the Delta and with Neith as its goddess. The third stage was contemporary with the second, but its scene of action was Upper Egypt, where the provinces of the south formed a union with its centre at Nwbt (near modern Qena), taking Seth as their god. The fourth event took place in the north with the capital moving to Djedu in the east of the Delta, near Abu-Sir Bena, where Osiris was the main god. The fifth was an attempt by the north to subdue the south and to unify the two parts of the country, but the south broke free and the unification failed. The sixth episode was another attempt by the north to unify the country, but this time it was successful. The capital was established at Iwn, later Heliopolis, with the main god Atum being honoured there beside Osiris. In the seventh phase another conflict ended the unification of the country.

Thus in the Late Predynastic Period, just before the first Egyptian dynasty, Egypt was divided into two kingdoms. The Kingdom of Lower Egypt had Buto (present Tel al-Pharain at Kafr al-Sheikh in the northwest Delta) as its capital and the Red Crown, the honeybee, the cobra goddess, and the papyrus respectively as its crown, emblem, deity and symbol. In the south, the Kingdom of Upper Egypt had for its capital Nekheb, present al-Kab, twenty-two kilometres north of Edfu, and had the White Crown, the reed plant, the vulture goddess and the lotus plant respectively as its crown, emblem, deity and symbol.

The art of this Late Predynastic Period reached high levels of elaboration and development. Stone statues were sculpted out of basalt, limestone, lapis lazuli and schist. Commemorative scenes representing attempts at the unification of the two lands in this period were represented on palettes, cylindrical seals and mace heads such as the mace head of the Scorpion King now in the Ashmolean museum in Oxford, where the victorious king is shown inaugurating an agricultural project. We also see the first representation of an Egyptian temple on this mace head.

The greatest representation of the struggle for unification and its successful outcome was registered on the Palette of Narmer, the earliest such evidence in the history of dynastic Egypt.

1. Male Head

Terra cotta; Merimda Beni-Salama; H. 10 cm;
Predynastic period; *c.* 5000 BC; Ground floor, gallery 43; JE 97472

One of the oldest representations of a human in the prehistory of Egypt, this oval-shaped terracotta male head was found at the site of Merimda Beni Salama, 50 kilometres northwest of Cairo. The facial features are represented in a naive form, yet are very expressive. Holes around the face were probably for the insertion of locks of hair on the scalp and the chin. A recess underneath the head suggests it was attached to a sceptre or pole on a standard carried in religious ceremonies. Traces of colour on the surface indicate that it was probably painted.

Graves designed as oval pits were found in Merimda Beni Salama. The still-preserved corpses inside them were lying on their right sides in the primitive contracted position, wrapped in a skin to accentuate the idea of the rebirth. These graves were situated between the houses in the community rather than in a separate cemetery. The economy of Merimda Beni Salama depended on hunting, gathering, animal husbandry and the cultivation of wheat and barley.

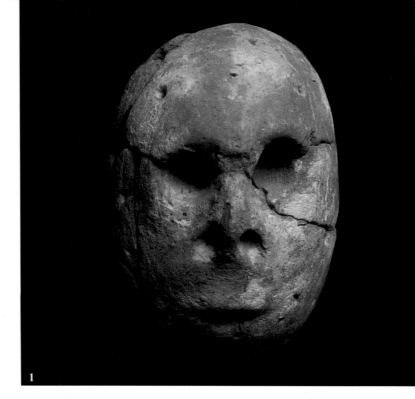

2. Bowl with crocodiles

Clay; Gebelein; H. 11 cm, Diam. 19.5 cm;
Predynastic period, Nagada I, *c.* 4000 BC; Ground floor, gallery 43;
JE 38284 = CG 18804;

This clay bowl is of uncertain provenance but thought to have come from Gebelein, which is 25 km south of Luxor. It bears images of crocodiles fixed with an application technique. Originally, there were four crocodiles, but one was damaged. Geometric motifs painted in white surround the creatures are also seen inside the bowl. The crocodile played a prominent role in ancient Egyptian mythology and magic, and was worshipped as the god Sobek with cult centres in several places like Fayum and Kom Ombo. The crocodile was the emblem of the sixth upper Egyptian nome called Tentyrus, now known as Dendera, 60 km north of Luxor. Crocodiles continued to live in the Nile till 1971 when the High Dam was built in Aswan.

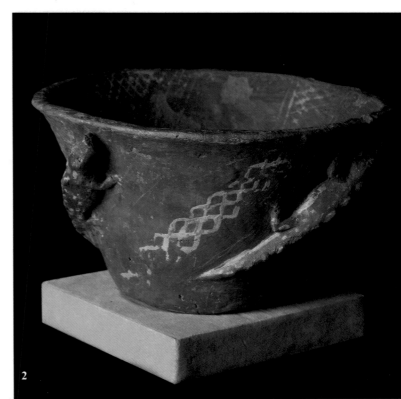

3

3. Vase with painted decoration

Painted terra cotta; unknown region; H. 22 cm; Diam. 15 cm;
Predynastic period; Nagada II, *c.* 3500 BC; Ground floor, gallery 43;
JE 64910;

This clay vase is of unknown provenance, but can be dated to
the predynastic Naqada II phase. It is oval-shaped with pierced lug
handles and is decorated with red paint, as is typical of vases from
this phase.

The motives over the vase show a large boat with two cabins
and stylised oars represented as lines, with five slender ostriches
standing in a line. Traces of wavy lines representing water are visi-
ble on the base of the vase. On the reverse side is another boat sur-
mounted by a stylised plant and another row of ostriches. This new
type of pottery, decorated with birds, animals and boats, suggests a
ritual practice. Similar themes were represented in the oldest pre-
served wall painting in Tomb Number 100 at Hierakonpolis, and in-
cluded symbols, portrayals of real events and objects that the
deceased wished to enjoy again in the afterlife. The same boat style
appeared on a rock carving at Garf Hussein, ninety kilometres south
of Aswan.

Naqada II saw the appearance of more affluent graves, indicat-
ing social developments. Pear-shaped mace heads, soon to become
the ceremonial sceptre of the kings, began to be produced. Tools
made of flint were widely used, together with copper tools.

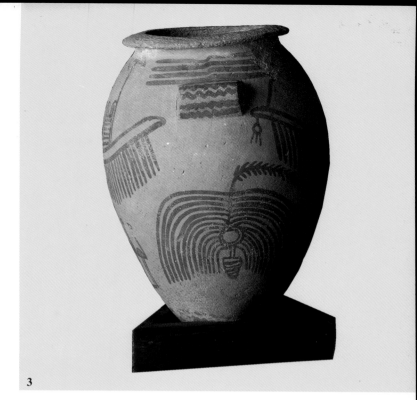

3

4. Flint knife with a fish-tail shaped blade

Flint, gold leaf; Qena; L. 30 cm; W. 6 cm;
Predynastic period; Naqada II, *c.* 3500 BC; Ground floor, gallery 43;
JE 34210 = CG 64868

This knife is of uncertain provenance, but is thought to have
come from Gebelein some twenty-five kilometres south of Luxor.
The handle is covered in gold leaf and decorated with scenes typical
of Naqada II phase paintings found on pottery vases. Three female
figures, probably dancers, stand in a line holding one another's
hand; the first one to the left holds a fan. The four wavy lines on the
right hand side of the handle represent the water of the Nile, while
the other side of the handle shows a boat with two cabins. Water
and boats were important decorative motives throughout the his-

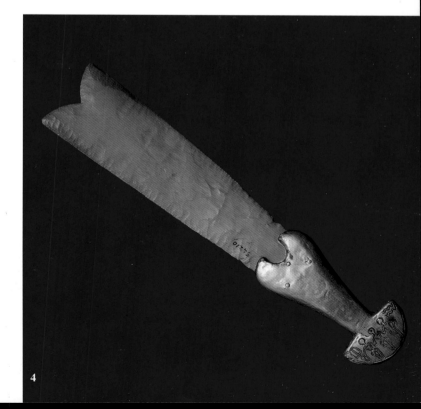

4

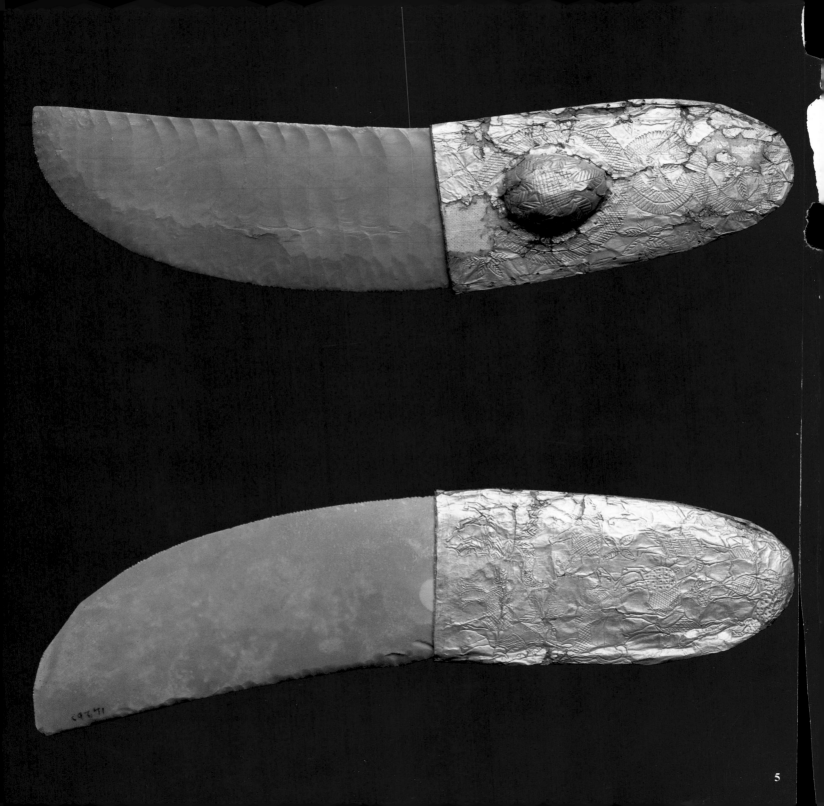

tory of Egyptian art, as the Nile was the backbone of their civilisation. The blade is flint.

The knife was not intended for use in daily life, but rather had a religious function and was used for rituals. The peculiar shape of the blade to resemble a fish tail is typical of knives used, with other tools, for the ceremony of the 'Opening of the Mouth', and would appear much later in scenes of funeral procession on the walls of the Tombs of the Nobles in Thebes. Such a fish-tailed knife, called *pseshkf*, was mentioned in Spell n°. 37 of the Pyramid Texts, which explains that using it to touch the jaw of a deceased person would enable the jaw to move. Its presence during this prehistoric period suggests that the rite of the 'Opening of the Mouth' was already being performed.

5. Flint knife with a gold handle

Flint, gold leaf;
Predynastic period; Naqada II, *c.* 3500 BC; Ground floor, gallery 43;

This knife has a flint blade and a handle covered with gold leaf. Dating from the prehistoric Naqada II phase, it is of unknown provenance. Both sides of the handle are decorated with various floral motives, combined on one side with stylised representations of animals. The Naqada II phase artists showed more skill when representing animals-one of their favourite themes for the decoration of knife handles and slate palettes-than in their depiction of human beings.

The technique employed to make the blade was very advanced and shows an excellent example of ripple flaking. In the Naqada II phase, flint was the most important material in use for making tools such as knives, chisels, punches and scrapers. Apart from its efficacy as a tool, flint, *ds* in the ancient Egyptian language, held a sacred and divine nature. It was used for working calcite and hard stone vessels, statuary, palettes, stelae and the cutting of sunken-reliefs and hieroglyphs, whereas copper or bronze was only effective with softer stones. The scientist Friedrich Mohs (1773-1839) classified the relative hardness of stones into ten ascending degrees, from the softest (one) to the hardest (ten). The placement of flint in degree seven gives an idea of its strength. The knife probably belonged to a chieftain or ruler, since gold was scarce and was used only rarely at the time.

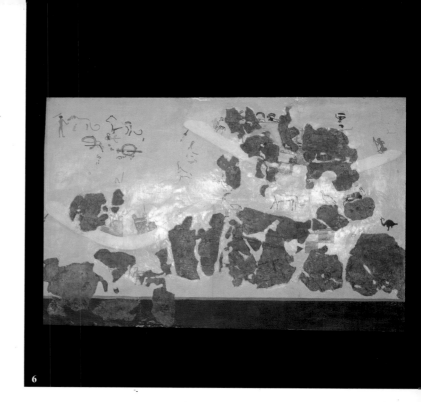

6

6

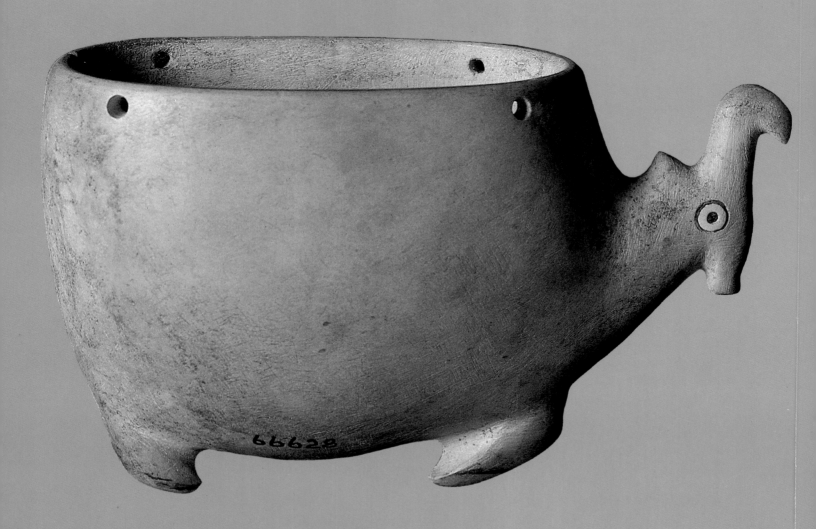

6. Wall painting in Tomb no. 100 at Hieraconpolis

Painted plaster; L. 497 cm;
Predynastic period, Naqada II, *c.* 3500 BC; Upper floor, gallery 54;

This scene, which comes from Tomb no 100 at Hieraconpolis, was discovered at the end of the 19th century by Quibell and Green. This the earliest example of a painted tomb built with brick. It probably belongs to a chieftain, who fought in the battles of the unification of Egypt. The scene shows various activities, including two human figures, fighting. In addition, sacred boats with two cabins are seen, resembling the boats illustrated on Naqada II vases. Another scene shows a man fighting animals. The same themes are repeated on the Gebel el-Arak knife, now in the Louvre, which is one of the most celebrated relics of the Gerzan Predynastic civilisation. The man fighting lions is highly reminiscent of the Mesopotamian Gilgamesh, the lord of beasts and one of the themes of Mesopotamian art that passed into Egyptian sacred art, albeit short-lived.

7. Antelope vessel

Limestone; H. 8.5 cm, L. 14 cm, W. 5 cm;
Predynastic period; Naqada II, *c.* 3500 BC; Ground floor, gallery 43; JE 66628;

During the Predynastic Period, stone vessels in the form of animals reached a perfection of artistry. This vase, which was cut out of limestone, is of uncertain provenance. It features an antelope, whose back is hollowed out to form a kind of oval cup, and has rudimentary legs. It was probably used to keep cosmetic oils or unguents. Surprisingly, it resembles a modern cup with handles. The four holes at the top were most likely meant for hanging it up, by means of a wire or rope.

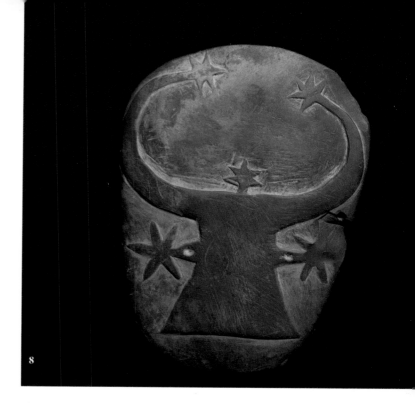

8

8. Cosmetic palette

Schist, Gerza; H. 15 cm; Predynastic period; Naqada II, *c.* 3500 BC; Ground floor, gallery 43; JE 43103;

This palette is made of schist, *bekhen* in the ancient Egyptian language, which was quarried in Sinai and the Eastern Desert. It was found in a tomb at Gerza, beside al-Lisht, 25 km south of Saqqara. It has the shield shape that was popular during the Naqada II phase and shows a very stylised representation of the head of a goddess with horns and ears. This is probably the first known representation of the goddess Hathor, who at this stage was associated with cosmology. The horns are raised and curved, ending with two stars. Two other stars adorn the ears and a fifth star is situated between the two horns. Zoomorphic palettes would continue to be produced during the Naqada II phase, taking the forms of fish, tortoises, elephants, hippopotami and rams. Such palettes made their first appearance in tombs, but later were also found in temple ruins where they are thought to have had a function in commemorating events.

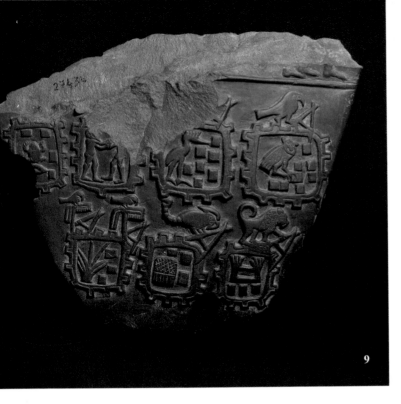

9. The Libyan palette

Schist; Abydos; H. 19 cm; W. 22 cm;
Predynastic Period; *c.* 3100 BC; Ground floor, gallery 43;
JE 27434 = CG 14238;

This schist palette found at Abydos dates from the Predynastic Period, and is an example of a palette commemorating a major event. Both its faces are inscribed, but its upper part has been destroyed. What remains of the back of the palette shows four registers. The division of the scene into registers was one of the conventions of Egyptian art that would be respected throughout the history of ancient Egypt. The first register shows oxen with stylised eyes and muscles reflecting their strength; the second shows donkeys with plump bodies; the third shows a row of three rams, with the fourth, looking backward, represented on a smaller scale, perhaps owing to the lack of space, or to the artist's desire to introduce variety in the poses to avoid the monotony of a line of animals or to add liveliness to the scene. The fourth register shows eight trees, probably olives. On the right hand side we can see one of the oldest specimens of writing ever found: the word *tehenw*, the name of the western Delta region that included parts of Libya, variously called *temehu*. These animals were probably spoils of war and the olive trees imported from Libya, so that this palette may have commemorated a victory over the Libyans.

On the other side of the palette we see representations of seven cities depicted as fortified enclosures, with their name inscribed in each. Over each fortification we see an animal such as a lion, a scorpion or a falcon holding a mattock, probably symbolising the foundation of these cities.

Several other predynastic palettes commemorating events or the theme of victory after a long struggle, such as the palette of the lion hunt and the palette of the battlefield, were found in Egypt.

9

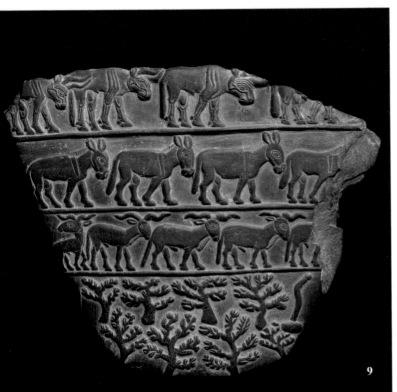

9

The Archaic Period

The Archaic Period lasted for two dynasties between about the thirty-first and twenty-seventh centuries BC, at the start of a very long history of thirty Egyptian dynasties. During this short period, Egypt developed from a range of small communities to a powerful, literate, unified, wealthy and integrated country. Elements of an extant Egyptian civilisation appeared during the Archaic Period, achieving forms that would persist for three thousand years and would make Egypt the first and most powerful states in antiquity. This era preceding the Old Kingdom is also known as the Early Dynastic or Thinite Period-after Thinis in Abydos, then an important centre in Upper Egypt where many powerful kings originated. This is the foundation period of a great civilisation, and surveying it is like digging to reveal the base of the glory of the thirty centuries to follow.

Ancient Egyptian writing seems to have developed at the beginning of the First Dynasty, replacing the use of symbols to register events. The pictorial script, an offshoot of pictorial art, comprised twenty-four letters. The ancient Egyptians called their language *mdw-ntr*, 'the divine words' or 'the words of the god'. The word hieroglyph comes from the Greek, and also means 'sacred writing'. An abbreviated and simplified form of writing, called hieratic, was used equally in the administration of the new centralised government. Paper was manufactured from the papyrus plant, while rush and reeds were used as writing tools. Other writing materials included limestone slabs, ostraca, and wooden and slate palettes.

Numbers appeared and symbols were introduced for ten, one hundred, one thousand, ten thousand, one hundred thousand and a million to facilitate calculation. Surveys were carried out every two years, and included counting cattle, measuring land and cultivated areas, calculating the revenues from quarries, carrying out censuses and evaluating individual property. These were first done during the reign of the First-Dynasty King Edjib and applied to administrative purposes.

The most important cities of the Archaic period were Thinis, near Abydos; Nekhen or Hierakonpolis, near al-Kab; and Memphis. Memphis, the new capital of the unified country, was built in a central place between the north and the south and was named at first *inb hedg* (white wall), which later became *mn-nfr* (stable and beau-

tiful), or Memphis in Greek. The pyramid of Pepi I at Saqqara, the cemetery of Memphis, was also originally named *mn-nfr*. Memphis would always maintain its position as an important political and religious centre even in the Middle and New Kingdoms when Egypt had moved its capital elsewhere.

The theologians of this city believed that the god Ptah created the world by the power of both his heart and his tongue. Other gods were worshipped beside him, such as the god Skr who was associated with the dead and after whom Saqqara was named.

The First and Second Dynasties each had eight kings. They lived in palaces made of mud brick with projections and recesses built into the walls, which were covered with painted plaster decorated with mats of woven reeds. No trace of these palaces exists today. The royal palace was called *pr-aa* (the great house), from which the title 'pharaoh' would be derived and given to the kings of ancient Egypt at a later period.

Kingship remained hereditary for the duration of each dynasty. Sometimes kings had recourse to political marriages to maintain the national unity of the country, as in the case of Narmer, the first king of the First Dynasty, who married a princess of Lower Egypt named Nithotep, or of another First-Dynasty king, Den, who married a northern princess, Mryt Nit.

The function of vizier appears during the Archaic Period under King Den, whose first recorded vizier was Hemaka. During this period the royal titulary included the king's name written in the *serekh*, a representation of the palace façade, and, since the king was recognised as the divine heir of Horus, was surmounted by a representation of that god. The second royal title was *nbty*, meaning 'the two ladies', which stressed his relation to the two female deities, Nekhbet, the vulture of the south, and Wadjet, the cobra of the north. Starting with Den, fifth king of the First Dynasty, the title of *nsw-biti*, 'king of Upper and Lower Egypt' was added.

The jubilee festival known as the *heb-sed* was also introduced. According to the Palermo Stone, Den was the first king to have marked his jubilee in this way. During the ceremony the king enacted his ceremonial rejuvenation to reassure his subjects of his fitness to rule and to be recoronnated as king of Upper and Lower Egypt. The *heb-sed* court beside the Step Pyramid at Saqqara demonstrates how the ceremony was enacted.

The stela of the fourth king of this dynasty, Djet, also known as the Serpent King, with its beautiful reliefs, was a prominent work of art created during this period. It is now in the Louvre.

The tombs of the kings of the Archaic Period adopted the form of the *mastaba* (bench), which consisted of a substructure comprising several rooms and a superstructure of mud brick. Stone was used for some parts of the buildings. *mastabas* had varied architectural features: some had two surrounding enclosure walls, the space between the enclosure wall and the *mastaba* being used to perform rites and present offerings. Some had pits containing a whole fleet of boats, while others had models of oxen supplied with real horns placed beside the enclosure wall. Some were built with steps. Qaa, last of the First Dynasty kings, constructed the earliest known funerary temple on the northern side of his *mastaba*. Noblemen were also buried in *mastaba* tombs at Saqqara.

Most of the kings of the Archaic Period had two tombs: one at Saqqara where they were represented as king of Lower Egypt, and the second at the site of Umm al-Geaab near Abydos, where they were represented as king of Upper Egypt. One was the actual tomb, while the second was a mere cenotaph or symbolic tomb; it has however proved difficult to determine with certainty which was which. Some Egyptologists think that the tombs at Saqqara were the real ones since this site was close to the capital, Memphis. These tombs are in better condition, richer and more grandiose, and are surrounded by the tombs of many noble people. A human arm adorned with four exquisite bracelets was found in King Djer's tomb at Abydos. This may well have belonged to his wife, indicating that she could have been buried there with the king himself. Further evidence that the kings may have been buried at Abydos may be inferred from the great pains taken there in the preparation of the royal tombs and in making provision for an everlasting life.

There is much evidence of foreign trade during the First Dynasty. Gold was imported from Nubia, and the name of Djer has been found inscribed on rocks at Wadi Halfa which at that time was called Kush or Upper Nubia. From the north, imported from Phoenicia (modern Syria and Lebanon), came oil, cedar and pinewood-pine resin was a necessary ingredient of mummification solution. Quarries were exploited along the Red Sea, with a road from Edfu in the Nile Valley forming an important link to the coast.

It was necessary to measure the Nile flood, since the payment of land taxes depended on the amount of water available in any given year. Assessing the level of floodwaters also enabled the central government to prepare for potential crises resulting from high or low floods. The main measurement of the Nile was probably taken not far from Memphis, at the place on Roda Island in south Cairo where the Nilometre stands today.

Two treasuries were established, one in the north and one in the south of the country, to collect taxes, the revenues of mining and quarrying expeditions and excise on imports to Egypt from abroad. The treasury of the south was called the *pr hedjet*, the White House while that of the north was *pr desheret*, the Red House.

During the reign of Djer, the third king of the First Dynasty, a treatise about the anatomy of the human body was written. The knowledge gained enabled artists to enhance the quality of their statues in human form. There was some artistic exchange between Egypt and its neighbours, especially Phoenicia and Mesopotamia, whose influence probably manifested itself in the cylindrical seals, the representation of combat against animals and the portrayal of mythical animals with very long necks.

Towards the end of the Second Dynasty the country underwent some political troubles. Conflict arose between the north and south over their respective gods. However, powerful kings, notably Khasekhemwy, put a stop to the insurgency and managed to preserve the unity of Egypt, thus providing a fresh climate for the start of the Old Kingdom.

10. The Narmer palette

Schist, Hieraconpolis; H. 64 cm; W. 42 cm;
First Dynasty, *c.* 3000 B.C.; Ground floor, gallery 43;
JE 32169 = CG 14716;

The Narmer palette, made of schist, was found among the relics of the temple of Horus at Hierakonpolis, the present al-Kom al-Ahmar, which lies twenty kilometres north of Edfu. Narmer was the first of the eight kings of the First Dynasty, so this is the oldest important relic of the Archaic Period and in the whole history of Egypt. The name of Narmer was found on a calcite vase from Abydos which is now in the Pennsylvania Museum. His name also appeared on seals found in recent excavations at Abydos dating from the reigns of Den and Qaa, which mention Narmer as the founder of the First Dynasty. He has been identified with Menes, whom the Egyptian historian Manetho designated as the founder of this dynasty.

Both faces of the palette document the struggle to unify the north and the south of the country. The reverse side is divided into three registers. In the first register is the name of Narmer represented as a fish and a chisel inscribed in the *serekh*. This, one of the earliest specimens of writing composed of two words, is flanked by two cow heads with human features representing the goddess Hathor in what is one of the oldest representations of a god with human features. In the middle register we see the king wearing the *hedjet* (the White Crown of Upper Egypt) and a short kilt to which an ox tail is attached; he is holding his mace, and is about to smite an enemy whom he holds by the hair. The king is followed by his sandal bearer who holds a jar for purification. On the right hand side is a falcon, representing the god Horus, leading six thousand enemies represented by six papyrus stems emerging from a stylised human body. Alternatively, the papyrus might represent the Lower Egyptian Delta region, underlining the supremacy of the king over the two parts of the country. In the third register we see two frightened enemies fleeing in panic.

The other side of the palette comprises four registers. The first is similar to its counterpart on the reverse, while the second shows Narmer wearing the *deshret* (Red Crown of the north) and a short kilt with the attached ox tail. The inscription of his name in front of his face stresses his identity. In one hand he holds his mace and in the other the *nekhekh* (flagellum) that will become a typical royal sceptre symbolising authority. The king is followed by his sandal bearer holding a jar for purification. In front of the king are his vizier and four persons carrying standards representing various nomes of the country. Victory is represented by ten decapitated enemies with their heads placed between their legs, while over them is a representation of a falcon and a symbolic boat, probably for pilgrimage to the sacred cities *p* and *dp* in the western Delta.

In the third register are two mythical animals with twisted heads, firmly held by two attendants by ropes attached to their necks. This may be a symbolic representation of the unity between the southern and northern parts of the country, or it may equally symbolise the end of the state of war between the north and south.

The fourth register shows the king as a strong bull, *ka-nkht*, destroying a fortress while one of his enemies lies beneath him. However he is not killing this enemy; rather it symbolises the stage of the bloodless 'white victory' which was the last phase of the struggle for the unification of Egypt.

The tradition of showing the king as a taller figure is respected in the representation on both sides. The Narmer palette is a reflection of the high artistic and symbolic levels attained in the Archaic Period, together with great technical skills in the polishing of schist and the representation of human anatomy.

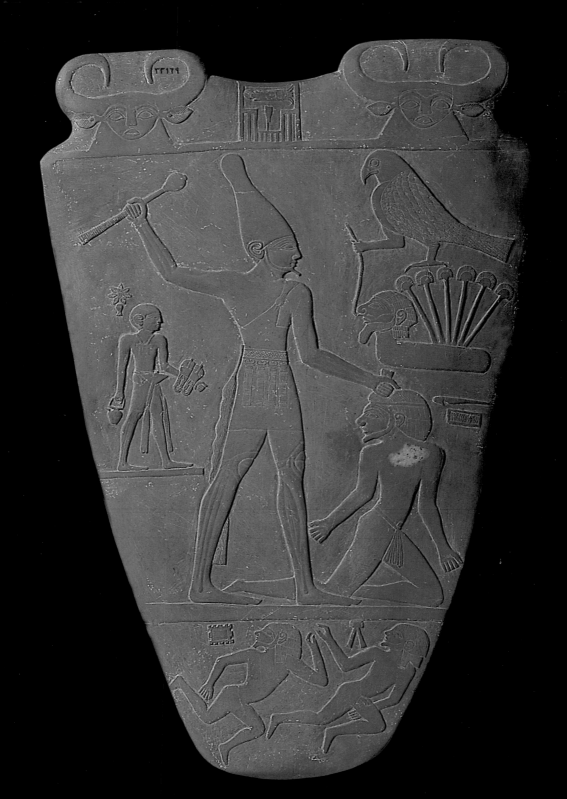

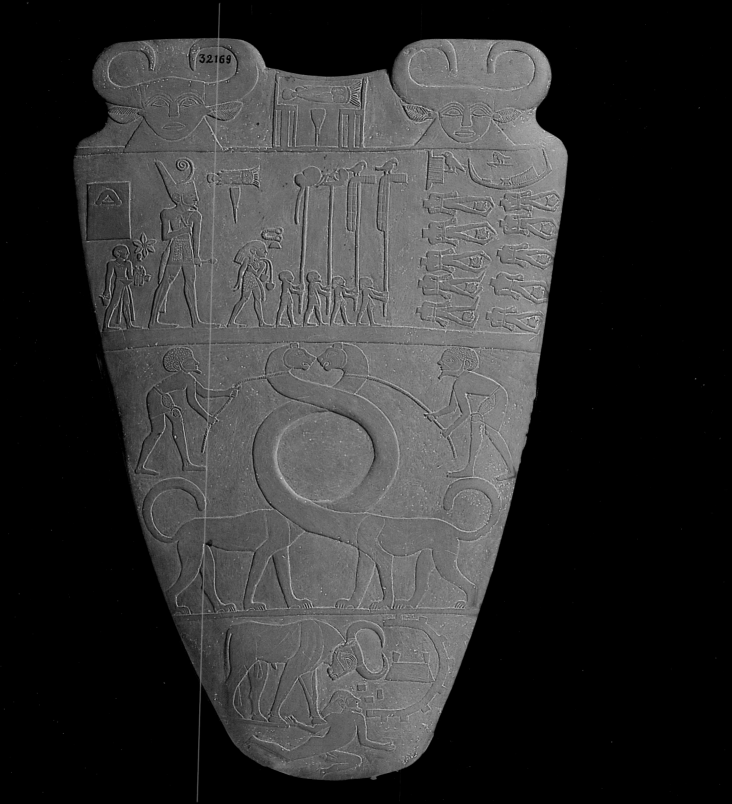

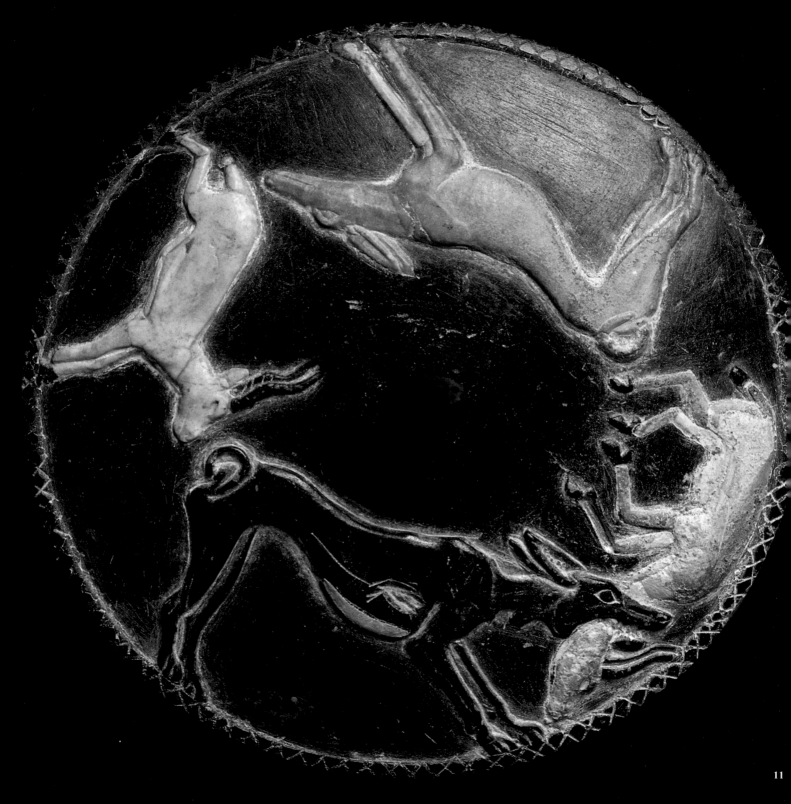

11 - 13. Discs from the tomb of Hemaka

Saqqara, 1st Dynasty, *c.* 3000 BC , reign of King Den;
Ground floor, gallery 43;

These three stone discs were discovered in a wooden box in the tomb of Hemaka at Saqqara. They are inlaid with various kinds of stone including black steatite, alabaster, granite schist and limestone, and are considered a testament to the refined workmanship of the period.

They may have been small spinning tops or pieces used for indoor games. One shows a hunting scene with two hounds and two gazelles represented in relief, with both gazelles and one of the hounds inlaid with pink alabaster. The representation is symmetrical and gracious, showing the artist's observance of the circular shape and the space available. The scene itself, which reveals the alertness of the hound preparing to attack the gazelle, adds to the beauty of the disc.

Geometrical motives and fine inlays decorate the second disc, while the third shows two flying birds facing each other together with geometrical motives.

The *mastaba* tomb of Hemaka was one of the richest in content ever discovered from the Archaic Period. Hemaka may have been the first person to occupy the position of vizier, and was an esteemed treasurer of Lower Egypt during the reign of the First-Dynasty king Den; he bore the title 'the one who rules in the king's heart'. His *mastaba* contained forty-two rooms in which many splendid objects were found, including knives, tools, jars and game pieces.

Hemaka probably lived in a mud-brick house in Memphis, but no private houses dating from this period have been found on the site of city owing to the degradability of that construction material. Moreover, it has been a permanently settled area and as such has been continuously built over. The tombs in the cemetery, hidden in the sand and situated above the flood plain away from the inhabited areas, were in a relatively safe location.

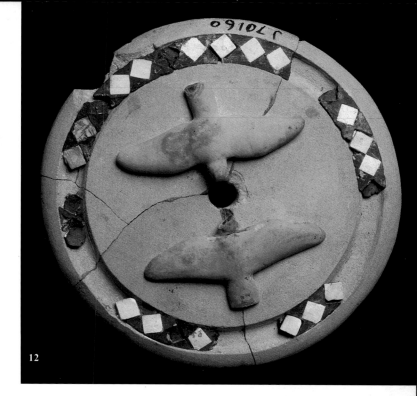

12

13

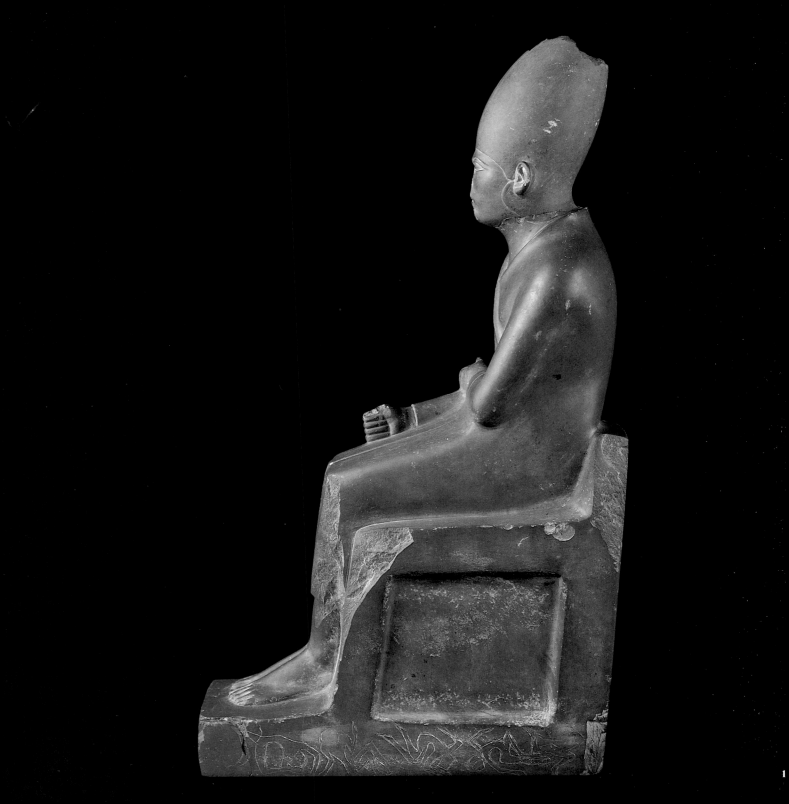

14. King Khasekhem

Schist, Hierakonpolis; H. 56.5 cm; W. 13.3 cm;
2nd Dynasty; reign of Khasekhem, *c.* 2714 - 2687 BC;
Ground floor, gallery 48; JE 32161;

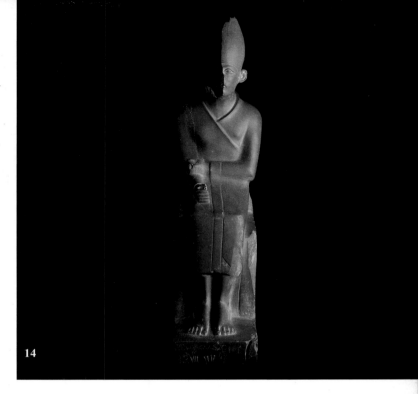

The statue of Khasekhem is the oldest royal statue found in Egypt, and was unearthed at Hierakonpolis. Sculpted out of schist, it shows the king sitting on the throne, wearing the cloak of the *heb-sed* jubilee festival and the *hedget* (White Crown of Upper Egypt). He places the left hand over the right arm in an archaic pose. Over the base of the statue are symbols and numbers enumerating the enemies he has overcome. They number 47,209, probably an exaggeration so as to add to the appearance of power. The number is written as four *djeba* (fingers) or 4×10 000; seven *kha* (papyrus plants) or 7×1000; two *mdj* (spirals) or 2 ×100; and nine *psdj* (strokes) or 9×1.

Khasekhem is wearing the typical garment for the symbolic *sed* festival, during which the king's power and kingship was confirmed and renewed. Kings underwent this ceremony after thirty years on the throne, or whenever they wished to show they had overcome a major obstacle. The festival was linked to the ancient belief that the welfare of the country and the fertility of the land depended on the vigour of the king.

Khasekhem's reign was a stormy one. His predecessor Peribsen, the sixth king of the Second Dynasty, had replaced the main god Horus with Seth, placing the latter on his *serekh*. Khasekhem was forced to take military measures to resolve the resulting conflict and succeed in tightening his control over the two parts of the country. His very name, Khasekhem, means the rise of power.

Another statue of the same king, sculpted in limestone, is now in the Ashmolean Museum in Oxford. This statue is the earliest example in stone of what would become a precept in the statuary of Ancient Egypt: a four-sided composition wherein the profile is as strong as the frontal view.

14

14

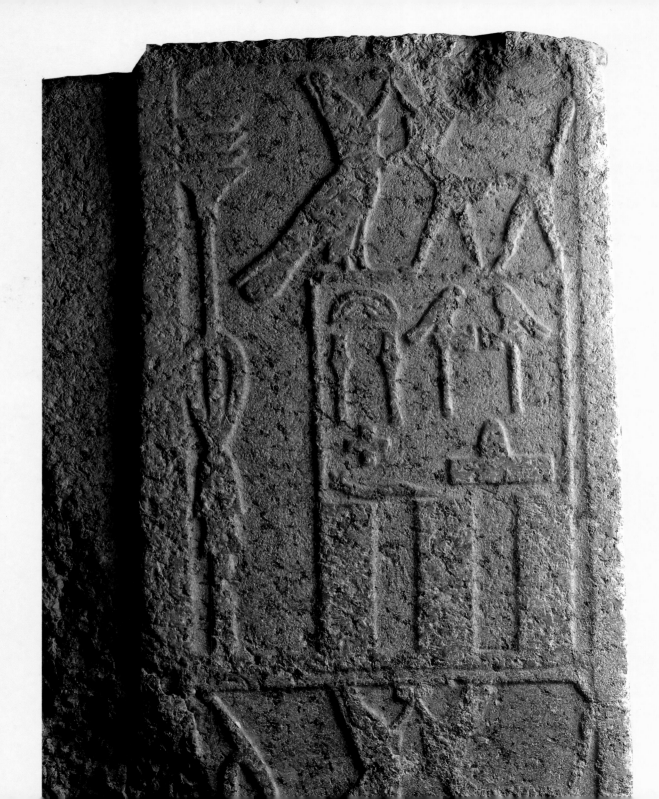

15. Relief showing the name of Khasekhemwy

Granite, Hierakonpolis; 2nd Dynasty; reign of Khasekhem,
c. 2714 - 2687 BC.; Ground floor, gallery 36; JE 33896;

This relief from a granite wall in the temple built at Hierakonpolis by Khasekhemwy shows an image from the king's *serekh*, the representation of a palace façade. In the Archaic Period the *serekh* was usually surmounted by the image of the god Horus, but during the reign of Peribsen Horus was replaced by the god Seth, represented as a mythical animal with an extended snout and short ears. Peribsen's successor Khasekhem re-established the god Horus over the *serekh*, while Khasekhemwy placed both gods over his *serekh*. The name of the king, Khasekhemwy, means 'the rise of the two powers', that is, the powers of Horus and of Seth, indicating that a compromise was reached between the north and the south of Egypt.

Some historians think that Khasekhem and Khasekhemwy may be one and the same person. They suggest Khasekhem initially attempted to check the conflict without putting an end to it, but later succeeded and managed to establish peace with the north, placing the two gods together on the *serekh* and adopting a new name, Khasekhemwy. His wife's name, Queen Ni-maat Hapi, means '*maat* belonging to Apis (the bull of Memphis)' and suggests her northern origin.

On the obverse face we see two eroded figures whose silhouette is still visible. The scene shows part of the ritual of the foundation of the temple in the presence of the king and Seshat, the goddess of calculation whose role was to represent the sacred powers. They hold a staff and a rope to measure the corners of the temple. There were two interwoven aspects in the erection of Egyptian temples: the cultic aspect and the practical matter of building.

The cultic aspect began with the foundation ceremony, the laying of the cornerstone. The first step of this rite was to mark the bounds of the building site by stretching a rope to create a sacred space. The next rite was to dig the earth from the foundations and pour in sand, to place sacrificial animals in the pit, and to smooth the sides and seal it with bricks. Khasekhemwy's reign brought the Second Dynasty to an end. He was succeeded by his son Djoser after the short reigns of two other kings in the Third Dynasty.

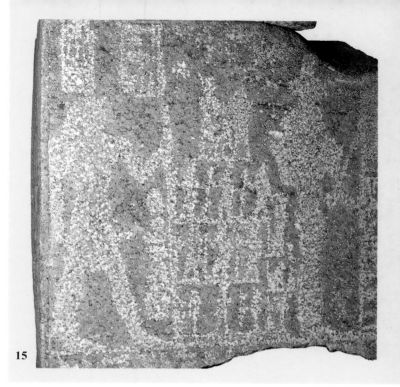

15

The Old Kingdom

The Old Kingdom went through periods of grace and innovation, splendour and stability, religious piety and luxury, but it also suffered cycles of revolt and a ponderous level of bureaucracy. It lasted from the Third Dynasty to the end of the Sixth Dynasty, that is between the twenty-seventh and twenty-second centuries BC.

The real founder of the Third Dynasty is considered to be Djoser (2687 to 2668 BC). This dynasty stands out as a time of refinement and invention. The architect of Djoser's Step Pyramid complex, Imhotep, who was revered in his lifetime and later deified, introduced two major innovations in building techniques: the creation of the pyramid shape and the use of dressed stone for the entire construction. The stone buildings of the funerary complex are assumed to have been modelled on their worldly counterparts in Memphis, which had walls of mud brick and supports of bunched papyrus stems. Fortunately the complex is in a good state of preservation, as the brick buildings have disappeared.

Imhotep was among the three most famous architects in ancient Egypt, the other two being from the New Kingdom: Senmut, the architect of the temple of Hatshepsut at Deir al-Baheri, and Amenhotep, son of Hapu, the architect of Pharaoh Amenhotep III. Imhotep was also a doctor, an astronomer and the inventor of proverbs. His deification was decreed during the Twenty-sixth Dynasty when he was declared the son of Ptah, the god of Memphis and of craftsmen. In the Graeco-Roman period he was likened to Asklepios, the Greek god of medicine. Djoser and Imhotep are mentioned on a stela now located on Suhail Island, on the Nile south of Aswan, in a story recounting how Imhotep helped the king to bring relief during a famine caused by a low Nile flood.

Egyptian civilisation took another turn in Djoser's reign when increased interest in astronomy led to the invention of a solar astronomical calendar. In this calendar, the year comprised 365 days and twelve thirty-day months. During the last five days, celebrations for the birth of Isis, Osiris, Seth, Nephthys and Horus took place. The year was divided into three four-month seasons starting with the *akhet* flood season, followed by *prt*, winter, and ending with *shemw*, the low water season. Ancient Egyptian astronomers had noticed that *spdt*, the dog star Sirius, disappeared for seventy days and then reappeared in the eastern horizon; that phenomenon marked the beginning of the first day of the first month of the first season, the *akhet* flood season, or 17th July according to the Julian calendar. These ancient calendar months with their pharaonic names still make up the Coptic calendar today, and were used by all Egyptian farmers as an agricultural guide before the construction of the high dam in Aswan.

Djoser's successor, Sekhemkhet, started but never finished a step pyramid at Saqqara. Several other rulers ascended the throne in quick succession ending with Huni, the first king to write his name in a cartouche, that is, an oval shape representing the eternal and endless authority of the king.

The Fourth Dynasty (2649 to 2513 BC) was a period of splendour and stability wherein the idea of divine kingship was accentuated. The king was at the summit of society; he was the source of power in the country and of the welfare of its people.

The Fourth Dynasty was established by the pious Sneferu. His Northern Pyramid at Dahshur is the oldest existing true pyramid in ancient Egypt, the fruit of an architectural sequence that began with the step pyramids in Saqqara, the Meidum Pyramid and his own Bent Pyramid at Dahshur. Several stories in ancient Egyptian literature describe Sneferu's qualities as a king and tell of his modesty and his respect for the savants at his court. The tale of 'Sneferu and the Wise Men' concerns the king's desire to meet Nefer-rehu, a wise and cultured lector priest from Bubastis in the Delta, to hear him tell short stories to enrich his own knowledge and culture.

When Cheops (Khufu) inherited the throne of Egypt from his father Sneferu in 2609 BC he continued his father's policy of consolidating the state, exploiting quarries and improving commercial relations with neighbouring countries. His priceless legacy was the new royal cemetery at Giza, where he erected the most famous and celebrated of all the monuments in the world, then and since: the Great Pyramid. His pyramid complex, apart from the mortuary temple, included a causeway, a valley temple, pyramids for the queens and a subsidiary pyramid, and five boat pits near the eastern and southern faces of the pyramid. Family members and nobles were buried in *mastaba* tombs which lie on the east and west sides of the pyramid. In the ancient tale of 'Cheops and the wise man Gedi', written down on the Westcar Papyrus, Cheops is shown as a benevolent man who held his ancestors and his savants in great esteem, seeking the advice of wise men in times of need.

Cheops was succeeded by his son Djedefre (2584 to 2576 BC), whose name was found on one of the blocks sealing the southern boat pit near Cheops's pyramid and who ruled for eight years, during which he produced the first statue of a sphinx in ancient Egypt. He built his pyramid at Abu Rawash, eight kilometres north of Giza.

Chephren (Khafre), son of Cheops and Djedefre's brother, followed him on the throne. His building projects, as gigantic as those of his father, included his pyramid, a mortuary temple, a causeway, the Great Sphinx and the valley temple lying in front of its paws. During Djedefre's reign the *sa-ra* or 'son of Ra' title was added to the existing titulary of the king, i.e., the Horus name in the *serekh*, the *nsw biti* and the *nbty*.

The third, smallest and last pyramid on the Giza plateau was built by Menkaure (Mycerinus), whose funerary temple was completed in haste by his successor Shepseskaf. Menkaure, who ruled from 2551 to 2523 BC, was the first king to open the royal palace to the sons of noblemen so they could be brought up with the king's heir, thus guaranteeing their friendship and loyalty.

Shepseskaf (2523 to 2519 BC) built a tomb resembling a *mastaba*, or even a sarcophagus (in Arabic *mastaba Faraoun*), in the southern part of Saqqara. The small size of the tomb exemplifies the decline of Egypt's economy as well as of the power of the king at the end of Fourth Dynasty. Also reflecting this situation, Shepseskaf would for the first time allow a nobleman, Shepsesptah, who had been brought up with Menkaure, to marry a princess of the royal blood, his own daughter. He would also exempt the high priests from taxation to win their fidelity.

Shepseskaf was succeeded by his wife and sister Khentkawes, who built a tomb similar to her brother's where her titles, 'Queen of Upper and Lower Egypt' and 'Mother of the King of Upper and Lower Egypt' were inscribed. She was the last sovereign of the Fourth Dynasty.

The Fifth Dynasty (2513 to 2374) was a time of religious piety and luxury. The cult of the sun god Ra spread to the whole nation, the ties between the royal palace and the noble class increased and trade between Egypt and its neighbours in Phoenicia and Punt (modern Somalia and Ethiopia) flourished. The first king of the Fifth Dynasty, Userkaf, who might have been either a descendant of Menkaure and a secondary queen, or might have been a high priest of Ra, married Shepseskaf's widow Khentkawes. Userkaf sought further to consolidate his legitimacy to the throne by claiming that he was begotten by the spirit of the god Ra transmitted to his mother by one of the high priests of the cult of this god.

Iwn, Heliopolis, the centre of the cult of the sun god Ra, would be of central importance for the eight kings who succeeded Userkaf. Other temples dedicated to the sun were built at Abu-Sir and Abu Ghourab, a few kilometres north of Saqqara.

The kings of the Fifth Dynasty continued to build pyramids at Saqqara and Abu-Sir but they were neither as large nor as grandiose as those of the Fourth Dynasty, and neither were they so solidly-built and so long-lasting.

Part of the revenue and interests of the country were funnelled towards the cult of Ra, its temples and its priesthood, reflecting the national spirit of the Fifth Dynasty. The artistic sense in the temples of the funerary complexes and the sun temples was very strong, with great attention being paid to mural decorations and to the forms of columns. Userkaf's successor Sahure (2506 to 2492 BC) placed a 10 000 m^2 mural relief in his funerary temple decorated with scenes representing the king's victories, his relationship to the gods, feasts, quarrying expeditions, sea trade, and imports from neighbouring countries. Only 150 m^2 of this great mural are now left. An elaborate drainage system was introduced in temples to carry excess rainwater or water used in rituals.

The pyramid of Unas, the last king of the Fifth Dynasty (2404 to 2374 BC), contains the first example of an inscription of the Pyramid Texts. These well-preserved religious and mythical texts were carved in relief and painted in a highly artistic style and with a great awareness of symmetry in the details. The ceiling of the burial chamber was painted blue and decorated with stars as though the king's mummy was directly under the protection of the heavens.

The Pyramid Texts were not composed especially for Unas, nor do they relate to a certain era. They consisted of religious ideas and formulas created at various ages according to different creeds and theological attitudes. In the period prior to the reign of Unas these texts were familiar to the lector priests and wise men, who memorised and repeated them orally during certain rites, occasions and ceremonies. It was Unas who ordered that the texts, which had already existed long before him, be registered inside his pyramid in order for his mummy to benefit eternally from their power.

The texts turned out to be very important, not only for the king, as was their intention, but also for Egyptologists. They have provided an invaluable source of knowledge about the religious beliefs of the ancient Egyptians of that time. This includes religious formulae, names and attributes of gods, divine qualities of kings, theories about the creation of the world, the relation between the gods, the hopes of pious kings for the afterlife, and their fear of the obstacles that might hinder their way to immortality.

In the Fifth Dynasty, during the reign of Sahure, Egypt consolidated its commercial relations with Punt by importing such commodities as incense, spices, gum used in temple rites, ivory, semi-precious stones, and wood. Commercial relations with Phoenicia also grew stronger, and a Phoenician princess-bride was even sent to the king to confirm the good relations between the two countries and to assure their future friendship and cooperation. This is the very first example of a political marriage between an Egyptian king and a foreign princess.

The kings of the Fifth Dynasty gave increased privileges to the priesthood of the cult of the god Ra to ensure their loyalty, and like Shepseskaf in the Fourth Dynasty they exempted them and some of the other priests from taxation. They also loosened their grip over the government, allowing high officials to take the post of vizier which in the Fourth Dynasty had been the exclusive preserve of princes of the royal family. They authorised marriages between these high officials and princesses of the royal blood, and they allowed sons to inherit the high posts occupied by their fathers. The kings would compliment these high officials, as can be seen in the letter of the Fifth-Dynasty King Isesi to his vizier Shepsesra praising him, paying him compliments and expressing his appreciation of him.

The viziers acquired great prestige during the Fifth Dynasty, and their responsibilities increased in correspondence to their wealth and power. They were no longer committed to building their tombs beside the pyramids of the kings but dispersed them instead throughout Giza and Saqqara. The governors of the nomes built their tombs in local cemeteries. Their *mastaba* tombs were vast and grandiose, consisting of a superstructure containing several rooms, pillars and statues, and decorated with exquisite reliefs showing scenes of daily life complete with servants, a life of luxury they would continue to enjoy in the hereafter. These depictions are like an open book, enabling the beholder to glimpse the lifestyle of the Old Kingdom aristocracy. They listed their property, sports, pastimes and entertainment as well as the activities of the labourers and craftsmen in the workshops they owned. The *mastabas* of Ti and Ptahhotep attest to the luxurious way of life of these viziers and high officials.

A sage and also a vizier in the court of Isesi, Ptahhotep composed a famous compilation of maxims about good behaviour, values, and ethics. He addressed his instructions to his son, advising him about the proper behaviour he should adopt towards his wife and family, his superiors at work and his profession in general, and about his duties towards the gods and himself.

The first king of the Sixth Dynasty was Teti (2374 to 2354 BC). The pyramid he built at Saqqara followed the style of Unas in having the walls of the burial chamber inscribed with the Pyramid Texts. His high officials, including Kagemny and Mereruke, built their *mastaba* tombs around his pyramid. Mereruke, who married Teti's daughter Seshseshet, built for himself the largest *mastaba* in Saqqara which consists of 32 chambers and attests to his wealth and prestige. *Mastaba* tombs of the high officials of the Sixth Dynasty surpassed those of previous dynasties in grandeur, innovation in terms of the artistic depiction of the clothes of the figures, the poses of the dancers and the freedom of expression.

The kings of the Sixth Dynasty built their pyramids in the northern part of Saqqara with the exception of Pepi II, who built his in the southern part of this necropolis. Like those of the Fifth Dynasty, their pyramids were small but were carefully inscribed with the Pyramid Texts.

New poses were introduced for the royal statues. Pepi I (2354 to 2310 BC), for example, is represented as a naked child in one, sitting on his mother's lap in another, while in a third he is kneeling to present an offering. A fourth shows him as an old man accompanying his son and heir. It is believed these statues prove the king was thought of as a mortal rather than a god, since he is shown kneeling in submission to present an offering to a god.

The high officials of the Sixth Dynasty became even more prominent and powerful, especially those in the large provinces of Middle and Upper Egypt. Following the custom initiated in the Fourth Dynasty by Menkaure, the sons of high officials were brought up in the royal palace at Memphis. This not only brought

them close to the throne and guaranteed their loyalty, but also increased their status and power base.

Throughout the Sixth Dynasty there were changes in the political and social aspects and in relations with neighbouring countries. For the first time in the history of Egypt we see a king, Pepi I, marrying a non-royal bride, the daughter of Khwy, a governor of one a province in Upper Egypt, whom he chose over others as his main queen. Pepi looked beyond the borders of Egypt, sending his army general Wni to check the advance of nomadic tribes in Palestine who were raiding commercial expeditions on the way to what is now Syria. More expeditions were sent beyond the southern borders of Egypt to fetch gold, quarry diorite stone and on trade missions. One governor of Aswan who lived in the reign of Pepi II, Horkhof, led four expeditions to the south. He and other local dignitaries were buried in a cemetery overlooking the Nile at Aswan in tombs hewn out of the mountains on the west bank.

Pepi II inherited the throne of Egypt as a small boy in 2300 BC, and for the first years was supported by his mother and uncle. His reign of ninety-four years is the longest in the history of ancient Egypt. It resulted in a weakening of the central royal power and an increase in the wealth and power of the high officials and local governors of the provinces, who maintained a hereditary hierarchy by passing on their posts and rank to their sons without a need for the king's consent. Meanwhile, the northeastern boundaries were under constant threat from warring nomads from Palestine and rebellious tribes in Sinai who were imperilling the country's security and depriving it of the wealth generated by trade with its northern and eastern neighbours.

The picture of events at the end of the Sixth Dynasty was revealed by Ipw-wer, a sage who lived at the end of Pepi II's reign. He wrote about what he described as a social revolution in protest at deteriorating social and political conditions. The revolution started in the capital. According to Ipw-wer, "The capital was turned upside down in one hour… people looted the houses of the rich class and also looted their tombs… the land diminished, its rulers multiplied… The neighbours who used to fear Egyptian power now think that Egypt has nothing but the sand for protection… Nomads are depriving the Egyptians of their living… Foreigners are everywhere, meanwhile the Egyptians are foreigners in their country… Aswan and Upper Egypt no longer send taxes to the central government… No ships sail to Byblos to fetch cedarwood… Law records were trampled by the mob in the streets… The land is turned as a potter's wheel, the rich are impoverished and the poor enrich themselves by looting; those who used to go barefoot now have sandals and the servants who only used to see their faces reflected in the water now have mirrors… People find nothing but grass to eat."

Although it presents a bleak picture, the revolution caused a growth of social awareness which spread among the intelligentsia. They reacted to the civil unrest by seeking to determine a new image for the king, an imperative step after the long years of deterioration.

Pepi II died in 2206 BC. At the end of the Sixth Dynasty, according to the Turin Papyrus, a queen by the name of Nitikrit ruled for a short time. But the last years of the Old Kingdom are clouded in mystery, as are conditions in the short Seventh Dynasty.

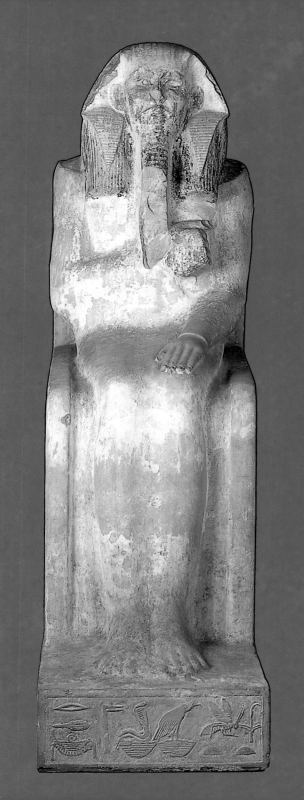

16. King Djoser

Painted limestone, Saqqara; H. 142 cm; W. 45.3 cm;
3rd Dynasty; reign of Djoser, 2687 - 2668 BC;
Ground floor, gallery 48; JE 49158;

This Statue of Djoser is the oldest life-size statue so far found from ancient Egypt. It was made of limestone, *inr-hedj* in ancient Egyptian, brought from the district of Tura, south of Cairo, or from the Muqqatam Hills, also near Cairo. It was found in the *serdab*, a closed chamber adjoining the north side of the pyramid of Djoser at Saqqara, beside his mortuary temple. In front of the eyes of the statue were two holes to allow the king to look at the offerings presented in the nearby mortuary temple and to gaze at the northern stars. Today, a replica replaces this original statue in the Step Pyramid's *serdab* at Saqqara.

Djoser is dressed in a long robe, hiding the details of his body. Here, for the first time, a king is shown wearing the *nemes*, the pleated royal headdress which covers his heavy wig, both used by the artist as devices to consolidate the neck of the limestone statue. The ears remain uncovered to enable the king to hear the prayers said in the mortuary temple. He wears a false beard, one of the emblems of royalty, as well as a moustache, which is only very rarely represented on royal statues. His eyes, probably made of a precious material such as crystal, were taken by tomb robbers.

Djoser places his right hand over the left side of his chest, on his heart, which was considered by the ancient Egyptians as the centre of thinking and wisdom. In so doing he indicates the principle of his reign in which his powerful right hand will follow the wisdom of his righteous heart. His bare feet signify his constant purity.

The name of the king, Neterykhet (*ntry-khet*) or 'the one who has a divine body', is inscribed on the base of the statue. It underlines the idea of the divinity of the king which prevailed during the Old Kingdom. The name Djoser, which means 'the divine' and is represented by a strong arm holding an object (perhaps the Arabic word *djasor*, brave, is derived from this ancient Egyptian word) was added retrospectively during the Middle Kingdom. He also bore titles such as *ra-nbw* or 'golden Ra', *nsw-biti* which was depicted by a reed and a honey-bee designating the king of Upper and Lower Egypt, and *nbty*, the cobra and vulture emblems of the north and south of the country affirming the unification of Egypt.

Djoser made Memphis the capital of Egypt, the position it held throughout the Old Kingdom. Manetho designated him the first of the Memphite kings. His name in the Turin Papyrus is written in red, which suggests the esteem in which he was held by ancient historians.

The heavy proportions of the statue increase the king's majesty. Ancient Egyptian artists were still experimenting with the use of limestone, and shortly after his reign Old Kingdom sculptors produced overwhelmingly beautiful statues that would be considered among the highlights of the ancient Egyptian art.

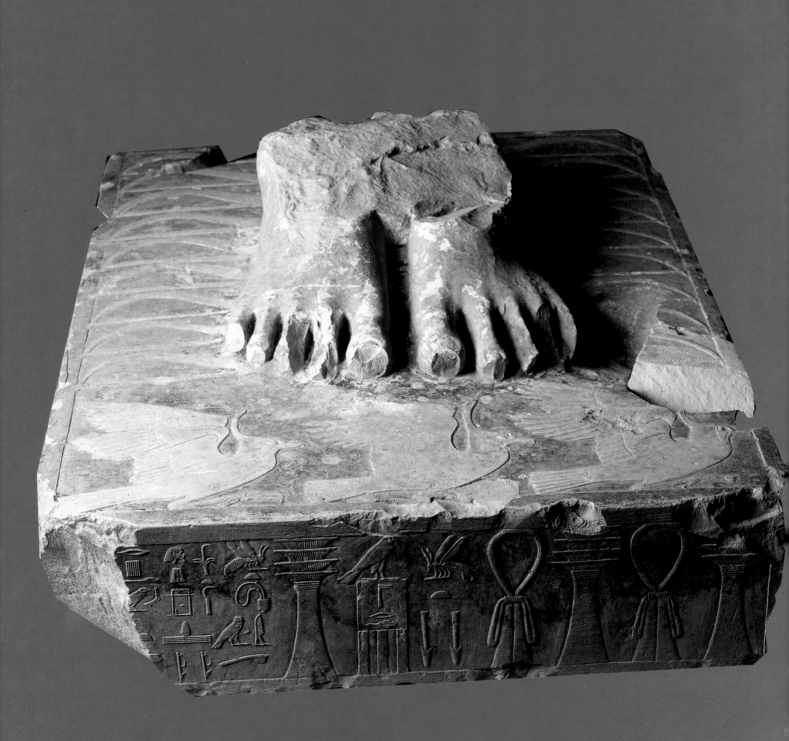

17. Statue base of King Djoser

Painted limestone, Saqqara;
3rd Dynasty; reign of Djoser, 2687 - 2668 BC;
Ground floor, gallery 48;

This base of a limestone statue was found in the south wall of the entrance colonnade, standing between two columns, at Djoser's funerary complex in Saqqara. Inscribed on it is the king's name *ntry-khet* or 'the one who has a divine body'. The king's feet trample over nine bows, representing the traditional enemies of Egypt. The number nine might represent the twice addition of the number 'three' which was frequently used by the Egyptians for symbolizing the plural that it signifies all the enemies. Later statues replaced the bows with real images of chieftains that were the king's enemies.

The base shows the *rkhyt* or 'lapwing birds' that symbolise his Egyptian subjects. The birds' wings are tied and twisted, to show his domination and authority. He does not trample over the *rkhyt* bird as he does over the nine bows, but is seen ruling over them peacefully.

Another title of this pharaoh present on the statue base is *biti,* 'King of Lower Egypt'. We also see the *djed* pillar of Osiris and the *tit* knot of Isis, representing classic signs of stability and fertility in ancient Egypt. One exceptional feature of this royal statue is the presence of a noble man's names; Djoser's great architect Imhotep was honoured by having his titles inscribed here. His name means, 'the one who comes in peace', and his titles on the statue mentions that he was *sedjawty-biti* 'the treasurer of the king of Lower Egypt', *hr-tp-nsw,* 'the one who is under the king', *r-paet,* 'the noble one', *heka hwt aa,* 'the administrator of the great house', *wr maa,* and 'the great seer' (a title of the high priest of god Re in Heliopolis, who was the chief astronomer).

During the 26th Dynasty, Imhotep was deified as the son of the creator god of Memphis Ptah, and of the craftsmen.

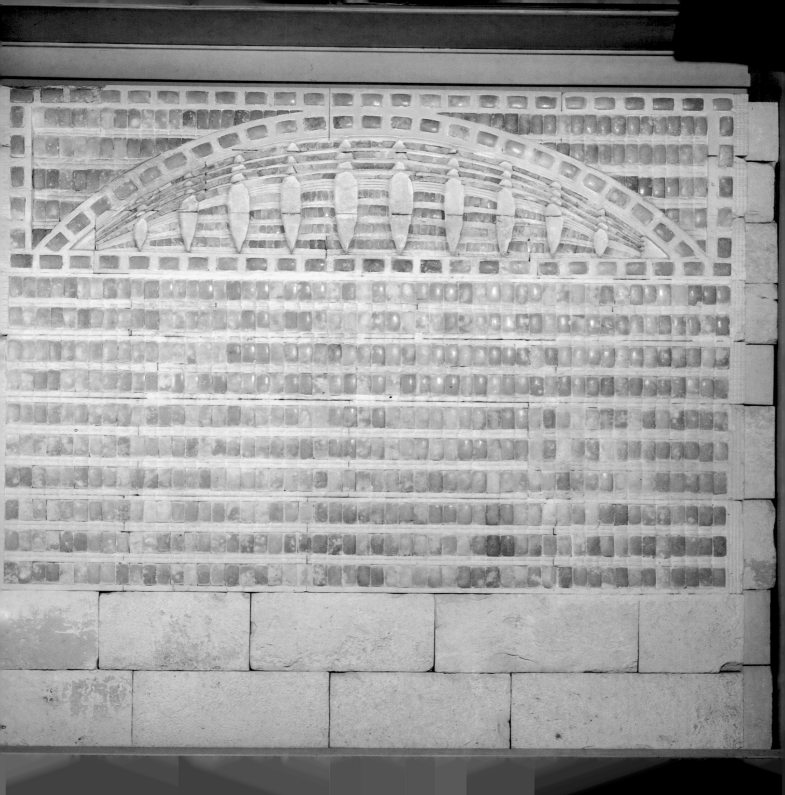

18. Curtain-like faience panel

Limestone and fiance, Saqqara; H. 181 cm, W. 203 cm;
3rd Dynasty; reign of Djoser, 2687 - 2668 BC;
Upper floor, gallery 42; JE 68921;

One of several panels made of faience tiles, and set on limestone walls, this comes from Djoser's Step Pyramid in Saqqara. The panels adorned the four long galleries parallel to the sides of the burial chamber as well as the walls of the connecting passages underneath.

This panel is a reproduction, in blue glazed tiles, of the coloured reed matting, which had hung on the walls of the king's palace during his lifetime in Memphis. The panel top is arched and supported by several representations of *djed* pillars.

Another panel, on the west wall of the east gallery in the substructure of the Step Pyramid, comprised three reliefs, showing the king performing one of the rites of the *sed* festival, with inscriptions of his names and titles. Similar panels were also discovered in Djoser's mastaba tomb in the south west corner of his funerary complex, known as Djoser's southern tomb or the southern mastaba. It was probably a cenotaph tomb for the king.

Some of these tiles were taken to the Egyptian Museum in Berlin by the German Egyptologist Richard Lepsius, in 1843.

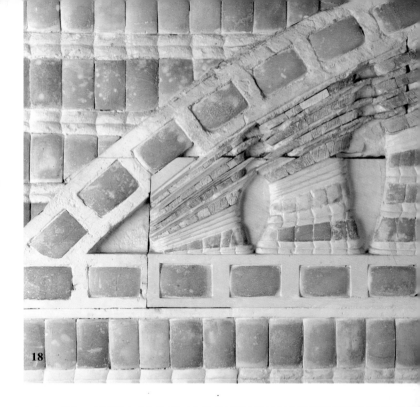

18

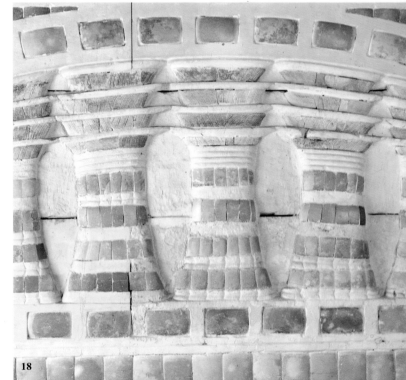

18

19. Statue of King Senefru

Limestone; Dahshur;

4th Dynasty; reign of Sneferu 2649 - 2609 BC;

Ground floor, room 32;

 This statue of Senefru was found in the valley temple at Dahshur by Ahmed Fakhry, in 1954. It shows the king in the traditional manner, wearing the crown of Upper Egypt and the pleated royal kilt, while advancing his left leg forward. He wears a *usekh* pectoral and bracelets on his arms. Senefru's cartouche, giving the name *nsw- biti* king of Upper and Lower Egypt is inscribed on the buckle of the belt. This was one of several statues of the king that were attached to niches within the six shrines, which were in a pillared portico inside the temple. This statue, like the others is larger than life, and is the type of figure that is carved in very high relief, as opposed to a free standing statue.

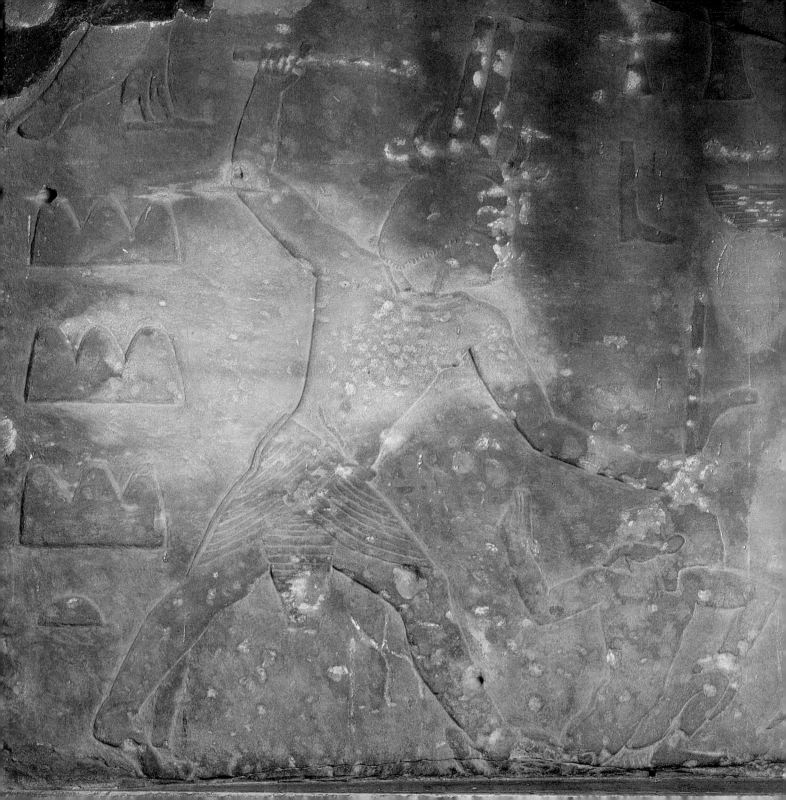

20. Relief of Sneferu from Wadi Maghara

Red sandstone, Wadi Maghara, Sinai; H. 112 cm; W. 130 cm;
4th Dynasty; reign of Sneferu 2649 - 2609 BC;
Ground floor, gallery 31; JE 38568;

This relief of Sneferu was found near the turquoise quarries at Wadi Maghara in South Sinai. It is carved in red sandstone and shows Sneferu, founder of the Fourth Dynasty, in the traditional scene of smiting an enemy.

Here the king raises a mace with his right hand, while holding an enemy by the hair with his left. This pose would be maintained as symbolic of victorious kings for centuries to come. In this scene, the king wears a crown with two feathers and two horns, and the royal pleated kilt or *shndyt*. The name Sneferu, which means 'the one who performs perfection', is shown inside a cartouche. It is preceded by the word *ntr-aa* or 'the great god'. The scene also shows his name in the *serekh* as *neb-maat*, 'the lord of justice and order'. For the ancient Egyptians, *maat* did not only mean order in their country but also cosmic and universal order.

There is evidence that the inhabitants of Sinai may have been smelting copper since the Chalcolithic era, which corresponds to Egypt's Late Predynastic Period. The ancient Egyptians embarked on mining ventures to Sinai to extract its copper and quarry its turquoise and schist. They also sent punitive expeditions against the Sinai tribesmen. Sinai was known to the ancient Egyptians under the name *ta-mfkat*, the land of turquoise stone, and *djw-mfkat*, which means the mountain of turquoise. Gods worshipped there were Hathor, one of whose titles was *nbt-mfkat* or the lady of turquoise, the jackal god Wep-wawut, the opener of the roads, and the god Thoth. Sneferu himself was deified and worshipped there as early as the Middle Kingdom.

Forty-five or so reliefs of ancient Egyptian kings were found at the site of Wadi Maghara, several of which mention the names of Old Kingdom rulers including Djoser and his successor Sekhemkhet. Many reliefs were found with the names of rulers of the Middle and New Kingdoms including Amenemhet III, Ahmose, Queen Hatshepsut and Tuthmosis III, indicating that expeditions and mining activities in Sinai continued. On hearing of the destruction of the historical site by a British mining company using explo-

sives in the area, the Egyptologist Flinders Petrie removed this relief in 1905.

Sneferu built several pyramids: one at Sela, near Fayoum, the Bent Pyramid or Southern Pyramid, and the North Pyramid or Red Pyramid, both at Dahshur. The ancient name of both of the Dahshur pyramids was *kha-sneferu*, or 'the rise of Sneferu'. This king also completed the Meidum pyramid initiated by his father Huni. During his reign, the arrival of a fleet of forty ships carrying cedarwood imported from Lebanon suggests strong commercial relations between Egypt and her neighbours.

21. Relief of Sneferu from Wadi Maghara

Red sandstone, Wadi Maghara, Sinai; H. 112 cm; W. 130 cm;
4th Dynasty; reign of Sneferu 2649 - 2609 BC;
Ground floor, gallery 31; JE 39567;

This relief, also found in the site of Wadi Maghara in Sinai, consists of two registers. The first one shows the king wearing the *hedjet* crown of Upper Egypt and in the conventional pose of a victorious king smiting his enemy, whose hand is raised as though beg-

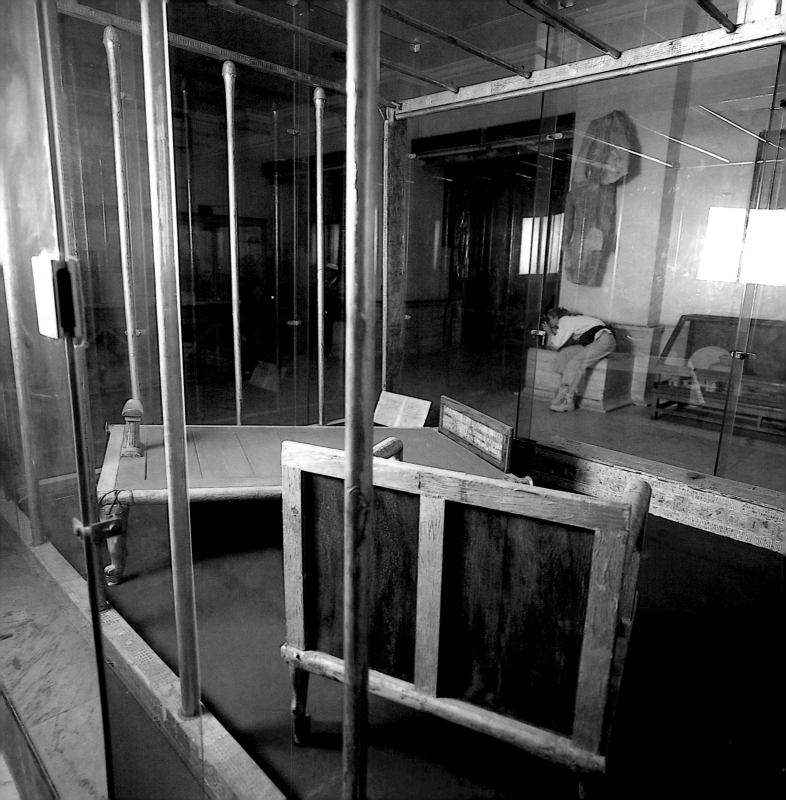

ging for mercy. His Horus name is inscribed as *nb maat*, or 'Lord of Justice'.

The second register shows two representations of the king. He is wearing the crown of Lower Egypt on the right side and on the left side, the crown of Upper Egypt.

22 & 23. Furniture of Queen Hetepheres

Wood, gold, ebony, Giza;
4th Dynasty; reign of Sneferu 2649 - 2609 BC;
Ground floor, room 32;

The furniture and funerary regalia of Queen Hetepheres, the wife of Sneferu and mother of Cheops, was found intact in her makeshift tomb on the Giza plateau in 1925 by a Boston Museum-Harvard expedition led by the Egyptologist George Reisner. According to inscriptions she died while her son was on the throne.

Her exquisite wooden furniture, including a portable canopy, was partly covered with gold leaf. The funerary equipment included pots, gold vessels, a toilet box containing eight small alabaster vases filled with oils and kohl, gold manicure instruments, several anklets and bracelets, and the four canopic jars.

The canopic jars were placed in a chest carved out of a block of translucent alabaster and divided into four square compartments. Each compartment contained a mass formed of the internal organs-the liver, lungs, intestines and stomach-removed during the process of mummification and immersed in a weak solution of natron. These jars and the chest are the oldest ever discovered from ancient Egypt.

The queen's portable canopy was entirely covered with gold leaf and had been fitted with a curtain to provide privacy and protection from insects and cold weather. The curtain was stored in a long gilt box inlaid with the cartouche of her husband Sneferu. The furniture also included two armchairs and a bed frame with headrest, all covered with gold leaf and probably used during the queen's lifetime. The panel on the footboard of the bed was inlaid with a blue and black floral design.

The wood of the sedan chair was badly damaged and had to be replaced. The carrying poles end with palmiform capitals, and gold layers cover the chair edges and borders. A horizontal ebony panel is inscribed in gold with the queen's name and titles: 'The mother of

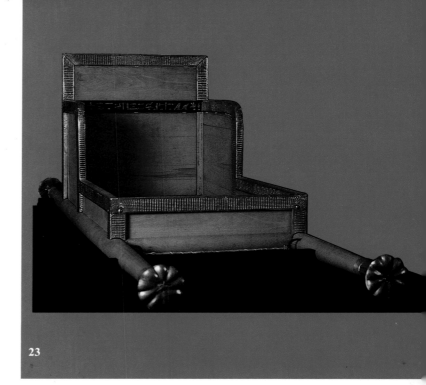

23

the King of Upper and Lower Egypt, Follower of Horus, she who is in charge of the affairs of the harem, whose every word is done for her, daughter of the god, of his loins, Hetepheres'. Queen Hetepheres's name means 'Satisfied is her face'.

It seems that her burial near the three small pyramids beside her son's Great Pyramid was enacted in haste after her original tomb was violated. It is probable that she was first laid to rest near the pyramids of her husband at Dahshur, but that her funerary belongings were taken to the Giza tomb following this robbery. The arrangement of the tomb contents was the reverse of the norm, with the personal articles being placed inside first and the sarcophagus last. Yet the sarcophagus, although carefully interred, proved to be empty and the queen's body was never found. It had probably been stolen, either by the original tomb robbers for the valuables wrapped in the mummy bindings or during its journey from Dahshur to Giza. Whichever, no one dared tell her son the king, who knew that the first tomb had been disturbed but believed she was being safely reburied.

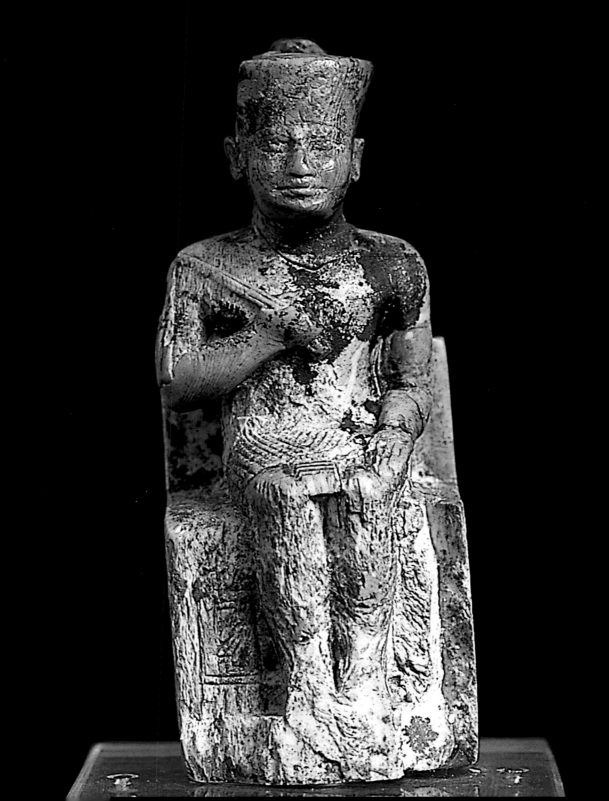

The tomb has a ninety-nine-foot-deep shaft ending in a burial chamber. No superstructure was added so that it would remain completely concealed from the eyes of future tomb robbers.

It took many years to restore this collection, which now provides us with a clear idea of the quality and type of furniture used by the royal family of the Fourth Dynasty. An equally remarkable set of royal furniture is represented on the wall reliefs of the tomb of Queen Meresankh III, also at Giza.

24. King Cheops

Ivory; Abydos; H. 7.5 cm; W. 2.5 cm;
4th Dynasty; reign of Cheops, 2609 - 2584 BC;
Ground floor, room 32; JE 36143;

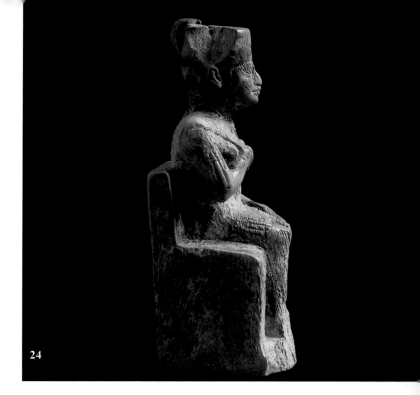

24

This ivory statuette of Cheops (Khufu) was found by Flinders Petrie in 1903 in the temple of the god Osiris-khenty-imentew, Lord of the Westerners, in the region of Kom al-Sultan at Abydos. One day a workman found a headless statue of a man seated on a throne. Reading the hieroglyphic name, Petrie immediately recognised that of Cheops. He urged all the workmen to look for the head, offering a handsome reward for the finder. Three weeks later the head of this valuable statue was found. The king is shown seated on the throne and holding the *nekhekh* flail, one of the symbols of royal authority.

This is the only existing statue of the famous King Cheops, builder of the Great Pyramid which counts among the seven wonders of the ancient world. We have no clue as to the whereabouts of the other statues that would have honoured the king. There must have been many at one time, for it is hard to believe that this great majesty had only this small figurine to his name. The others may have been deliberately destroyed or stolen, or may yet be discovered in the ruins of his valley temple, now buried under the modern village of Nazlet el-Samman in Giza.

The king is presented here as a benevolent man rather than the tyrannical despot described by the Greek historian Herodotus. This contrasts with the statue of his successor Chephren, who is shown as a strong, divine king. One can suppose that this statue was made at a later period than the Old Kingdom, perhaps as a sacred figurine or amulet. It probably dates from the Twenty-sixth Dynasty when

Cheops was deified and worshipped as a god, with his names appearing on scarabs and priests maintaining his cult.

Cheops was the son of Sneferu and Hetepheres. His name in the ancient Egyptian language, *KhnomKhwfu-wy*, means 'the god Khnom, (who is a creator god), protects me'. He was probably brought up on one of the estates called *Mnat khwfu* near the zone of Beni Hassan in Minya. His pyramid is named *Akhet khwfu* or 'the horizon of Khufu'. The name of the king has been found in a temple at Byblos in Lebanon, as well as in a cartouche in the diorite quarries at Tushki near Abu Simbel, 750 miles south of Memphis. Amazingly, there was a copper chisel beside this inscription suggesting that it was the tool used for quarrying this extremely hard stone.

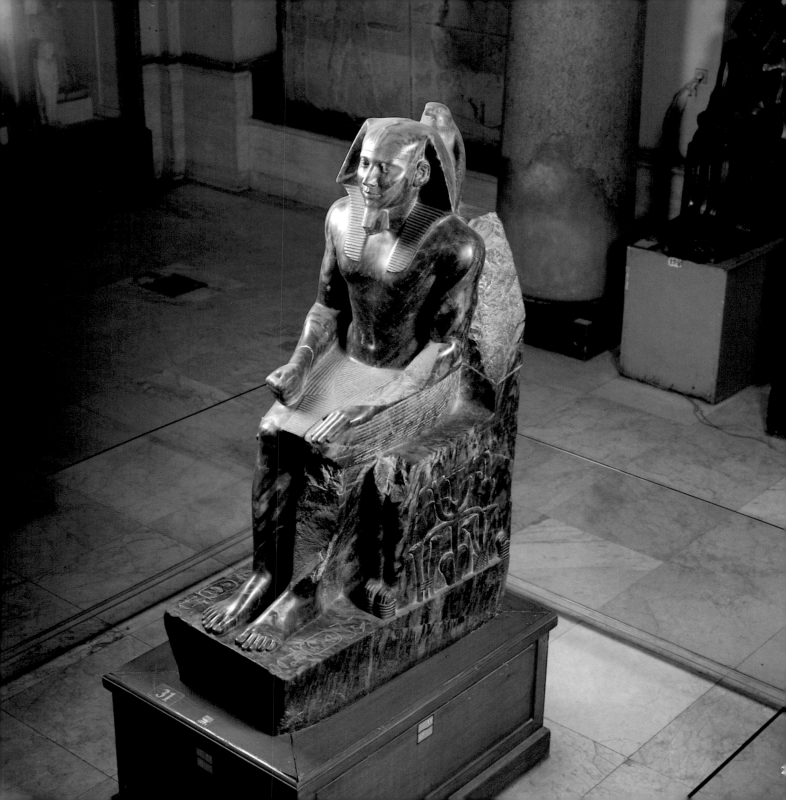

25. King Chephren

Diorite; Giza; H. 168 cm; W. 57 cm; L. 96 cm;
4th Dynasty; reign of Chephren, 2576 - 2551 BC;
Ground floor, room 42; JE 10062 = CG 14;

This outstanding statue of Chephren (Khafre) is one of the most beautiful examples of the art of ancient Egypt. It is made of diorite quarried in Tushki near Abu Simbel, and was found in the king's valley temple adjoining his pyramid at Giza. The sculptor's use of this stone, which is harder than marble or granite, suggested the strength of the king himself.

The statue shows him seated on the throne, aloof and striking a divine pose. He wears the *nemes* royal headdress, while the cobra, one of the symbols of royalty and protection, appears on the forehead. The false beard attached to the chin is another royal symbol.

The body is very stylised, showing the king as an idealised man, strong and powerful, with wide shoulders, a firm body, and prominent arms and torso muscles. The king wears the pleated kilt and carries his seal in his right hand while the other hand is open and lying over his lap.

It was thought that the sun god Ra rose between the two lions that protected the horizon. These are evoked here by the lion heads and paws on either side of the throne, which add to the feeling of strength transmitted by the statue. This representation of the king as the god Ra illustrates his name, *Kha-ef-ra*, 'the rise of the god Ra', inscribed in the cartouche on the throne.

The *sematawy* symbol on the side of the throne corresponds to the unification of the north and the south of the country. It consists of the *seshen* (lotus flower), symbol of Upper Egypt, and the *wadj* (papyrus plant), symbol of Lower Egypt, tied together as they emerge from human lungs. The lungs represent the notion that the whole country, north and south, is ruled by the king who himself gives it the breath of life.

The falcon god Horus appears behind the head of the statue, spreading his wings behind the king's head and extending his tail feathers over the throne. He thus expresses the protection bestowed on the king and throne of Egypt; in other words, securing the king to the throne. The size of that falcon, which is represented relatively smaller than Chephren, reflects the idea of the divinity of the king. In addition, this representation expresses the unity of the Osirian Triad: Horus as the king himself alive on earth, Osiris as the dead king in the hereafter and Isis symbolising the throne.

This is one of twenty-three statues from King Chephren's valley temple, and shows the majesty of the god-like ruler who is represented with perfection, in harmony with his pyramid which is called *Wr-khaef-ra* , 'great is KhaefRe'.

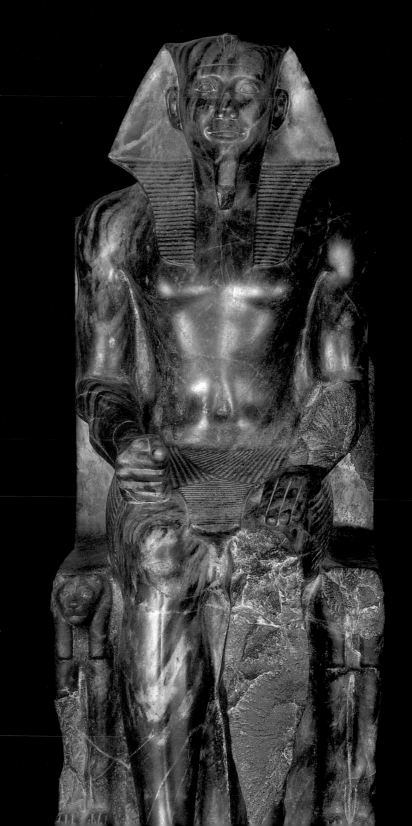

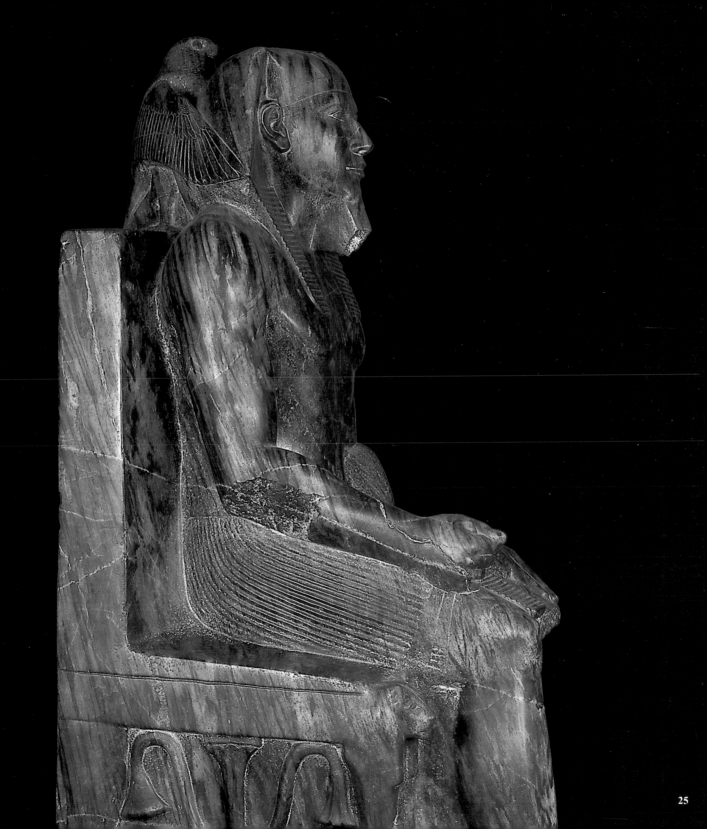

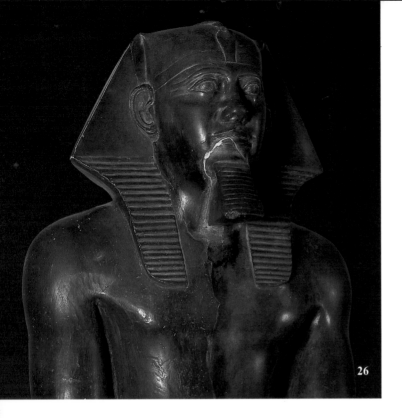

26. Schist statue of King Chephren

Diorite; Giza; 4th Dynasty; reign of Chephren, 2576 - 2551 BC;
Ground floor, room 42;

This statue of King Chephren was sculpted of schist and was found in his valley temple at Giza, together with his outstanding diorite statue.

It shows the king sitting on a throne, which is a backless seat or block. The king is wearing the *nemes* headdress, and the royal cobra that used to rest over his forehead is now destroyed. He has a false beard and is wearing the *shendyt* royal kilt.

The muscles are sculpted beautifully. Chephren has one hand on his lap, and in the other is holding a royal seal or a kind of a handkerchief. On the sides of the throne is the *sematawy* scene, representing the unification of Upper and Lower Egypt. The inscription on the throne gives the pharaoh's names and titles.

26

26

27. Alabaster statue of Menkaure

Alabaster; Giza;

4th Dynasty; reign of Menkaure, 2551 - 2523 BC;

Ground floor, gallery 41; JE 40704;

Discovered in 1908 by Reisner in the king's valley temple at Giza, this alabaster statue of Menkaure shows excellent workmanship, in spite of being partially damaged. It shows the king enthroned with the traditional emblems of royalty like the *nemes* headdress, the cobra over his forehead, the false beard and pleated *shendyt* kilt. The figure is idealised, shown with strong muscles and wide shoulders in a similar manner to the diorite statue of his father King Chephren. One of his hands lies flat and open on his lap and the other is closed, and is holding a kind of royal handkerchief, possibly expressing the pharaoh's benevolence and strength. Menkaure's cartouche is inscribed on the left side of the statue base.

28 - 30. Triads of King Menkaure

Schist; Giza;

4th Dynasty; reign of Menkaure, 2551 - 2523 BC;

Ground floor, gallery 47;

28. H. 95.5 cm; JE 46499;

29. H. 92.5 cm; JE 40679;

30. H. 93 cm; JE 40678;

These three schist triads of Menkaure were found by the Egyptologist George Reisner in the valley temple of Menkaure near his pyramid in Giza. Menkaure was the fifth king of the Fourth Dynasty. The name of his pyramid, the smallest of the three pyramids of Giza, is *Ntry mn-kaw-ra*, meaning 'divine is Menkaure'.

These are the oldest triads in the history of ancient Egyptian statuary. Each one represents the king accompanied by the goddess Hathor, goddess of love, joy, music and beauty, and by the personification of one of the nomes of Egypt where the cult of Hathor was prominent. The Egyptian nomes or provinces numbered between twenty-eight and forty-two; it was therefore thought that there must originally have been an equivalent number of statues. However this idea was rejected when it was found that the valley temple could not

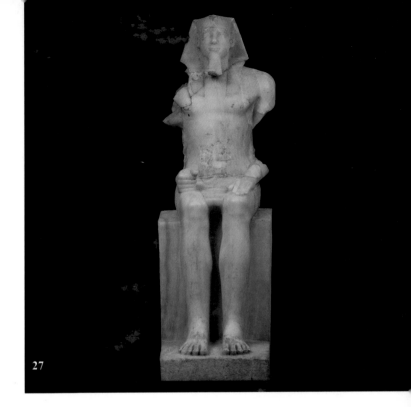

27

accommodate such a large number. There were probably only eight statues altogether in the eight niches of the temple.

The first triad (28) shows the king standing, wearing the crown of Upper Egypt and a short royal *shndyt* kilt and holding a royal seal. The muscles of his shoulders, chest, torso and legs are faithfully represented, and conforming to tradition he advances his left leg. The goddess Hathor stands to his right wearing a wig with a central parting surmounted by two cow horns framing a solar disc. She wears a tight dress, revealing the details of her firm body. Her facial features resemble those of Menkaure's queen, Khamrr-nbty II, who appears on a slate dyad of the king and queen also found in the valley temple and now in the Museum of Fine Arts in Boston. The inscription on the base reads *nsw-biti Mnkaw-ra mry Ht-hr nbt nht*, 'King of Upper and Lower Egypt, Menkaure, beloved of Hathor, the mistress of the sycamore tree'. Hathor is holding Menkaure's hand in an affectionate manner. Standing on the other side is the personification of the seventh nome of Upper Egypt, later Diospolis Parva, which lay near Hiw 110 kilometres north of Thebes. It is represented here as a woman wearing a tight dress and

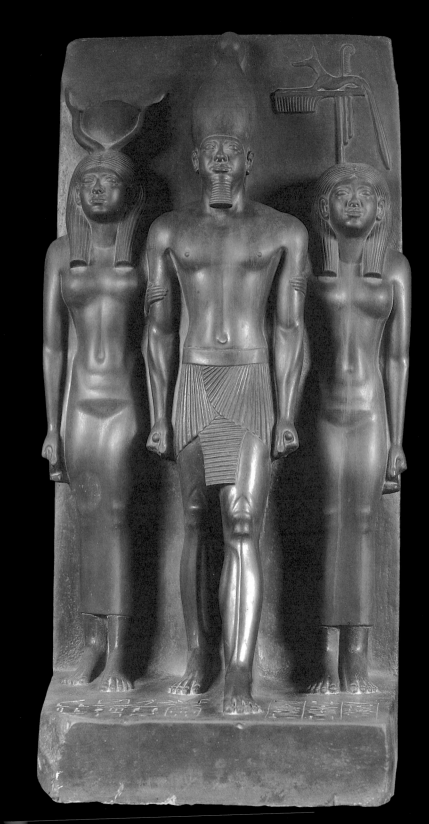

a wig with a central parting similar to Hathor's, and holding two seals. The name of the nome appears over her head as *Bat*.

In the second triad (29) the king and the goddess Hathor appear with the goddess representing the seventeenth nome of Upper Egypt, later known as Cynopolis and near modern-day al-Quees at Minya. The king is shown in the centre wearing the White Crown, the traditional false beard and the royal kilt. His left leg is advanced, and his muscles are very finely depicted.

Both goddesses, their arms extended behind the king's back, hold him in an embrace. This position imbues the statue with an air of humanity and intimacy which contrasts with the older, more formal royal postures. The ancient name for Cynopolis is written over the head of the goddess as *Inpw*.

In the third triad (30) the king stands between the goddess Hathor and the personification of the fourth nome of Upper Egypt, Waset, later Thebes. The king originally had a false beard which is now missing. The personification of the fourth nome is represented as a shorter man, advancing his left leg and wearing a wig with central parting, a false beard and a short kilt. On his head are the three emblems of the nome: the *djed* symbol of stability, the *was* symbol of prosperity and the *ankh* symbol of life. The text in front of him mentions the offering of all the good things of the south to the king, who will shine as king of Upper and Lower Egypt forevermore.

The two other triads discovered in the valley temple of King Menkaure are now in the Boston Museum of Fine Arts.

As one admires these triads, one cannot help but be overwhelmed by the high artistic sense and the skilled workmanship of the sculptors of the Old Kingdom. Comparing the dimensions of the figures, one observes that the king is represented on a larger scale than the two gods, reflecting the concept of his divinity during the Old Kingdom. In turn, the goddess Hathor was more important than the gods and goddesses of the nomes, so she is therefore taller than the local gods. The king chose the goddess Hathor to accompany him in these statues because, according to the legend of Isis and Osiris, it was she who took the infant Horus into her care and suckled him with the royal and divine milk while his mother Isis searched for the pieces of the body of Osiris. The presence of Hathor beside him therefore highlights the concept that he is a manifestation of the god Horus on earth.

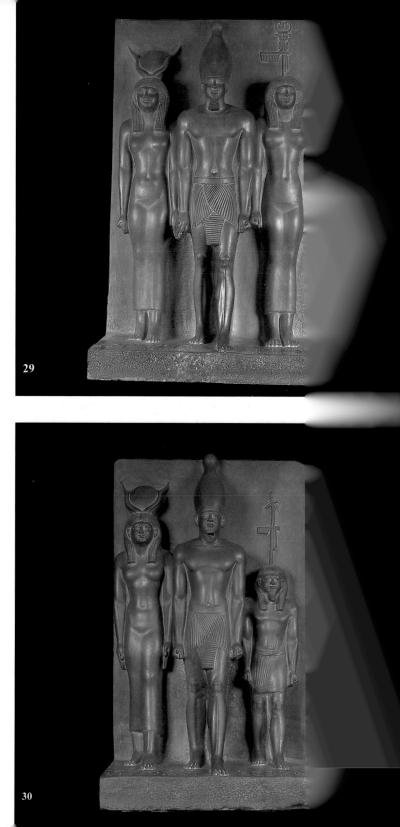

29

30

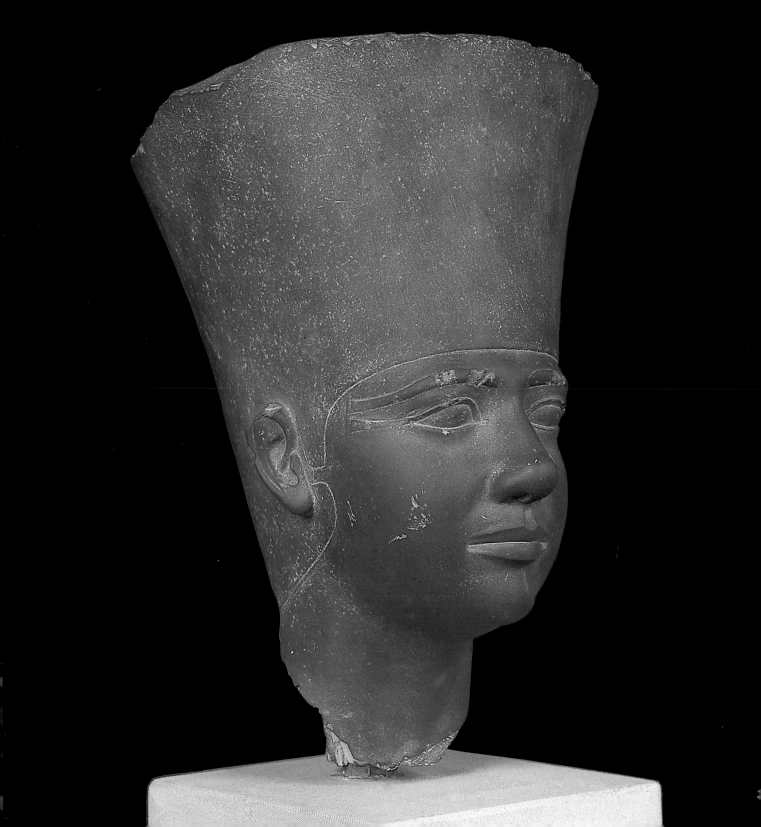

32. Colossal head of Userkaf

Granite; Abu-Sir;
5th Dynasty; reign of Userkaf, 2513 - 2506 BC;
Ground floor, gallery 46; JE 52501;

This colossal head of Userkaf carved in pink granite was found by the Egyptologist Cecil Mallaby Firth in the king's mortuary temple which stood beside his pyramid in Saqqara. The name of his pyramid was *Wab swt wsr-ka.f*, which means 'pure are the sites of Userkaf'.

This is the first and only example from the Old Kingdom of a colossal statue, a type that would become common in the Middle and New Kingdoms. The king is here shown wearing the *nemes* royal headdress over his hair with a cobra over his forehead. The body of the statue was not found, but one can assume that it was seated and about five metres high, since the head is three times life-size. The head is exceptionally aloof and majestic; the use of a very hard stone, granite *mat* in ancient Egyptian, adds to the impression of majesty. The pink granite came from the quarries in Aswan, about a thousand kilometres south of Cairo, and was carried by Nile barge in the inundation season.

The colossal size reflects the character of the strong-willed founder of the Fifth Dynasty, whose relatively short rule lasted from 2513 to 2506 BC.

33. King Neferefre

Pink limestone; Abu-Sir; H. 34 cm;
5th Dynasty; reign of Neferefre, 2475 - 2474 BC;
Ground floor, gallery 47; JE 98171;

This statue of King Neferefre, who ruled for a short time after Shepseskare in the Fifth Dynasty, was found in the mortuary temple adjoining his unfinished pyramid at Abu-Sir. The name of his pyramid was *Ba ntr nfref-ra*, which means 'divine is the soul of Neferefre'. Although the body of the statue is not well preserved, the head presents an example of high quality artwork. The representation of the king with a round face and full cheeks was unusual in the royal statuary of the Old Kingdom, and is thus considered an innovative step in the art of that period.

33

Neferefre is shown as a youthful king, full of life. His curly wig is typical of the Old Kingdom, with a hole over the forehead, probably for inserting the royal cobra-usually made of gold inlaid with precious stones, but now lost. The false beard is missing and so is the left arm. He holds a *hedj* sceptre or ceremonial mace in his right hand.

The most interesting feature of this statue is the presence of the falcon god Horus behind the head of the king. Horus spreads his wings in a gesture of protection, while in his claws he holds the *shen* amulet to symbolise duration and infinity. The position of the falcon behind the head is comparable to its counterpart behind the head of the diorite statue of Chephren. What remains of the base of the statue shows the *nsw-biti* name of the king in a cartouche.

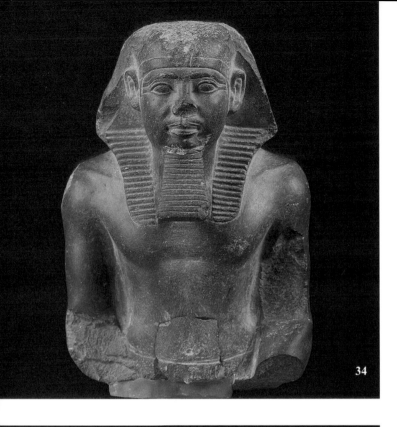

34

34. Bust of Neferefre

5th Dynasty; reign of Neferefre, 2475 - 2474 BC;
Ground floor, gallery 47;

This bust is the only remaining part of the seated black statue of Neferefre. He is represented wearing the *nemes* royal headdress, his eyebrows are sculpted, and the cosmetic line of the eyes follows the line of the eyebrows. His moustache is painted in black. He is shown with a fleshy face and full lips.

35. Schist Statue of Neferefre

5th Dynasty; reign of Neferefre, 2475 - 2474 BC;
Ground floor, gallery 47;

This statue, sculpted of schist, shows the king standing in the traditional manner, and wearing the crown of Upper Egypt. His false beard is missing, however. He is holding the *hedj* or mace scepter across his chest. Wearing the *shendyt* royal kilt, he is standing in the traditional manner, advancing his left leg forward.

36. A sacrificial or libation altar

Alabaster; mortuary temple of Djoser, Saqqara;
H. 38 cm, L.89 cm, W. 42 cm; end of 2nd Dynasty;
Ground floor, gallery 47; JE CG 1321;

Sculpted from an alabaster block, this altar was used either as a sacrificial altar or a libation table. It is decorated with the forms of two lions, whose front and back paws are beautifully defined. The altar slopes downward towards a circular basin, around which the tails of the lions are curled.

Magical offering formulas and prayers were recited when libations like water, milk, beer or wine were poured over the altar. The liquids were then collected in the basin and presented to the gods or to the *ka* of the deceased. The same magical and sacred formulas were required during sacrificial rites performed on the altar, and in this case, the blood of the sacrificial animal was collected in the basin.

The use of lion heads and paws, as decorative elements on thrones, chairs and beds, was a popular theme in ancient Egypt. The lion was associated with the horizon, where the sun god rose, and

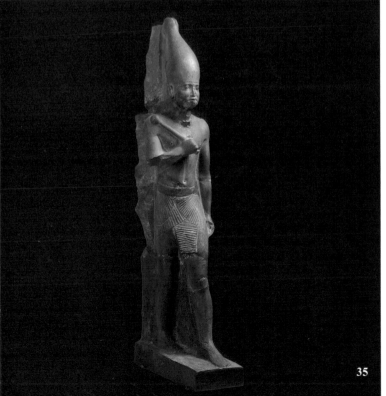

35

these features imbued the item of furniture with an air of strength and protection. Funerary beds matching the style of this altar were found in the tomb of King Tutankhamun, as well as in the funeral procession scenes in the Tombs of the Nobles in Thebes from the New Kingdom Period.

The alabaster stone, often referred to as calcite by Egyptologists, was called *shes* by the ancient Egyptians, and quarried at Hatnub near Minya, 250 km south of Cairo.

37 - 39. Panels of Hesire

Wood; Saqqara;
3rd Dynasty; *c.* 2650 BC; Ground floor, gallery 47;
37. H. *c.*114 cm; CG 1426;
38. H. *c.*114 cm; CG 1427;
39. H. *c.*114 cm; CG 1428;

These three wooden panels were found in the *mastaba* tomb of Hesire, situated to the north of the funerary complex of Djoser in Saqqara. His name means 'the one who is praised by the god Ra'. Seals mentioning the name of King Djoser were found beside his tomb.

Of the eleven panels that were hanging in niches in the superstructure of the *mastaba*, six complete ones remain, while there are only fragments of the other five. In the three panels shown here we have a kind of biography of Hesire which depicts him at various stages of his life and career. The art of the noble people's tombs kept abreast with the innovations introduced in royal art, and the quality of the reliefs on these panels can be compared to those of Djoser himself found in the substructure of his Step Pyramid and southern *mastaba* in Saqqara.

What is remarkable about these graceful representations of Hesire is the use of the slight projection typical of Third Dynasty reliefs. The accuracy of the detailed figures illustrates the sculptors' tenacity in creating such quality art. The mural decoration of the tomb of Hesire still retains its original bright colours, showing a design of curtains made of woven reeds.

37. On the first panel, Hesire Ra is shown standing, wearing a short curly wig, with the emblem of the scribe hanging over his shoulder; this consists of a palette including two colours, usually black and red, a pen case and a leather bag for fibres or for a small bottle of water. He appears here as a young man. The artist placed

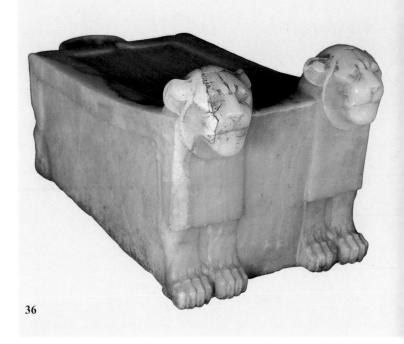

36

the body slightly to the side rather than in the middle of the panel in order to leave enough space on the right hand side for the hieroglyphic inscription. The text in front of him gives his names and titles and lists the offerings he would like to receive in his second life. These are *seneter* (incense), *mw* (cold water), *ta* (bread), *henket* (beer), *kaw* (beef).

38. On the second panel we find Hesire represented in the prime of life. He is standing with his left leg advanced and holding a long staff, the scribal palette, pen case and a small leather bag. In his right hand he holds the *kherep* sceptre representing authority, power and nobility. He has a long, straight wig of an innovative style, and wears a short kilt with a pleated edge. The facial features reveal his strong character and self-confidence. The representation of Hesire's body conforms to the ancient Egyptian convention in art of showing the face, legs and feet in profile, the eyes and the shoulders in full view, and the body and stomach in three-quarters view. The hieroglyphic inscriptions describe him as a *rekh-nesw*, 'Royal acquaintance, known by the king' and a *wr*, 'great nobleman'. In addition, the inscription indicates his offices as a chief of the royal scribes, the 'greatest of the ten' of Upper Egypt. The 'ten' probably

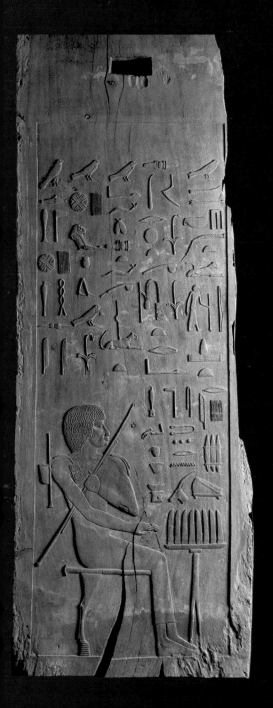

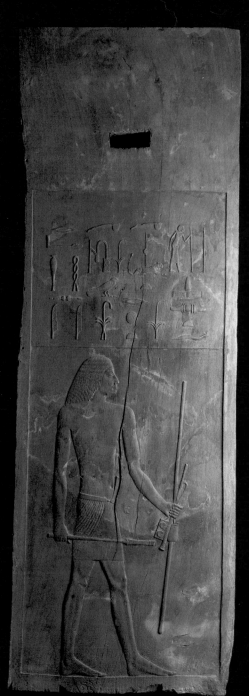

39

38

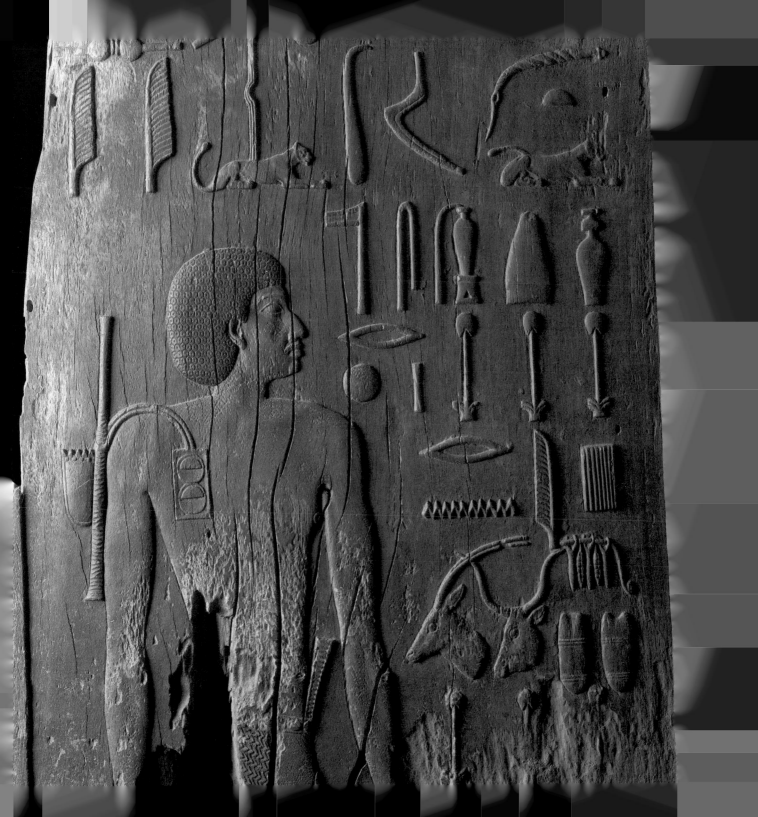

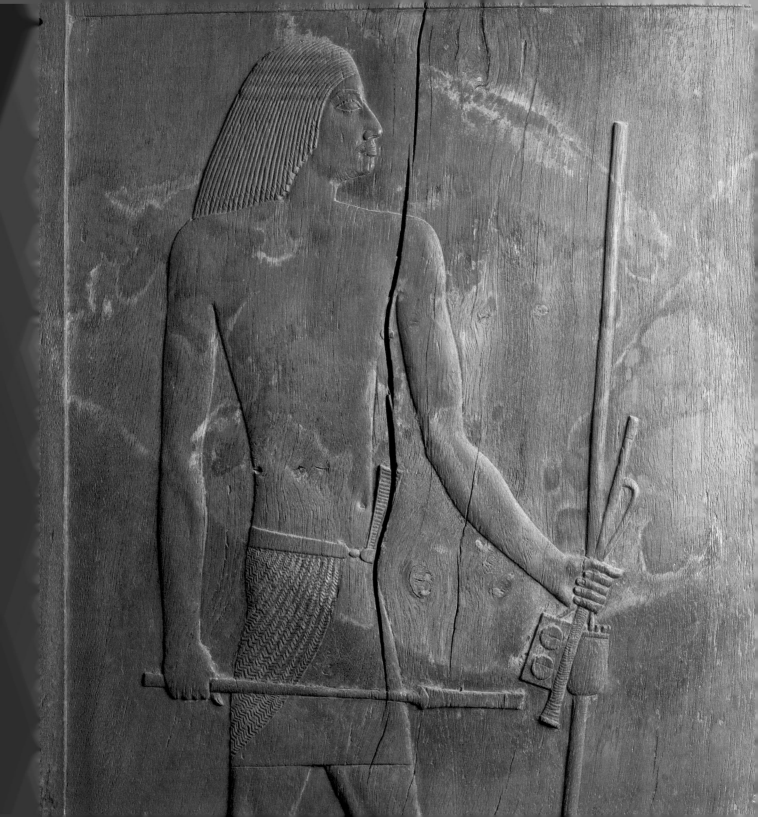

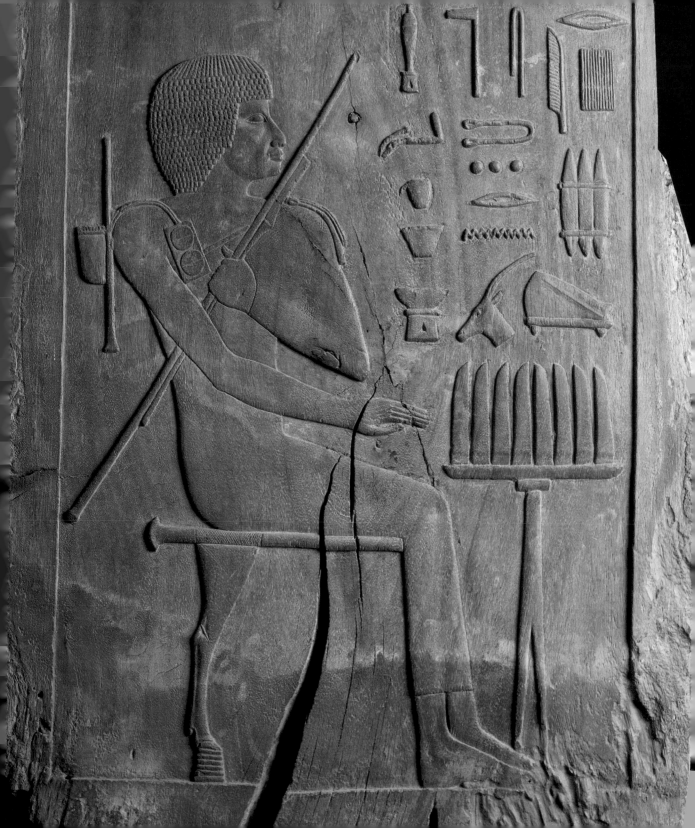

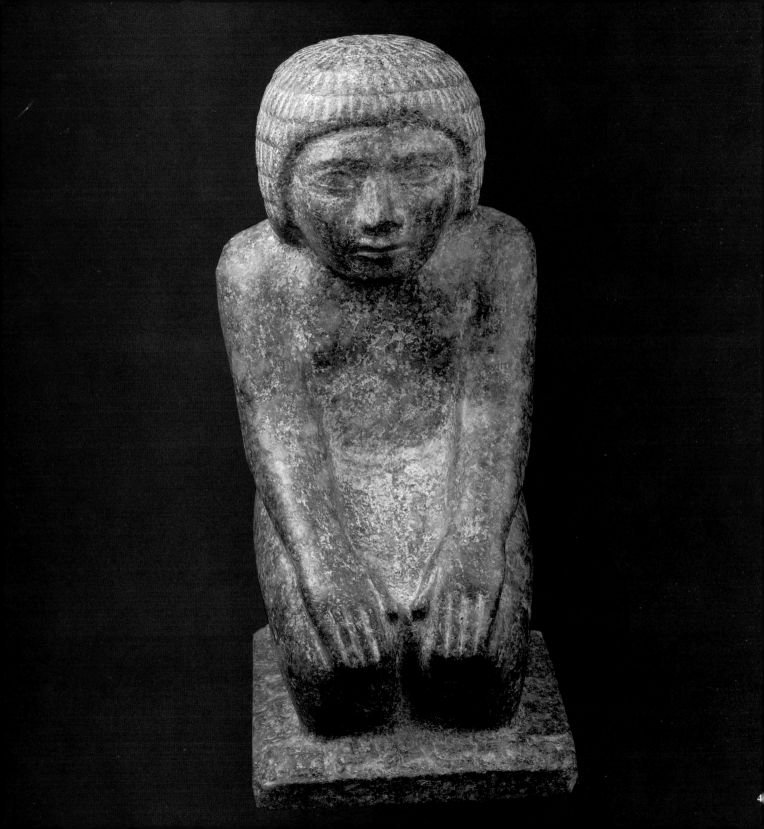

correspond here to the ten most important provinces of Upper Egypt, which means that he was the greatest man of those ten nomes.

39. On the third panel, Hesire is shown as an elderly man seated on a chair decorated with lions' paws. He wears a short curly wig and a cloak covering his entire body except for the right arm and shoulder. The scribal emblem and equipment are represented on his shoulder. His age is expressed by the facial features, such as the wrinkles around the eyes. In his left hand he holds a long staff, while his right hand reaches out to an offering table covered with vertically placed loaves of bread. Again there is a list of the offerings he desires in the second life. New titles are added to the previous ones such as 'the greatest of the dental surgeons', 'the one who sees Min'-that is, the high priest of this god, 'the high priest of Horus', and 'the high priest of Buto'-present-day Tell al-Pharaeen in the northern Delta.

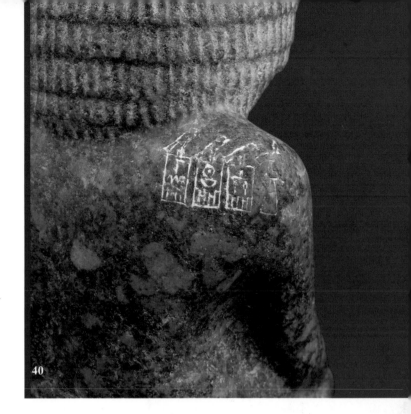

40. Hetepdief

Red granite, Memphis; H. 39 cm; W. 18 cm;
3rd Dynasty; *c.* 2650 BC; Ground floor, gallery 47; JE 34557 = CG 1

This statue of Hetepdief is one of the Egyptian Museum's earliest examples of a statue of a nobleman. Made of pink granite, it shows a kneeling man wearing a short, curly wig and spreading his palms on his knees. It is also one of the first depictions of the kneeling position, which would become common in the New Kingdom and the Late Period. In some variations the figure carries a stela, a sistrum or a *naos.*

This statue was probably made in the royal workshop as a mark of the king's favour, since in that period it was he who granted access to the quarry and gave permission to use certain stones such as granite. Hetepdief's statue antedates the oldest known statue of a kneeling king, that of PepiI in the Sixth Dynasty. In the Middle and New Kingdoms it would be more common to see the kings represented in the kneeling position when they were performing rites such as presenting offerings or invoking the gods.

The title of the nobleman inscribed on the base of the statue indicates that he was a priest responsible for the incense in the royal palace in Lower Egypt.

Although the statue dates from the Third Dynasty it has a special link to the Archaic Period. On the right hand of the back of the figure are the names of the first three kings of the Second Dynasty-Hetepsekhemwy, Raneb and Nynetjer-inside a *serekh*, and surmounted by the falcon god Horus. The importance of the sun is emphasised through two symbols: a phoenix and a small *bnbn* (pyramidion), one on top of the other, and also by the use of the granite itself. The statue, especially the face and wig, has heavy proportions and its quality in terms of composition and workmanship is inferior to the royal statuary of the period.

41. Reliefs with paste inlays from the tomb of Nefer-Maat

Limestone, coloured paste; mastaba of Nefer-Maat, Meidum;
4th Dynasty, reign of Sneferu 2649 - 2609 BC;
Ground floor, gallery 41; JE 43809;

Found in the tomb of prince Nefer-Maat and his wife princess Itet in Meidum, this piece is divided into two registers. The upper one shows a crouching man, whose head and shoulders are missing. The sticks in his hands are a kind of a boomerang used for hunting and fowling from a distance. He is observing the panther depicted in front of him.

The second register shows another hunting scene, this time of three foxes, one behind the other. A dog is biting the tail of the last one.

The technique used in this piece is unique in the Old Kingdom Period. The sculptor first carved out the scene, hollowing it out of the wall, and then made rectangular incisions to allow for the inlay work; filling in the grooves with coloured paste. However, this paste later cracked and fell out when it dried. The new technique was abandoned when it proved to have little resistance to time and the elements. Accordingly, sculptors returned to creating the usual sunken or raised reliefs that gave more enduring results.

42. Rahotep and Nofret

Painted limestone; Meidum;
4th Dynasty; reign of Sneferu, 2649 - 2609 BC;
Ground floor, room 32;
Ra Hotep : H. 121 cm; CG 3;
Nofert : H. 122 cm; CG 4;

These two statues are among the masterpieces of the statuary of the Old Kingdom's Fourth Dynasty. They are made of very fine quality limestone, the block carefully chosen so as to bring about this outstanding result.

The statues were unearthed in 1871 by French Egyptologist Auguste Mariette in Rahotep's *mastaba* north of the Meidum Pyramid. When Mariette's workmen entered the dark chamber they were terrified to see the statues, which were in such an excellent state of preservation that they appeared to them at that moment as a real live couple sitting in their tomb.

The statue of Rahotep shows him seated with his right hand laced over the left side of his body, the side of the heart, which the ancient Egyptians considered the centre of wisdom and sensitivity, while his other hand is on his lap. He has a neat haircut and a moustache; his eyes are framed with black paint and inlaid with white quartz, rock crystal and resin. He wears a necklace with an *ib* heart amulet. His names and titles are painted over the back of his seat; his name, Rahotep, means 'the god Ra is satisfied'. He carries an honorary title, *sa-nswt-n-ghetef* or 'the son of the king, begotten of his body', which was given to the high nobility throughout Egyptian history. His other titles describe him as a priest of Ra and a supervisor of the works. He is painted reddish-brown in accordance to the artistic tradition of giving men a darker skin colour, probably also to symbolise how active and hard working they had been.

The statue of his wife Nofret emphasises the princess's beauty. The noble lady is represented seated, wearing two dresses; the inner one is a typical, tight Old Kingdom dress with two large straps, whereas the outer dress is like a tight cloak. Her wig is of a straight style with a central parting and adorned with a band with floral motives, while some of her real hair is shown underneath. Her eyes are outlined with paint and inlaid with the same materials as those of her husband. She wears a large collar typical of the Old Kingdom, the *usekh* collar, made of alternating rows of malachite and carne-

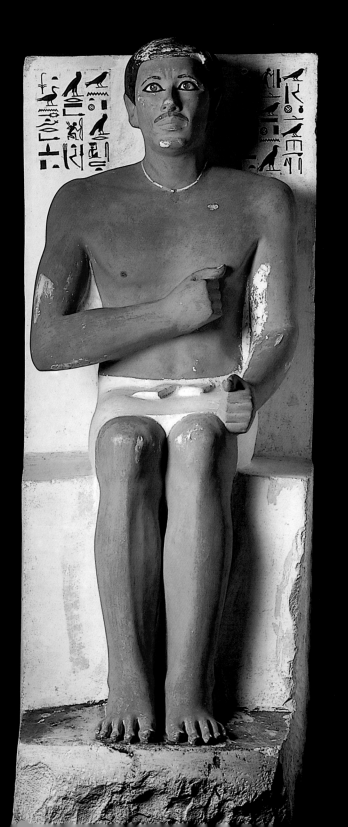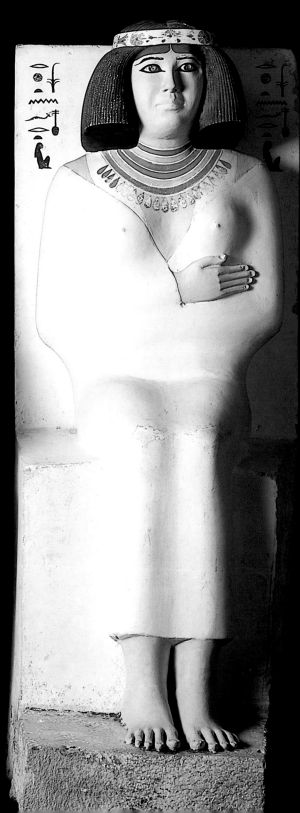

lian beads. Her name painted beside her head is *rekhet-nsw Neferet*, the princess Nofret, 'the royal acquaintance'. The name Nofret means 'the beautiful'. Other instances of names alluding to beauty are found throughout ancient Egyptian history such as Nefertiti, wife of Akhenaten, whose name means 'the coming beauty', and Nefertari, wife of Ramses II, whose name means 'the most beautiful of them'. The princess is given a creamy yellow colour conforming to the tradition that fair skin was a symbol of nobility and beauty in women.

43. Reserve Head

Limestone; Giza; H. 22.5 cm; W. 18 cm;
4th Dynasty; *c.* 2600 BC; Ground floor, gallery 46; JE 46216;

These heads of nobles, made of limestone, are termed reserve heads. Most date from the Fourth-Dynasty reigns of Cheops and his son Chephren, and the majority were found in Giza. Recent excavations however have led to the discovery of reserve heads at Dahshur and Abu-Sir. They were concealed in the substructure of the tombs, placed in an opening in the northern wall between the funerary chamber and the bottom of the descending shaft and thus facing the northern stars.

These heads are different from the usual cult statues as they were related to the hereafter. They are life-size and consist of the head and neck only, without the shoulders; some of them are earless. Extra care was given to the depiction of the features of the deceased as his name did not appear.

They may have been prepared to act as substitutes for the dead body if the latter were destroyed or robbed, or as protection for the real head of the deceased against evil spirits who would harm these rather than the real ones. Another theory describes them as being models for the artists to produce plaster funerary masks or plaster casts of the deceased. Yet another theory is that since Cheops had forbidden the nobles to make statues of themselves they resorted to making secret reserve heads and hiding them in the substructure of their tombs. Recent research also associates them with magical rites performed to eliminate the evil in the deceased person himself; the lack of ears in some of these heads would have to do with the *sgrt* (silence) of the necropolis. In the light of these recent theories, they are now designated as 'magical heads'.

43

44

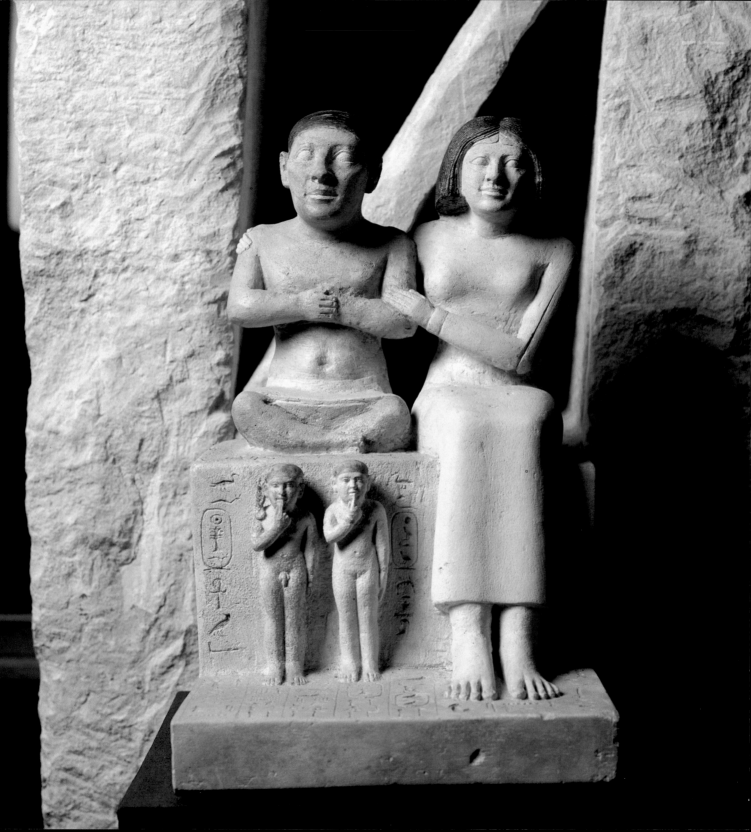

44. Birds in the Delta marshes

Limestone; Saqqara; H. 102 cm; W. 77 cm;
5th Dynasty; reign of Userkaf, 2513 - 2506 BC;
Upper floor, gallery 54; JE 56001;

This relief was part of the decoration on the limestone walls in the funerary temple adjoining the pyramid of King Userkaf in Saqqara. It was brought to light by Cecil Mallaby Firth, in 1928.

The remaining traces of colour on this high relief suggest that the whole wall was originally painted in the same way as the Old Kingdom *mastaba* tombs of the nobles. Funerary and cult temples had previously been reserved for cult and offering scenes, and it was Userkaf who introduced the representation of nature in royal funerary temples.

Here we have part of a hunting scene in the marshes of the Nile Delta, a sport which would have been represented for its recreational value for the deceased in the afterlife as it had been in the first life, but would also have had a religious significance by symbolising the victory of the king over the evil forces endangering the cosmic order.

For the latter reason, it is thought that this scene in Userkaf's funerary temple was there to represent one of his titles, *ir maaet*, 'the one who establishes order'. In addition, the presence of scenes of nature with living creatures imparts the presence of the sun god Ra, who was held in high esteem by the kings of the Fifth Dynasty as is proved by the numerous solar temples erected throughout this period.

The scene gives an idea of the flora and birds of ancient Egypt. We see the thick *wadj* papyrus plant, the most typical plant of the Delta swamps, which was chosen as a symbol of Lower Egypt, the northern part of the country. Seventy species of birds were known and depicted by artists at various periods throughout ancient Egyptian history. In this scene, we see a butterfly with outspread wings. Seven species of birds are represented underneath: a hovering pied kingfisher, a green kingfisher facing a grey heron, a hoopoe facing a purple water-hen, a sacred ibis with a typical long, curved beak, and in the lowest part the head of a bittern.

The relief's astonishingly delicate and minute carving exhibits great artistic sense and excellent technical skill.

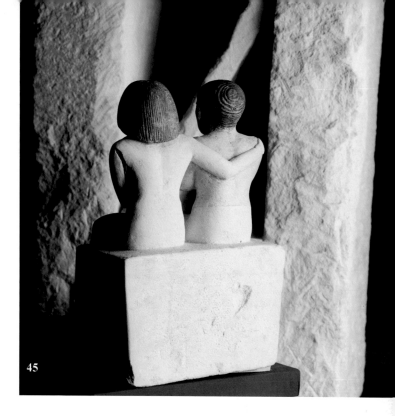

45

45. Dwarf Seneb and his family

Painted limestone; Giza; H. 22.5 cm; L. 25 cm;
4th or 5th Dynasty; *c.* 2550 BC; Ground floor, room 32; JE 51280;

This limestone group statue shows the dwarf Seneb and his family. It was found in his *mastaba* tomb in Giza by the German Egyptologist Herman Junker in 1926 and shows this favourite nobleman sitting cross-legged, accompanied by his wife and children.

Seneb's wife, who was one of the royal acquaintances, embraces him with one arm as a gesture of love and places her other hand over his arm as a sign of support. There is a slight smile on her face, revealing her contentment and satisfaction. Where one would expect to find Seneb's legs, one finds instead his two children. It seems that the artist sought not only to preserve the symmetry of the statue but also to show Seneb as a perfect man with a happy family. The names of the members of the family are inscribed beside them.

The children are represented with the typical symbols of childhood in ancient Egypt, the index finger placed in the mouth and the lock of hair on one side of the head. It was only after puberty that male Egyptians acquired a short and neat haircut. It is interesting to

46

note that in Upper Egypt villagers still adopt that ancient hairstyle for their male children, leaving one lock of baby hair uncut for good luck.

The customary difference in skin colour for males and females is observed in this piece both for the parents and the children. Both females have fair skin whereas the males' skin is darker.

Seneb suffered from a pathological deformity which is clearly depicted in the statue: he has a large head and torso but very short arms and legs. In spite of this, he was a highly esteemed, rich and prestigious nobleman, and the chief priest of the funerary temples of Cheops and Djedefre. Some of the activities depicted on the walls of the niche from the tomb where the statue was found show that Seneb was a man of class and quality who owned estates, leisure boats and a great number of servants and attendants.

46. Khnomhotep the dwarf

Limestone; Giza;
5th Dynasty; *c.* 2450 BC; Ground floor, gallery 47;

This limestone statue of the dwarf Khnomhotep was found in his *mastaba* tomb in Saqqara. He was named after the god Khnom, a creator god who formed the body of creatures on a potter's wheel, and the name Khnomhotep means 'the god Khnom is satisfied'. This statue shows the high ability of the artist in the realistic depiction of the body deformity of his subject. Khnomhotep was an overseer of the wardrobe, in charge of funerary services as well as a *khry-heb*, or lector priest. Ancient Egyptian history has cast a spotlight over a number of dwarves in both iconography and statuary, such as in the scenes where they are depicted working as goldsmiths or overseers of gold stores on the walls of tombs.

There were two types of dwarves in ancient Egypt: the first were Egyptians who suffered from a pathological deformity, probably owing to glandular disorders; the other type belonged to short-statured races from sub-Saharan Africa and were brought to Egypt as sacred dancers. The latter were mentioned in the Pyramid Texts as being religious dancers, 'dancers before the gods'. These pygmies used to perform special dances in front of the kings, not only to entertain them but also to inspire them too to dance before the god. Their importance is attested by a letter inscribed in a tomb in the Old Kingdom cemetery of the nobles in Aswan, on the west

47

bank of the Nile. This letter was sent by the Sixth-Dynasty King Pepi II to Horkhof, who led an expedition to sub-Saharan Africa and brought back a pygmy. The letter instructs Horkhof to take good care of him until he arrives safely at the royal palace.

Pygmy populations still live throughout equatorial Africa. An anthropologist who visited central Africa in 1874 mentioned seeing a tribe of pygmies, their bodies well-proportioned but very short; the men were about 140 centimetres tall and the women about 130 centimetres. He also reported that they performed peculiar ritual dances that were perhaps similar to the dances of those ancient pygmies.

47. Hunchback noble

Wood; Saqqara;
5th Dynasty; BC; Ground floor, gallery 46; JE 52081;

This statue shows a nobleman with a hunched back caused by Pott's disease. It is one of those examples of a deformity faithfully reproduced in ancient Egyptian art, the religious reason for which being to emphasise the person's individuality. A deformed man wished to be represented with his deformity so that his *ka* would recognise him in the afterlife.

There appears to have been no shame about being deformed in ancient Egypt, and it neither prevented a person from attaining high position nor disqualified him from esteemed office. The wise vizier Ptahhotep advised his son, in the maxims he composed during the reign of Djed-kare-Isesi of the Fifth Dynasty, never to make fun of any human being whether he was a dwarf or blind, which shows the refinement of ancient Egyptian civilisation in encouraging the respect of human beings whatever their physique or social status. The same concept would be promoted in today's religions.

48. Male statue

Wood; Saqqara; H. 69 cm;
5th Dynasty; reign of Userkaf, 2513 - 2506 BC;
Ground floor, room 42; JE 10177 = CG 32;

This statue of a nobleman from Saqqara is the second best preserved wooden statue from the Old Kingdom after that of the Sheikh al-Balad. Some Egyptologists have suggested that it repre-

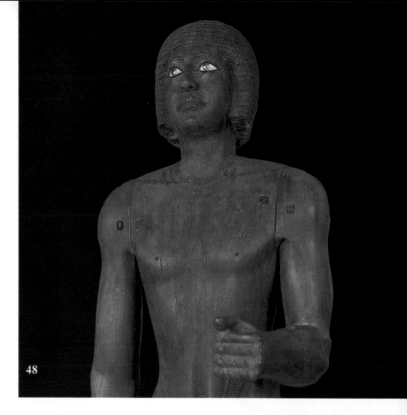

48

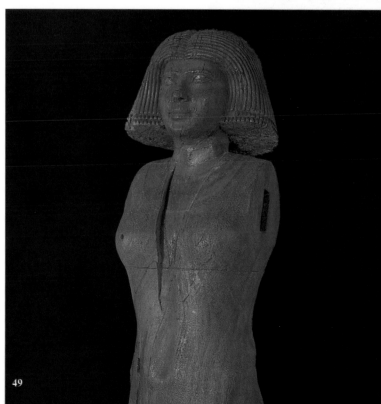

49

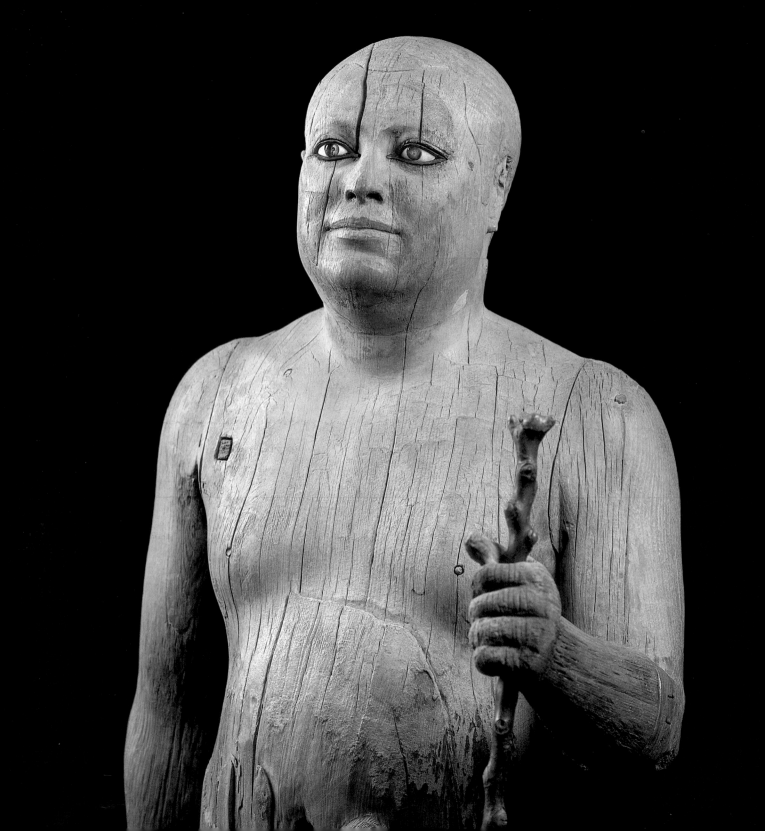

sented Ka-aper when he was younger and fitter, but there is no hard evidence to support this.

In this realistic depiction we note the natural style of the thin face and firm body. The nobleman wears a curly wig typical of the Old Kingdom and his eyes are stylised, imbuing him with alertness and strength. They are inlaid with the three classical materials: white quartz, rock crystal and resin. The lower part of the statue, the right hand and the sceptre he held in his left hand were damaged or lost. Wooden statues were carved with adzes, or *nwt* in the ancient Egyptian language.

Owing to the lesser solidity of wood in comparison with stone, far fewer wooden statues have been preserved, and they are therefore all the more special. The ancient Egyptian sculptors themselves were aware of the greater frailty of wood, but nevertheless the beauty and rarity of this material appealed to them throughout ancient history.

49. Wife of Ka-aper

Wood; Saqqara; H. 61 cm;
5th Dynasty; reign of Userkaf, 2513 - 2506 BC;
Ground floor, room 42; CG 33;

This wooden statue was discovered in the same *mastaba* as Ka-aper, and it is therefore thought to belong to his wife. It shows a noble lady with a plump face wearing a wig with a straight hairstyle and a central parting, which was in high fashion in the Old Kingdom. She also wears a tight dress and the *usekh*, a wide collar, both also typical of Old Kingdom fashion. The rest of the statue is damaged and the arms that were attached to it are lost.

The ancient Egyptians obtained wood from various local tree species such as *shendt* (Nile acacia), *nht* (sycamore fig), and *isr* (tamarisk). These species gave short, medium quality timber with a narrow cross-section. Cedarwood was imported from Lebanon and ebony wood, used to make inlays, was brought in from Africa. One of the purposes of the commercial expedition that Queen Hatshepsut sent to Punt in Africa was to import ebony trees, two of which she planted in front of her mortuary temple at al-Deir al-Baheri in Thebes. The lower parts of these trees can still be seen there.

50. Ka-aper, called sheikh al-Balad

Sycamore wood; Saqqara; H. 112 cm;
5th Dynasty; reign of Userkaf, 2513 - 2506 BC;
Ground floor, room 42; CG 34;

This is the oldest known life-size wooden statues in ancient Egypt. Carved of sycamore wood, it was discovered at Saqqara in the *mastaba* tomb of Ka-aper which lies west of the pyramid of Userkaf. It represents a *khry-heb* (lector priest) named Ka-aper, who is depicted in a realistic style with a neat hair cut, a round face and full cheeks. His eyes are inlaid with white quartz, rock crystal and resin, and surrounded by a copper frame. He is represented with a large stomach, heavy hips and fleshy wrinkles on his back.

The statue shows the priest with the long kilt which the nobles probably wore when they were at home in place of the semi-pleated kilts reserved for their office. He advances his left leg and holds two sceptres, now lost. Some of the missing parts have been substituted by modern replacements: the staff which he holds in his left hand, the left leg and foot and the right leg are all modern. Here, as in a number of other instances, ancient Egyptian art presents plump human bodies to reflect the owner's prosperity.

When the Egyptian workmen first saw the statue it reminded them of village mayors who often have a paunch and a round face, hence his Arabic appellation, sheikh al-balad or village mayor. Similar facial features can indeed still be found in Egypt today and one cannot help from being amazed at this resemblance across the millennia.

The use of sycamore wood imbued the statue with a divine aura, as sycamore was a sacred wood under the protection of the goddess Hathor, one of whose titles was *nbt nht*, 'the lady of the sycamore'. The arms were made separately and fixed to the statue with tenons, demonstrating great technical skill.

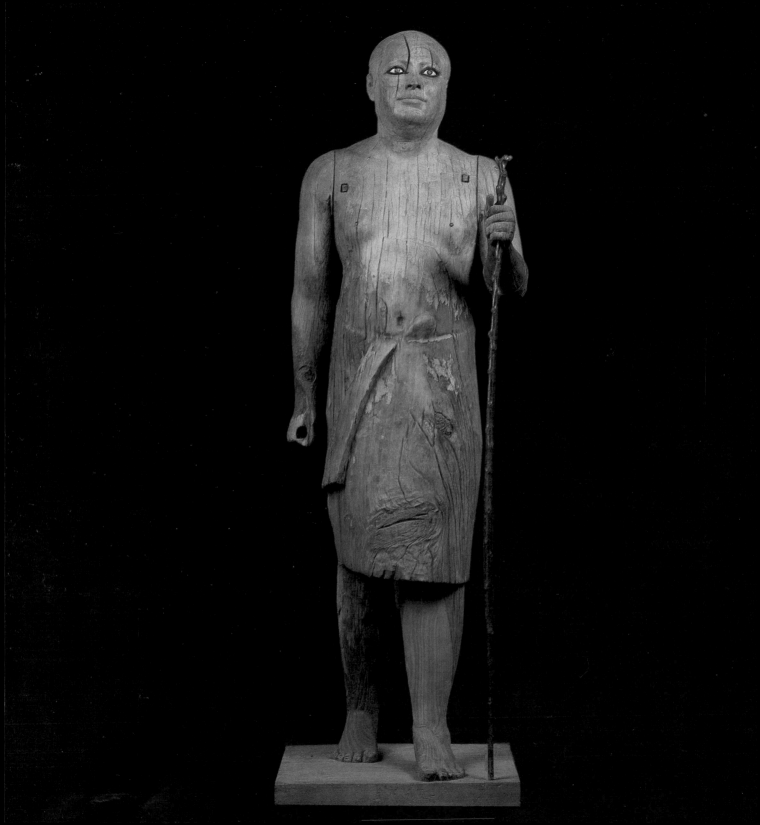

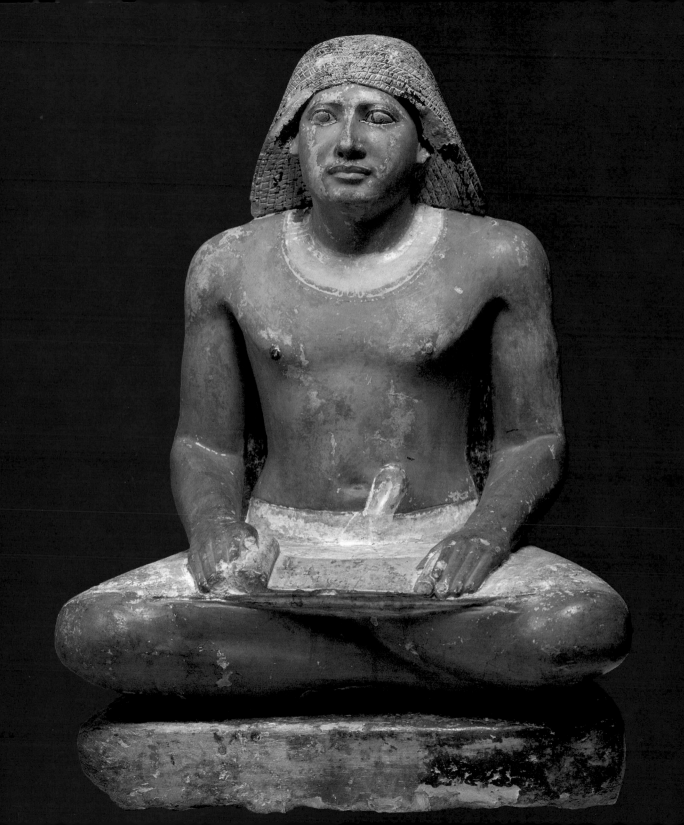

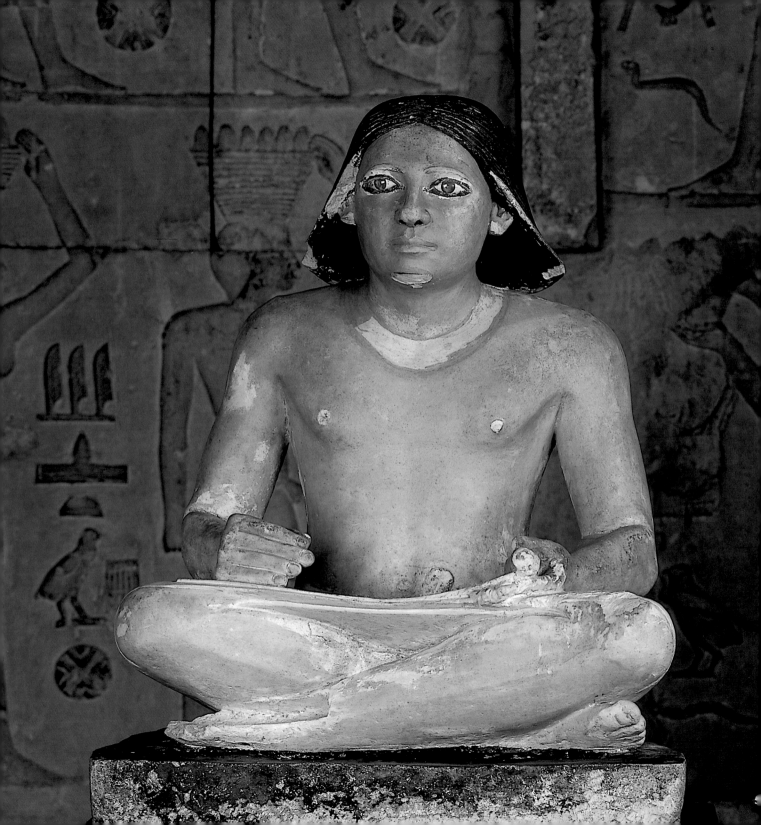

51. The scribe

Painted limestone; Saqqara;
5th Dynasty; *c.* 2450 BC; Ground floor, gallery 46;

Here is an excellent limestone example of the fine scribe statues of the Old Kingdom. In that glorious period, scribes were needed for the elaborate organisation and management of the state and the profession of scribe was very prestigious, even being considered the noblest of all. It was a hereditary profession, taught from father to son; scribal schools probably existed as early as the Middle Kingdom, and from the Middle Kingdom until the Late Period statues of scribes were found in temples. Some scribe statues do not actually represent the profession of the tomb owner but suggest his literacy and underline the importance of the written word in the afterlife.

Royal and private statuary shared many poses such as sitting, standing or kneeling. No king, queen or noblewoman, however, was ever represented as a cross-legged scribe, although some kings had the title 'son of Thoth', god of wisdom and writing. This cross-legged pose was reserved only for a particular social class of high officials involved in the administration.

Being represented as a scribe was truly a matter of honour for princes. The oldest scribe statue is that of Ka-waeb, a son of Cheops. The cross-legged scribe pose was common in the Old, Middle and New Kingdoms but became rare during the Late Period and disappeared in the Ptolemaic era.

Scribes were sometimes represented writing and at other times reading what they had written. They specialised in certain subjects such as administration, theology and medicine. The centres for scribal activities were near the temples in the so-called *pr-ankh*, 'the house of life'.

The two most famous royal scribes in ancient Egypt were Imhotep, the architect of Djoser, and Amenhotep, son of Hapu, the architect of Amenhotep III.

Many of the noble ladies were literate but the only instance of a female scribe is Seshat, goddess of writing. The word *sesh* was the masculine form of the word scribe, while Seshat was its feminine form.

52. Seated scribe

Painted limestone; Saqqara; H. 51 cm;
5th Dynasty; *c.* 2450 BC; Ground floor, room 42; JE 30272 = CG 36

This limestone statue from Saqqara shows a cross-legged scribe with a papyrus scroll over his knees, his hands ready to write. He wears a wig with a central parting as was fashionable in the Old Kingdom, and his eyes are inlaid to express his wisdom and the depth of his psyche. On contemplating this statue one cannot help but feel that one is facing an intelligent and thoughtful person. His gaze gives one the impression that he is meditating and thinking about what his hand will write, so that he appears to be at the very moment of the inspiration and creation of an intellectual work. The level of his gaze is high, probably because the artist wanted to show that he was looking far away, pondering what he was about to write.

By carving wrinkles beside his nose to indicate that this scribe was not a young person the artist probably signified that he had experience in his profession, so adding to his status. These wrinkles contrast with the strong body which is that of a young man, thus showing the combination of the intellectual qualities of maturity with youthful physical strength.

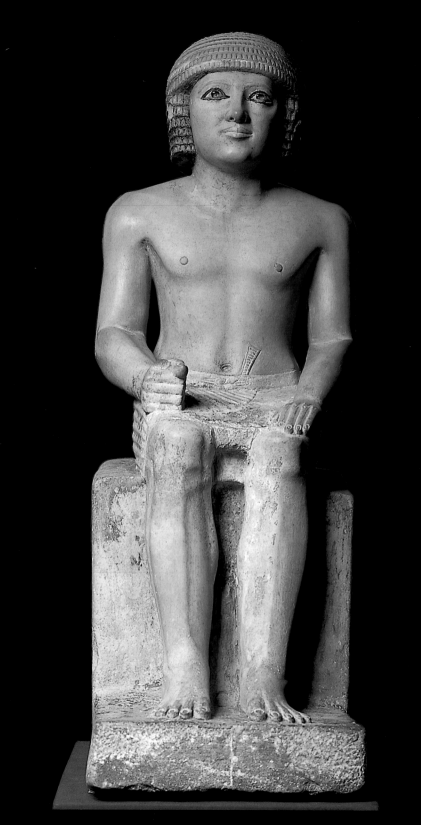

53. Seated man

Painted limestone; Saqqara; H. 61 cm;
5th Dynasty; *c.* 2450 BC; Ground floor, room 42; JE 30273 = CG 35;

This limestone statue was found near the famous statue of the seated scribe in Saqqara, and some Egyptologists therefore think they were one and the same person. However, there is no evidence to prove this suggestion.

The quality of the limestone is remarkable and so is the representation of the face. It is created in a naturalistic style that strongly expresses intellect and spirituality. The man's eyes are surrounded by copper inlay to represent the malachite paint used by the ancient Egyptians to protect their eyes from the glare of the sun and from eye diseases. A unique feature of this statue is the copper accessory shown over the curly wig near the ears.

54. Double statue of Nimaatsed

Painted limestone; Saqqara; H. 57 cm; W. 29 cm;
5th Dynasty; *c.* 2430 BC; Ground floor, gallery 46; CG 133;

This limestone statue found in a *mastaba* tomb at Saqqara is a double representation of Nimaatsed, a nobleman. Inscriptions at the base of the statue, which is in an excellent state of preservation, show that he was a judge and a priest in the solar temple of the Fifth-Dynasty King Neferirkare (2492 to 2482 BC) at Abu-Sir. Nimaatsed is represented with reddish-brown skin, wearing a wig with a central parting, a *usekh* collar and a short kilt, pleated on one side. He advances his left leg and his closed hand holds his seal. His second figure is slightly shorter than the first. The realistic face gives great attention to detail and shows him in the prime of life.

Such statues showing double, triple, or even quadruple representations of one person are known as 'pseudo-groups'. In some instances, the second figure is represented in a different pose or with a different hairstyle or dress. In the present case, the two statues are almost identical. This duality probably represents Nimaatsed and his double, which was one of the spiritual elements of the person, termed the *ka*.

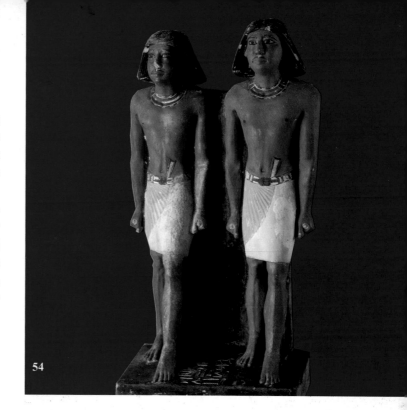

54

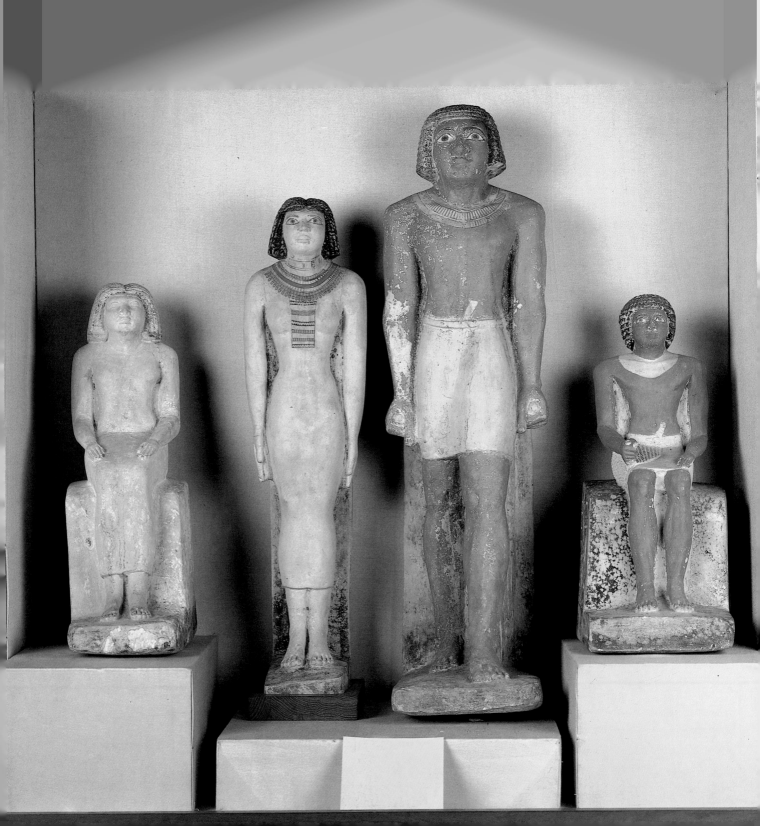

55. Family of Neferherenptah, called Fifi

Painted limestone; Saqqara;

5th Dynasty; *c.* 2400 BC; Ground floor, gallery 47;

Fifi, H. 65 cm; JE 87804;

Fifi's wife, Sat-meret; H. 53 cm; JE 87806;

The boy Itisen; H. 37 cm; JE 87805;

The girl Meritites; H. 39 cm; JE 87807;

This limestone group belongs to the family of Neferherenptah, a *wab* (purification priest) for the mortuary cult of Cheops and Menkaure. It was found in the *serdab* of their *mastaba* tomb in Giza.

Neferherenptah is represented wearing a curly wig with straight ends, a white and blue *usekh* collar, probably made of quartz and turquoise, and a short plain kilt.

His wife, Sat-meret, was a royal acquaintance. She is represented wearing a wig consisting of tresses, a novel feature, with a central parting; part of her real hair is shown underneath. She wears a *usekh* collar of carnelian, quartz and turquoise and a tight-fitting dress revealing details of her body. She is shown smaller than her husband in accordance with tradition.

Their son, Itisen, is represented seated, wearing a round curly wig, the large *usekh* collar, and a short kilt with innovative pleats at the side. Conforming to tradition, he is painted reddish-brown. His round face has a youthful look. The daughter, Meritites, is also represented seated, wearing a wig similar to her mother's and a tight-fitting dress. Her face is slightly turned up, giving her a dignified air.

Nobles of the Old Kingdom were often designated by two names. The major name included a meaning, such as Neferherenptah, or 'beautiful is the face of Ptah', a theophoric name describing attributes and characters of gods. The other was the *rn nedjes* or the short name, described as *rn nfr* (beautiful name), which was acquired sometime after birth. In this case, Fifi is the *rn-nfr* of Neferherenptah. This tradition continued throughout ancient history and we find other examples with *rn-nfr* 'beautiful names' such as Kiki, Toto, Ta and To. Perhaps the modern Egyptian practice of giving a nickname to a person by which his friends call him has its root in this ancient Egyptian custom.

56. False door from the mastaba of Nikaure

Painted limestone; Saqqara; H.227cm, W. 235 cm;
5th Dynasty, reign of Neferirkare, 2492 - 2482 BC;
Ground floor, room 42; CG 1414;

A false door is a stela built into the tomb walls and panelled so as to represent a part of the façade of a house. Its function was to enable the *ka* of the deceased, a spiritual element which was his double, to enter and leave the tomb in order to fetch the offerings which were usually piled on the offering table in front of the false door.

In the centre is a narrow panel representing the door itself, which in most cases bore no decoration but sometimes was filled with the figure of the owner in profile or in full face and high relief in the act of passing through the door to receive the offerings. To the sides are two door leaves over which is the figure of the deceased with his sons and important members of his family. Above the panel of the door is a drum, which is a roll imitating the curtain in real houses and on which the principal titles and the name of the owner are inscribed. Above the drum is a horizontal lintel, over which either the titles of the owner or the contents of the meal prepared for the nourishment of the *ka* of the deceased are represented.

In the upper part is a stela on which the owner of the tomb is shown, sometimes with his wife, in front of an offering table, and covering that part is an upper lintel.

This false door belonged to Ihat, the wife of Nikaure, a judge, chief administrator of the palace and chief of the envoys. Ihat herself was a 'royal acquaintance'. The chapel of Nikaure contained two false doors; this one was dedicated to his wife who is represented in the central niche with her name and title on the drum. On the right hand side Ihat is smelling a lotus flower, accompanied by her son. Then Nikaure is represented as a priest wearing a curly wig, a collar, a starched kilt and a leopard skin, accompanied by his daughter who repeats the same act as her mother. On the left hand side, Ihat is accompanied by her daughter who is embracing her mother. Another representation shows her daughter smelling the lotus flower. In the lower part are her servants and children, as well as a harp player and a singer. Her children are represented naked, with

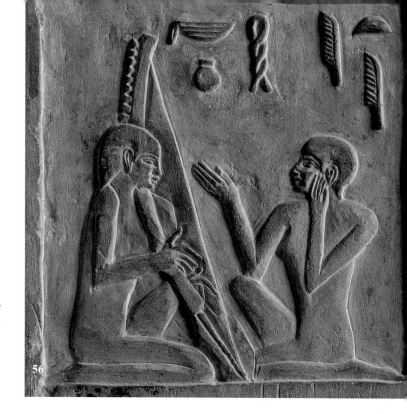

a lock of hair on one side of the head and holding birds such as pigeon and hoopoe.

In the upper part are two representations of Nikaure and Ihat. The first shows them sitting in front of an offering table laden with loaves of bread and innumerable offerings. The second shows Ihat holding her husband tenderly, representing her love and support for him.

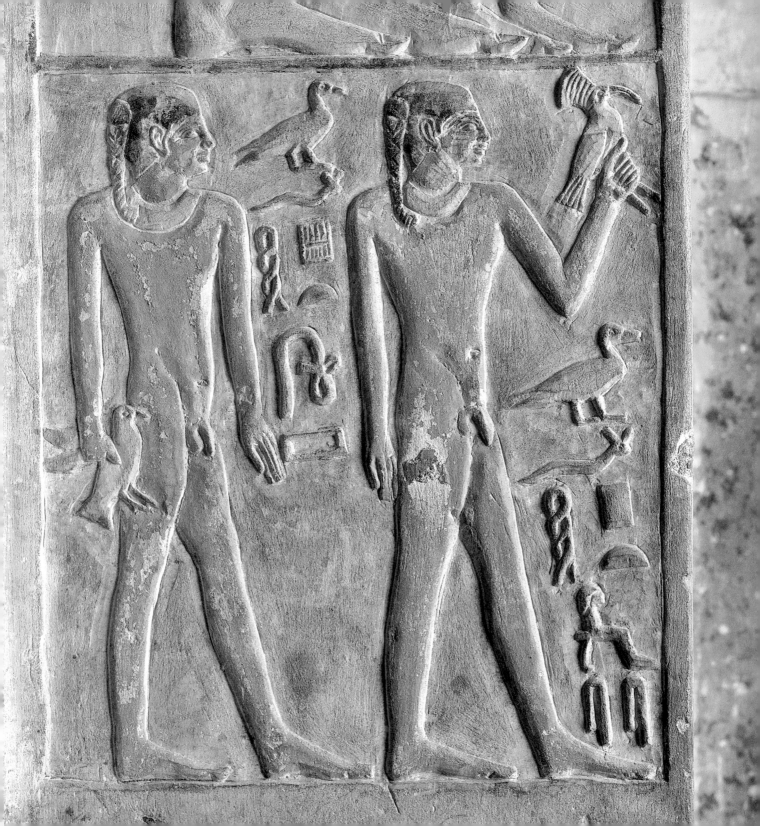

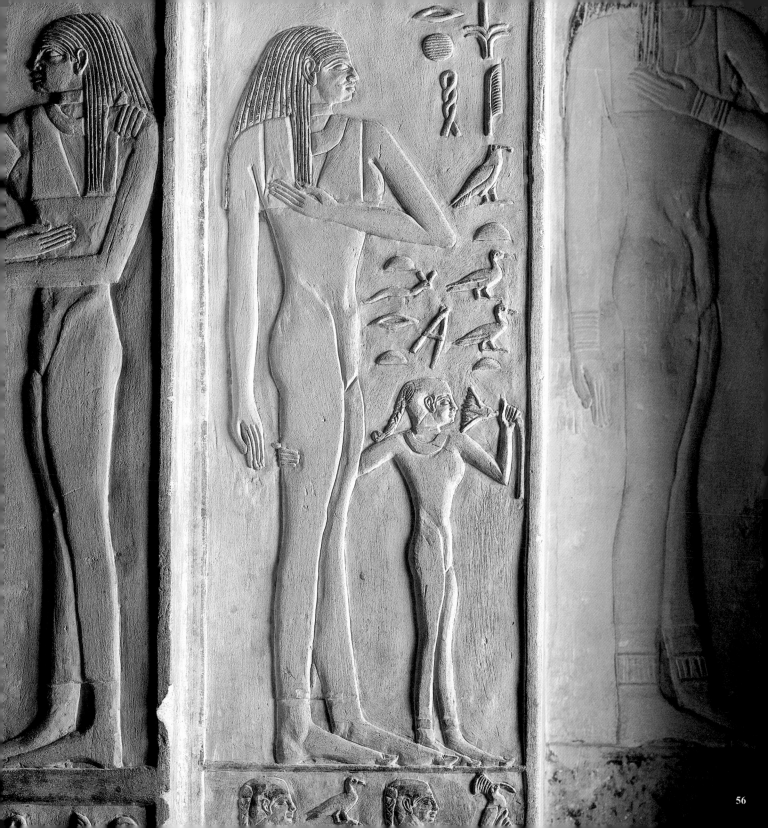

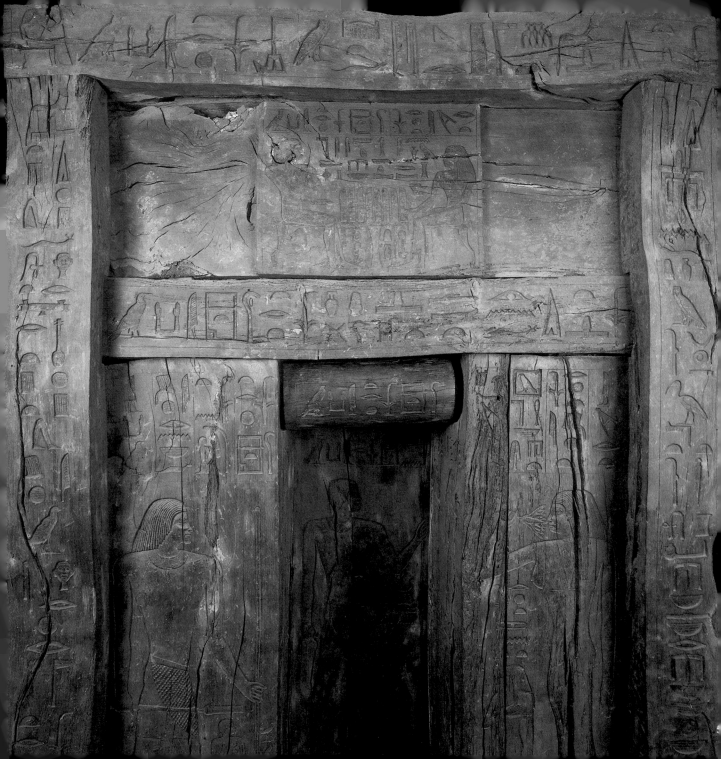

57. False door of Ika

Wood; Saqqara; H. 200 cm; W. 150 cm;
5th Dynasty; *c.* 2450 BC; Ground floor, room 42; JE 72201;

This wooden false door was found by the Egyptologist Zaki Saad in a tomb close to the causeway which leads to the pyramid of Unas at Saqqara. The only wooden false door to have been found in an Old Kingdom *mastaba*, it belonged to a *wab* (purification priest) and a governor of the great house by the name of Ika. His name and titles are inscribed on the drum. In the central niche he is represented with his son, while on the right hand side his wife Iymeret is shown smelling a lotus flower, accompanied by her daughter. Her titles indicate that she was a priestess of Hathor. On the left hand side Ika appears accompanied by his son, holding his *kherep* (sceptre of leadership) in one hand and a staff in the other.

There are also several representations of the *htp-di-nsw* offering formula, which enumerates and validates the offerings of bread, beer, poultry, cows, alabaster and clothes.

The indigenous trees of Egypt produced a medium quality wood of short length and narrow width, and the different parts of the door are therefore held together by tenons, pegs and leather thongs.

58. Relief from the mastaba of Kaemrehu

Painted limestone; Saqqara; H. 97 cm, W. 235 cm;
end of 5th Dynasty; Ground floor, gallery 41; CG 1534;

This wall relief decorated the walls of the mastaba of a noble man called Kaemrehu. He lived during the Fifth Dynasty and was a high priest of the Pyramid of King Niuserre at Abu-Sir.

It shows themes of daily life episodes that noble men used to have in their actual life and wished to be repeated once again in their afterlife.

The lively scenes covering the walls of mastabas represent different aspects and various activities including the court of justice (58.1 & 2). In this example we see two naked men kneeling on the ground and being lead in a humiliating manner by two attendants. Probably, these two men were punished for trying to mislead the authorities about taxes they ought to pay. They were taken to the court of justice where the scribes sat squat-legged registering the trial. Two scribes on the right hand side are holding a papyrus scroll and placing pencils behind their ears. A bag with extra roll of papyrus lies on the ground in front of them. Another scribe is sitting also squat-legged and writing over the papyrus scroll while another assistant is helping by holding the scribal palette.

Several scenes of artisans in the workshops are represented over the walls of the Mastabas (58.3). Two sculptors are working on a standing statue of the deceased represented naked and supplied with a wig. They are polishing the wig with a sandstone tool, putting the final touches for the completion of the work, meanwhile another sculptor is squatting on the ground to carve the lower part of another statue.

Two artisans (58.4) are preparing metals to be manufactured, they are squatting, weighing the metal pieces, one of them is adjusting the balance; the other is registering and recording the actual weight.

Shown here are also dwarf goldsmiths (58.5) are working to produce gold collars and different jeweller. Dwarves were frequently represented in this profession of jewelers and goldsmiths in ancient Egypt. Represented above their heads we see the word *nbw* which means gold. Goldsmiths were known as *nby* "gold workers" and their supervisor who was overseeing their work in the workshop had the title "overseer of the gold workers".

We see also different household activities (58.6 - 58.12) like making and polishing jars. One of the potters counts the jars and covers them with lids. Represented in full detail is baking bread and cake which was eaten by the ancient Egyptians in every meal. It was baked from a variety of ingredients. Women are making the dough, and then placing the dough on a strainer in order to prepare yeast. One of them squeezes it while the other is pouring water over it. A woman is represented winnowing grain. Three persons a woman and two men are cooperating in grinding grain that will be used in making that dough for various shapes and types of bread.

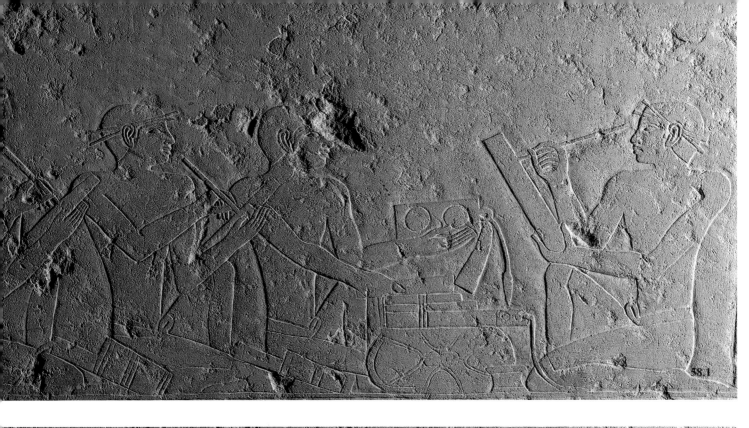

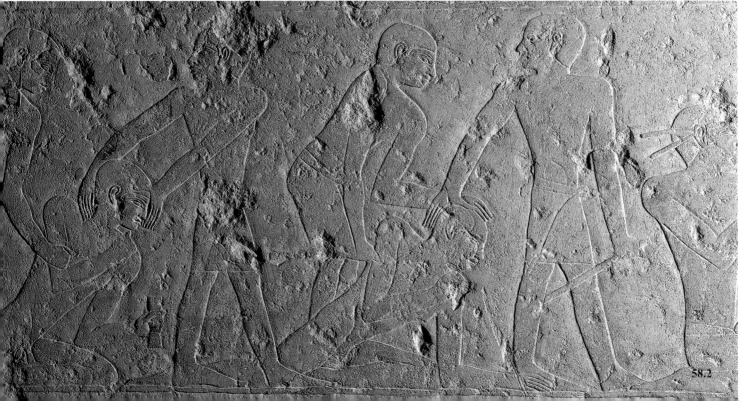

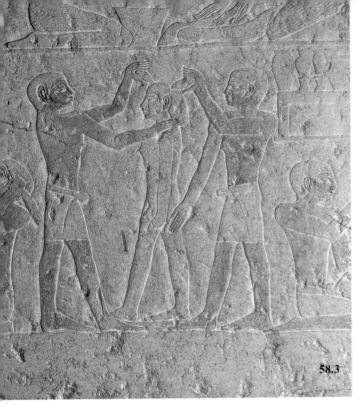

58.3

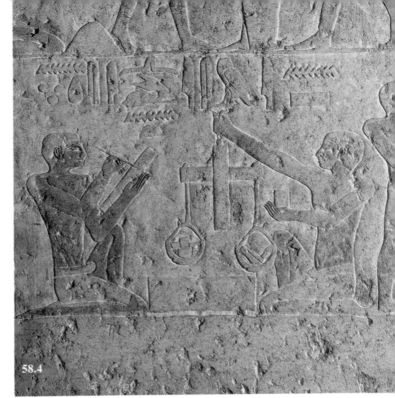

58.4

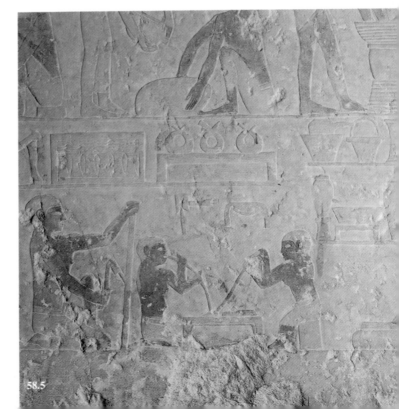

58.5

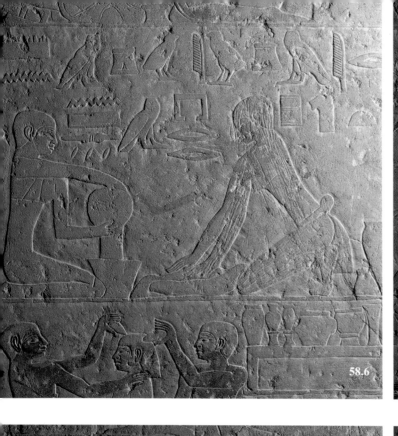

58.6

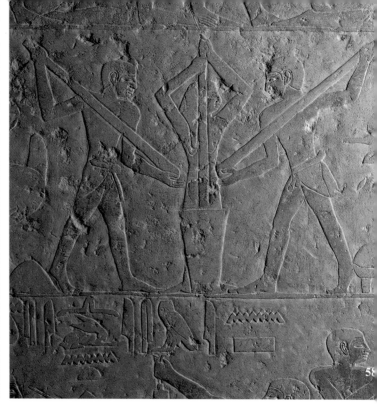

58

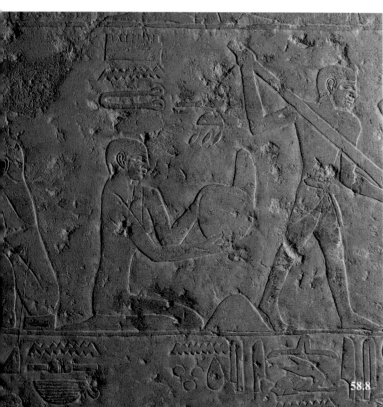

58.8

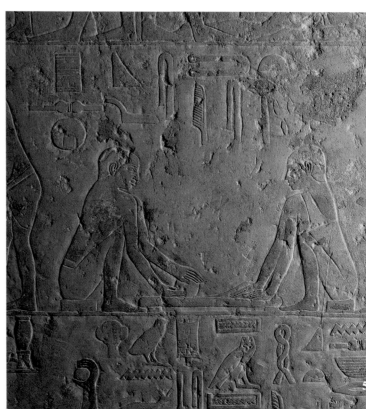

58

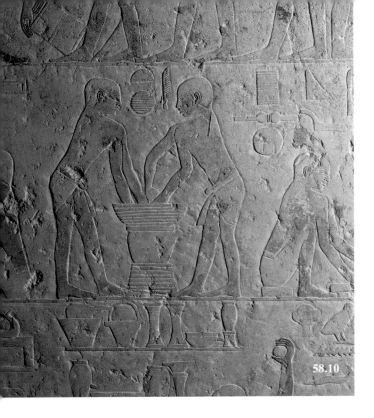

58.10

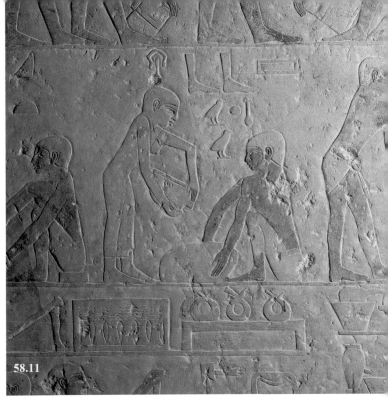

58.11

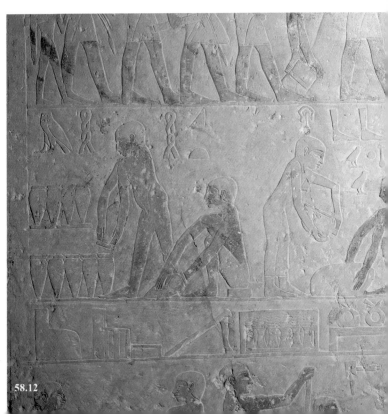

58.12

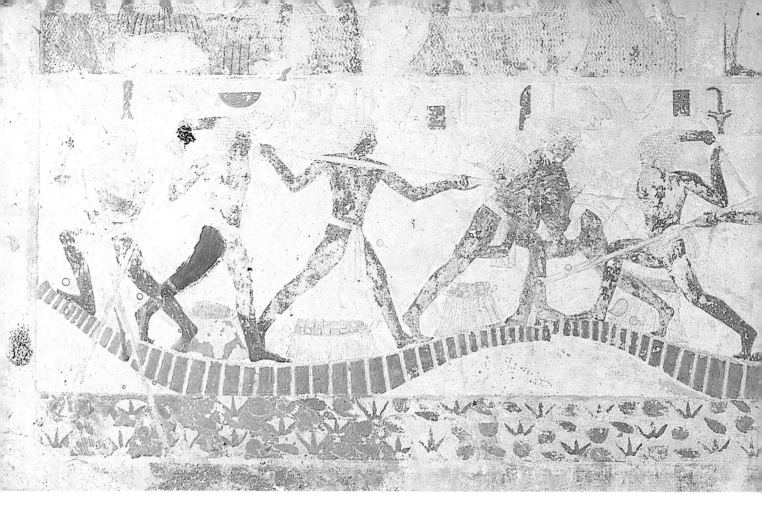

59. Boatmen in a sporting competition

Painted limestone; Saqqara; H. 145 cm;
5th Dynasty; *c.* 2400 BC; Ground floor, room 32;
JE 30191 = CG 1535;

This scene was painted on the limestone walls in one of the *mastaba* tombs at Saqqara. It represents one of the sporting competitions which would have been performed in front of the tomb owners and their families to entertain them during their life on earth. Wishing to experience such a sight again in the afterlife, noblemen had it depicted on the walls of their *mastaba*s.

The scene here shows a group of boatmen fighting together in a great variety of postures. The contestants are holding fencing poles similar to those still used nowadays in fencing games in Egyptian villages. They are standing on light skiffs made of papyrus stems

tied together, sailing in the marshes of the Nile Delta which here are represented in a very innovative style. Instead of showing the water as wavy lines coloured light blue or green, the artist has represented aquatic flora with lotus flowers, leaves and buds.

Varied body movements enhance this very lively scene, which is accompanied by cheering when one contestant tells his mate to crack his opponent's head and to split his back open.

Long before the Olympic Games were held the ancient Egyptians were interested in sports, including running, hunting, and fowling. Fighting sports such as wrestling, boxing and fencing provided a rich subject for the decoration of tomb walls as early as the Old Kingdom. The depiction of this type of scene would reach its apogee in the Middle Kingdom tombs of Beni Hassan.

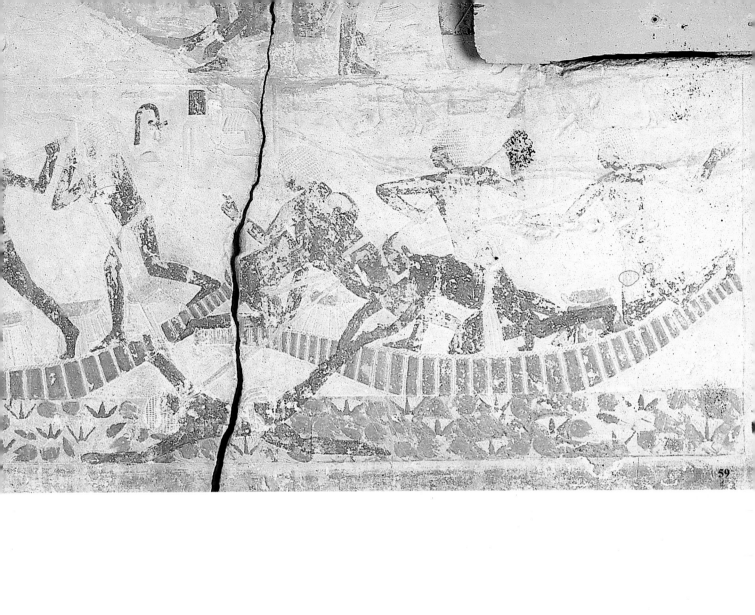

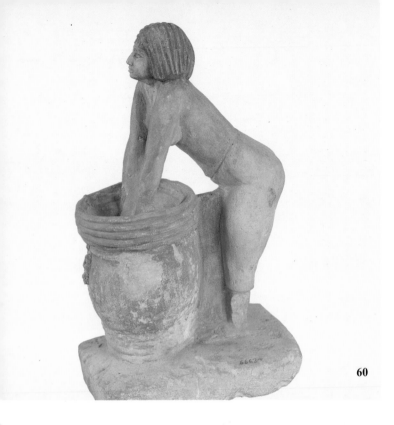

60. A Female Brewer

Painted limestone; Giza, mastaba of Meresankh; H. 28 cm;
end of 5th Dynasty; Ground floor, gallery 47; JE 66624;

The woman depicted preparing beer, called *henket* in ancient Egypt. She is wearing a straight wig, a large pectoral and a long kilt. Her torso is naked like most statues of servants, who were shown naked or with bare chests. Her reddish skin colour is unusual, as females were normally shown with creamy yellow skin. But because she was a servant she might have been tanned from working for long hours in the sun. Her face is very realistic, revealing tiredness as well as contentment, while she is engaged in preparing beer. As the national Egyptian drink, beer was an important part of the meal. It was also a major element in the offerings to the dead and to the gods. Prepared by pouring water on barley cakes and leaving the mixture to ferment in a warm place, beer was brewed in houses as well as in state breweries. Sometimes ingredients like dates, honey or spices were added.

60

61. Servant carrying two bags

Painted wood; Saqqara; H. 36 cm;
6th Dynasty; reign of Pepi II, 2300 - 2206 BC;
Ground floor, gallery 46; JE 30810 = CG 241;

This wooden servant statue was discovered in the tomb of his master, a nobleman named Niankhpepi, a grandee in the cemetery of Meir, near Assiut. It shows a servant carrying two very ornate baskets decorated with colourful geometrical motives. Judging by his very dark skin, flat nose and large, full lips, it is evident that he was of Nubian descent. On the base of the statue is an inscription mentioning that he was 'the black'. The naturalistic expression on his face shows his contentment.

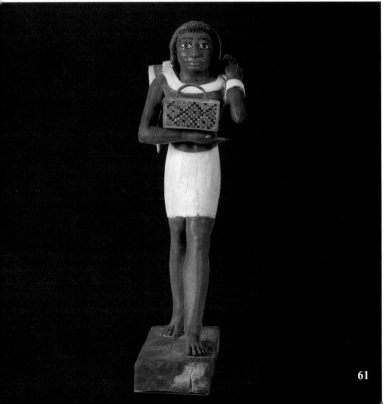

61

62

63

62. Sandal bearer

Painted limestone; Saqqara;
5th Dynasty; *c.* 2450 BC; Ground floor, gallery 47;

This limestone statue represents a young man carrying a bag on his back while holding his master's sandals in one hand. He is represented nude.

Already in the Old Kingdom children were represented without clothes both on wall reliefs and in statuary. Women were never represented entirely naked, but were sometimes shown wearing transparent dresses revealing details of their bodies. In some wall reliefs women wear clothes with straps that show their breasts, represented in profile. In the case of servant statues, the religious significance of nudity was probably to ensure the restoration of all vital functions in the afterlife. In addition, some servants would probably remove their clothes to facilitate movement, as is attested by wall reliefs showing servants performing certain activities.

64

63. Servant plucking a goose

Painted limestone; Saqqara; H. 28 cm;
5th Dynasty; *c.* 2475 BC; Ground floor, gallery 47; JE 72232;

This limestone statue of a servant plucking a goose was found in the *serdab* beside the statue of his master, the tomb owner, in his *mastaba* at Saqqara. The innovative pose of the legs imbues the statue with a lively air.

The presence of statues of servants performing tasks in the tombs of their masters was common in the Old Kingdom. The noblemen believed that they needed their servants in the afterlife, which was seen as a continuation of earthly life.

64. Woman grinding grain

Limestone; Giza; H. 32 cm;
5th Dynasty; *c.* 2450 BC; Ground floor, gallery 47; JE 87818;

This limestone statue of a woman grinding grain was found in a *mastaba* in Giza. She seems distracted and not concentrating completely on what she is doing, perhaps because this task is repetitive. She may be raising her head to listen to the instructions of her master. The pose of the woman is innovative, showing her kneeling and placing her two hands on the grinding tool. The hairstyle and ribbon are also innovative. Her torso is bare, as is common in statues of servants engaged in household activities.

The production of these servant statues gave the artist the freedom to be creative and to introduce innovative poses and styles. Wooden servant statues made their first appearance beside the common limestone servant statues during the Fifth Dynasty, when this statue was made.

The Middle Kingdom

After the fall of the Old Kingdom came an interim period of ineffective government known as the First Intermediate Period. This covered the period of the Seventh to the Tenth dynasties and lasted for about two centuries, and was an era of decentralization in which the unity of the country fell apart. This in turn led to changes in certain political, social and even religious traditions.

Nothing is known about the short-lived Seventh Dynasty apart from the legend that seventy kings ruled in as many days, which while an exaggeration certainly indicates severe unrest. The Eighth Dynasty included one hundred and eighty kings who ruled from Memphis. The Ninth and Tenth Dynasties saw the emergence of two ruling houses, one based in the north at Ahnasia, near Beni Suef, and the other ruling over seven southern provinces from a base at Coptos, in the neighborhood of Thebes. Shortly after this phase, the leadership of the south fell into the grip of a powerful Theban family, the Intefs, who would eventually reunite Egypt.

There was great competition between the two ruling houses of Upper and Lower Egypt, and this continued through the hundred years of the Ninth and Tenth Dynasties (about 2165 to 2040 BC). Military conflict erupted between them; this conflict raised the military spirit in Egypt and led to closer contact between the rulers and their people, whose support they depended upon. The noblemen, meanwhile, were testing their authority. During the First Intermediate Period, quite apart from the rivalry between the ruling houses of the north and the south, each nomarch within the two kingdoms was jockeying for power within his own nome, while attempting to solve such internal problems as famine and security. These nomarchs had become increasingly dominant, passing their positions down through the male line.

Thus the sovereign no longer had the luxury of semi-divine isolation from the nobles or from the public, and social and political change was inevitable. Accordingly ordinary people began to reconsider their traditional rights during their lifetime and in the hereafter. This marked the beginning of the democratization of religion. There was a marked change in religious traditions concerning the afterlife and in the significance of the destiny of the individual. As a result every deceased person became an Osiris, a privilege hitherto reserved exclusively for royalty.

The leader of the struggle for the reunification of Egypt was Montuhotep Nebhepetre, a member of the ruling house of Thebes. Montuhotep succeeded in gaining victory over the Ihnasian family in the north and ascended the throne over all Egypt, thus founding the Middle Kingdom. He commemorated his victory by building a chapel to Hathor at Dendara, sixty kilometers north of Luxor (Thebes), and a temple to the war god Montu at al-Tud, south of Luxor.

The reigns of Montuhotep's successors, are notable for widespread exploitation of stone quarries in desert wadis (dry water courses), particularly Wadi al-Hammamat in the Eastern Desert where they left many traces of their activities, and for their commercial relations with Punt in Africa. These activities had ceased during the First Intermediate Period, but texts from the Eleventh Dynasty describe them in detail and indicate that such trading missions were considered great achievements. The texts relate the progress of these expeditions and the obstacles faced by the envoys, including the lack of water and the effort of sinking wells in the desert.

The Twelfth Dynasty was a prosperous period for Egypt. Its founder, Amenemhet I Sehetepibre, ruled from 1991 to 1962 BC, claiming that he was chosen by the will of the gods to be king and that an old prophecy from the reign of Sneferu, founder of the Fourth Dynasty, foretold his ascendance to the throne of Egypt. He began his reign in Thebes, paying great esteem to its god, Amen, but some years later moved the capital to al-Lisht, twenty five kilometers south of Saqqara. He named the new capital Ithet-tawi, or 'the seizer of the two lands', by which he wished to demonstrate the power of his dynasty as having its own capital in virgin territory, an area blessed moreover with abundant natural resources, notably the fertile soil and plentiful water of Fayum. It was also an advantaged location strategically, being more or less in the centre of the country. Thebes, however, remained the political capital.

Amenemhet I erected fortifications and citadels, named 'the walls of the prince', to protect the north eastern borders. Other fortifications, 'the walls of the honoured Amenemhet', were built at Karma near the Third Cataract in Nubia. At that time Lower Nubia, or Wawaat, included the First and Second cataracts, or the area from Aswan to Wadi Halfa, today the most southerly part of central

Egypt. Upper Nubia was then known as Kush, and included the land between the Third and Sixth cataracts as far as Khartoum.

Ten years before the end of his reign Amenemhet appointed his son Senusert (Sesostris) I as his co-regent. The death of the old king appears to have been the result of a conspiracy, details of which are registered in the form of maxims he wrote to his son. In these, he mentioned that he was a fair and righteous ruler whose great deeds benefited the country and its people, but who had been deceived and cheated by persons to whom he had been benevolent. He advised Senusert to trust no one, and not to depend on any of his courtiers. These maxims may have been written by a scribe as a record of the end of his life while the king lay dying.

Senusert I, however, seems to have realized that these maxims reflected his father's reaction to the plot, and rather than losing entire confidence in the courtiers he continued to depend on the more honest of his high officials such as his vizier, Montuhotep. The nomarchs also enjoyed great privilege, and further enriched themselves. In the tombs of some of these officials have been found some of the best preserved, most informative and best illustrated scenes of sports and games in the art of ancient Egypt. One tomb shows two hundred and nineteen different wrestling positions, while another figures a weightlifting display and a high jump from the back of an ox.

The power of the king and his successors Amenemhet II and Senusert II was bolstered by the honour and respect accorded them by their subordinates. Senusert III, however, instituted another policy, taking measures to minimize the power of the nomarchs and their custom of passing their positions to their sons even if these were still minors. He removed some of the authority attached to the titles of the nomarchs so that they became less important, and from then on even their graves were less grandiose. Yet despite this policy, Senusert appears to have allowed them to keep their fortunes and property. The governor of what is now Deir al-Bersha, near Minya, a noble man named Djehotihotep, was permitted to erect a colossal statue of him, represented in his tomb. Six meters high, it was transported by a hundred and seventy-two workmen and attendants.

Senusert II, the fifth ruler of the Twelfth Dynasty, built his pyramid at al-Lahun, twenty-five kilometers south of Fayum. Here excavations have yielded the remains of a Middle Kingdom city built on edge of the desert and subsequently engulfed by sand. It was this circumstance that ensured its preservation until it was discovered by Flinders Petrie, who found that its inhabitants had been the architects, artisans, supervisors and workforce who had helped build Senusert's pyramid and its funerary complex. It also contained a royal rest house where the king could stay when he visited the site of his pyramid. The city was enclosed by a thick brick wall and had two quarters, one for noblemen and the other for working people and their families. In these houses were found a quantity of everyday utensils and personal effects including boxes, sandals, mats and tools. There were also a large number of papyri written in the hieratic script which included medical, teaching and administrative texts such as population and personal statistics for the residents of the city and mathematical lessons for students greatly contributing to our store of knowledge about the Middle Kingdom.

Major agricultural projects such as the building of dams and dykes were undertaken in Fayum at this time, especially in the reign of Amenemhet III (1843 to 1797 BC). This ruler tightened his grip on the government, yet was greatly respected and honored by the high officials and nomarchs.

Peace and security prevailed during the Twelfth Dynasty, while commercial relations between Egypt and her neighbours were extended, especially during the reigns of Amenemhet II and Senusert II. Many Egyptian statues, scarabs and other artifacts have been found in Byblos, Palestine and Syria, in addition to some objects of value including an obsidian jar with a gilt top and a sphinx statue of a princess. There was artistic and religious interaction between Egypt and neighboring countries, as manifested by statues of Egyptian divinities discovered in Byblos and vice versa.

In the tomb of the nobleman Khnumhotep, who was buried at Beni Hassan, was found a representation of a Semitic delegation from Palestine. Its members were depicted as families or tribes, one of them numbering thirty-seven persons, arriving to settle in Egypt. Many families came to earn their living by working in quarries and in the Sinai turquoise mines, or as temple and private servants in the capital itself.

International relations were also extended to Mesopotamia. At al-Tud, south of Luxor, were found four boxes containing amulets of lapis lazuli and cylindrical seals dating from the time of the

Sumerians. Other items discovered include Babylonian statues and jewelry in a fashion popular around the Aegean Sea.

At Hawara, near Fayum, archaeologists have found vases with a decoration resembling the Minoan style. Correspondingly, Egyptian artifacts have been found in Crete; this commerce seems to have been conducted via Phoenicia. One cultured Egyptian scribe wrote that he was proud that he "holds the pen of the Hawnbw", meaning that he spoke and wrote the language of the Mediterranean islands known at the time as Hawnbw, yet more evidence of cultural interaction between Egypt and Crete.

Amenemhet III was succeeded by two rulers: Amenemhet IV and Queen Sobkneferu. This queen who successfully claimed the throne of Egypt was probably a daughter of Amenemhet III. Her reign lasted for about four stormy years and was noted for the increase of the Asiatic immigrants from the northeast of Egypt. Its end marked the end of the Twelfth Dynasty and the beginnings of the so-called Second Intermediate Period.

After the fall of the Twelfth Dynasty another dynasty of obscure origin took over the throne, with some of its kings ruling from Thebes and others from Ithet-tawi. The southern borders were maintained as far as the Second Cataract. However a more turbulent period was to come, the country's unity was weakened and fragmented, and the Egyptian historian Manetho mentions that at the end of the Thirteenth Dynasty Egypt was invaded from the east.

These newcomers were the Hyksos, the so-called Shepherd Kings, who razed the cities, plundered the country and usurped the throne. Their name indicated the hekaw khaswt, the rulers of the high lands; and was mentioned as early as the Twelfth Dynasty in the story of Sinuhe. It is believed they originated from Asia, infiltrating in small groups to Egypt through Palestine and the east of the Delta, and acquired authority after the fall of the Middle Kingdom. They were helped by their weaponry—large shields and composite bows—which gave them confidence and made them feared by the Egyptians. Above all they were helped by their chariots drawn by war horses from the steppes.

The Hyksos did not rule a unified country; rather their system of governance was under a number of tribes. In addition to the Hyksos kings, another dynasty of rulers appears to have established itself at the west of the Delta forming the Fourteenth Dynasty, probably contemporaneous with the Fifteenth Dynasty. While it is extremely difficult to ascertain the exact dates and dynasties of the period, some scholars consider it likely that the members of the Fourteenth Dynasty were nomarchs trying to keep control away from the Hyksos, the Fifteenth and the Sixteenth Dynasties applied to the Hyksos kings and the Seventeenth Dynasty to the sovereigns in Thebes.

The Hyksos controlled Memphis and the east of the Delta, building a capital at Ht-waret (Avaris), today Tel al-Dabaa near Zagazig. This was not far from the ancient route linking Egypt to Palestine. They fortified their new capital with huge fortresses where they stationed large numbers of troops, and built a temple to honor and worship the god Seth. Their rule lasted for 108 years, during which time they became Egyptianised enough to take theophoric names and represent themselves wearing traditional royal dress. However they had little impact on artistic trends in statuary and painting, and made no perceptible alterations to Egyptian traditions, religion or language. On the contrary, they did their best to identify with the Egyptian character. They clearly thought the country was theirs and they fully intended to stay.

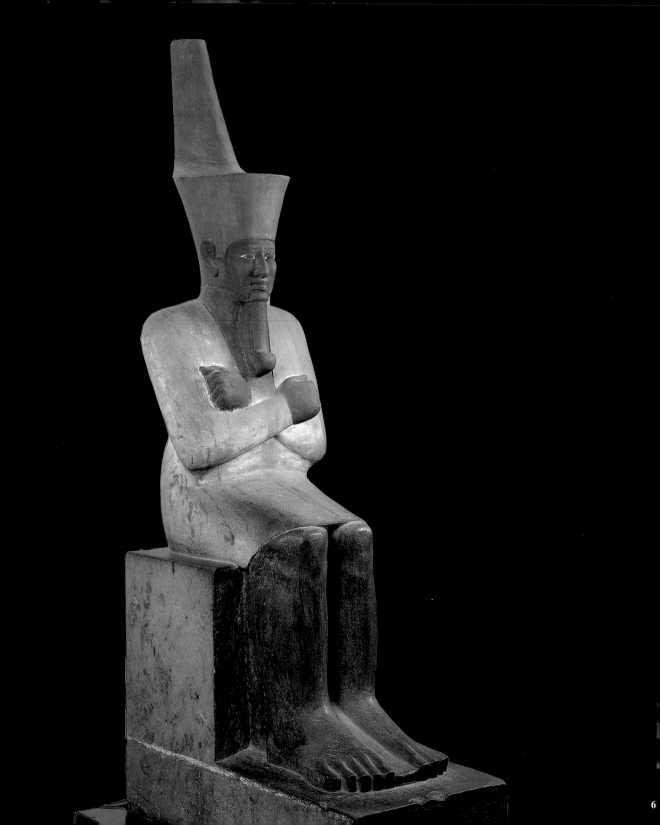

6

65. Statue of Montuhotep Nebhepetre

Painted sandstone; Thebes; H. 138 cm, W. 47 cm, L. 101 cm;
11th Dynasty; reign of Montuhotep II Nebhepetre, 2061 - 2010 BC;
Ground floor, gallery 26; JE 36195;

This sandstone statue of the founder of the Middle Kingdom, Montuhotep Nebhepetre (2061 to 2010 BC), was found in Luxor in 1901 by the British Egyptologist Howard Carter, discoverer of the tomb of Tutankhamen. It was unearthed on the west side of the Nile close to his temple at Deir al-Baheri at a site now called Bab al-Hossan, the Horse Gate. The discovery came by chance when a horse stumbled into a hole, giving a clue as to the presence of a tomb where the statue was discovered wrapped in linen mummy bandages.

The statue shows the king seated on the throne and wearing the *desheret* Red Crown of Lower Egypt and the dress of the *heb-sed* rejuvenation festival, which he celebrated after a rule of thirty years to affirm his fitness to continue governing. Although he was originally from a Theban family, Montuhotep wears the Red Crown of Lower Egypt to accentuate the fact that he has extended his authority to that area.

The king is shown with a curved false beard which represented the realm of the hereafter, while his arms are crossed over the chest in the Osirian posture. The statue shows him with black skin, the colour of the Nile mud that seeped over the land and renewed its fertility every year, and so symbolized the underworld, resurrection and continuity of life. It was also one of the colours associated with the representations of the skin of Osiris, and therefore accentuated the belief that after death the king was personified with the god and all the goodness of the hereafter. The short *sed* festival dress that the king wears does not conform to the dress of Osiris, which was usually a long robe.

The representation of the face is typical of the Middle Kingdom, showing the eyes extended with the cosmetic line ending at the eyebrow, a broad nose, and a firm mouth. The legs are disproportionate; with this representation the artist probably wanted to emphasize the power of the king and to show him as imposing and fearsome to the enemies of unified Egypt. However, it might merely be a reflection of the deterioration of the art, which had lost much of its earlier quality during the upheavals of the First Interme-

diate Period. Accordingly, at this very beginning of the Middle Kingdom the artist may not have been skilled enough to produce truer proportions or better depiction of the muscles. It has been suggested that the king might have suffered from elephantiasis, but this is unlikely as it was not customary for artists to depict bodily imperfections in royal statues. Nevertheless, the sculptor has succeeded in creating this statue without a back support, and has also managed to render naturalistic curves in the king's back.

The name Montuhotep means 'the god Montu is satisfied'. This deity was the god of war, honoured by the sovereigns of the Eleventh Dynasty as the local god of Armant, twelve kilometers south of Thebes, where they originated. Montuhotep Nebhepetre built his funerary temple in the area of Deir al-Baheri, designing it as two terraces which later inspired the New Kingdom architect Senmut to build the three terraces of Queen Hatshepsut's temple. The king had two tombs, one near his mortuary temple and the second the so-called Horse Gate tomb mentioned above which might have been a cenotaph or symbolic burial place. His body was not found in either of these tombs.

Montuhotep Nebhepetre curbed the authority of the nomarchs and tightened his grip over the nomes, reuniting Upper and Lower Egypt after the long years of decentralization which followed the fall of the Old Kingdom. Narmer, Montuhotep II and Ahmose are the three great sovereigns who each won his struggle to unify north and south, Upper and Lower Egypt, at the beginning of the three Egyptian kingdoms: the Old, the Middle and the New.

66. Wooden statuette of Senusert I

Cedar wood; Lisht, Fayum; H. 56 cm, W. 11 cm, L. 26 cm;
12th Dynasty; reign of Senusert I, 1971 - 1928 BC;
Ground floor, room 22; JE 44951;

This statuette carved of cedar wood was found in the tomb of a chancellor named Imhotep at al-Lisht. It is the earliest surviving wooden royal statue from ancient Egypt.

The statuette shows Senusert I (1971 to 1928 BC), second sovereign of the Twelfth Dynasty, wearing the White Crown of Upper Egypt and a white *shndyt* royal kilt pleated at the sides. He is represented in the traditional manner of advancing his left leg forwards; he holds a stick with a crook-like end representing the *heka* royal

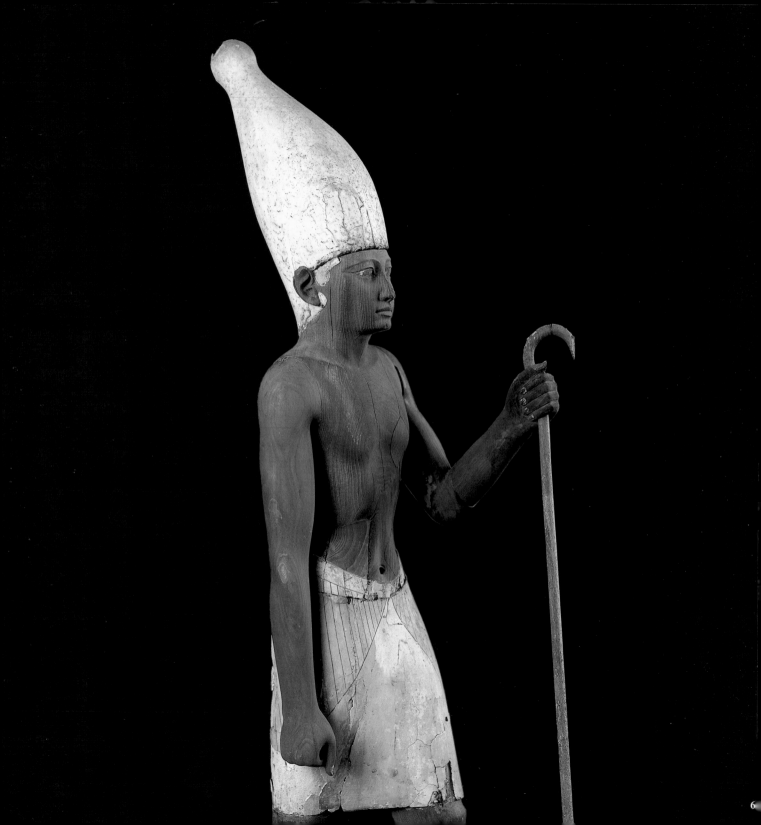

scepter symbolizing power. The royal scepter he held in his other hand, now lost, was probably the *nekhekh* flagellum symbolizing authority.

This is a composite statue made of several wooden pieces attached together by means of tenons. Another statue found beside this one showing the king wearing the Red Crown of Lower Egypt is now in the Metropolitan Museum in New York. The cartouche giving the king's name on the statue has never been found, and the assumption that it belonged to Senusert is based on the proximity of the tomb where it was discovered to his pyramid.

In the scenes of funerary processions in tombs belonging to the nobles, royal statues were shown being carried by porters along with the funerary possessions of the deceased for the equipment of his tomb, which indicates they were associated with certain rites. Such a funeral procession appears in the Twelfth-Dynasty tomb of Intf-ikr at Thebes (TT 60) and in several New Kingdom Theban tombs such as the tombs of Sw-m-niwt in Qurna (TT 92) and Samwt in Khokha (TT 247).

Senusert I ruled for forty-two years in addition to his ten years as co-regent with his father Amenemhet I. His name Sn-wsrt Kheper-ka-re means 'the one who belongs to the goddess Wsrt, the form of the ka of the god Ra'. Although he lived at al-Lisht he paid great respect to Thebes and its god Amen, and in this god's great Karnak Temple he built a limestone chapel, the White Chapel, one of the highlights of the temple and one of the most celebrated works of art of the Middle Kingdom. Senusert installed the chapel as a resting place for the divine boat of the god Amen, although some scholars think this might have been where the king celebrated his *sed* festival.

At Iwn, later called Heliopolis and now also known as Mataria or Ain Shams ('spring of the Sun'), twenty kilometers northeast of Cairo and then the centre of worship of the creator sun god Atum, Senusert I erected two obelisks. One still stands today; it is twenty-two meters high and is the oldest obelisk preserved from ancient Egypt.

67

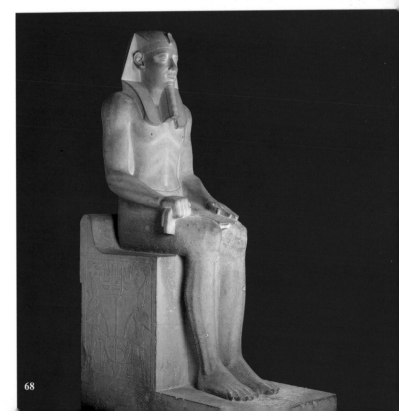

68

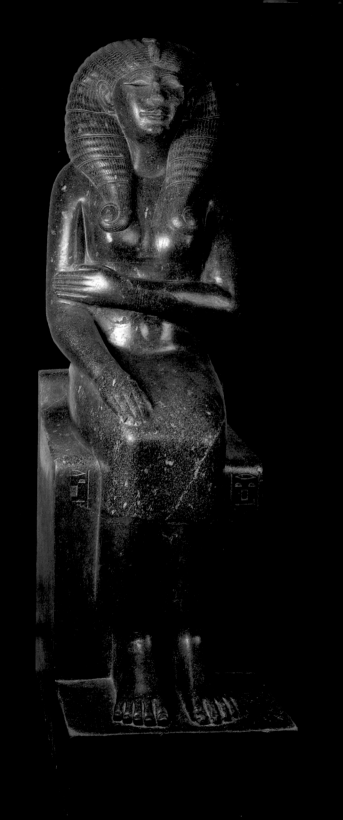

67. Granite head of a sphinx of Senusert I

Grey granite; Karnak; H. 38 cm,
12th Dynasty; reign of Senusert I, 1971 - 1928 BC; Ground floor,
room 22; JE 45489 = CG 42007;

This head was found in 1902 - 1903 by the French Egyptologist George Legrain, in the so-called Karnak *cachette*, a secret hiding place beneath the courtyard in front of the seventh pylon at Karnak Temple. The *cachette* contained thousands of statues of sovereigns, private individuals and deities dating from the Eleventh Dynasty to the Ptolemaic Period. This head, sculpted of grey granite, was probably the head of a statue in the form of a sphinx. It depicts Senusert I wearing the royal *nemes* headdress with the cobra on his forehead. He has a slight smile, as is typical of the art of the Middle Kingdom when expression was often reflected on the faces of rulers, as occasionally were their age, physical status and even their mood. Senusert I was deified at Buhen, north of the Second Cataract, as the sovereign who extended the Egyptian empire to Nubia. During his reign Egypt exercised tight control over this southern region. Senusert appointed Egyptian governors as local rulers in Karma, the most important city in the vicinity of the Third Cataract and a major commercial centre. One of these governors was Hapydjefay, who originated from Assiut and carved a tomb which is considered to be the largest rock–cut tomb from the Middle Kingdom in Assiut. His title was 'the supreme chief of the south and the top of the southern chieftains'.

One of the most famous pieces of literature from ancient Egypt is the story of Sinuhe, which was composed during the reign of Senusert I. It tells the story of Sinuhe, a devoted courtier who accompanied Senusert on an expedition to the Western Desert but was afraid of being incriminated in the assassination conspiracy against Amenemhet I, Senusert's father and co-regent. Although innocent, when Sinuhe learnt of the plot he fled Egypt, wandering the Eastern Desert and crossing the frontiers to Palestine and Lebanon where he stayed for many years. In his old age he asked Senusert's forgiveness, and eventually was allowed back to Egypt.

68. Statue of Senusert I

Limestone; Lisht, Fayum; H. 200 cm, W. 58 cm, L. 123 cm;
12th Dynasty; reign of Senusert I, 1971 - 1928 BC; Ground floor,
room 22; JE 31139

This is one of ten limestone statues found to the northeast of the funerary temple adjoining the pyramid of Senusert I at al-Lisht. They were found in a pit known as the Lisht *cachette*, which had been used to store those statues. Similar *cachettes* were found at Karnak and Luxor temples. They may originally have stood in the mortuary temple.

The statue shows Senusert I seated on the throne in the traditional pose. He wears the *nemes* headdress with the cobra on his forehead, a false beard and the *shendyt* royal kilt. In his right hand he holds a folded cloth which was sometimes also held by nobles, while his left hand rests on his knee. His muscles are faithfully represented and his face shows an air of serenity and satisfaction.

The side of the throne is particularly interesting. It shows the traditional *sematawy* scene signifying the unification of the two lands, the south and the north, Upper and Lower Egypt. This unity is represented here by the gods Horus and Seth, the two mythical powers of the country. They are represented tying together the two traditional plants, the *wadj* papyrus plant, symbol of the north, and the *seshen* lotus plant, its counterpart in the south.

In five of the ten statues the papyrus and the lotus are being tied together by the Nile god Hapy, who is represented as a man with full breasts and a large belly to symbolize the fertility of the Nile, where cultivation was made easy by the rich mud carried by the annual flood. This symbol of unification is surmounted by the royal cartouche and a wish that the king be granted a stable and prosperous life.

Senusert I's pyramid at al-Lisht, lies one and a half kilometers from that of his father Amenemhet I. It is constructed of mud brick and cased with limestone, and was surrounded by a funerary complex consisting of a mortuary temple and an ascending causeway. This was lined with Osirian statues representing the king as a mummy in the posture of the god Osiris. No remains of the valley temple have so for been found. This funerary complex is surrounded by nine pyramids for royal princesses, and the whole site is enclosed by two mud-brick walls.

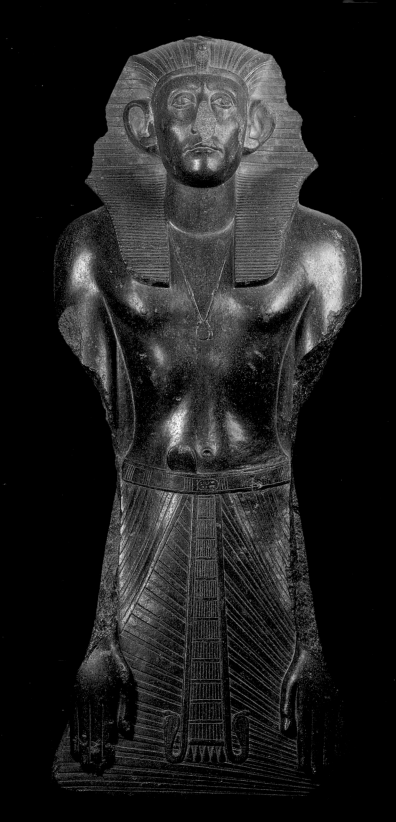

The foundation deposits of the pyramid were found in a pit on the southwestern side of that pyramid. These votive offerings of pottery vessels, bovine sacrifices and inscribed plaques were buried beneath the ground during the course of the foundation ceremony before construction began.

69. Queen Nefret

Black granite; Tanis; H. 165 cm, W. 51 cm;
12th Dynasty; reign of Senusert II, 1897 - 1877 BC;
Ground floor, gallery 26; JE 3748 = CG 381;

This granite statue of Queen Nefret, wife of Senusert II, fourth king of the Twelfth Dynasty (1897 to 1877 BC), was found in Tanis by the French Egyptologist Auguste Mariette. The queen is seated on the throne wearing a wig associated with the goddess Hathor and consisting of locks of hair falling on the shoulders and ending in curved spirals. She wears the royal cobra on her forehead, a tight dress and a necklace consisting of a pendant suspended on a wide ribbon, typical of the Middle Kingdom and similar to those found in the tombs of princesses at Hawara and Lahun. On the pendant is the royal cartouche of Nefret's husband Senusert Khaakheperre, a cobra wearing the crown of Upper and Lower Egypt, a pair of *udjat* eyes—a symbol of protection—and a *djed*, the pillar symbol of stability.

Above the throne are inscribed the queen's titles, but all are damaged except for *rpctt*, 'the noble woman'. Her other titles, however, are on a twin statue: *kherpt*, 'the leader'; *wrt heswt*, 'the one who is highly praised'; *sma-nbty*, 'the one who unifies the two goddesses of the north and south'; *mryt*, 'the beloved'; and *m-ab-hemwt imntt*, 'the one who is in the company of the ladies of the west'.

The statue does not have a back support, and the feet and waist are disproportionate. In this it can be compared to the statue of Montuhotep Nebhepetre with its massive legs. This statue is an example of the female royal statuary that shows the mix of the traditional, idealized artistic school of Memphis and the naturalistic school of Thebes. The combination of these two influences imbues it with vigour and power in addition to expression as seen on the queen's countenance.

70. Senusert III

Granite; Thebes, Deir al-Baheri; H. 150 cm, W. 58 cm, L. 54 cm;
12th Dynasty; reign of Senusert III, 1878 - 1843 BC;
Ground floor, gallery 21; RT 18.4.22.4;

This statue sculpted of black granite was found in the forecourt of the temple of Montuhotep Nebhepetre at Deir al-Baheri. It was one of six statues that Senusert III (1878 to 1843 BC) dedicated to the temple of his ancestor Montuhotep Nebhepetre.

This is the first known statue representing a sovereign in the posture of a prayer. He wears the pleated *nemes* headdress with the cobra on his forehead and a pleated kilt. His hands are represented flat over his kilt while he prays to the gods or carries out a priestly function. His mood is written on his face; here he seems exhausted, and the wrinkles between his eyes both accentuate this and suggest his advanced years.

Senusert III was an aggressive administrator and a shrewd warrior. Here he is represented with these tired eyes after leading several long campaigns to Nubia and Palestine to restore Egyptian power and prestige. The peaceful policies of his predecessors Amenemhet II and Senusert II encouraged some tribes to revolt and make a bid for control, and even to cut off commercial routes from Egypt to Nubia in the south and to Palestine and Lebanon in the northeast. Senusert III cut a pass through the rocks of the First Cataract to facilitate the traffic of his army and fleet, and increased the hill fortifications bordering the Nile and on the island that existed between Aswan and Wadi Halfa, the First and Second cataracts. Some of these fortifications, consisting of ten-meter walls surrounded by towers containing army barracks, still stand in Semnah and Kemnah north of Wadi Halfa. He placed two granite stelae there making known his policy concerning the securing of the frontier .

Senusert's name, S-n-wsrt kha-kaw-re, means 'the one who belongs to the goddess Wsrt, may the doubles of the god Ra shine'. He was honored by his own people, and four hundred years after his death, the glorious Eighteenth-Dynasty warrior king Thutmosis III erected a stela in his honor.

Other building projects of Senusert III's reign included a statue and a limestone gate in the temple of the war god Montu at Medamud, ten kilometers northeast of Luxor. The gate carried a re-

7

lief of Senusert's *sed* festival, showing him enthroned under the double-throned festival pavilion while the gods Horus and Seth offer him the *ankh* symbol of life.

Senusert's pyramid at Dahshur was built of mud bricks and cased with limestone. Exquisite jewelry was found in the graves of the female members of his family who were entombed nearby.

Like the other members of the Twelfth Dynasty who shared his name, Senusert was called Sesostris by classical Greek historians. They attributed to him, or more probably to Senusert I, the digging of a canal between the Red Sea and the Nile to facilitate the transport of goods.

71. Amenemhet III in priestly costume

Grey granite; Fayum; H. 100 cm, W. 99 cm;
12th Dynasty; reign of Amenemhat III, 1843 - 1797 BC; Ground floor, gallery 21; JE 20001 = CG 395

This statue sculpted of black granite was discovered in Fayum at what is today Kiman Fares, but was then a town named Shedet, later known by the Greeks as Crocodilopolis. Amenemhet III (1843 to 1797 BC) is represented wearing a very peculiar wig consisting of bulky braids, while the growth of hair of the beard on his face is real and not just the traditional false royal beard fixed to the chin by strings. He once had a cobra on his forehead, but this is now missing. He has high cheekbones, heavy eyelids and deep lines indicating his advanced age, and he wears the priestly leopard skin with the head and paws on his shoulders. He once held royal scepters surmounted by falcon heads, still visible above the sides of the wig.

This statue reflects current religious belief concerning the divinity of the sovereign. In the Middle Kingdom, he was no longer represented as a god but as a priest making obeisance a god to ensure the welfare and prosperity of his country. Meanwhile, the god bestows his blessing on him and helps him to victory over his enemies and the forces of cosmic disorder.

When this statue was found Egyptologists at first mistook it for a Hyksos ruler from the later Second Intermediate Period. Although it subsequently proved to be of Amenemhet III, the Semitic influence in the art is still evident. The Middle Kingdom witnessed the immigration of many tribes from Palestine who were driven to settle in Egypt by economic hardship in their homeland.

This is an example of the Middle Kingdom approach of showing individual character in royal statues rather than representing the sovereign as a god like the rulers of the Old Kingdom. It was a mixture between the idealized school of Memphis and the naturalistic school of Thebes. There were also changes in the representations of royal images according to differences in role and age.

Amenemhet III, sixth king of the Twelfth Dynasty, ruled for forty-six years, during which time he was in charge of a highly centralized government. He devoted much energy to building and urban activities, having inherited a country where the government was in a full control of all mines, quarries and commercial routes in the south and the northeast. Numerous graffiti left by members of mining and quarrying expeditions testify to the amount of activity in his reign. There were important commercial relations with Phoenicia, where a statue of Amenemhet III in the form of a sphinx was found.

Amenemhet III began to build a pyramid at Dahshur, but when it suffered partial collapse he built a second one at Hawara, nine kilometers southeast of Fayum.

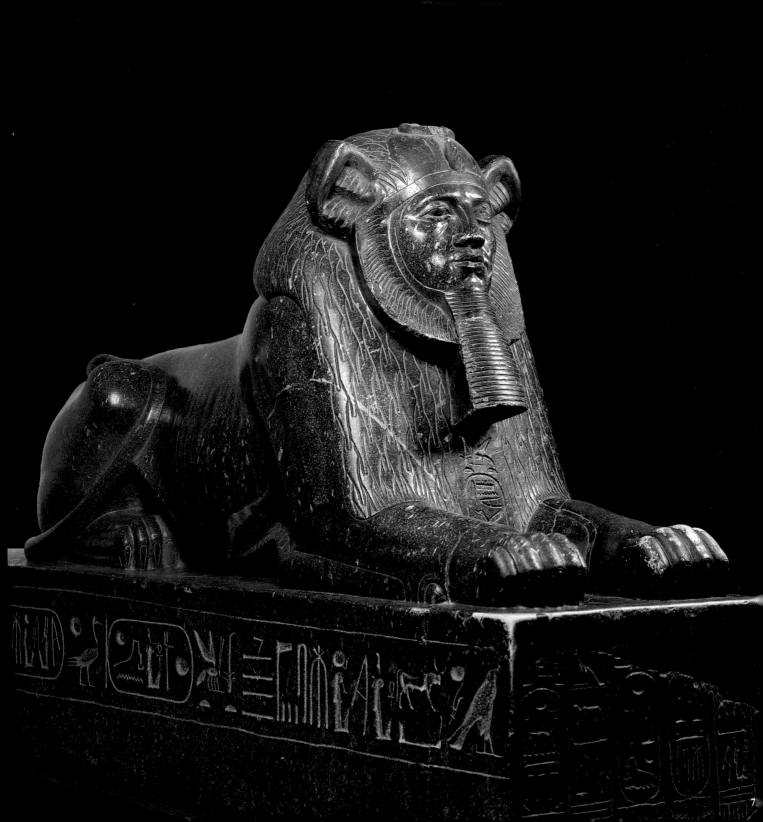

72. Sphinx of Amenemhet III

Grey granite; Tanis; H. 150 cm, L. 236 cm;
12th Dynasty; reign of Amenemhat III, 1843 - 1797 BC;
Ground floor, gallery 16; JE 15210 = CG 394;

This granite sphinx of Amenemhet III, sixth king of the Twelfth Dynasty, is one of seven discovered in 1836 by the French Egyptologist Auguste Mariette at Tanis, today San al-Haggar, a hundred and fifty kilometers northeast of Cairo. It was from Tanis, Egypt's capital in the Twenty-first Dynasty, that the obelisk now in front of Cairo Airport was brought.

The sphinx shows Amenemhet III with a human face and a lion's body, in other words a perfect creature, as intelligent as a human being yet as strong as a lion. The face has high cheekbones, full lips and wrinkles beside the nose. Instead of the *nemes* headdress are the lion's ears and mane. The anatomy of the body is faithfully represented, as are the paws and the tail of the lion. The sphinx reflects the iron character of Amenemhet III, who was later deified.

These sphinxes probably stood at a Middle Kingdom site before being usurped by a Hyksos ruler of the Fifteenth or Sixteenth Dynasty, who had them transported to Avaris, the Hyksos capital, which today lies at Tel al-Dabaa in the east of the Delta. The Nineteenth-Dynasty kings Ramsses II and Merenptah also inscribed their cartouches on the base of the sphinx, while in the Twenty-first Dynasty Psusennes I (1055 to 1004 BC) had them brought to Tanis where they were found.

Statues showing kings as sphinxes existed as early as the Old Kingdom. The oldest statue of a sphinx was made for Djedefre, the son of Cheops, while the most famous sphinx of all is that of Chephren, which was hewn out of the native rock beside his pyramid at Giza. Other famous sphinxes are those bordering the two-mile path between Karnak and Luxor temples in Thebes and the criosphinxes, or ram-headed sphinxes representing the god Amen, in front of Karnak Temple. Sphinxes with the head of the falcon god Ra Hor-akhty have been found in the temple of Gebua in Nubia, and a sphinx with the head of a crocodile was discovered in a mortuary temple. Sphinxes had a connection with the sun god Ra, as besides Ra Hor-akhty they represented Amen-Ra or Sobek-Ra.

The word sphinx is derived from the ancient Egyptian word *shesep ankh*, meaning the living statue or image. It was modified to shephankhes, then to sphinx. In Arabic the sphinx is called Abu al-Hool. This word was derived from the ancient name *bw hr*, or the place of god Horus, and was first modified to *bw hol*, then Abu al-Hool.

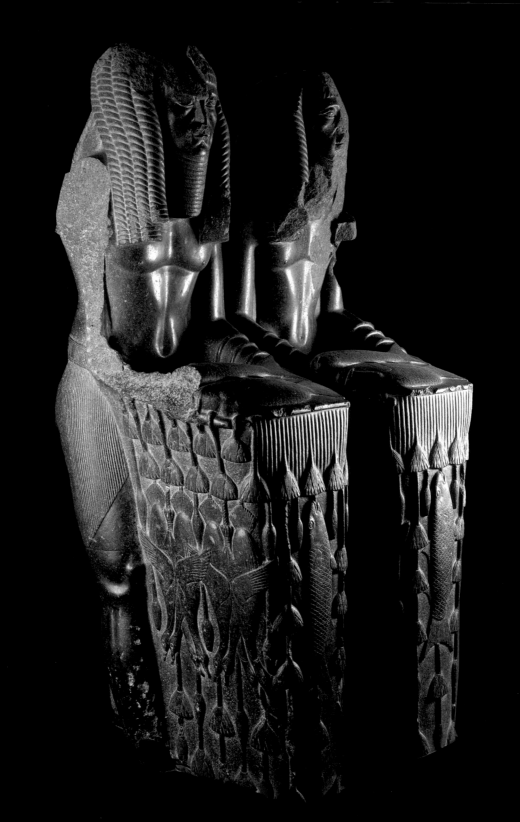

73. Double statue of Amenemhet III as a Nile god

Grey granite; Tanis; H. 100 cm, W. 80 cm;

12th Dynasty; reign of Amenemhat III, 1843 - 1797 BC;

Ground floor, gallery 21; JE 18221 = CG 392;

This statue of Amenemhet III is sculpted in black granite. It was usurped in the Twenty-first Dynasty by Psusennes I, who transported it to Tanis where it was found in 1861.

Amenemhet III (1843 to 1797 BC) is represented twice. He wears a wig of long locks of hair and a broad beard in an unusual style, and is portrayed here as the Nile god Hapy who brings welfare to the country, enriching its soil with the fertile mud and presenting such gifts as fish, poultry and aquatic plants. The altar depicts the flora and fauna of the Nile.

The muscles in the front and the rear of the body are detailed with great care and accuracy. In order to preserve the symmetry, the sculptor broke the ancient Egyptian statuary rule of showing figures with the left leg advanced forward, representing only one figure with an advanced left leg while the other has the right leg advanced, thus creating a balance.

When this double statue was found it was first thought to date from the Second Intermediate Period and the reigns of the Hyksos kings. Although it proved to belong to Amenemhet III with his high cheekbones, full lips and lines beside the nose, the Semitic influence in the art is still evident

During the time of year when there was no inundation, the Egyptians called the Nile 'Itrw'. During the inundation season they called it 'Hapy', deifying it as a god represented as a man with pendulous breasts and a prominent belly. In some representations the body is covered with wavy blue lines to indicate water. This figure frequently occurs in pairs flanking the images of the *sematawy* (unification), signifying that the Nile is the basic element of the unification of Egypt. In some other instances, processions of the figures of Hapy carry on their heads the name of the nomes of Egypt, or hold lotus or papyrus plants. They are often represented bearing plants, trays of offerings or libation jars.

Amenemhet III completed great agricultural projects in Fayum, some of which may have been initiated in the reign of his grandfather Senusert II (1897 to 1877 BC). The cultivated land was extended, while Nile water was diverted and stored in the lake at Fayum for use in the dry season or in years of low flood. A dam with several openings in the passage was built and named *ra-hent*, or the mouth of the lake. This site was later called lahent, and later still al-Lahun.

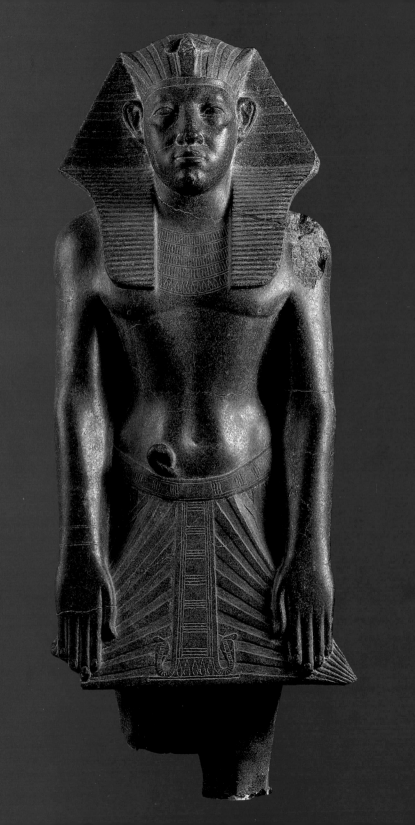

74. Statue of Amenemhet III

Grey granite; Karnak; H. 73.5 cm, W. 31 cm;

12th Dynasty; reign of Amenemhat III, 1843 - 1797 BC;

Ground floor, gallery 16; JE 37400 = CG 42015;

This standing statue sculpted of black granite was found by George Legrain in 1903 in the Karnak *cachette*. It shows Amenemhet III wearing the *nemes* with the cobra on the forehead, and a short, starched kilt decorated with geometrical motives ending with two cobras. The king is portrayed in the posture of prayer with his arms beside his body and his open hands placed over the kilt, thus showing himself not as a divine god but as a person offering devotions. This posture can be compared to that of his predecessor Senusert III.

Amenemhet is represented here as a man in middle age, not with facial lines as in his other statues. This is a fine example of the joining of the idealized Memphite School of art and the naturalistic style of the Theban School, a mix which produced a statue with traditional representation of the body that is with square shoulders and strong muscles, and the new posture of praying but with tired and preoccupied facial features.

Classical historians linked Amenemhet III, whom they referred to as Lamarres, with a huge construction at Hawara in Fayum now called the Labyrinth. This construction consisted of two floors and included three thousand rooms in its superstructure and substructure. Some descriptions mention that the Labyrinth contained several palaces linked together by means of elaborate passages, and that one needed a guide to lead the way so as not to get lost. Archeological research indicates that this building was actually a huge mortuary temple built beside the pyramid of Amenemhet III for his funerary cult.

75. The pyramidion of Amenemhet III

Basalt; Dahshur; H. 140 cm, W. 185 cm;

12th Dynasty; reign of Amenemhat III, 1843 - 1797 BC;

Ground floor, gallery 33; JE 35122;

This basalt pyramidion is the capstone of the pyramid of Amenemhet III at Hawara, nine kilometers southeast of Fayum. It must have presented a spectacular contrast to the pyramid's white outside casing of Tura limestone.

The pyramidion is a small pyramidal-shaped stone representing the *bnbn* or the primeval mountain, the first to emerge from the ocean at the creation of the world by the god Atum. It is decorated with a solar disc flanked by two cobras with outspread wings. The two eyes are to see the *nfrw*, the beauty of the god Ra, as inscribed there in sunken relief. The cartouches bearing the name of Amenemhet III as Imn-m-hat n-maat-re, which means 'Amen is in the front and the one who belongs to the justice of the god Ra'. The phrase *di ankh mi re djet* is a wish that the king be granted life ever after, like the god Ra.

The mud-brick pyramid was fifty-eight meters high, while each side of the square base measured a hundred meters. It reflected the talent of its architect that such a maze of complicated corridors led to the burial chamber to mislead tomb robbers

Beside the pyramid was the tomb of Amenemhet's daughter Nefruptah, which revealed a treasure of gold jewelry inlaid with semi-precious stones. Excavations uncovered several tombs, near the pyramid, of Middle Kingdom officials, while five hundred meters northeast of the pyramid was a tomb for mummified crocodiles—the god Sobek incarnate. Tombs from the Roman Period excavated in this area revealed the beautiful portraits which, although they are not restricted to this area, have become known as the Fayum portraits.

Amenemhet III was deified in Fayum at a later period, with his divine triad consisting of the sovereign, the god Sobek and the goddess Rnnwett

76. Ka statue of Hor Auibre

Wood; Dahshur; H. 170 cm, W. 27 cm;

13th Dynasty; reign of Auibre III, *c.* 1700 BC;

Ground floor, gallery 16; JE 30948 = CG 259;

This wooden statue of Hor Auibre, thirteenth king of the Thirteenth Dynasty, was found in a tomb near the pyramid of Amenemhet III at Dahshur. He is here represented standing with two arms above his head to represent his *ka* or double. His face is oval and naturalistic; the alert eyes inlaid with white quartz, rock crystal and resin and encircled with bronze. He has a curved false beard and advances his left leg forward. Contrary to the norm he is naked; it is very rare to see nudity in kings, but it seems he was not always so as holes indicate that a kilt was once fixed to his loins and has been lost. There are still traces of gold leaf on the usekh collar and the wig, which has straight hair. The staff and scepter that would have been in his hands are missing.

This statue was found in a wooden naos chapel, and seems to have been placed there as if the naos was the underworld and the ka of the king was emerging from it. It is carved of separate pieces joined together by means of tenons, a technique used since the Old Kingdom. The dating of the statue was a result of much discussion between two pioneer Egyptologists: Gaston Maspero, who dated it to the Thirteenth Dynasty, and Jacques de Morgan, who believed it was from earlier in the Middle Kingdom. They finally agreed to date it to the former.

The *ka* is represented in the form of two arms as a symbol of embrace and protection. It was regarded as the personality and it designated character, nature and temperament. It is born with the person, as can be seen from scenes of the god Khnom creating the baby and his *ka* together on a potter's wheel, and is one of the necessary elements of the body needed for his well being. These elements included the *khet*, the body that the ancient Egyptians were so keen on preserving by mummification and by hiding the tomb to protect it from robbers; the *rn*, or the name and the identity of the person, without which this identity would be lost and the person would not recognize his being; the *shwt* or shadow; the *ba* or the spirit or soul which flies in the form of a bird with a human head and comes back to the body; the *ib* or the heart, the centre of intelligence, wisdom, thinking and feeling; the *akh*, which is the light of the person that

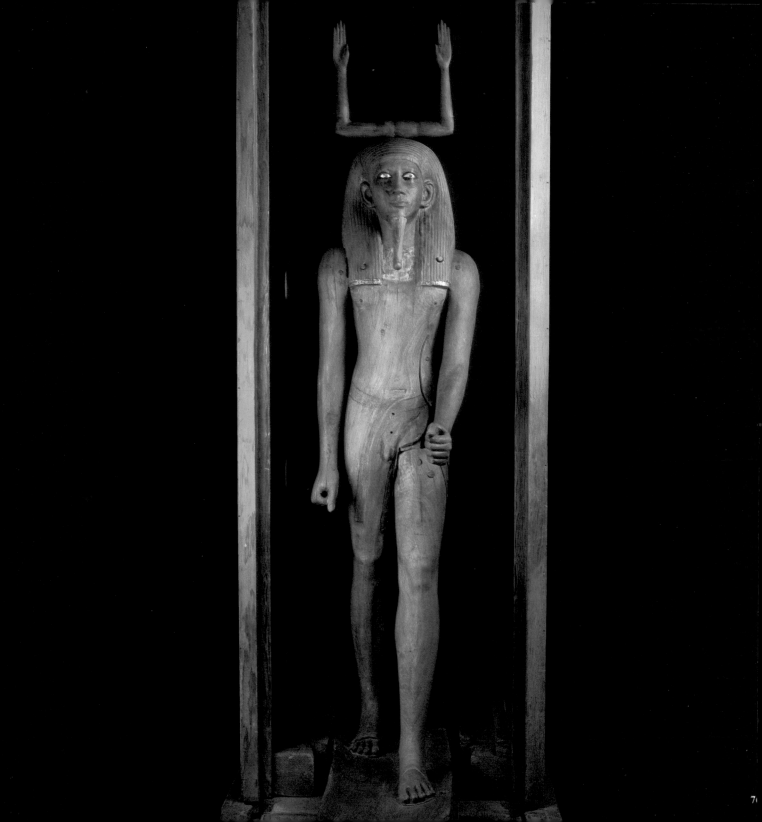

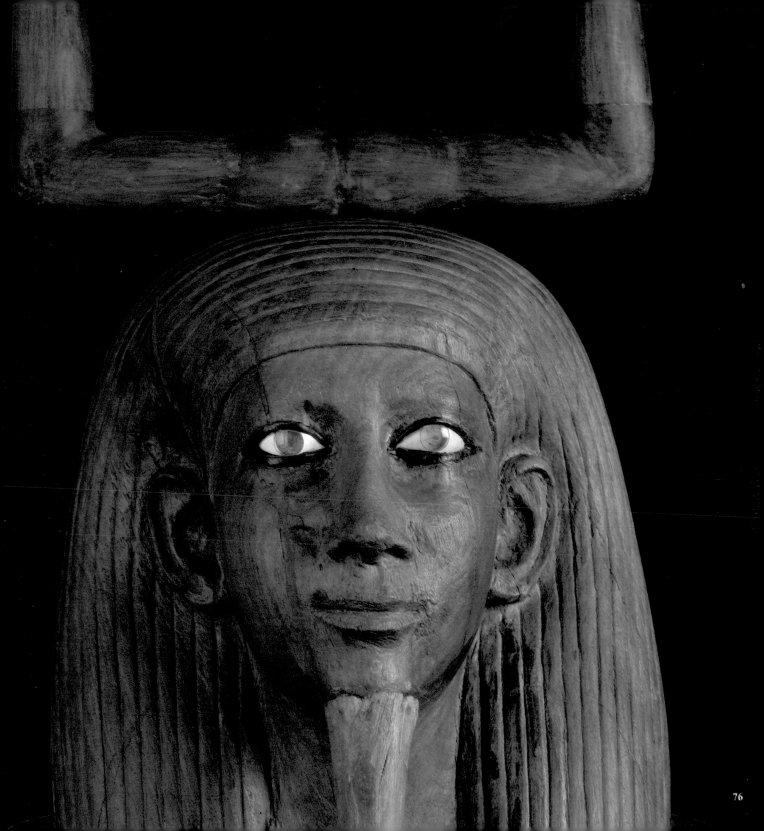

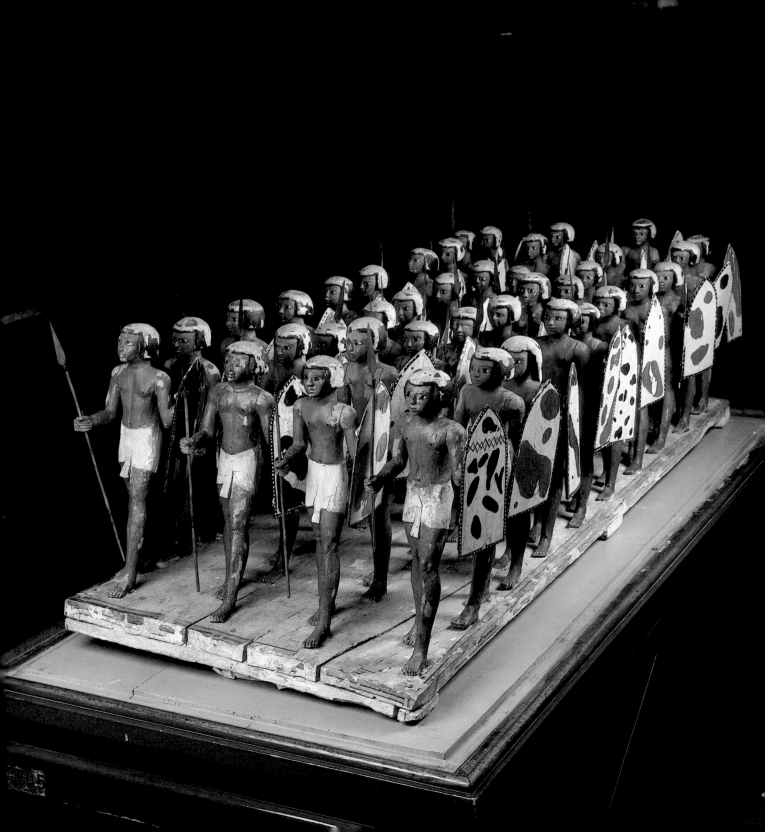

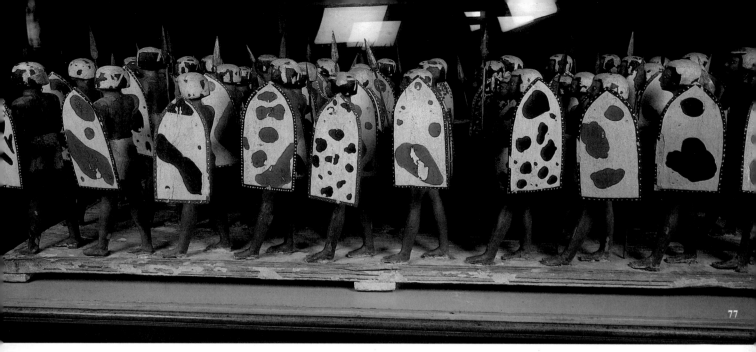

lives between the earth and the stars. Upon death these elements are dispersed, and to achieve resurrection they must be reunited.

The ka is the double and a person's vital force, the person himself but in a transparent form. The *ka* stays with the body and eats and drinks the offerings placed inside the tomb or painted on the walls. In addition, sometimes the *ka* is represented as an identical image of the person.

77. Troop of pike men

Painted wood; Assiut; H. 59 cm, W. 62 cm, L. 169 cm;
11th Dynasty; *c.* 2000 BC; Upper floor, room 37;
JE 30986 = CG 258;

This group of statues of ancient Egyptian pike men was found in the tomb of Meshety, a local governor of Assiut at the end of the First Intermediate Period and the beginning of the Middle Kingdom.

The group consists of forty soldiers arranged in ten lines. They are coloured reddish brown, their strong tan indicating their continuous and elaborate open-air training. They have a tidy hair cut which covers their ears and a very short kilt to facilitate movement, and they carry lances and shields. The artist varied the decorations

on the shields to add interest and break up the monotony of the group, and also portrayed them with different facial features and heights to create liveliness. This is further accentuated by the eyes which show their alertness and strength, while their representation in parallel lines and advancing their left legs creates a rhythm that imbues the group with still more animation.

The most common material for shields was cow hide, and the ancient word for shield, *ikm*, is typically determined with a sign identified as a cow hide. In later periods shields were covered with copper or bronze. They varied in size, some being small and easily portable like the ones shown here and others long enough to protect a standing man.

The lance is a hand-held stabbing weapon like a spear, but with a long shaft. It appears in siege scenes in tombs of Middle Kingdom nomarchs at Beni Hassan, in which soldiers are attacking with lances.

Nomarchs at that time enriched themselves greatly and acquired complete authority over their nomes. They made their position hereditary, passing their posts to their sons even if the latter had not reached majority. Every nomarch added to his power and prestige by raising a local army and a fleet, the size of which corresponded to his wealth and the importance of the nome. Army units

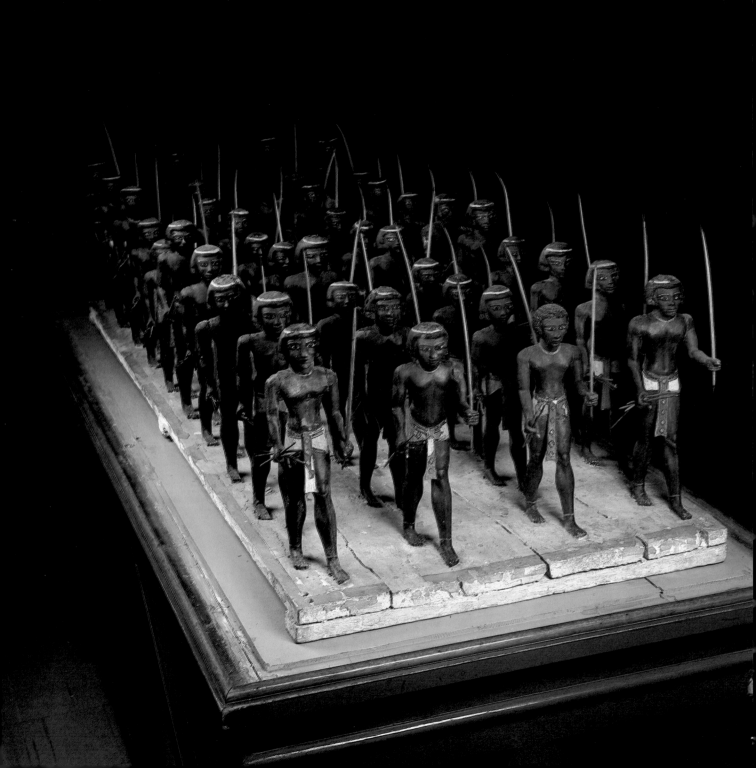

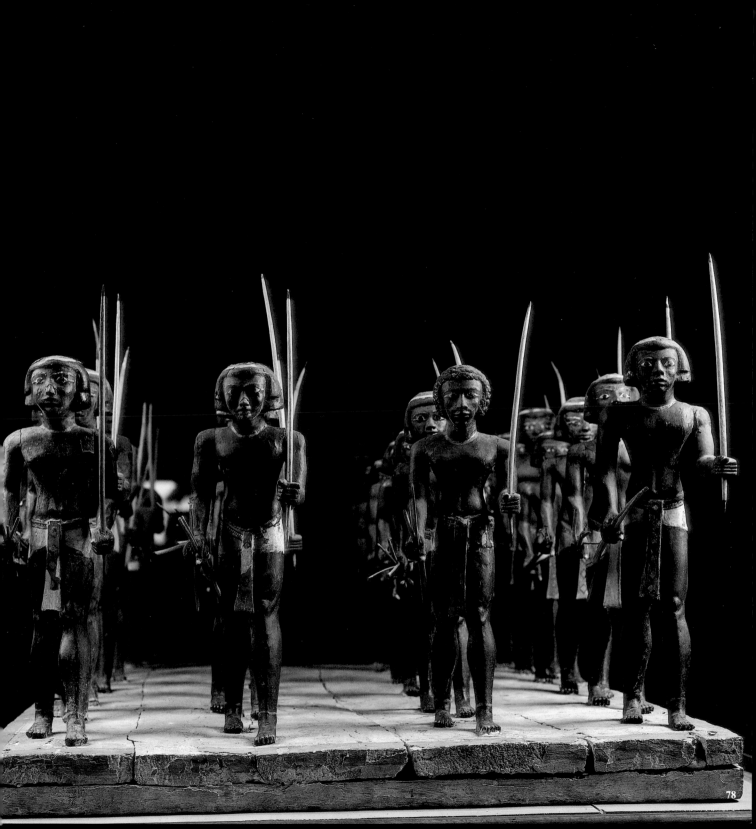

were carefully trained and were held in high esteem by the nomarchs, some of whom attacked their neighbors to seize control of their territory. Many nomarchs depicted scenes of preparations for war and equipment for the army on the walls of their tombs.

78. Troop of Nubian archers

Painted wood; Assiut; H. 55 cm, W. 72.3 cm, L. 190.2 cm;
11th Dynasty; *c.* 2000 BC; Upper floor, room 37;
JE 30969 = CG 257;

This group of statues of Nubian archers was found with the previous group of Egyptian pike men in the tomb of Meshety, a local governor of Assiut. This group consists of forty men arranged in ten lines; they have the black skin and features of Nubians with large eyes, full lips, a flat nose and curly hair. Nomarchs sometimes hired Nubian mercenaries for their military activities and to protect the desert fringes of the nome.

They carry a bow and arrows and wear a chain around their necks, anklets and the characteristic very short kilt with a colourful design of red, yellow and green motives. As with their Egyptian counterparts, their eyes reflect alertness and their fierce look reveals their strength. There is no monotony in the group as they have different heights and facial features.

The bow was the most sophisticated long-range weapon in ancient Egypt. As early as the Predynastic Period, bows had a single curvature. Made of a single piece of wood, these were simple or self bows and were used up until the New Kingdom even when the more powerful composite bow had appeared. Composite bows had an effective range of a hundred and sixty to a hundred and seventy-five meters, and an exceptional shot could attain distance of five hundred meters.

79. Model of a fishing scene

Painted wood; Thebes; H. 31.5 cm, W. 90 cm, L. 62 cm;
11th Dynasty; *c.* 2000 BC; Upper floor, room 27; JE 46715;

This model of a fishing scene is one of twenty-five models found in the tomb of Meketre, a nobleman of the Eleventh Dynasty, who was buried beside the tomb of Montuhotep Nebhepetre at Deir al-Baheri. These small figurines represented activities in the life of Meketre that he wished to see repeated in the afterlife. Such activities would have been represented on the walls of a noble's Mastabas in the Old Kingdom, but here Meketre wanted them as miniature replicas to fulfill his needs in the hereafter. Part of this collection is now in the Metropolitan Museum of Art in New York.

Such models have made a valuable contribution to our understanding of daily life in this period. These lively portrayals of the equipment of nobility shed light not only on the lifestyle of all sections of the community but also on the history of ancient Egypt.

This image shows two boats carrying fishermen on the River Nile, with the boats colored green to represent the papyrus plant of which they were made. The papyrus bundles are tied by cords, represented by yellow lines over the green of the boat. The boats are being rowed by oarsmen while the fishermen are occupied with their catch, which is in a net tied between the two boats. Two fish have been caught and are on board of one of the boats, while more fish are trapped in the net which the fishermen are preparing to pull in. Fishing was a popular sport in ancient Egypt. The ancient Egyptian was a keen observer of nature, and fish were depicted in tombs in precise detail as to species as early as the Old Kingdom. Fishing scenes in Old Kingdom Mastabas at Giza and Saqqara provide a record of the many kinds of fish in the Nile. They were attributed with certain symbolic and magical powers by virtue of their biological behavior. Mullets that travel from the Mediterranean to the First Cataract were honored as a herald of the flood and a messenger of the god Hapy. The Tilapia's mouth brooding practice led it to be associated with the god Atum; thus related to the sun, it was called the red fish since it accompanied the sun boat and protected it on its nocturnal journey. Fishing in certain areas was forbidden owing to the association of fish with the myth of Osiris, whose male organ was swallowed by a fish and was thus the only part of his body Isis was unable to recover.

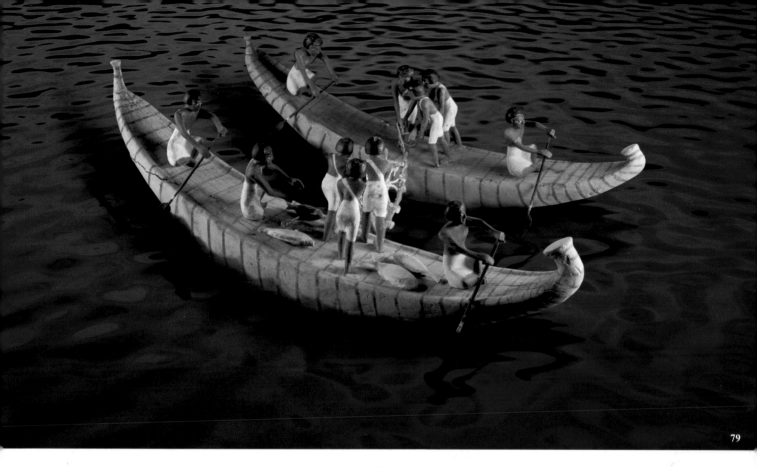

80. Model of a sailing boat

Painted wood; Thebes;

11th Dynasty; *c.* 2000 BC; Upper floor, room 27, JE 46720;

This model shows the Eleventh-Dynasty nobleman Meketre sailing in his boat. Models of boats were believed to provide the deceased with a means of Nile transport in the hereafter. This model shows Meketre in the cabin decorated with matting while the sailors reef the ropes of the sail on the instruction of their captain, who stands with a staff. The sail is made of woven linen, which was also used for the sailors' kilts to render them more lifelike.

The earliest boat models date from the Predynastic Period and were made of ivory, bone and fired clay. Wooden models began to appear in tombs in the Old Kingdom. Two kinds of boat models were usually put in the tomb, one for sailing south with the prevailing wind and the other for rowing downstream in a northerly direction with the water current. Meketre was clearly fond of boats and

did not want to be deprived of this pleasure in the afterlife: thirteen were found in his tomb, while the tomb of Tutankhamen contained thirty-five. Taking a boat trip on the river was a favorite pastime of Egyptian royalty and nobility, who continued to enjoy it until the 'Nile Cruise' was taken over *en masse* by foreign tourists in the second half of the twentieth century. Old Kingdom literature relates the story of King Sneferu, who would sail for pleasure accompanied by an assortment of courtiers. The Westcar papyrus tells that on one of these excursions one of the young ladies in the party lost a precious turquoise overboard, but thanks to a powerful magic spell the waters parted and the stone was found on the riverbed. Thousands of texts and scenes of boats and ships have come down to us from ancient Egypt. There seem to have been about a hundred and twenty different types of vessel. About twenty ancient boats have so far been recovered from sites at Abydos, Dahshur, Giza, al-Lisht and Mataria (Iwn or Heliopolis); all are full-sized and date from various historical periods.

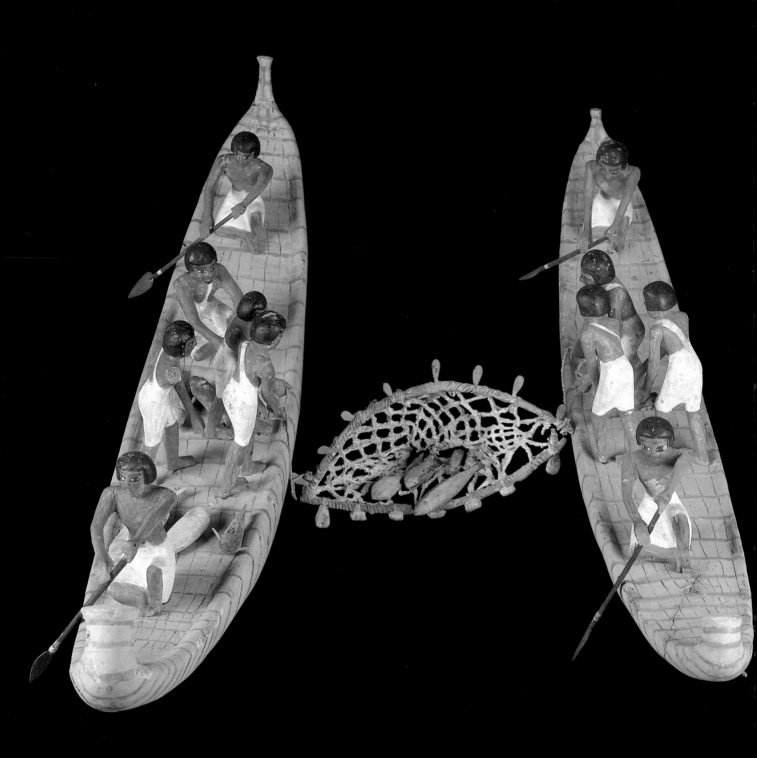

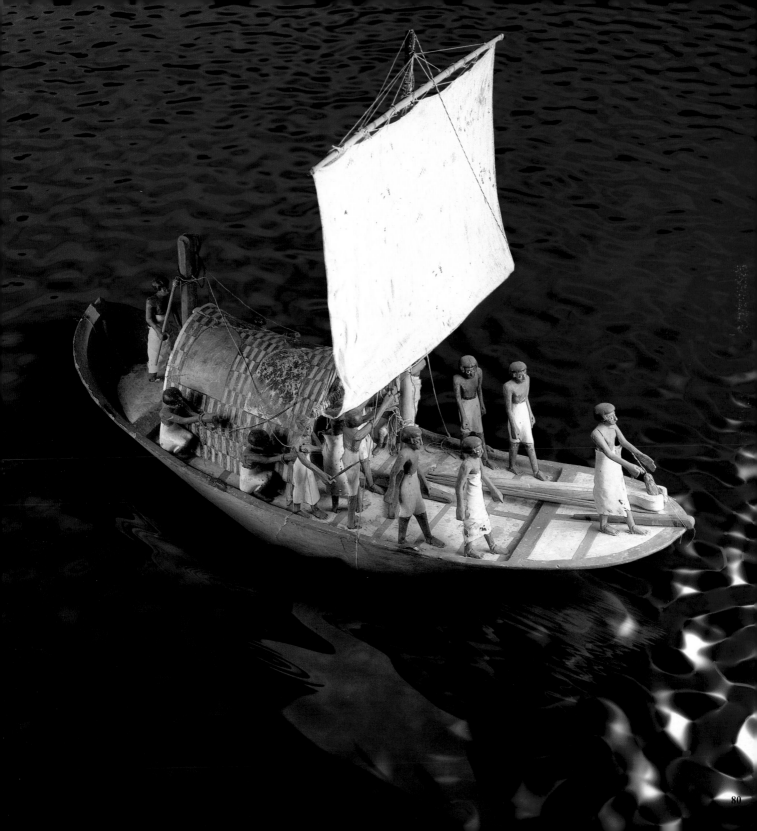

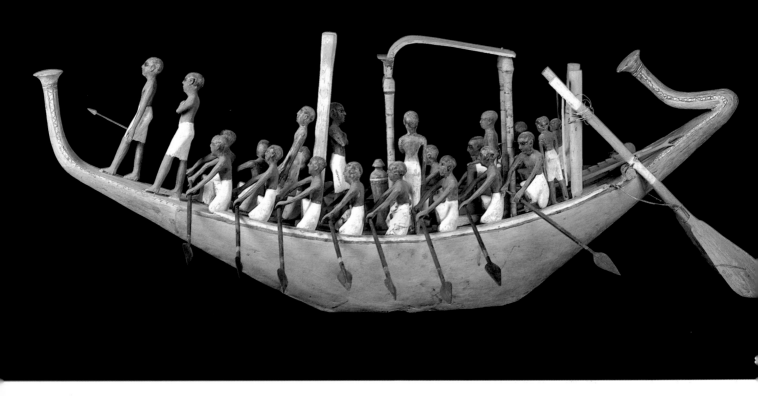

81. Row boat of Meket-re

Painted wood; Thebes;

11th Dynasty; *c.* 2000 BC; Upper floor, room 27;

This model of the boat of Meket- re was carved out of wood that is covered with gesso and painted. On the prow of the boat, we see a man watching the circumstances of the river navigation, holding a spear in his hand accompanied by another look-out man assisting him. A third man is present wearing a linen kilt.

Sixteen rowers are present on board in addition to two pilots using rudders. The pilots maneuver the rudders and direct the rowers who hold their oars. Meket-re is sitting under a canopy on a stool with low back. His son is sitting on the ground in front of him while an attendant is standing beside him holding his scepter. Another attendant is standing in front of his master, paying homage to him.

We see a big jar represented in front of the canopy and we see also on the stern two forks which were used to move the boat when it got grounded on a sand bank.

82. Statue of an offering bearer

Painted wood; Thebes; H. 123 cm, W. 17 cm, L. 47 cm;

11th Dynasty; *c.* 2000 BC; Upper floor, room 27; JE 46725;

This statue is one of the most delightful pieces of Middle Kingdom art in existence. One of two identical statues of an offering bearer, it was found in the tomb of Meketre at Deir al-Baheri. The other is now in the Louvre. It was carved in wood with the most high quality workmanship and great attention to detail.

Two-thirds life size, it shows a woman carrying a duck in her hand and a basket on her head in just the same manner as peasant

women carry produce in the Egyptian countryside today. The woman has a wig with straight hair reaching to her breast. Her eyes are painted white and black, with one slightly larger than the other. She wears a green and red net dress and a large collar with matching colors, as well as matching bracelets and anklets.

The theme of women carrying offerings first appeared in the reliefs of the valley temple of the Bent Pyramid of Sneferu, first king of the Fourth Dynasty, in Dahshur. Here the offering bearers personified the royal estates and the bringing of produce from these estates to the pyramid. Similar scenes often appeared in tombs of the nobles of the Fifth and Sixth Dynasties such as the Mastaba of Ptahhotep at Saqqara. Here the offering bearer is portrayed faithfully in a statue, revealing the wealth and bounty of Meketre. Offering bearers are usually females, but in the Old Kingdom male offering bearers carry libation jars and scribal equipment in contrast to the females, who carry food. Sometimes the offering bearers are in pairs, either two single figures or two figures sharing the same base.

Duck was a common offering for the deceased. A generous amount of waterfowl was included in the *hetep-di-nsw* offering formula where it was referred to as *apdou* and presented to the *ka* of the deceased. It also appeared on offering tables and on lists of temple offerings. Goose was also popular, but chicken was unknown to the Egyptians until it was introduced from Asia in the New Kingdom.

The basket shows four jars of wine with conical stoppers. Wine was one of the main alcoholic drinks in ancient Egypt; called *irp*, it was made from grapes and was produced in Egypt from Predynastic times, as confirmed by the presence of wine jars in tombs dating from this period. Vintage scenes were portrayed on murals in tombs throughout the history of Egypt, and as seen in several scenes on temple walls all over the country. Wine was used as an offering to the gods. Among the gods and goddesses to whom wine was offered was Hathor, who is often referred to as 'the lady of drunkenness'. While wine in daily life was merely an enjoyable drink, in myth and theology it was a symbol of blood and the power of resurrection.

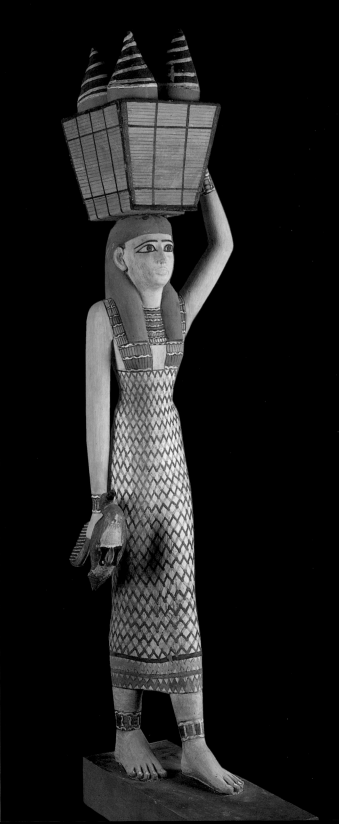

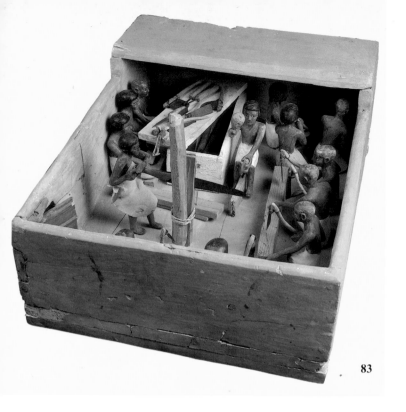

83. Model of a carpentry workshop

Painted wood; Thebes; H. 26 cm, W. 52 cm, L. 66 cm;
11th Dynasty; *c.* 2000 BC; Upper floor, room 27; JE 46722;

 This model from the tomb of Meketre shows a group of carpenters in a workshop. In the centre is a man using a pull saw to saw a large log of wood, which is steadied by being tied to a short post. A large chest is shown with a variety of tools: the *mdja* mortice chisel, the *nwt* adze, the *tf* saw and the *minb* axe. Other carpenters are squatting or kneeling to carry out other tasks. The movements of their bodies give the figurines an air of realism.

 On mural scenes in Old Kingdom Mastabas like that of Tiy are scenes of carpenters engaged in woodworking using drills and sandstone rubbers. Carpentry scenes appeared again in the New Kingdom Theban tombs such as that of Rekhmire in Qurnah (TT 100). As well as a variety of tools, this scene showed a try square and a cubit rod used to test the accuracy of wooden elements.

83

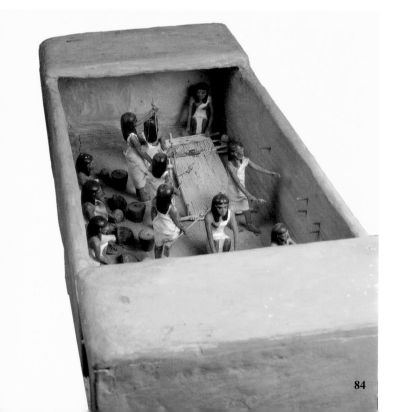

84. Model of a weaving workshop

Painted wood; Thebes; H. 25 cm, W. 43 cm, L. 93 cm;
11th Dynasty; *c.* 2000 BC; Upper floor, room 27; JE 46723;

 This model of a weaving workshop from the tomb of Meketre shows a group of women busy at their spinning and weaving activities in a room with a door on one side.

 Inside the workshop are two horizontal looms. Two types of loom were used in ancient Egypt: the ground, horizontal loom and the fixed beam or vertical loom. The horizontal loom had a simple construction consisting of a horizontal warp stretched over the length between two beams, at top and bottom. The beams were kept in place by means of two pegs fixed in the ground. In the vertical looms, the threads were pulled and tensioned vertically, while the loom was placed upright or leant against something firm like a stone block. Fibers were usually spun on a hand spindle, the most common form of spinning equipment used in ancient Egypt. Similar weaving scenes were depicted on mural scenes in the tombs of Theban nobles of the New Kingdom.

 Wealthy people would have had workshops in their own homes, within which dozens of people, usually women, produced cloth for

84

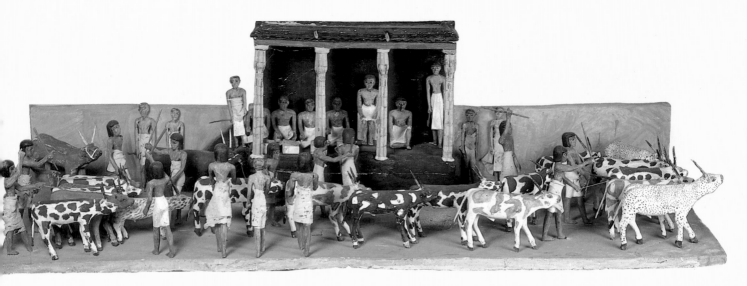

the household. Egypt was famed for its high quality linen, which was taken abroad to be exchanged for goods. Linen came in different qualities; some of these were referred to as bleached linen, close-woven linen, fine linen and royal linen, the last being almost transparent. Other textiles were made of wool, goat hair, palm fibers and papyrus plants.

85. Model depicting the counting of cattle

Painted wood; Thebes; H. 55.5 cm, W. 72 cm, L. 173 cm;
11th Dynasty; *c.* 2000 BC; Upper floor, room 27; JE 46724;

This is another model from the tomb of Meketre, this time showing the nobleman, who sits in a kiosk under a roof supported by four columns topped by lotus-bud capitals, inspecting the counting of cattle as they are paraded in front of him. With him is his son, who sits beside four scribes squatting on the floor with their papyri and writing tools. Before them are seventeen men herding animals, directing them by means of ropes tied round their horns. Real cloth is fixed to some of the figures, which adds realism and imbues the

scene with life. The earliest evidence of domestication of cattle in ancient Egypt comes from Predynastic sites in Merimda Beni Salama and Fayum. In those days cattle were mostly herded and range-fed, but later on they were farmed much as they are today. Herdsmen ensured their charges ate the correct food: tomb scenes show they were sometimes hand fed, and that they ate fresh green produce but that, in the dry season if this was not available, bread dough was substituted. Scenes on tomb walls depict cows being milked or nursing their calves. Egyptian herdsmen seem to have been aware of breeding practices and assisted the cows in calving, and there is even evidence of some basic veterinary treatment. Some cult priests, like those of the goddess Sekhmet, were famed for their special skills with cattle.

One of the most important cults was that of the Apis bull, whose centre of worship was Memphis. In order to be chosen to be an Apis god a bull had to have certain physical qualities: a saddle-marked back and a colored patch on the tongue and forehead. Several other bulls were held sacred in other areas, such as the Mnevis bull of Heliopolis and the Buchis bull of Armant.

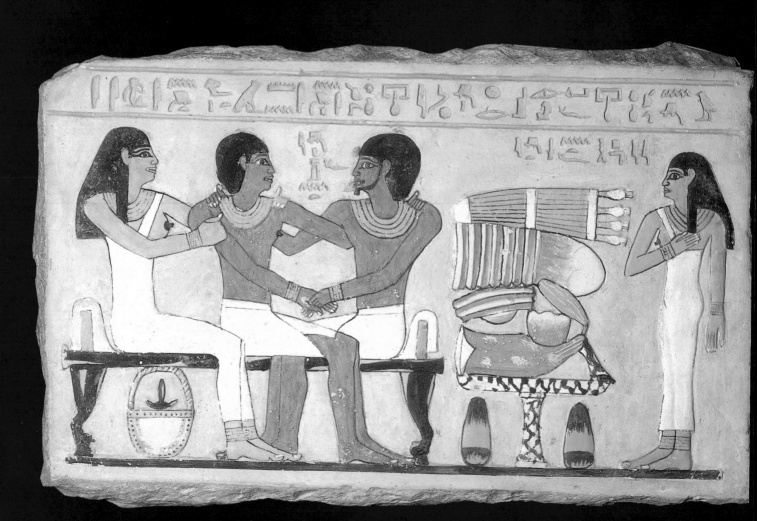

8

86. Funerary stela of Amenemhet

Painted limestone; Thebes; H. 30 cm, W. 50 cm;
11th Dynasty; *c.* 2000 BC; Ground floor, gallery 21; JE 45626;

This limestone funerary stela found at Assasif on the Theban Necropolis shows members of a family in an intimate embrace. In the line of hieroglyphs is the expression *prt kherw*, an invocation of the offerings for the family; it literally means 'the going forth of the voice' (reading the formula for the dedication of offerings to the deceased). In this case the nobleman Amenemhet and his wife Iyi are embracing their son Antef, who is sitting between them on a settle decorated with lion's paws. Under the settle is a basket from which a handle of a mirror emerges. Their daughter-in-law, whose name is Hapy, stands near an altar on which is piled a large quantity of offerings including meat and vegetables, while two loaves of bread are represented underneath.

All the figures wear *usekh* collars and bracelets, and the two women wear anklets. They have straight wigs and tight dresses with one strap, revealing their breasts. Amenemhet has an orderly hair cut and a beard. The way the two men are represented with legs crossed is very stylized.

The colors of the stela are very well preserved, showing extraordinary freshness. The tradition of a dark reddish brown for men and light, creamy yellow for women is respected in the coloring of the figures.

The name Amenemhet, meaning 'the god Amen is satisfied', was common in the Middle Kingdom and was the name of several kings. Theophoric names, or ones referring to a deity, were used frequently at this time by both royalty and private people. Basilophoric names, or names based on a deceased or reigning king, were also very popular, especially during the Twelfth Dynasty which was a time of strong royal authority. The names Montuhotep, Amenemhet and Senusert occurred frequently.

87. Statuette of a hippopotamus

Blue fiance; Thebes; H. 11.5 cm, L. 21.5 cm;
11th Dynasty; Upper floor, gallery 48; JE 21365;

This faience hippopotamus statuette was found in Draa abu el-Naga in western Thebes. The glossy blue glaze is the colour of the Nile, where the animal lived, and the decoration shows various representations of fauna and flora that grew by the river. The flowers, papyrus plants, and perching bird, are depicted in black, linear forms. Such animal figurines were popular in tombs of the Middle Kingdom in the Second Intermediate Period.

The hippopotamus was associated with the fertility of the Nile mud or silt. The hippopotamus goddess Taweret was, moreover, a protector goddess of women and newly born children. Figurines of her were used as amulets to drive away danger.

An emblem of goodness, the hippopotamus conversely signified evil at other times. The animal appears in Nile hunting scenes on mastaba tomb walls in the Old Kingdom Period as hunting was a pursuit of noble people. At the same time, the scene symbolised the victory of right and order over chaos and disorder.

88

88. Game with Three Pygmies

Ivory; Lisht; H. 7.8cm, L. 15.8 cm, W. 4.5 cm;
12th Dynasty, *c.* 1900 BC; Upper floor, gallery 48; JE 63858;

Found in a girl's tomb in el-Lisht, this ivory-carved toy is composed of three naked dwarves, who are represented with great realism. Wearing bead necklaces and sashes around their chests, the dwarves also had inlaid eyes originally. Their arms are raised as they are probably the dancing dwarves who were well-known for their ritual dances, and were often called 'dancers for the gods'. This game may therefore have served a religious function as well.

Each dwarf is placed on a circular base that is, in turn, inserted into a rectangular base. The bases have holes, through which a thread would be passed and pulled, allowing the dwarves to revolve, to perform a dance.

A fourth ivory figure, clapping his hands to create a rhythm for the dancers, which was found alongside these, is now in the Metropolitan Museum in New York.

The New Kingdom

The New Kingdom, the third glorious period in the history of ancient Egypt, lasted from the sixteenth to the eleventh centuries BC and included the Eighteenth to the Twentieth dynasties. This was a whole new empire in which the expression *usekh n tashw*, meaning 'expanding Egypt's borders' first appeared in the phraseology of its rulers.

The founder of the Eighteenth Dynasty was Ahmose I Nebpehtire, who after the disruption caused by the Hyksos occupation united Egypt into one nation once more. During the Second Intermediate Period, control of Egypt had been divided between the Hyksos in the north, whose rule extended as far as Abydos, and the Thebans who had authority over the southern half of the country. The Theban ruling house is identified as the Seventeenth Dynasty and was contemporaneous with the Sixteenth Dynasty of the Hyksos. Sekenenra Taa II (1600 to 1571BC), one of the last rulers of the Seventeenth Dynasty, took secret measures to consolidate his army in preparation for a war of liberation to expel the Hyksos. The Hyksos king Apophis, who ruled from Avaris in the north, meanwhile, provoked Sekenenre by sending him a messenger to tell him that the noise made by the hippopotami in Thebes bothered him in Avaris to such an extent that it deprived him of sleep. The message was written in narrative style: "Let there be a withdrawal of the hippopotamus from the canal which lies on the east of the city, because they do not let sleep come to me neither in the daytime nor the night for the noise of them is in the ears of my citizens." Apophis probably meant to show Sekenere that he was aware of the military training in the south, and was making a counter-threat.

It seems to have been Sekenenre who began the struggle for the liberation of the country, as examination of his mummy revealed five deep wounds in his head which indicates he was killed on one of the military campaigns he waged against the Hyksos. He was succeeded by his son Kamose (1571 - 1569 BC), who also continued the struggle against Hyksos occupation. Three stelae in Karnak Temple attest to this phase of the war, and show Kamose setting out with his powerful army of Egyptians and Nubians to travel northwards, where he overcame the Hyksos in the provinces of central Egypt and assumed control. Kamose returned to Thebes where he was received in triumph and honoured as a victorious king.

Kamose was succeeded by his brother Ahmose (1569 - 1545 BC), who was destined to be the liberator of Egypt and the one who delivered the country from Hyksos domination. The military expeditions and victories of Ahmose were recorded in the autobiographies of two professional soldiers: Ahmose son of Abana, who was an admiral in the Egyptian navy, and Ahmose Pennekhbet, who originated in Nekheb, now al-Kab, near Edfu. These two soldiers gave accounts of the expeditions of which they were a part, as well as of the rewards they received for their strength and courage. Their diaries manifest the great respect they had for Ahmose.

Ahmose's decisive steps to drive the Hyksos out of northern Egypt at length succeeded, and he thus completed the task begun by his father and brother. His major attack was on Avaris, the Hyksos capital. When the city fell he chased the remaining Hyksos to what is now Sharuhin in southern Palestine, where he laid siege to them for three years and eventually subdued the city. Ahmose was the last ruler of the Seventeenth Dynasty and the Founder of the Eighteenth; he marked the end of an era and the beginning of a new, regaining the prestige of the royal house and its position as an esteemed and sacred image. Thebes remained as the capital of the unified country, and now acquired greater importance.

Thebes was the cult centre of the great deity Amun, the divine god who helped Egypt and its sovereigns to endure and solve the crisis of Hyksos occupation. The rulers of Thebes fought under the banner of Amun and dedicated their victories to him, a tradition that was maintained through out the duration of the New Kingdom.

The New Kingdom sovereigns paid great attention to the army and improved methods of training and equipment. The priests of the god Amun at his cult centres in Karnak and Luxor temples became extremely important figures in society; temples enjoyed great economic advantages, endowed with wealth and great estates. In Thebes, the vizier was the next in command after the sovereign, while a second vizier was sometimes appointed in Memphis. Some viziers were also high priests of Amun. The vizier supervised the nomarchs and held firm control over the provinces.

Ahmose I was succeeded in about 1545 BC by his son Amenhotep I Djeserkare, who inherited a strong and peaceful country and continued to consolidate and strengthen his father's achievements. His rule lasted for 20 years. The admiral Ahmose son of Abana who had served in the campaigns of Ahmose accom-

panied Amenhotep I on an expedition to Lower Nubia to secure the boundary and reincorporate the area between the First and Third cataract into the Egyptian empire, recording the events in his diary. He established an administrative centre at the Second-Cataract fort at Buhen, creating the new post of the viceroy of Nubia. Thus Egyptian control of the trade route to Africa was reaffirmed.

Among Amenhotep I's great building activities were the construction of the alabaster chapel in Karnak called 'Amun with enduring monuments'. At Deir al-Baheri and Draa abu el-Naga he built boat chapels for the divine god Amun; at al-Kab, he built a temple to Nekhbet. He built the artisans' village at Deir al-Medina, attached to the necropolis at Thebes, where he was venerated and deified. Feasts were held in his honour throughout the year, and he was represented in three forms: 'Amenhotep of the forecourt', 'Amenhotep beloved of Amun' and 'Amenhotep of the Town'.

Cultural life and sciences flourished during Amenhotep I's reign, as attested by the Ebers Papyrus which contains a list of medical diagnoses and prescriptions composed at that time.

Amenhotep I died in 1525 BC and was succeeded by his son Thutmosis I. He ruled for only nine years, but his reign, was noted for three military expeditions to Nubia and the northeast (Palestine). In contemporary records he described these campaigns as a great delight to his soul, because he was consolidating his country. He extended the southern boundary of his empire to the Fourth Cataract in Kush, where he appointed a native ruler who was given the title *Sa nswt in kash*, 'Son of the king in Kush'. He extended his northeastern operations to the neighbouring countries of Asia in order to check the advance of the Mittani (Northern Syria and Northern Iraq) and secure the Egyptian borders and trade routes. On reaching Naharina, in Iraq, he crossed the Euphrates River and laid a stela marking his border as being across the river on its eastern bank. He described this river as having a reversed current, with the water flowing south contrary to the Nile whose water runs north. Thutmosis enjoyed great success in his campaigns, and found much pleasure in hunting, especially elephant. He was proud of his achievements for his country and the state of security and prosperity he maintained in Egypt. His building operations were remarkable; he added two pylons to the Karnak Temple, where he also erected two obelisks. He was the first king known to be buried in the Valley of the Kings, where Ineni, his architect, described his tomb as a secret, sacred place: 'no one seeing, no one hearing'.

The crown prince Amenmese, an army commander, predeceased his father and the throne passed to his brother Thutmosis II Akheperenre (1516 to 1504 BC). Thutmosis II was not the son of the 'Great Royal Wife' but of a secondary wife named Mutnefret; however he married his half-sister Hatshepsut Maetkare and with her had one child, the princess Nefrure. Apart from an expedition to Nubia to suppress a minor uprising, his reign was peaceful and uneventful. Following the premature death of Thutmosis II, his son by a minor wife, Thutmosis III Menkheperre, inherited the throne of Egypt. Since he was a child, his stepmother Hatchepsut became his co-regent and the country's *de facto* ruler.

Seven years later Hatshepsut appointed herself the sole crowned sovereign and adopted the royal titles. She sat on the throne of Egypt for twenty-one years in a reign which stands out for the high quality of its art and architecture. Hatshepsut sent military campaigns to secure the borders in Nubia in the south and in the region of Syria and Palestine, and she undertook great building operations and restorations in temples nationwide. As well as her temple in Deir al-Baheri, she built a rock-cut temple in the vicinity of Beni Hassan called by the Greeks Speos Artemidos (Grotto of Artemis), thought to be the first rock-cut temple in ancient Egypt.

After her death Thutmosis III, who had been kept very much in the shade of events, became the sole sovereign of Egypt. He dated this first year as the twenty-first year of his reign, as he considered himself to have been the legitimate king of Egypt all through Hatshepsut's reign.

Thutmosis III now came into his own, making a name for himself as a great warrior king. He led 17 military campaigns in Syria-Palestine, where several towns and rebellious principalities had formed an alliance against Egypt under the leadership of the prince of Kadesh, a city on the River Orontes southwest of Homs in Syria, Tunip in the Lower Ornate and Mittani beyond the Euphrates. Thutmosis III led his first campaign and reached Megiddo in northern Palestine, which controlled the major trade route between Asia and Egypt. His military tactics proved his iron nature and excellent strategic ability. He defeated the prince of Megiddo and shattered his forces, capturing his strongholds.

Thutmosis went on to lead several campaigns in Syria- Palestine. In the thirty-third year of his reign he defeated the king of Mittani crossed the Euphrates and set a boundary stela that marked the northern limit of his empire. In the campaign of the year forty-two he was able to win victory and to subdue Kadesh and Tunip. In addition, his southern campaigns in Nubia secured the Egyptian border at the Fourth Cataract.

Egypt was showered by booty and tribute from Nubia and Asia, which increased the wealth of the country. Thutmosis used this abundance of resources to undertake massive building operations of his own, while not neglecting the great monuments of his predecessors. In Karnak Temple he listed sixty-one of his distinguished forefathers to whom he made offerings, also honouring them in their own temples. Two ancestors he particularly admired were Senusert III and Thutmosis I who had so distinguished themselves by their military actions to secure Egypt and its borders.

Thutmosis III died in the fifty-third year of his reign (1504 to 1452 BC) and was succeeded by his son Amenhotep II (1454 to 1419 BC). At this time Thebes was the hub of political power and economic wealth, as well as being the centre of the expanding cult of Amun. Meanwhile Memphis continued as a northern residence and important strategic military base, and Iwn (Heliopolis) was an important theology centre.

Amenhotep II Akheperure was given a special sporting upbringing and military training during the life of his father Thutmosis III. Following in his father's footsteps, he placed stelae at Naharina on the Euphrates River and in Nubia, thus confirming Egyptian authority at those borders. The stories he related on them exaggerated his physical power, courage and strength, in contrast to the modest and analytical description of events registered in the annals of his father on the walls of Karnak Temple.

Amenhotep II was succeeded by his son Thutmosis IV Menkheperure, who inherited a rich and powerful country extending from Nubia in the south to Syria in the north. Throne rivalries may have accompanied his accession to the throne of Egypt, as he wrote a fictitious story of the event on a stela and placed it between the paws of the Great Sphinx at Giza in order to verify his legitimate claim to the throne. On it Thutmosis states that as he lay sleeping in the shade of the Sphinx after a day's hunting the god Heremakhet appeared to him in a dream in the form of the Sphinx and promised that if he would clear away the accumulation of sand around his body he would grant him the throne of Egypt.

During Thutmosis IV's reign (1419 to 1410 BC) peace prevailed throughout the Egyptian empire. And there was consequently less manifestation of Egypt military achievement and power. Thutmosis IV married the daughter of Artatama, the ruler of Mittani, so as to guarantee continued peace and diplomatic accord. This princess became one of his main wives, while the Asiatic princesses his father Amenhotep II and grandfather Thutmosis III had married were considered only minor wives.

One of those wives of Thutmosis IV, Mutemwia, was the mother of his son and heir Amenhotep III Nebmaetre (1410 to 1372 BC). During the reign of that great king, Egypt reached its highest apogee in wealth and luxury. Rich resources flooded the country with income from taxes, tributes, commercial relations, trade, quarrying and mining. Artistic and cultural interactions with Asia increased.

Amenhotep III sent a punitive expedition to Nubia, building a temple and a fortress at Soleb. His building activities included the third pylon at Karnak and the southern half of Luxor Temple, in addition to a palace and a residential complex including houses for his family and close court officials on the west bank of the Nile at Thebes, at the site now called Malqata. Also on the west side of the Nile, he built a great mortuary temple, now mostly lost apart from two colossi that stood in front of its pylon, called now the colossi of Memnon.

The diplomatic correspondence between Amenhotep III and neighbouring Asiatic rulers is recorded in the Amarna letters, which are cuneiform tablets found at Tel al-Amarna that show how Amenhotep brought Asiatic princesses to Egypt in order to marry them, and how the Hittites attacked Mittani.

Amenhotep III was succeeded by his son and heir Amenhotep IV, who also inherited a strong and stable empire that stretched end to end for two thousand miles. His relatively brief reign—he ruled from 1372 to 1355 BC—was unique in the history of ancient Egypt. Remarkably, he overturned Egypt's traditional religious concepts and introduced an entirely new idea—monotheism. Perhaps not surprisingly, this unorthodox theory was not well received, and after a brief flowering was not seen again in Egypt for fifteen hundred years when Christianity made its tentative beginnings in the region.

This short-lived but extraordinary era instituted by Amenhotep IV, which came to be known as the Amarna Period, brought dramatic changes not only in religion but in art and social philosophy. Yet although innovative artistic themes were introduced, the deep-rooted traditional canons and compositions were never entirely abandoned.

One of Amenhotep's first steps was to change his name to Akhenaten Neferkheperure-waenre which means 'the devoted to Aten, beautiful is the form of Ra, the sole one of Ra'. Akhenaten could mean the 'illuminated manifestation of Aten' or 'the one who is effective to Aten'. The change Akhenaten initiated concerned the nature of the deity. This change was fundamental. From the dawn of civilisation Egyptians, in common with other peoples, had been polytheistic, believing in a number of gods each bearing a relation to an abstract or a physical quality or entity. Akhenaten did away with all this. He proposed that the only necessary god was the sun god, Aten, a revolutionary doctrine which is regarded as monotheistic and as such ahead of its time, but which proved to be fatally flawed in that the attempt to rewrite the beliefs of millennia did not make allowance for the firmly held convictions of the Egyptian people.

The new, pivotal worship of Aten developed out of the worship of the traditional sun gods. Akhenaten announced that Aten was the sole creator. Solar religion was by no means new in Egypt, and even the god Amun was associated with Ra, god of the sun; however the emphasis in the case of Aten was in regard to his nature as a life giving light as manifested in the sun's rays. Akhenaten prohibited the old cult of Amun and eliminated its powerful priesthood, dealing a further blow with the closure of Amun's temple at Gebel Berkel near the Fourth Cataract.

Egypt also had a new capital. The centre of administration shifted from Thebes northwards, down the Nile to Akhet Aten, 'the horizon of Aten', today at Tell al-Amarna near Minya. The name was taken from a tribe known as Beni Omran who lived in the area. AkhetAten was not just a new capital but was also the centre of the new religion. The city stretched for some ten kilometres along the east side of the Nile, and here Akhenaten lived with his wife Nefertiti—the epitome of classical beauty and one who enjoyed exceptional power as a queen consort—and their six daughters,

Akhenaten did not only order changes in the culture, art, religion, iconography and architecture of the country, but he also modified the language. He introduced linguistic changes and used less formal patterns to compliment his elaborate plan of emphasising his divinity and demonstratimg his uniqueness by means of a distinct literary style. These changes influenced Egyptian culture for generations.

Akhenaten had another, minor wife named Kiya, who was described as the *hemet mrrty aat*, 'the great beloved wife', and who probably have predeceased him. Kiya's eldest son was Semenekhkare, who probably ruled for three years after the death of his father. Semenekhkare was the brother of the next king, Tutankhamun.

The young king was only eight or nine years old when he succeeded to the throne, so he was under the regency of the priest Ay, who, doubtless much to the relief of the people, moved the court and administration back to Thebes and restored the old cult of Amun-Ra and the worship of other divinities. Twt-ankh-aten, 'the living image of the god Aten', changed his name to Twt-ankh-amen when he moved back to Thebes, while his wife and half-sister Ankh-es-en-pa-aten, 'the one who lives for Aten', in turn changed hers to Ankh-es-en-pa-amen. By the end of the Eighteenth Dynasty the cult of Aten had been almost completely erased.

In 1346 BC the young king died after ruling for only ten years and was buried with elaborate ceremony. His tomb was left undisturbed until 1922 when it was discovered by Howard Carter on a mission sponsored by Lord Carnarvon. Tutankhamun's tomb is the most complete evidence yet of the extravagance of royal burials.

When Tutankhamun died leaving no heir, his wife Ankhesenpaamen became the heroine of the final crisis of the lingering shadow cast by the Amarna Period; she wrote to the Hittite king Shuppiluliuma I begging him to send her a prince to take in marriage, since no suitable man for her to marry could be found in Egypt. "Never shall I take a servant of mine and make him my husband!" had she written. The Hittite king overcame his surprise and sent her one of his sons, prince Zannanza, but the unfortunate bridegroom died on the way, probably murdered by Ay who was destined to become the next king.

Ay Kheperkheperure, whose name means 'the forms of Ra exist', married the queen and ruled for three years (1346 - 1343 BC).

He had been a prominent nobleman during the reign of Akhenaten, and is believed to have been a kinsman or even the father of Nefertiti. He acquired titles such as 'Overseer of all his majesty's horses', 'The royal scribe' and 'The fan bearer on the right of the king'. Under Tutankhamun, he was given the principal priestly title of 'God's father', and as we have seen played a key role in the restoration of the old cult of Amun and the other deities of Thebes and the rest of Egypt. On the death of Tutankhamen, Ay was represented as performing the funerary rite of the opening of the mouth for the dead king and was an influential supporter of the royal family.

Upon Ay's death an army general, Horemheb, ascended the throne. He took the name Djeserkheperure, which means 'Horus is in feast, sacred are the forms of a', and so became the last sovereign of the Eighteenth Dynasty. Horemheb had been granted several titles during the reign of Tutankhamun, among them 'The king's two eyes throughout the two banks', 'The king's deputy in every place', 'Foremost of the king's courtiers', 'Overseer of the generals of the lord of the two lands', 'Overseer of every office of the king' and 'Overseer of the overseers of the two lands'. Before ascending the throne he built a tomb at Saqqara, from which we can infer that he led several military expeditions during the reign of Tutankhamun.

Horemheb (1343 to 1315 BC) issued a series of decrees known as the rules and laws of Horemheb, declaring his intention to restore order and to put a stop to injustices resulting from the actions of high officials. Thus he put in place measures to protect taxpayers and working people from the domination of bribed employees, and conducted a firm policy within the army, announcing his intolerance of disorder. He was also engaged in building activities, adding the second, ninth and tenth pylons at Karnak Temple and incorporating the stones from the dismantled Talaatat, Akhenaten's temple to Aten, in his constructions. On his death he was buried in a second tomb he had built in the Valley of the Kings (KV 57). Horemheb was venerated during his lifetime and respect was paid to him in his unoccupied 'general's tomb' at Saqqara.

Horemheb nominated Ramsses I as his crown prince. Ramsses I Menpehtire (1315 to 1314 BC), whose name means 'born by Ra the endurance of the power of Ra', was the founder of the Nineteenth Dynasty. He had been a vizier and a high official, son of an army officer called Seti from Avaris, the city of the god Seth and the former Hyksos capital in the eastern Delta.

The period of the Nineteenth and Twentieth dynasties is referred to as the Ramesside Period, since many of the sovereigns of the two dynasties bore this name. Ramsses I ruled for less than two years and was succeeded by his son Seti I. Ramsses I too was buried in the Valley of the Kings.

Seti I's reign (1314 to 1304 BC) was described as *wehem msw*, meaning 'the renaissance'. He wanted to regain the power and prestige Egypt had enjoyed under Thutmosis IV and Amenhotep III, and launched three military campaigns in Palestine-Syria, recovering Amurru and Kadesh although these would be lost again the following year. In the third year of his reign he foiled an attack from Libya on the northwest front. He also launched a massive building programme; he began the construction of the First Hypostyle Hall at Karnak and built a funerary temple at Qurna on the west bank of Thebes, as well as a vast temple at Abydos dedicated to Osiris, together with the Osireion, a symbolic cenotaph for the cult of Osiris and of himself likened to Osiris. His tomb (KV17) is the longest and most beautiful tomb in the Valley of the Kings.

Seti I was succeeded by his son Ramsses II (1304 to 1237 BC), a brave fighter and a great constructor of monuments, a man of peace and champion in war. He built a new capital of Pr Ramessu in the eastern Delta near modern Qantir, forty-eight kilometres from Zagazig and twenty from Tanis. His rock-cut temples in Nubia included Beit al-Wali Derr and two at Abu Simbel; his part rock-cut temples were Gerf Hussein and Wadi al-Sebóua. As well as these, he built a chain of fortresses along the Libyan coast route. Fine statues were produced in his reign, although they could be said to have been mass-produced.

Ramsses II's most famous battle was the battle of Kadesh, against the Hittites, in the fifth year of his reign. Troubles rumbled on with the Hittites until his twenty-first regnal year, when he signed a peace treaty.

Ramsses II reign's fell in a cosmopolitan period. Foreigners had been moving in large numbers to Egypt and occupying various jobs on all social levels.

Ramsses outlived three crown princes and was succeeded by his thirteenth son, Merenptah. Merenptah (1237 to 1226 BC) was an active warrior king, crushing the attack launched on Egypt by the

Libyans—who were allied with the Proto-Hellenic 'sea peoples' in his fifth regnal year. His viceroy meanwhile managed to overcome a threat from the Nubians in the South

Merenptah was succeeded by Amenmes, who was probably a son of a secondary queen. His reign lasted only for three years, after which the throne passed to Seti II. His reign was also short, (1221 to 1215 BC), but during this time he completed the triple room chapel for the sacred bark of Amun in the great open court at Karnak and his own tomb in the Valley of the Kings (KV 15). He was succeeded by his son Siptah who died when still young. For the next two years Egypt was ruled by another queen, Tawosret who had been the queen consort of Seti II. The Nineteenth Dynasty came to a close in civil conflict, with the higher administrators fighting over the throne.

The struggle was won by Sethnakhte, who in his brief reign (1200 to 1198 BC) managed to bring an unsettled decade to an end, founding the Twentieth Dynasty. He was an elderly man, but when he died after only two years he was succeeded by his son Ramsses III, the dynasty's greatest figure, whose rule lasted from 1198 to 1166 BC.

Ramsses III was an active builder and a great warrior. He repelled two attacks from Libya in the fifth and eleventh years of his reign, and in the eighth year he defeated the 'sea people', who migrated from the Aegean Sea and brought down the Hittite authority.

Towards the end of his reign there was a conspiracy in the royal *harim* over the succession. When Ramsses III died, his sons and grandsons ruled after him: all were called Ramsses, from Ramsses IV to Ramsses XI. Down to the last sovereign of the Twentieth Dynasty, they were less able and powerful. National insecurity prevailed, with the Libyans repeating their raids on the Nile Valley. Egypt's empire fell apart; it lost its territories in Asia and Nubia, together with the tribute it had received from them and access to their gold mines. This resulted in impoverishment of the country and a weakness in the economy that led in turn to lawlessness, which included robbing the riches buried inside private and royal tombs and temples.

The first of the line of kings responsible for this downslide was Ramsses IV (1166 to 1160 BC), who began his reign in good faith by adding the finishing touches to the temple of Khonsu at Karnak initiated by his father. He began building his tomb in the Valley of the Kings (KV 2), the plan of which is on a papyrus in the Turin museum today. For materials he sent quarrying expeditions to Wadi Hammamat and to Sinai.

Ramsses IV was succeeded by his son Ramsses V, who ruled for only three years before himself being succeeded by his uncle Ramsses VI (1156 to 1149 BC). The famous Wilbur Papyrus, which is ten metres long and dates from his reign, has contributed much to our knowledge of agriculture in ancient Egypt.

Ramsses VI, the son of Ramsses III and his queen, Isis, completed for himself the tomb in the Valley of the Kings (KV 9) that Ramsses V had begun. The position of this tomb was fortuitous, for it was the reason why the entrance to the tomb of Tutankhamun remained hidden for so long and thus escaped violation. Ramsses VI was the last sovereign whose name was found engraved in mines and quarries in Sinai, and it was during his reign that the viceroy in Nubia, Penny, constructed his fine tomb at Aniba.

He was succeeded by his son Ramsses VII (1149 to 1141 BC), whose tomb is in the Valley of the Kings (KV 1). Since he outlived the son and heir he was succeeded by his uncle Ramsses VIII, another son of Ramsses III, who reigned for only three years and left no tomb. The next in line to the throne was his nephew Ramsses IX.

Under the eighteen-year rule of Ramsses IX insecurity increased, with raids from across the desert by marauding Libyans forcing people on the west bank to resort to take refuge within the fortress walls of the mortuary temple of Ramsses III (Medinet Habu). Economic downturn led to inflation in grain prices in Thebes which caused great unrest. In the thirteenth year of his reign a gang led by an artisan began a systematic robbing of the tombs of the nobles, and within a short time had violated the tomb of one of the kings of the Seventeenth Dynasty. A year later another band from the artisans' village at what is now Deir al-Medina robbed the tomb of Isis, queen consort of Ramsses III of its valuables. Tomb robberies continued throughout the reigns of the next two kings.

Ramsses IX was buried in the Valley of the Kings (KV 19) and was succeeded by his son Ramsses X, who probably ruled for only nine years and whose tomb (KV 52) was never finished. He was followed by his son Ramsses XI (1111 to 1081 BC), who ruled for twenty-seven years. In the ninth year of his reign a scandal erupted concerning a robbery at the Ramesseum, the funerary temple of Ramsses II, where a large amount of gold and other treasure was

kept. Priests and temple officials from the temple of Ramsses III (Medinet Habu) were accused of the theft, but the scale and manner of the incident drew attention to the loss of law and order to the extent that Ramsses recalled his viceroy at Kush, Panehsy, to Thebes and commissioned him to impose martial law.

In Ramsses XI's eighteenth regnal year, Panehsy had a conflict with Amenhotep, high priest of Amen, who had wall relief carved for himself at Karnak, which was as large as the king's, thus breaking the tradition of showing the king as the highest figure among the nobles. Confronted by Panehsy, Amenhotep fled to the north where his assailant chased him with an army but later retreated all the way back to Nubia. The army he left behind caused havoc in the county, looting and destroying towns. This is the event described as "the year of the hyenas … when one was hungry".

The following year Ramsses XI left Pr Ramessu, the Delta capital, and traveled south to Thebes to restore order and announce the onset of a new era of authority, order and justice. It was to be a *wehem mswt*, a renaissance. His dream of greatness, however, was short-lived: he was overshadowed by the powerful men he appointed in order to achieve that very renaissance. He himself took up residence in Memphis, and appointed Herihor as viceroy in Nubia and governor of Upper Egypt, also making him a high priest of Amun. In the north, the king appointed Semendes as governor of Lower Egypt.

Herihor oversaw the capture and trials of the tomb robbers and ordered the reburial of Ramsses II and Set I, whose tombs had been looted. He made additions to Karnak Temple, augmenting the decoration of the temple of Khonsu, where he assumed royal titles and placed his name in a cartouche. He sent the priest Wenamun to Byblos on the Phoenician coast to obtain precious wood to build a new bark for Amun, but Wenamun was maltreated in Byblos and registered that fact in a story that illustrates the loss of Egyptian prestige in that region. This story is told on a papyrus which today is in the in Pushkin Museum in Moscow.

Herihor was succeeded by the high priest of Amun, Piankh, who led an unsuccessful expedition against Panehsy in Nubia. This marked the mysterious and inglorious end of the New Kingdom and the advent of a new era called the third Intermediate Period.

89. Anthropoid Coffin of Queen Ahhotep

Wood, gold leaf; Western Thebes; H. 212cm;
18th Dynasty; Reign of Ahmose, 1569 - 1545 BC;
Upper floor, gallery 46; JE 4663= CG 28501;

Carved of wood, this coffin is covered by a thin layer of stucco, and overlaid with gold leaf. It was discovered in the tomb of Queen Ahhotep in Dra Abu el-Naga, Western Thebes, in 1859. The mummy was found still in its coffin, decorated with funerary jewellery and surrounded by ornamented weapons. The queen is shown wearing a long, curly wig, which resembles the wig of the goddess Hathor. The cobra, which once lay over her forehead, is now lost. The eyes are inlaid with alabaster and obsidian; and painted long feathers adorn the body. By the Late Second Intermediate Period, in the 17th Dynasty, the anthropoid coffins were being decorated with a feathered pattern called *rishi*, an Arabic word meaning 'feathered'. This pattern originated in Thebes and was used first on the coffins of kings then extended to queens and nobles. The feathers represent the goddesses Isis and Nephthys, who were considered as divine mourners of the deceased. In addition, the feathers also recall the wings of the *ba* bird, which represents the soul, one of the parts of the person that needed to be reunited with the body before he could be reborn in the next world.

Ahhotep was the queen consort of King Skenenra Taa II and mother of King Kamose and King Ahmose. When King Kamose died, during the struggle against the Hyksos, his brother Ahmose ascended the throne. As he was still a boy, probably about ten years old, his mother Queen Ahhotep acted as regent until he was about sixteen. When she died, King Ahmose honoured her by placing some very fine funerary jewellery in her tomb including an extraordinary, beautiful necklace with three pendants in the form of flies, which was of the type usually given as an award to the commander of a victorious army. Such a tribute affirms the role the queen played. King Ahmose also placed his axe, which is decorated with scenes of victory over the Hyksos, in her coffin as well as his dagger, another gift to her.

Her other jewelry, including bracelets and pendants, show excellent workmanship and a high level of artistic sensibility. Queen Ahhotep was a great queen, bearing the titles *nbt hawnbw,* meaning 'the lady of the Mediterranean', who was praised in a hymn found at Karnak that describes the great efforts for the army and state. A stela from Edfu records a cult commemorating her, along with other Seventeenth Dynasty royal wives, who helped the kings to overcome the threat from the Hyksos.

90. Bracelet of Queen Ahhotep

Gold, lapis lazuli; Western Thebes; Diam. 5.5 cm, H. 3.4 cm;
18th Dynasty; Reign of Ahmose, 1569 - 1545 BC;
Upper floor, room 4; JE 4684 = CG 52069;

This rigid bracelet belongs to Queen Ahhotep, mother of King Ahmose. It is made of gold inlayed with lapis lazuli. It shows the advanced technique of making hinges.

Both sides are decorated with symbolic representations. The first side shows four kneeling figures the two at the right side have a head of a jackal and the other two at the left hand side have head of a falcon. Those figures represent the legendary *baw P and baw Nkhen*, the souls of the city *P* in the north and the souls of the city *Nekhen* in the south, thus symbolizing the Lower Egyptian and Upper Egyptian kings before the unification of Egypt.

They raise their arms in expression of jubilation and the hieroglyphs beside them mention the word *rshwt* meaning joy.

This symbolized that fact that the ancestors of the Egyptian kings are rejoicing at the presence of King Ahmose.

The other side of the bracelet shows a fan in the middle of a mirror image scene representing the god Geb, the god of earth and husband of the sky goddess Nut, enthroned and dressed in a large and short garment wearing the double crown on the right side and the crown of Lower Egypt at the left side. He is holding the arm of a kneeling figure and pats his shoulder with his other hand. The kneeling man is King Ahmose whose name is represented in his cartouches at the right and left extremities of the scene; the king is represented with a royal cobra, curly wig a *usekh* collar and a short *shendyt* kilt.

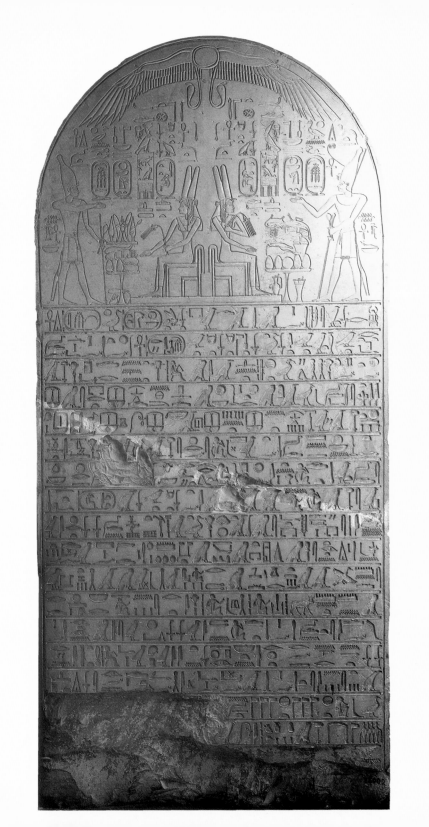

91. Stela of King Ahmose

Limestone; Abydos; H. 225 cm, W. 106 cm;
18th Dynasty, reign of Ahmose, 1569 - 1545 BC;
Ground floor, room 12; JE 36335 = CG 34002;

This commemorative stela of King Ahmose is sculpted of limestone and was found in the mortuary monument dedicated by King Ahmose to Queen Tetisheri in Abydos, south of the temple of Seti I.

The lunette, the space within the upper curve of the stela, shows a winged-solar disc with two cobra heads, symbolising protection, a royal emblem seen on the pylons of temples. The scene is divided into two symmetrical parts; both showing King Ahmose and his grandmother Tetisheri behind him. On the right side, the king wears the *psekhnet*, which is the Double Crown of Upper and Lower Egypt. He is also wearing a short kilt with an ox tail attached, and holding a staff and mace in his left hand, while talking to his grandmother, who is seated in front of an offering table.

On the left side, the king and queen are represented in the same manner, but the king is wearing the crown of only Upper Egypt. The hieroglyphic inscriptions carrying their names and titles are given on both sides: *di ankh djet sa nswt Iah-ms ntr nfr nb tawy Nb phty ra, hr behdty Ka m was ntr aa.* 'To be given life, the son of the king, begotten of his body, King Ahmose, the good god, the lord of the two lands, King Nbpehtyre, 'the one identified with Horus of Behdet King Kaemwas, the great god.' Her names and titles are *hemet nswt, mwt nswt, tti sheri ankhty djet,* 'the wife of the king, the mother of the king, Tetisheri, the living forever.'

The inscription under the scene, carved in sunken relief, records how King Ahmose had sat with his wife Queen Ahmose Nefertary and told her the following: "The memory of my great grandmother Tetisheri passed in my mind and I want to glorify her and to commemorate her great deeds for our country. She organised the soldiers and spurred them on as well as dealing with the country's domestic affairs while my father was away. I suggest and intend to make a beautiful monument to her and give offerings and endowments to her temples in Thebes and in Abydos. I will make a lake and plant trees beside that temple and appoint many priests for her cult and for the upkeep of the temple.

Queen Tetisheri was the first lady to have the title *hemet ntr* or 'the god's wife'; she also bore the title of *mwt it*, the mother of the father. Queen Ahmose Nefertary, the wife of Ahmose was also involved in the state's religious life, as second priest of Amen and she was also named *hemet ntr* , which gave her great political and religious prestige, in addition to personal wealth.

92. Anthropoid coffin of Queen Ahmose Merit Amun

Wood, Deir al-Bahari; L. 313.5 cm, W. 87 cm;
18th Dynasty, reign of Amenhotep I, 1545 - 1525 BC;
Upper floor, gallery 46; JE 53140;

Carved of cedar wood, this anthropoid coffin was found in the 'cachette' of mummies in Deir al-Bahari, where it was transported by the kings of the 21st dynasty, who transported many mummies and coffins of former kings to this hiding place, to protect them from further robberies. It contained a second anthropoid coffin, which, in turn, contained the mummy. Before this coffin was removed from its original burial place, tomb robbers stripped off the gold leaf that adorned the surface of the lid.

Merit Amun was the queen consort and sister of King Amenhotep I. She is represented wearing a large wig decorated with blue colour; her lifelike eyes and her eyebrows are inlayed with blue and black glass paste, imitating lapis lazuli and obsidian. Her arms are crossed over her chest and in each hand she holds a papyrus plant, which represented freshness, green and youthfulness to the ancient Egyptians, as mentioned in chapters 159 and 160 of the Book of the Dead. In addition, the plant was thought to symbolise good fortune. One papyrus plant is called *wadg*, and two are called *wadjwy*, which means 'how fortunate'. The pair of papyrus plants were among the essential items carried with the funerary outfit to the tomb, as seen in scenes of the funeral processions of the nobles depicted in their tombs in the Theban necropolis. The body of Merit Amun is decorated with long feathers conforming to the *rishi* or the feathered pattern of the Seventeenth and Early Eighteenth Dynasty coffins.

In the centre, the offering formula is inscribed in a long column giving her names and titles. She inherited from her mother the title 'God's wife of Amen', and she was revered in the cult of her husband in the 21st Dynasty.

93. Head of Queen Hatshepsut

Painted limestone, Deir al-Bahari; H. 61 cm, W. 35 cm;
18th Dynasty, reign of Hatshepsut 1502 - 1482 BC;
Ground floor, gallery 11; JE 56259, 56262;

This limestone head was part of a colossal statue of Hatshepsut in the Osirian posture, attached to the pillars on the third terrace colonnade at her mortuary temple in Deir al-Bahari. She is seen with a false beard and probably wore the *sekhmety* crown of Upper and Lower Egypt originally.

The head has delicate feminine features, almond-shaped eyes, and a small mouth with a slight smile. Although female, the queen was always represented as a male king with reddish-brown skin, the traditional colour used for male skin on statues, and a false beard.

She was the daughter of King Tuthmosis I and his queen consort Ahmose. Hatshepsut ruled first as regent with Tuthmosis III, her stepson and son-in-law for few years, before assuming full power, and crowning herself as sole king of Egypt, acquiring the royal titles. To legitimize her rule, she related the story of divine birth, claiming to be the divine daughter of the god Amen. She proclaimed this story and had it illustrated on the walls of the northern colonnade on the second terrace at her temple in Deir al-Bahari. That scene shows the divine meeting between her mother, Queen Ahmose, and the god Amen, who sit facing each other, while the god extends a sign of life to the queen, symbolically impregnating her with the divine child. Next, they are raised to heaven by two goddesses, where the god Khnum shapes Hatshepsut and her royal *ka* on the potter's wheel. The pregnant queen is then led to the birth room, where various gods record the divine birth. After the birth of Hatshepsut, her mother, Ahmose receives the congratulations of Amen, as her daughter Hatshepsut will be the ruling king of Egypt. Although female, Hatshepsut took on the appearance of a king.

Hatshepsut was not the first queen to rule Egypt, as there were previous instances of ruling queens, but for shorter periods and without the great monuments or achievements of this queen. In the Turin papyrus, we read that at the end of the Sixth Dynasty, a queen called Nitikris ruled Egypt for two years, and had the title *Mn kaw re,* 'stable are the doubles of re', but little is known about her reign. Then at the end of the Twelfth Dynasty, there was another queen, called *Sobek Nefru,* who ruled for four years.

94. Granite Sphinx of Hatshepsut

Red granite, Deir al-Bahari; H. 160 cm, L. 260 cm;
18th Dynasty, reign of Hatshepsut 1502 - 1482 BC;
Ground floor, gallery 7; JE 53114;

This granite sphinx also came from Queen Hatshepsut's mortuary temple in Deir al-Bahari. It was broken and has undergone restoration several times. The queen is seen wearing the *nemes* headdress, with a cobra over the forehead and is wearing a false beard. The muscles and ribs are represented with great accuracy and elegance, and the front and back paws and nails are shown with an impressive realism.

When Hatshepsut ascended the throne, she always appeared as a male, wearing a beard and wearing a pharaoh's dress. The texts refer to her as King of Upper and Lower Egypt, not as Queen. In this sculpture she shows herself as a sphinx, to accentuate the impression of power, and to be seen as wise as a man and as strong as a lion.

In spite of the records that she sent military expeditions to Nubia, Syria and Palestine, her reign was a peaceful one and it was known as an era of extensive building activities. She built the red chapel at Karnak, which is now in the open-air museum. She also erected two obelisks in front of the fifth pylon at Karnak in the 16th year of her reign, which were cut out of a monolith granite block from the quarries at Aswan and transported within seven months. The apexes were once covered

with a mixture of gold and silver. One obelisk weighs approximately 320 tons. One of the pair still stands at Karnak, and is the tallest to be found in Egypt today. Only the upper part of the second has survived, and it now lies beside the sacred lake at Karnak. This obelisk was damaged, despite the wall built around them by Pharaoh Tuthmosis III in order to hide the names of Hatshepsut that was inscribed on them. He did not destroy the obelisks out of respect for the god Amen Re, to whom they were dedicated. At the same time, this pharaoh defaced Hatshepsut's images obliterated her names, inserting his own instead.

Hatshepsut, in addition, built the first rock-cut temple in Egypt. It lies in Estable Antar, three km south of Beni Hassan in Middle Egypt, and is dedicated to the goddesses Bakhet and Bastet, who are known to the Greeks as Speos and Artemidos. In this temple, a

94

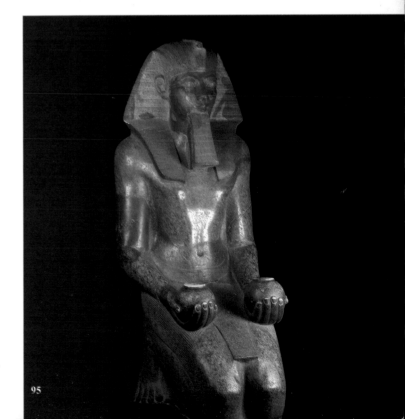

95

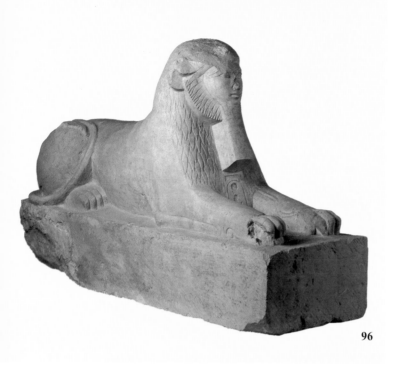

96

famous text declares how she devoted herself to repairing buildings that were damaged during the Hyksos invasion.

She built two tombs; the first when she was still "the great wife" of Tuthmosis II, and is situated near the Valley of the Queens, where her first sarcophagus was found. The second is in the Valley of the Kings, (KV 20) where her red quartz sarcophagus and canopic chest were found, together with a sarcophagus belonging to her father Tuthmosis I. Her body was not found in either of them.

95. Kneeling statue of Hatshepsut

Red granite; Deir al-Bahari; H. 210 cm;
18th Dynasty, reign of Hatshepsut, 1502 - 1482 BC;
Ground floor, gallery 7; JE 53115;

This colossal kneeling statue of Hatshepsut, sculpted of granite, comes from Deir al-Bahari. It shows the queen wearing the traditional *nemes* headdress and false beard, offering two *nw* jars of milk or water. Her name *Maet ka re* is inscribed in the cartouche above the buckle of her belt. This kneeling position, while presenting jars of offerings is commonly seen in representations of New Kingdom kings. The oldest such statue known is that of Pepi I, sculpted of green slate, and now in the Brooklyn Museum. Other kneeling statues show kings presenting an offering altar or a Naos of a god's statue.

Emphasising physical strength, the statue boasts large shoulders and powerful muscles. The curves in the body and feet help to imbue the statue with naturalism. On the dorsal support at the back, the following text mentions her name and titles: *nswbiti, nb tawy maet ka re sat re mry f hashepswt khnemet amen di ankh djet,* 'The King of Upper and Lower Egypt, the Lord of the Two Lands, Maetkare the daughter of the king his beloved Khnemetamen Hatshepsut to be given life forever and ever.' In this inscription, the queen used both male titles and referred to herself in the feminine. This characteristic also appeared in the literature of the period as one of the nobles was speaking of her as a male and a female at the same time: "I followed His Majesty, King of Upper and Lower Egypt on her journey." Over the dorsal support, the name of her Deir al-Bahari temple appears as *Djeser djeserw,* 'the holy of holies'.

97

Hatshepsut's successor, Tuthmosis III defaced her statues and obliterated her name. The queen's name was also omitted from kings' lists compiled later, such as the Abydos list, written during the reign of Seti I.

Many of Hatshepsut's high officials had their tombs in the Theban Necropolis; Senmut was one of the most influential among them. Beginning his career as a tutor to the royal princess Nefrure and steward of the estates of Queen Hatshepsut, Senmut was then commissioned by the queen to quarry stone for her obelisks from Aswan, leaving records of his work inscribed in the quarries. He was awarded the high post of Great Steward of Amen, administering the wealth of the priesthood at Karnak Temple. He built his tomb in Assasif, near the Deir al-Bahari temple. Senmut was also the royal architect of Hatshepsut's mortuary temple, his title as royal architect appearing in his burial chamber and on one of his statues. He is considered one of the three great architects in ancient Egypt, alongside Imhotep, the architect of Djoser's Pyramid, and Amenhotep son of Hapu, the royal architect of King Amenhotep III.

96. Limestone sphinx of Hatshepsut

Painted limestone; Deir al-Bahari; H. 59.5 cm, L. 105 cm;
18th Dynasty; reign of Hatshepsut 1502 - 1482 BC;
Ground floor, gallery 11; JE 53113;

One of a pair, this sphinx is sculpted of limestone and originally stood in front of the first ramp leading to Deir al-Bahari mortuary temple, called *Djeser djeserw*, 'the holy of holies'. The other is in the Metropolitan Museum, New York.

The queen takes the traditional posture of a sphinx with its forepaws laid on the ground and its tail curled. Both the front and back paws were executed with great care and realism. The head is framed by a lion's mane instead of the *nemes* similar to the Middle Kingdom sphinxes of Amenemhat III. The facial features are fine, showing femininity. Here again are the almond-shaped eyes, curved eyebrows and small mouth. The light yellow colour of her skin is in keeping with the usual colour of female statues. On the chest, the queen's name is inscribed in a cartouche, *Maet ka re mry imn di ankh djet,* 'Maet ka re, the beloved of Amen, given life forever and ever.' 'Maet *ka* re' means 'the justice of the ka' or 'double

of Re', which is the coronation name of Hatshepsut. The name Hatshepsut khenemet Imn was her birth name and means 'the united one with Amen, the one who is in front of the noble ones.'

97. Statue of Hatshepsut standing

Granite; Deir al-Bahari;
18th Dynasty; reign of Hatshepsut 1502 - 1482 BC;
Ground floor, room 12;

This granite statue of Queen Hatshepsut was found in Deir al-Bahari. It shows the queen standing in the traditional manner, advancing the left leg forward. She is wearing the nemes royal headdress, having a cobra over the forehead and a false beard. She is wearing the royal *shendyt* royal kilt and the buckle of the belt shows her name inscribed in the cartouche. Her kilt is pleated and starched and she has her two hands spread over her kilt as if she is praying.

98.1

98. Expedition of Punt

Painted limestone; Deir al-Bahari; H. 49 cm, W. 45 cm;
18th Dynasty, reign of Hatshepsut, 1502 - 1482 BC;
Ground floor, room 12; JE 14276, 89661;

These limestone blocks were taken from the southern colonnade of the second terrace at Queen Hatshepsut's temple in Deir al-Bahari, Western Thebes. The colonnade commemorates the commercial expedition the queen sent to Punt, now Somalia or northeastern Ethiopia or Eritrea, in the ninth year of her reign. Periodically, pharaohs used to dispatch commercial expeditions to Punt, to barter for *antyw* and *seneter*, 'myrrh' and 'incense', or gold, electrum, panther skins and ebony. There were two routes to Punt; by the Nile or the Red Sea, and the high official Nehsy led Hatshepsut's expedition to the Red Sea.

One of the blocks show the chief of Punt, called Parehu, accompanied by his fat wife Ati, who probably suffered from elephantasis, walking towards the Egyptian leader of the expedition, in order to greet him. When they saw the statue of Hatshepsut, they paid it the highest homage, calling her 'the great King of Egypt, the female shining sun'. A pile of gifts are laid in front of the chief of Punt for the Egyptians; and behind his wife are servants with curly hair and beards, also wearing headbands, and carrying gifts and goods from Punt.

The donkey that transported the fat wife is seen on the other block. The hieroglyphs above include the sentence *aa fai hmt.f* 'The donkey that carries his wife to accentuate that she did not have a special royal means of transport except for this poor donkey.' In situe, on the temple walls, are carved scenes of the houses of Punt. They are constructed over water, with ladders leading up to the entrances, and surrounded by cattle, giraffes, baboons, doum palms, incense trees and rhinoceros. Even fishes of the Red Sea and Indian Ocean are represented. In addition, ebony trees are depicted, planted in small tubs, ready to be taken to Egypt and planted in front of Hatshepsut's temple. Two roots still exist today in front of the temple in Thebes.

The two blocks were at one time stolen from the temple, but later found and taken to the Museum. A cast of them was made and fixed on the walls of the temple in their stead. The hieroglyphics were translated by Auguste Mariette.

98.2

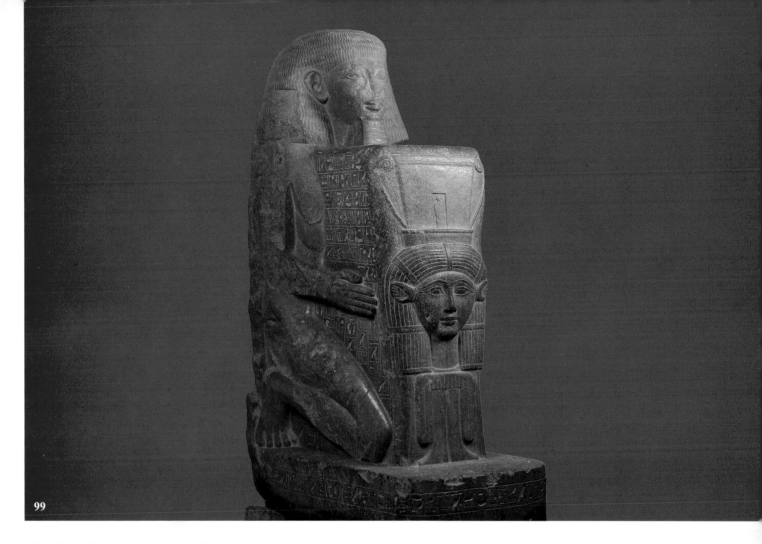

99

99. Hatshepsut presenting a naos of Hathor

Granite; Deir al-Bahari;

18th Dynasty, reign of Hatshepsut, 1502 - 1482 BC;

Ground floor, gallery 11; JE 14276, 89661;

This statue was sculpted of granite and it shows Queen Hatshepsut represented kneeling and presenting a Naos of the goddess Hathor, the goddess of love, joy music and beauty. The queen is represented with a short wavy –style wig and a false beard. Her body is represented as a male figure and it shows the folds of fat over the chest and the tummy. The head of goddess Hathor was represented as a female head having ears of a cow.

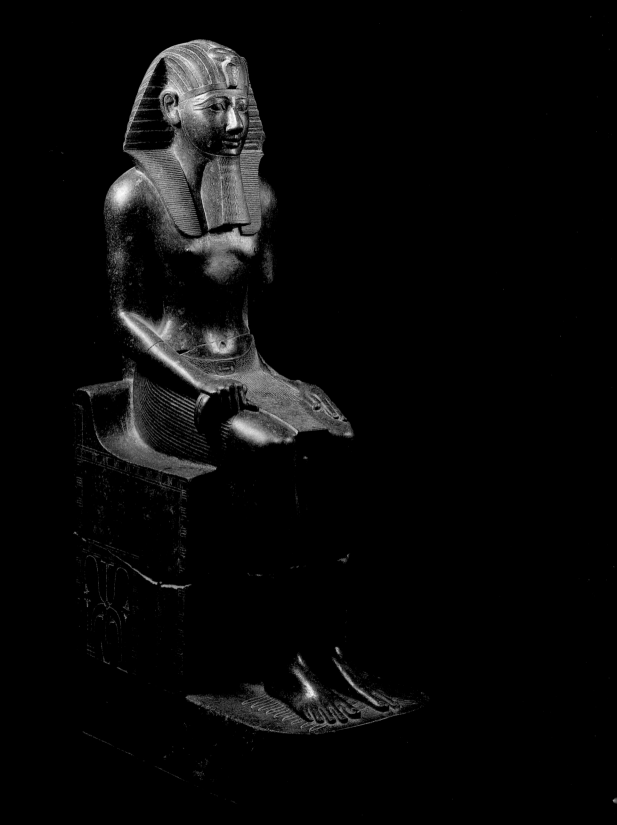

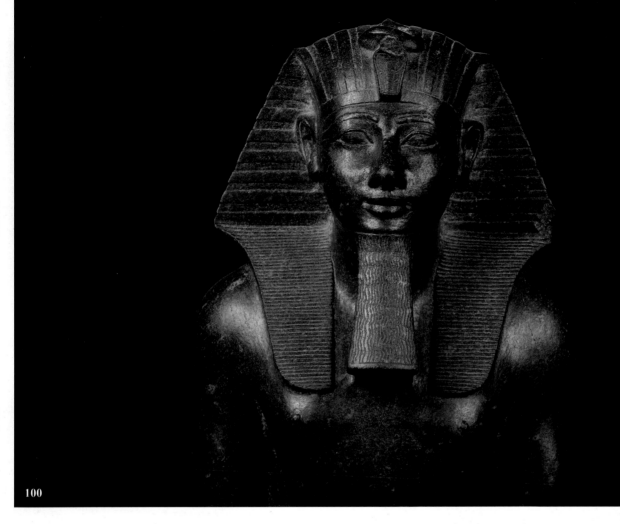

100

100. Seated statue of Tuthmosis III

Granite, H. 169 cm;
18th Dynasty, reign of Tuthmosis III, 1504 - 1452 BC;
Ground floor, room 12; JE 39260;

This granite statue was found at Karnak, and shows the king on his throne. To the side the sematawy scene is depicted, formed of lotus and papyrus plants. The king is represented in the traditional pose, wearing the nemes, false beard, and shendyt, the 'royal kilt'. He is also holding a royal handkerchief and has a ka nakht, or 'strong ox tail' as a metaphor of his strength. The ox tail had been used since the First Dynasty when it was represented on the Narmer palette. The pharaoh's belt is shown with an innovative design in the form of the wavy lines that signified water, and his cartouche is inscribed on the buckle.

The king is trampling over nine bows, which represent the nine enemies of Egypt. The dorsal pillar displays his name and titles in a cartouche. His statues reflect the strength, nobility and elegance that Tuthmosis was known for.

King Tuthmosis extended the Egyptian Empire, spending twenty years leading military expeditions. The royal scribes, who accompanied the king on his campaigns, inscribed a series of annals at Karnak. Considered the longest and most valuable historical records of ancient Egypt, these annals give full details of Tuthmosis's achievements in Asia during seventeen campaigns. Fascinating details are narrated; of the spoils from Asian battles, for example,

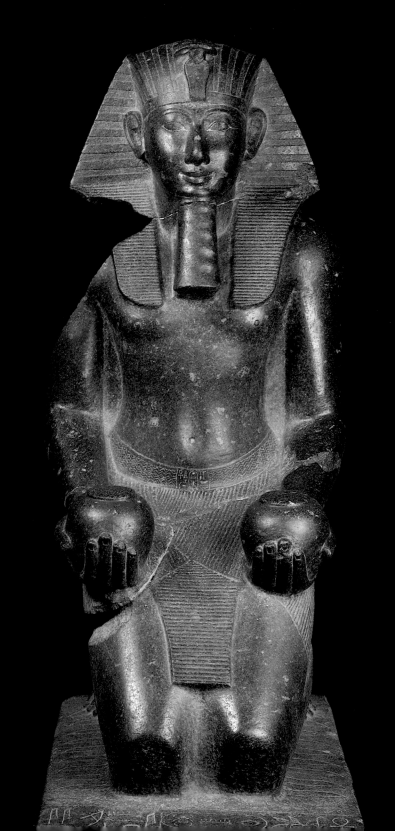

which included gold vessels and gilded chariots. Tributes, such as silver, lapis lazuli, wine, timber for boat building and a metal alloy called Asiatic copper, also came from Asia as well as Nubia.

Conducting his campaigns in summer, the pharaoh used to return to Egypt in winter to supervise building operations. Tuthmosis's first campaign began as soon as he succeeded Hatshepsut, following her death. This campaign revealed his strategic brilliance when he led 15,000 soldiers to Gaza, traveling from Tharo fort, on the eastern frontiers for nine days. He spent one day in Gaza, where he celebrated his coronation feast, and then resumed travel for another 12 days. At one point, the king had to choose between three roads: one very narrow and two others that were wider. When consulted, the military chiefs suggested avoiding the narrow road, which might be dangerous and exhausting, allowing, as it did, only for horses to pass in single file. Tuthmosis, however, decided to take the narrow road and surprise the enemy. This he did, besieging the city of Megiddo for seven months until its occupants surrendered. A list at Karnak Temple enumerates 119 towns that were conquered in this first campaign when the king captured Megiddo. The conquered territories are shown in an oval-shape surmounted by a male bust representing Syrians wearing pointed beards with their arms tied behind them.

The eighth campaign, in year 33 of Tuthmosis' reign, was also memorable. Setting out to attack the Mittani king, he prepared a fleet off the Lebanese coast, then dismantled the ships and transported them for 250 miles by road, using oxcarts. At Carcemish, on the Euphrates, he reassembled the ships and conducted naval battle.

101. Kneeling statue of Tuthmosis III

Granite; Karnak;
18th Dynasty, reign of Tuthmosis III, 1504 - 1452 BC;
Ground floor, room 12; JE 43507;

This kneeling black granite statue of Tuthmosis was found in Karnak. He is shown in the traditional *nemes* headdress, with a false beard and *shendyt* kilt. On his belt, which is decorated by a motif of wavy lines, is the pharaoh's cartouche, containing the king's names and titles: *ntr nfr nb tawy Mnkheperre di ankh djet,* 'the good god, the lord of the two lands, King Menkheperre (Tuthmosis III), to be given life forever and ever.' He is shown kneeling over the nine bows that represented the traditional enemies of Egypt. This statue shows innovation, as kings were usually shown trampling over the nine bows, rather than kneeling on them. The curvature of the feet adds naturalism to the statue. The king's names and titles are repeated on the base.

Tuthmosis's reputation for diplomatic brilliance is attested by his policies. He never, for example, appointed an Egyptian governor in conquered territories, empowering local chieftains instead. He also forged cultural relations by bringing the chieftains' sons to study in Egypt and absorb its culture, religion and civilisation, before returning to their land. In addition, the king extended his commercial relations with the 'Genbetiew' tribes in the Arabian peninsula.

The wealth of the country enabled Tuthmosis to undertake ambitious building work. His contribution at Karnak includes the Sixth Pylon, and the Hall of Records, where state records, compiled by the temple priests, list the gifts and booty acquired during the pharaoh's successful campaigns. He also built the two heraldic granite pillars; one of which bears the lotus of Upper Egypt and the other, the papyrus of Lower Egypt, both in high relief.

Tuthmosis also built the festival temple *Akh menw*, the most glorious of monuments. While the rest of Egypt was intoxicated with feelings of national pride, the victorious king himself was modestly giving thanks to the god Amen, by raising this temple at Gebel Barkal in Nubia, at the fourth cataract. There, he inaugurated the cult of the god Amen.

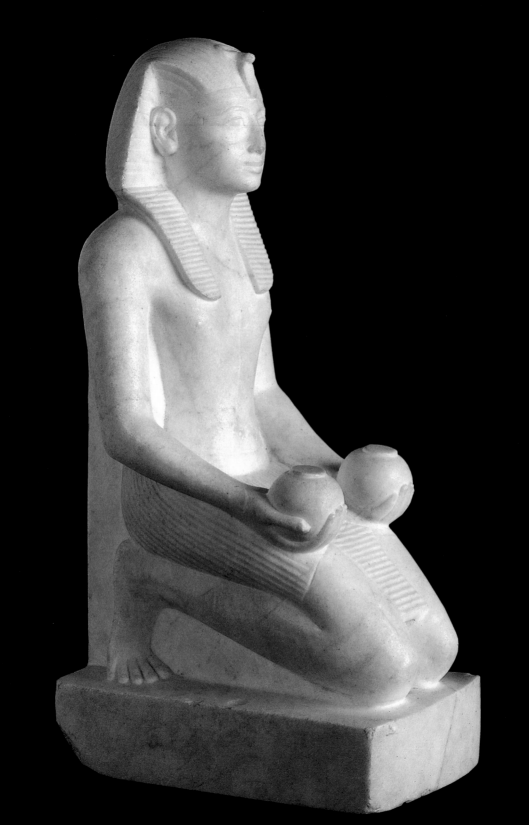

102. Kneeling statue of Tuthmosis III

Marble; Deir el-Medina; H. 26.5 cm, W. 9 cm;
18th Dynasty, reign of Tuthmosis III, 1504 - 1452 BC;
Ground floor, room 12, JE 43507;

This statue of King Tuthmosis was found at the site of the ancient village of Deir el-Medina in Western Thebes, where the tombs of the artisans are situated. The king is wearing the *nemes* headdress, with a cobra over his forehead, and the pleated shendyt. He is kneeling and presenting two *nw* jars as offerings, probably for wine, water or milk. Tuthmosis himself brought the marble for this statue from Asia, apparently in small quantities, judging by the small size of the statue.

The sculptor has expertly brought out the muscles and curves of the kneeling form; the serene face is fine and delicate, and the almond-shaped eyes, high eyebrows and full cheeks are reminiscent of the feminine features of Hatshepsut's statues. Here, Tuthmosis appears benevolent. Although a mighty military leader, he was also known for his kindness: the vizier Rekhmire having described the king as a father and mother to all his people. Despite being largely occupied with military strategies and battles, Tuthmosis also interested himself in collecting rare flowers, birds and animals from conquered lands, to bring back to Egypt, and many of them can be seen on the walls of a room in Karnak, now called the 'Botanical Room'. The first prophet of Amen, Menkheperresoneb, testified to the pharaoh's piety, as he spent his free time making small pots, vessels and statuettes, dedicating them to the temples of Amen. The inscriptions on the back pillar of the statue state that Tuthmosis also dedicated it and the *nw* jars to the god Amen. This statue must have been situated in one of the temples at Thebes before being moved and hidden in Deir el-Medina.

The king's love of justice is illustrated in his maxims to the Vizier Rekhmire, written on the walls of the latter's tomb in Qurnah, Western Thebes (TT 100). It is considered as the constitution for viziers, at least as far as their dealings with the public were concerned. "The god is fair, you have to stick to being fair", " Be alert in your tough job", "Listen to the one who comes to complain to you", "The god hates inequality", "Be respectful so that people would respect you", "Stick to being righteous and you will be rewarded by success."

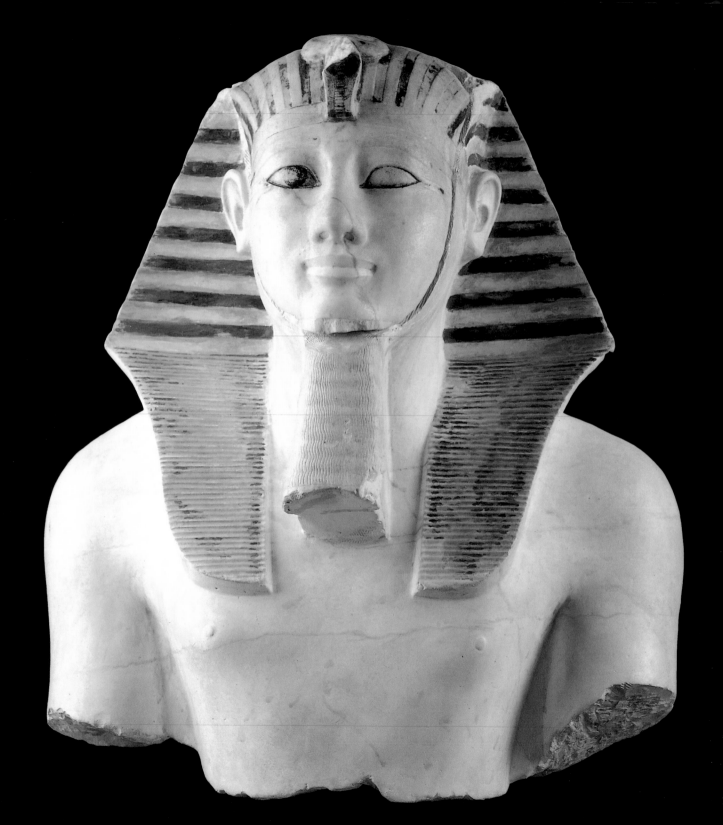

103. Bust of Tuthmosis III

Marble; Deir al-Bahari; H. 39.5 cm, W. 41 cm;
18th Dynasty, reign of Tuthmosis III, 1504 - 1452 BC;
Ground floor, room 12;

The bust, sculpted of crystallised limestone was found in Deir al-Bahari. The original body of the bust was found in 1907 and taken to the Metropolitan Museum in New York, where it is still kept. This bust is a cast of the original.

The head of the bust was found in 1964. The original head was placed on the original bust for a period of only four months in 1978, at the exhibition 'The Renaissance of Egypt' in Hildesheim, Germany. After the exhibition, the body was returned to New York and the head to the Egyptian Museum, to be joined on to the cast. The face of the king is sublime, and is characteristic of the early period in his reign when artists were still influenced by the gracious artistic qualities inherited from the time of Queen Hatshepsut. The black-painted eyes help imbue the statue with life.

King Tuthmosis III died at the end of his fifty-third regnal year and was buried in a beautifully decorated rock-cut tomb in the Valley of the Kings (KV 34). His cartouche-shaped burial chamber is adorned, in hieratic, by texts from the "Book of the Emdouat" meaning 'that which is in the underworld'. Figures are rendered in simple linear forms.

The pharaoh also allowed his high officials and viziers to acquire wealth and make large tombs, reflecting their status. The noble Rekhmire, who built his tomb in Qurnah (TT 100), is one example, and Tuthmosis's military lieutenant commander Amenemhab, who also constructed his tomb in Qurnah (TT 85), is another example. Puemre the second prophet of Amen, in addition, built an impressive tomb for himself in Khokha in western Thebes (TT 39).

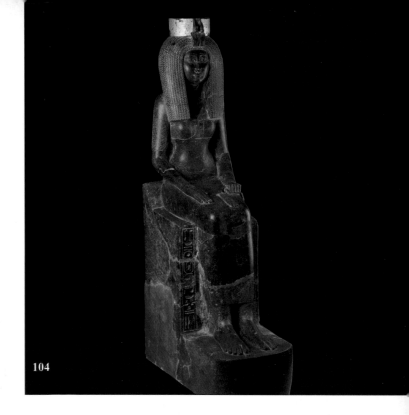
104

104. Queen Isis

Granite; Karnak; H. 98 cm, W. 25 cm, L. 52cm;
18th Dynasty, reign of Tuthmosis III, 1504 - 1452 BC;
Ground floor, room 12; JE 37417 = CG 42072

Found in the Karnak 'cashette', this statue of Queen Isis, the mother of King Tuthmosis III, is sitting in the traditional manner on the throne. She is wearing a wig with fine tresses, surmounted by a diadem covered with gold leaf. Over her forehead are two cobras, one wearing the White Crown and the other the Red Crown. The queen is also wearing a close-fitting dress with two straps, and a *usekh* necklace as well as bracelets on her arms. She holds a lotus flower scepter in one hand, and the other hand is placed on her lap.

The inscription over the jambs of the seat states that the statue was dedicated by her son Tuthmosis III. It reads : *nter nfer, nb tawy, Mnkheperre, mry Imnre, nb nswt tawy, ir.n.f m mnw.f n mwt.f mwt nsw ist* 'The good god, lord of the two lands, Menkheperre Tuthmosis III, beloved of Amen, lord of the throne of the two lands, has made this as his monument for his mother, the king's mother Isis, justified.'

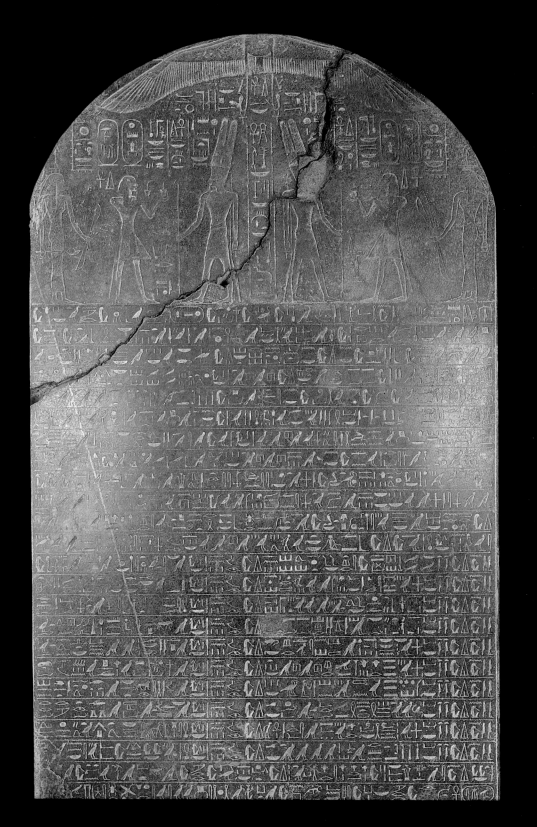

Queen Isis was a minor wife, or lesser queen, of Tuthmosis II, and there is no mention on this statue of the usual titles acquired by royal wives in the New Kingdom. To compensate for this disadvantage, Tuthmosis III related the tale of how a divine oracle had proclaimed him to be the rightful successor of his father Tuthmosis II, inscribing it on the walls at Karnak Temple. The text claims that the god Amen had selected him as pharaoh. During a religious festival, when Tuthmosis III was at Karnak temple, the procession of the divine barque of Amen, accompanied by King Tuthmosis II, was passing. Amen ordered the procession to head for the place where Tuthmosis III stood watching, ordering it to halt in front of him. The priest considered this event as an expression of Amen's wish for the young Tuthmosis III to succeed his father. Subsequently, Tuthmosis III knelt to pray, in order to give thanks to the god Amen, was led by the priests towards the coronation dais and crowned the future king of Egypt. Tuthmosis III recorded this story at Karnak Temple, probably assisted by his father, to legitimise Tuthmosis III as the next rightful ruler, despite his mother Isis being only a minor wife.

105. Victory stela of Tuthmosis III

Granite; Deir al-Bahari;
18th Dynasty, reign of Tuthmosis III, 1504 - 1452 BC;
Ground floor, room 12;

This votive stela of King Tuthmosis III was found in Karnak and is dedicated to the god Amen. It expresses the king's emotions and thanks to that god for his victories, and is written as though the god himself were praising the king, following his successful campaigns. The lunette at the top of the stela shows a winged-solar disc with two cobra heads, which symbolise protection and defence. This royal symbol also appears at the entrances of temples. The scene is divided into two symmetrical parts, each showing Tuthmosis standing in front of the god Amen, who is represented in his human form, wearing the traditional crown of two tall feathers. Behind Amen is one of the Theban goddesses called *Khefet her neb es*. On the right side of the stela, the king is seen offering two libation jars, and on the left side, he presents incense. The scene was defaced during the revolutionary period of King Akhenaten, but later

restored. The inscription includes a poetic piece of writing, attributed to the god Amen. Addressing the king, it tells how Amen himself had enabled his victory over the enemies in Nubia, Mesopotamia, Phoenicia, and Syria as well as over the people of the Mediterranean. This rhyming poem has a rhythmic structure, and some of the phrases start with the words as *ii.n ntr rdi* 'the god came to give'. Other phrases begin with *rdi ntr*, 'the god gives'. These features are characteristic in ancient Egyptian literature, which boasts a large variety of lyric poetry, comprising verse utterances that express the views and feelings of the speaker. Many poems were actually plaintive hymns or prayers addressing the gods or kings; others expressed joy and thanks; yet others requested guidance. In addition, there were poems connected with the priestly rituals performed during various ceremonies.

106. Chapel with the cow goddess

Painted sandstone; Deir al-Bahari; H. 225 cm, L. 404 cm;
18th Dynasty, reign of Tuthmosis III, 1504 - 1452 BC;
Ground floor, room 12; JE 38574-5;

This chapel and statue were found at the sacred place at Deir al-Bahari, which the god Amen was thought to visit when he crossed the Nile from Karnak, on the east bank, to Thebes on the west bank, during the annual Festival of the Valley. The hidden chapel was situated between the Temple of Montuhotep Nebhepetre and that of Hatshepsut in the Mortuary Temple of Tuthmosis III, which was later destroyed.

The statue shows the cow goddess Hathor protecting King Amenhotep II, who is standing under her head. His cartouche is inscribed on her neck. A second representation of the king on the left of the statue shows him drinking from the udder of the Hathor cow.

Amenhotep is seen wearing his *nemes* headdress and *shendyt* kilt; his hands are placed over his kilt as though praying.

The cow has a cobra and a solar disc between its horns. Papyrus stems, decorated by wavy lines representing the water of the Nile, surround the cow's head.

The cow goddess Hathor was one of the most popular goddesses in ancient Egypt. In the Predynastic Period, she was venerated as the embodiment of fertility and nature, and she also had a

role as a sky goddess. Hathor was connected to love and fertility, and a source of assistance during conception and childbirth. Associated, moreover, with papyrus marshes and vegetation, Hathor was sometimes depicted as a tree goddess, called 'Mistress of the Sycamore', who extended her care to the deceased, dispensing food and drink from her branches as well as offering shade. She was an important funerary goddess, known in Thebes as 'Mistress of the Theban Mountains', and one belief surrounding this mythological figure was that she received Re, the sun, each night, protecting him in her body so that he could be safely reborn the next morning. Likewise, Hathor aided in the regeneration of the deceased. Cult centers for the goddess were numerous; Deir al-Bahari was an important cult site of Hathor, and it was there that King Montuhotep Nebhepetre identified himself with the falcon god Horus, and took the title 'Son of Hathor, Lady of Dendara'.

The scenes on the chapel's limestone walls are in an excellent state of preservation, keeping the original colours without any restoration work having been done. On the left side, Tuthmosis III, accompanied by his wife Merit Re, is presenting offerings to Hathor, who is represented as a cow, suckling the king. The king is shown again in another scene in front of the same goddess, this time represented in her human form with two cow horns framing a solar disc. The scene is repeated on the right wall, with two princesses accompanying the king.

On the back wall, the upper part of the scene shows a winged-solar disc, symbol of protection and defence. Underneath, we see the god Amen enthroned, represented in his human form. He wears a crown surmounted by two feathers, and holds the *was* scepter of prosperity in one hand and the *ankh* sign of life in the other hand. King Tuthmosis III is shown presenting incense and pouring libations in front of the god. The graffiti in hieratic is a later addition.

The chapel's vaulted ceiling is painted blue to represent the sky, and adorned with golden stars. The upper section of the side walls is decorated by the *khekeru* frame, representing the tied reeds, which used to form enclosure walls around primitive buildings or was woven over mud brick buildings.

106

106

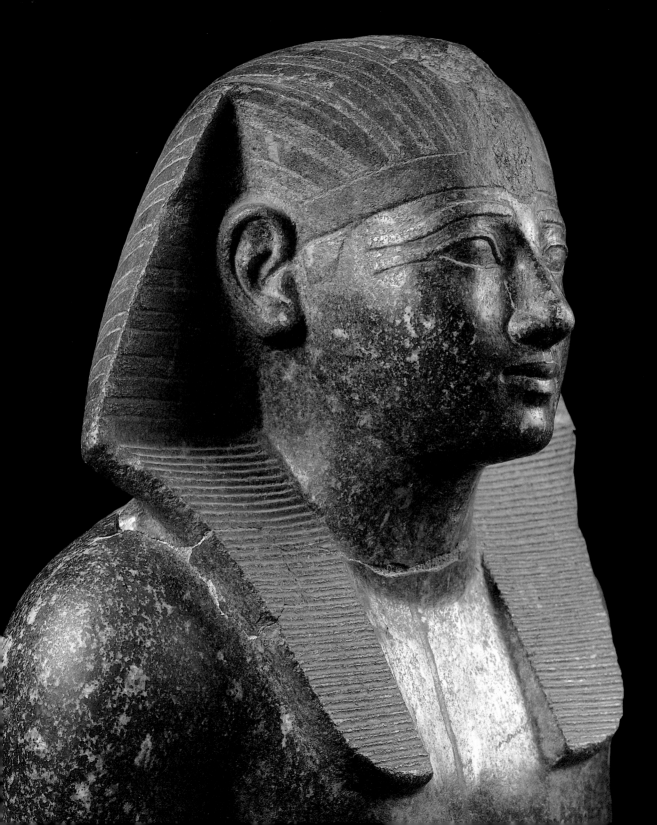

107. Statue of Amenhotep II with an offering table

Granite; Karnak; H. 120 cm;

18th Dynasty, reign of Amenhotep II, 1454 - 1419 BC;

Ground floor, room 12; JE 36647;

Sculpted of black granite, this statue of Amenhotep II was found in Karnak. It shows the king kneeling to present an altar decorated with the *htp* form, which signifies the word 'offerings' in hieroglyphs, in addition to representations of poultry, bread, the haunch of a calf and various jars as well as vegetables and fruits. On the dorsal support, an inscription gives the name and titles of Amenhotep II: *ntr nfr nb tawy nb irt nswbiti Aakheperre mry Imn di Ankh djet*. 'The good god, the lord of the two lands, the lord of action, the king of Upper and Lower Egypt.'

Son of the royal consort Merit re Hatshepsut, Amenhotep was born in Memphis, where he spent his early years. His father Tuthmosis III entrusted his chief archer Amenmose with the boy's upbringing and military training. King Amenhotep II later became known for his physical strength and skills as a charioteer, huntsman and archer. Many stelae relating his victories in Asia and Nubia were found in Memphis, Karnak, Giza and Medamud, boasting the king's abilities and accomplishments. He brought back seven captives from one campaign, to hang them from the gates of Thebes and the walls of the city of Napata in Nubia. His name was also found in the Temple of Hathor at Sarabit el-Khadem in Sinai. In addition, faience apes bearing his cartouche have been found in Mycenae and Greece.

108. Statue of King Amenhotep II

Schist; Karnak; H. 68 cm;

18th Dynasty, reign of Amehotep II, 1454 - 1419 BC;

Ground floor, room 12, JE 36680 = CG 42077;

Sculpted of schist, this statue of Amenhotep II was found in the Karnak 'cachette'. It shows the king standing in the traditional pose, advancing his left leg forward. He is wearing the *khat* headdress with the royal cobra over his head, the pleated *shendyt* kilt and a belt decorated with geometric motifs. He holds what are probably

107

108

177

two seals in his hands. The statue has the elegance and grace characteristic of statues from the time of his father Thutmosis III as well as of Hatshepsut.

King Amenhotep II was married to Queen Tia, the mother of his son and heir King Tuthmosis IV. He was buried in The Valley of the Kings (KV 35), where his mummy was discovered still in its sarcophagus, after being reburied in the Late New Kingdom when the tomb was used as a 'cachette' for the royal mummies.

109. Statue of Amenhotep II with Mryt sgr

Granite; Karnak; H. 125 cm;
18th Dynasty, reign of Amenhotep II, 1454 - 1419 BC;
Ground floor, room 12; JE 39394;

This black granite statue was found in Karnak Temple. Here, the pharaoh is standing, wearing the White Crown of Upper Egypt with the cobra over his forehead, and the starched, pleated kilt, which has a band decorated with geometric motifs and two cobras. His outstretched hands are in the prayer pose.

Amenhotep's names and titles are given in the cartouche inscribed on the statue on the right we see *sa re Imnhtp mry Imn re di ankh,* 'the son of Re, Amenhotep, the beloved of the god Amen, to be given life.'

On the left side are additional names and titles: *ntr nfr Aa kheprw re mry Imn re di ankh,* 'the good god Aa kheprw re the beloved of Amen Re, to be given life.' The king is shown trampling over nine bows representing the traditional enemies of Egypt.

Behind the king we see a large cobra with cow horns framing a solar disc, meant as a sign of protection towards him, and papyrus stems, behind. The cobra represents Mryt sgr, the goddess of the Theban Necropolis, particularly in the Kings Valley area. She was thought to reside in silence in the heights of that necropolis. Her name indicates her nature as 'she who loves the silence'. She was personified as the pyramid-shaped peak that rises above the Valley of the Kings. She was also the subject of a domestic cult in the artisan's village at Deir al-Medina, where snake figurines in the likeness of the goddess, were found during excavations.

This theme of a pharaoh under the protection of a god or goddess occurs frequently in ancient Egyptian art. A different example is the diorite statue of King Chephren of the Old Kingdom, where the falcon god Horus appears much smaller than the divine, god-like king. Here, the situation is reversed, as Amenhotep II is seen much smaller than the goddess Mryt sgr; the scale and positioning are comparable with the statue of the king under the head of Hathor in Deir al-Bahari's chapel.

110. Coffin of Yuya

Cartonage, gold leaf, glass; Valley of the Kings, tomb of Yuya and Tuya, KV 46;
18th Dynasty, reign of Amenhotep III, 1410 - 1372 BC;
Upper floor, gallery 43;

This coffin was found in the tomb of Yuya and Tuya, discovered in the Valley of the Kings by Theodore Davis, Quibell and Weigall, in 1905. The tomb contained the couple's funerary furniture and was an impressive discovery, overshadowed only by the discovery of Tutankhamen's treasures, 17 years later.

Yuya was commander of the charioteers in the Army during the reign of Amenhotep III and father of Queen Tiye. His other son was the priest Anen, who occupied the position of second prophet of the God Amen. He was probably also the father of Ay, the High Priest of Amen, who became king after Tutankhamen's premature death. He and his wife Tuya were both honoured and privileged by being buried in the company of the pharaohs.

The tomb was not found intact, but partly robbed. Robbers had broken through the walls and stolen valuable jewellry and perfumes, but left the mummies undamaged.

Yuya's mummy was found in a coffin inside three others, one placed inside the other, all four enclosed by a sarcophagus. His wife Tuya's coffin was found in two anthropoid coffins, placed in a sarcophagus.

This gilded wooden coffin is the innermost one belonging to Yuya. The inside is lined with silver. Yuya is shown wearing a straight wig, his eye frames and eyebrows are inlaid with blue, glass paste, imitating lapis lazuli. The whites of the eyes are of alabaster, and the pupils formed of black, glass paste. In the corners of the

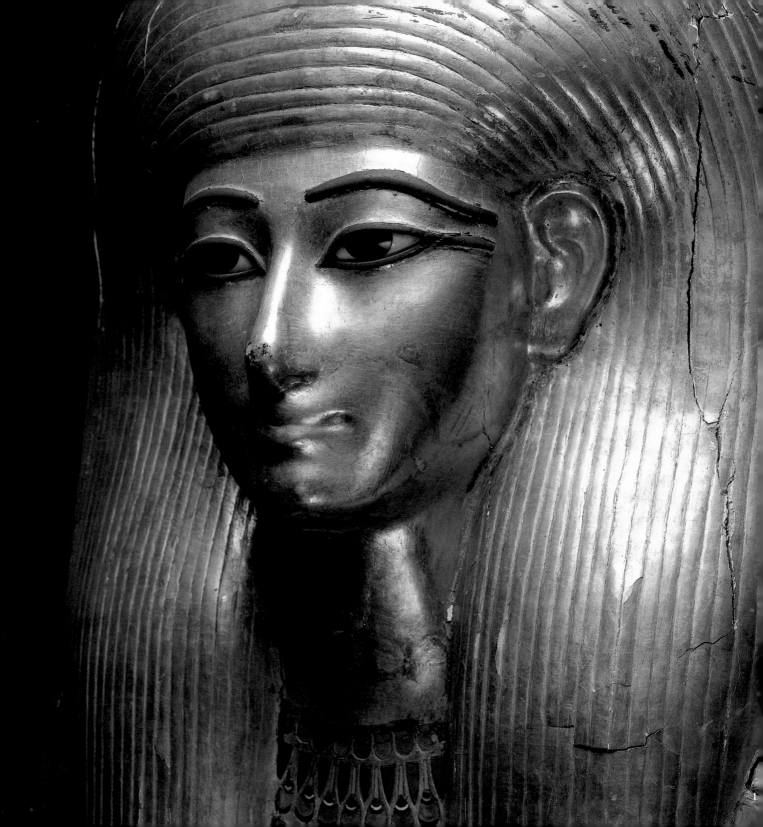

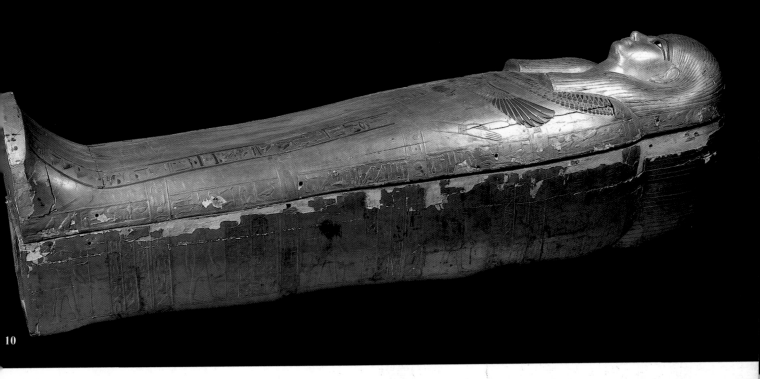

10

eyes is a red dot to add realism. Around the neck is a broad collar that is fastened on the shoulders by two falcon heads.

The vulture goddess Nekhbet is shown spreading her protecting wings, and holds in her claws the *shen* sign of duration and infinity. Like the collar, the vulture is inlaid with glass paste in imitation of turquoise and lapis lazuli, but real carnelian is used.

The sky goddess Nut is represented below the vulture above the sign *nbw* which means gold. In spell no. 44 of the 'Coffin Texts', a priest addresses the deceased thus, 'I have placed you in the arms of your mother Nut', which means that the deceased will be resurrected after being in the coffin, which is like the womb of his mother Nut. The priest's declaration also likens the deceased to Osiris, the god of the hereafter and son of Nut. There is an image of the goddess Isis, one of the traditional mourners of the dead, near the feet. On the lower casket, there are representations of the funerary deities or like the four sons of Horus who bear the deceased to the northern sky and are protectors of his viscera, they are called Dwamwtef, Qebehsnuef, Imsety and Hapy. Also present are Anubis, the god of mummification, and Thot, the god of wisdom and writing.

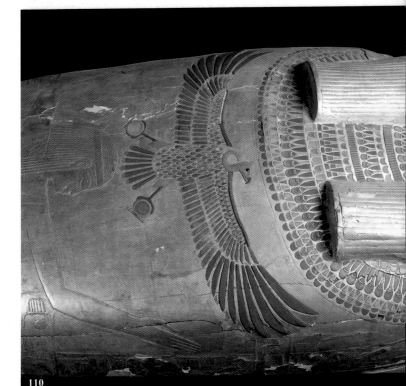

110

181

111. Colossal group statue of King Amenhotep III, Queen Tiye and their daughters

Limestone; Medinet Habu; H. 7 m, W. 4.4 m;
18th Dynasty, reign of Amenhotep III, 1410 - 1372 BC;
Ground floor, gallery 18;

This monolith colossal group came from Medinet Habu Temple in Western Thebes. It shows Amenhotep, his wife Queen Tiye and three of their daughters. The king is represented with the traditional *nemes* headdress, cobra over the forehead and false beard. The queen is wearing a close-fitting dress, a heavy wig surmounted by a diadem, and a cobra over the forehead. Her arm is affectionately placed around the king's waist. Her statue is the same size as the king's, demonstrating her equal status as a powerful and influential queen. The couple's high cheekbones, almond-shaped eyes and curved eyebrows are typical of the period. The three daughters, standing beside the legs of their parents are very small in scale. Two of their names remain, revealing that they are princesses Henuttaneb and Nebetah.

Some two hundred and fifty statues of King Amenhotep III have been found, along with a series of memorial scarabs, on which are recorded several events from his life, such as the arrangements of his marriage to Queen Tiye and his highly successful lion hunt.

Amenhotep overcame the problem concerning his legitimacy to the throne, his mother Mwtemwia being only a minor wife, probably from Mittani. The pharaoh, like others before him, therefore had to legitimize his position by relating the story that he was 'the divine son of the god Amen Re begotten of him and born under the protection of the gods.' He depicted the scenes for this story in a room beside the sanctuary in Luxor Temple. The god Khnum is shown moulding the body and *ka* of Amenhotep on the potter's wheel. The goddess Isis embraces his mother in front of god Amen, who is led by Thot, the god of wisdom, to the queen's bedchamber where he approaches her to beget the child, already moulded by Khnom. The pregnancy is attended by Bes and Taweret the divine gods of childbirth. After the delivery, Amen holds the child in the presence of the goddess Hathor.

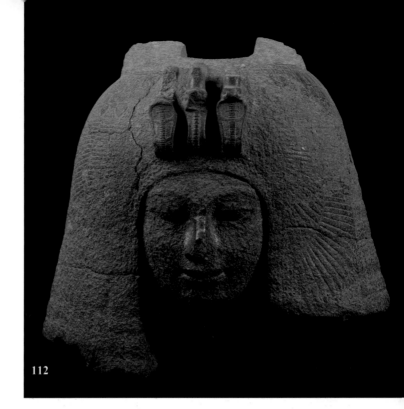

112

Amenhotep III also married two of his daughters, one of them was called Setamun. When his heir and first-born child Tuthmosis met a premature death, his younger son Amenhotep, who later re-named himself Akhenaten, became Crown Prince.

Queen Tiye was the queen consort of Amenhotep III. The daughter of Yuya, she came from Akhmim in Middle Egypt. Tiye was a very important and influential queen during the reigns of both her husband and son. Her position and status are attested by several monuments and statues, showing the queen in the company of Amenhotep III during the cult and the *sed* festival. Her role towards the king was compared to the goddess of justice, Maat as she followed the sun-god Re.

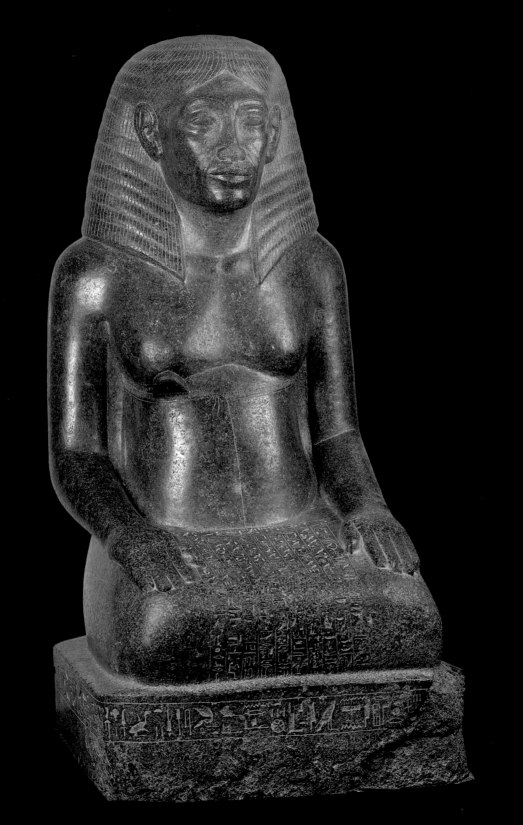

112. Head of Queen Tiye

Black granite; Reign of Amenhotep III, 1410 - 1372 BC;
Ground floor, gallery 8;

This granite head of Queen Tiye shows the queen wearing a huge wig, surrounded by the wings of the protective vulture. Over the forehead are two cobra heads and one of a vulture. The cobra on the right wears the *deshret* crown of Lower Egypt, and the cobra on the left probably wore the *hedjet* crown of Upper Egypt, now lost.

Her facial features reflect her strong character; Queen Tiye was an influential woman; the Amarna letters confirm that the queen played a political role. The king of Mittani, Tushrata sent her a letter, also sending two to Akhenaten, advising him to consult his mother concerning the country's problems. Although Akhenaten intended to bury his mother in his new capital, she was eventually buried beside her husband in the Valley of the Kings. A lock of Queen Tiye's hair was found in the treasures of Tutankhamun, demonstrating his love for his grandmother.

113. Amenhotep son of Hapu

Granite; Karnak; H. 117 cm, W. 70 cm, L. 78 cm;
18th Dynasty, reign of Amenhotep III, 1410 - 1372 BC;
Ground floor, room 12; JE 36368 = CG 42127;

Found near the Seventh Pylon in Karnak, this statue belongs to Amenhotep Son of Hapu, a famous courtier who lived during the reign of King Amenhotep III. He is sitting placing his hands upon his knees in a pose of a serene prayer, shown as an elderly man; his age is expressed by the facial features, such as the wrinkles around the eyes. The inscription over the statue mentions that he had reached the age of eighty and he hoped to attain the wise old age of one hundred and ten.

This highly esteemed nobleman held several offices including 'Royal Scribe under the King's Immediate Supervision. Other titles were 'Royal Scribe at the Head of the Recruits', suggesting his expertise in organisation and calculation; and 'Chief of all King's works' due to his talent for supervising large-scale works, such as building projects and colossal statues. Proud of his knowledge, the scribe claimed to know the secrets of Thot, the god of wisdom and writing; and people consulted him in times of need. His mother was honoured, deified and associated with Seshat, the goddess of writing and calculation.

Amenhotep Son of Hapu was very close to the king, also acting as steward to his daughter Setamun. King Amenhotep heaped further honours on the scribe by allowing him to place statues of himself at Karnak. In addition, he built an impressive tomb in the necropolis as well as a funerary temple among the royal temples on the west bank of the Nile at Thebes, again indicating his high favour with the king. During the Ptolemaic Period, Amenhotep Son of Hapu, was deified as a healing god, and associated with the wise physician Imhotep, who was King Djoser's architect. The successful scribe was sometimes identified with the Greek Askelepios at this time, and a shrine was built to him at Deir al-Bahari. Another granite statue of Amenhotep Son of Hapu in a young age, was found at Karnak beside the Tenth Pylon.

114. Goddess Sekhmet

Granite; H. 213 cm; 18th Dynasty; Ground floor, gallery 6;
CG 39070;

This black granite statue of the lioness goddess Sekhmet is one of dozens of such over life-sized statues produced in the New Kingdom. Some six hundred statues like this are thought to have been placed by Amenhotep III in the Mut Temple at Karnak, probably in an attempt to improve the King's ill health. Sekhmet was one of the healing goddesses who wielded special power, being well versed in magic.

Represented as a lion-headed woman, Sekhmet has a solar disc over her head and a cobra over her forehead. She is sitting on a throne, holding the *ankh* sign of life in her left hand, with her right hand open on her lap. She is wearing a close-fitting dress with two straps, decorated with two rosettes. A large *usekh* collar graces the goddess' neck, and she is wearing bracelets and anklets. On the side of the throne, the *sematawy* scene is shown, with lotus and papyrus plants tied together; suggesting the country's unification under the throne of Sekhmet. One of her titles was *Sekhmet aat nbt tawy,* 'the great Sekhmet, lady of the two lands'.

The name Sekhmet means 'the mighty one' and was derived from the word *sekhem*, which means power. Her many other titles include: *wrt hekaw*, 'the great of magic', *nbt srdjwt*, 'the lady of terror', *nbt irt,*' the lady of action'.

Sekhmet was one of the manifestations of the fiery eye of Re. A member of the Memphite triad, she was wife of Ptah and mother of Nefertum. Lions were viewed as magical guardian figures, and many other goddesses were often represented as lionesses, such as the goddesses Pakhet, Tefnut, Hathor, Bastet and Mut. The two lion gods called Akr were identified with the eastern and western horizons, between them supporting the rise of the sun. They represented 'yesterday and tomorrow', thereby symbolising eternity.

Ancient Egyptian divinities were represented in four different forms: animal figures, human figures, humans with animal heads or animals with human heads. Some of the statues of divinities were cult statues, others were votive statues given to temples by kings, courtiers and priests, in the hope of benefaction from the god. One of their roles was as temple guardian figures made for specific locations within the temple. Other statues of divinities were made in the smallest of sizes to be used as amulets or personal charms. In addition, some of these statues were incorporated into pillars and columns to form an architectural element of a temple.

115. A nurse and four princes and princesses

Painted limestone; H. 94 cm; 18th Dynasty; Ground floor, gallery 11; JE 98831;

This group statue was found in Kafr el-Nahhal near Zagazig in the eastern Delta. It shows a seated woman, holding four children; three standing and the fourth sitting on a cushion on her lap.

She is wearing a straight long wig, its tresses reaching down her back; and her eyes are inlaid with a black paste imitating obsidian. The standing prince and two princesses are naked and have only a lock of hair on their heads, which shows that they are younger than the prince who is sitting on her lap. He is wearing a kilt and holding a royal handkerchief. All four are wearing the heart amulet as well as bracelets inlaid with cornelian. These heart amulets are inscribed with lines from chapter 30 of 'The Book of the Dead', which is a prayer to the heart not to act against the person on the day of judgment.

The sides of the throne are decorated with a baboon; on the right side he is holding a cosmetic pot of the *kohl* eye liner, while on the left he is holding a special mirror, called *ankhet*, which was associated with the ritual of rebirth and with sun symbolism.

The posture of a nurse and child, or children, was a popular one in private sculpture, although it also appeared in royal statuary. One of the best-known examples is of Senmut and Princess Nefrure. The alabaster statue of king Pepi I sitting on the lap of Queen Ankhnesmrere, now in Brooklyn Museum, is the oldest such example in royal statuary. Another is found in the statuary of Akhenaten, where he is seen kissing the daughter on his lap. In sacred sculpture, the most famous pieces are representations of the goddess Isis and the god Herpaghered.

Nurses in ancient Egypt were called *mnat*, and they breast-fed the children for the first three years. The nurse lived in the child's home, later becoming his teacher, and she was held in very high esteem. Royal families had nurses from noble families, whose children grew up with the princes and princesses. Male instructors were also called *mnat*.

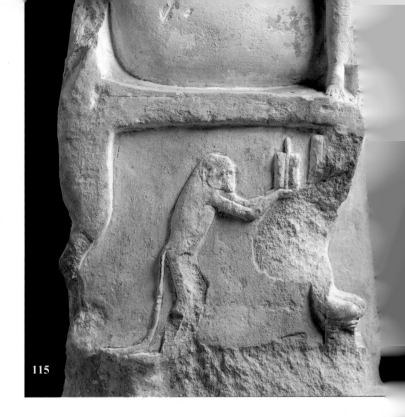

115

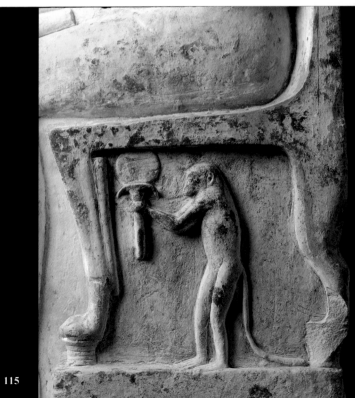

115

116. Colossal statue of Akhenaten

Sandstone; Temple of Aten, Karnak; H. 293 cm;
18th Dynasty, reign of Akhenaten, 1372-1355 BC;
Ground floor, room 3; JE 49529;

This colossal statue of King Akhenaten was found in Karnak in the temple Akhenaten built for the god Aten. It was situated outside the enclosure wall to the east of the Great Temple of Amen, when Thebes was witnessing the gradual appearance of the new religious reform. The name of the temple, *Gempaaten,* means 'Aten is found'. Some 28 pillars stood in the court of the temple, supporting colossal statues of the king, five metres high. Four of them are in the Egyptian Museum in Cairo, two are in the Luxor Museum, one is in the Louvre, one in Munich and the rest are in storerooms at Karnak and the Cairo Egyptian Museum.

Akhenaten is represented wearing the *khat* headdress, a symbol of rejuvenation, which represents the nocturnal side of the solar cycle. Surmounting the headdress is the *sekhmety* double crown of Upper and Lower Egypt. His peculiar face has slanting eyes, a long nose, thick lips, sunken cheeks and a drooping chin with a false beard attached. The arms are crossed over the chest, and the king is holding the heka emblem of power and the *nekhekh* symbol of authority. He is represented with a thin neck, narrow shoulders, a fleshy chest, and pendulous abdomen, with large thighs and full buttocks. He wears a short pleated kilt; and the cartouches bearing his names are inscribed on the belt. Other cartouches, giving the names of the god Aten, who is presented as the chief of the gods, are seen on the arms, under the neck and on the stomach. The strangeness of the face and shape of the body has made Egyptologists question Akhenaten's physical health and wonder if he had a pathological deformity. On the other hand, the king may have wished to represent himself in a unique shape, unlike an ordinary human, in order to stress the uniqueness of his religion. These greatly exaggerated features, characterising the early representations of the king, become more moderate in later years.

Statues of other kings that were attached to pillars in temples, usually took the Osiride form with the arms crossed over the chest, and the body covered with mummy bandages. Here, the king has taken on a different form, appropriate to his new religious philosophy and religious reforms, thereby creating a revolution in art. In ancient Egypt, art served the religion and the state. In some of the colossi of Akhenaten, he is represented naked and asexual, to emphasise a uniqueness in combining the two powers of nature present in the male and female sexes.

117. Bust of Akhenaten

Sandstone; temple of Aten, Karnak; H. 185 cm;
18th Dynasty, reign of Akhenaten, 1372 -1355 BC;
Ground floor, room 3; JE 49528;

Found at Karnak, this bust was part of one of the 28 statues of the king in his temple *Gempaaten*. He is wearing the nemes headdress, with stylised ornamentation at the ends, and surmounted by the two feathers of Shu, the god of air, with a cobra over the forehead. The face is represented in the characteristic exaggerated manner, having a long chin, v-shaped lips and long ears with pierced lobes. The feathers of the god Shu are present to show the religious connection with his father Amenhotep III, who was deified during his life in the form of the creator god Atum. Accordingly, Akhenaten, when he was living in Thebes, was deified as the son of Atum, who was the god of air, Shu. At the same time, Akhenaten's wife Nefertiti was deified as Tefnut, the goddess of humidity and wife of Shu.

Akhenaten's religious reforms also had a political side, and aimed to counter the power of the wealthy and influential priesthood of Amen and to promote of other cults. The promotion of other cults had existed only on a small scale during the reign of his father but King Akhenaten's reforms were far more dramatic. Following the Amarna period, the adoption of other cults continued up to the reign of king Ramsses II who adopted the cults of Ptah and of Rehorakhty, again to limit the influence of the powerful priests of Amen Re.

Akhenaten first called Aten, 'the father', and later, 'the king of the gods', placing these names in the royal cartouches, and displaying the Aten disc together with a royal cobra. Another name was 'the god Aten represented as Rehorakhty who rejoices to the horizon in his name that is Shu, the light residing in the solar disc.'

Aten was not new to the Egyptian pantheon but had always existed as a minor god. In the Middle Kingdom Period, his name ap-

peared in 'The Story of Sinuhe'. Aten was represented as a hawk-headed deity with a human body. The new cult of Aten was actually established during the reign of Tuthmosis IV, but on a very small scale. The cult was promoted further by King Amenhotep III, who was entitled 'the dazzling sun disc', signifying Aten. In addition, he applied the name Aten to some of the contents of his palace, and named the boat of his consort queen Tiye, *Aten tehen*, 'the shining Aten', combining the old and new cults.

In his first regnal year, King Akhenaten followed the cults of Amen-re and Rehorakhty, and he bore the names Amenhotep Neferkheperure 'Amen is satisfied, perfect are the forms of Re', and Waenra, 'the sole one of Re'.

In his second year as king, Akhenaten celebrated the *sed* festival and ordered the construction of the Temple of Aten to the east of Karnak, which was built of small-sized sandstone blocks that could easily be handled and transported from the Gebel el-Selsela quarry, to the north of Aswan. The blocks of his temple were therefore simple for King Horemheb to later dismantle. He ruled after the pharaoh Ay, and reused the blocks to fill in the core of his Ninth Pylon at Karnak, where 20,000 were found. Another 40,000 blocks, were found beneath the Hypostyle Hall and the Second Pylon at Karnak. Those blocks are now being reconstructed, giving valuable clues to that historical period.

The king started to build his new capital Akhet Aten in his fourth regnal year, at the place now called Tell el-Amarna, covering ten miles on the east bank of the Nile; and the royal family moved there in his sixth regnal year. Akhenaten constructed 15 boundary stela between his fifth and eighth regnal years, the inscriptions stating that Aten had chosen this virgin area, which was untouched by previous cults.

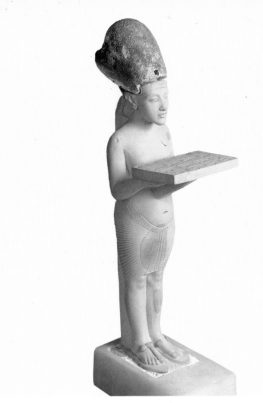

118

118. Akhenaten Making an Offering

Painted limestone; Tell el-Amarna; H. 35 cm;
18th Dynasty, reign of Akhenaten, 1372 - 1355 BC;
Ground floor, room 3; JE 43580;

Brought from Akhet Aten, now called Tell el-Amarna, in 1911, this statue had stood under the rays of the sun in a garden at one of the houses where private worship was performed. King Akhenaten is represented wearing the *khepresh* blue crown, the main crown

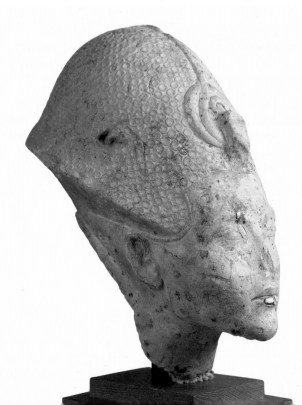

119

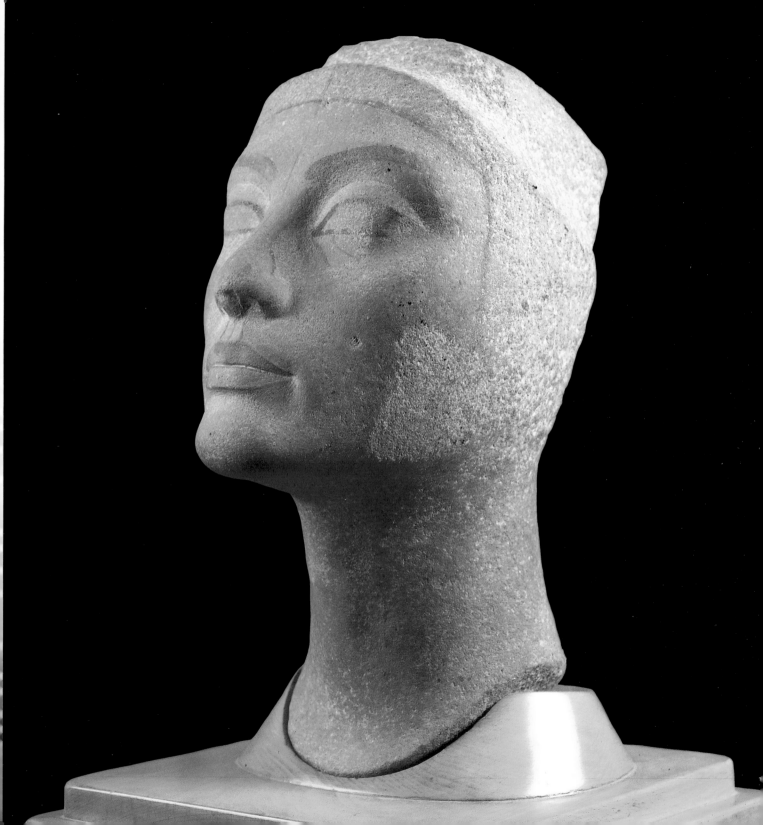

121. Unfinished head of Nefertiti

Brown quartzite; Tell el-Amarn; H. 35.5 cm;
18th Dynasty, reign of Akhenaten, 1372-1355 BC;
Ground floor, room 3; JE 59286;

This head of Nefertiti was discovered in the workshop of the chief sculptor Tuthmosis, at Tell el-Amarna. It is part of a composite statue that was made in separate parts, and fixed by means of tenons. Being unfinished, this piece is of special interest as it shows the techniques involved in making such statues. After sculpting the desired size and shape of the head, the artist drew a line over the centre to keep the symmetry of the face. The features were first marked in black, then corrected in red. After that, the artist outlined the exact shape of the eyes, which would be cut out and inlaid with white quartzite and obsidian. The eyes and eyebrows were cut out and inlaid with lapis lazuli. Composite statues were common in the Amarna Period statuary, and this one was meant to have a high blue crown over the head.

The queen is represented with a proud look that reveals her gracious and powerful character. The facial features of that head are identical to those of the famous head with the high blue crown kept at the Egyptian Museum in Berlin, since its discovery by the German Egyptologist Ludwig Brochardt in Tuthmosis's studio. This artist, who was probably patronised directly by the king, was well known for his numerous statues and plaster masks of the royal family. His workshop was located in the south suburb of Tell el-Amarna. Due to the need for highly skilled craftsmen, to build and decorate that new city, these craftsmen enjoyed a high status in Amarna society.

Queen Nefertiti, as the 'Great Wife' of King Akhenaten, is represented alongside her husband in the scenes where he performs his official and religious duties. In one scene, now in the Boston Museum, she is shown wearing her high, blue crown, standing on a boat and smiting an enemy. A posture normally reserved for the pharaohs, it appears to indicate her status and influence.

Her name Nefretiti means 'the coming beautiful', and another of her names, 'Nefer nfrw Aten' means 'perfect is the beauty of Aten'. She bore a series of titles and epithets that showed her high status with the king like *hemet nswt wrt mryt.f nebet tawy ankht*, 'the great royal wife, his beloved one, the lady of the two lands, the living one'. Despite wearing crowns and being represented with the royal cobra over her forehead, Queen Nefertiti was never mentioned in the Amarna letters, unlike Tiye, Akhenaten's mother.

The time of Nefertiti's death and the place of her tomb are a mystery. When Akhenaten issued a decree concerning the foundation of the capital, he expressed his intention to have Nefertiti buried there, but did not mention whether it would be in a separate tomb or in his own tomb. No funerary equipment bearing her name has ever been found, except for one *shawabti* figure.

The queen's cartouches, particularly the ones associated with Aten, were obliterated by the priests in the post-Amarna Period, trying to erase what they regarded as records of schism in the religion.

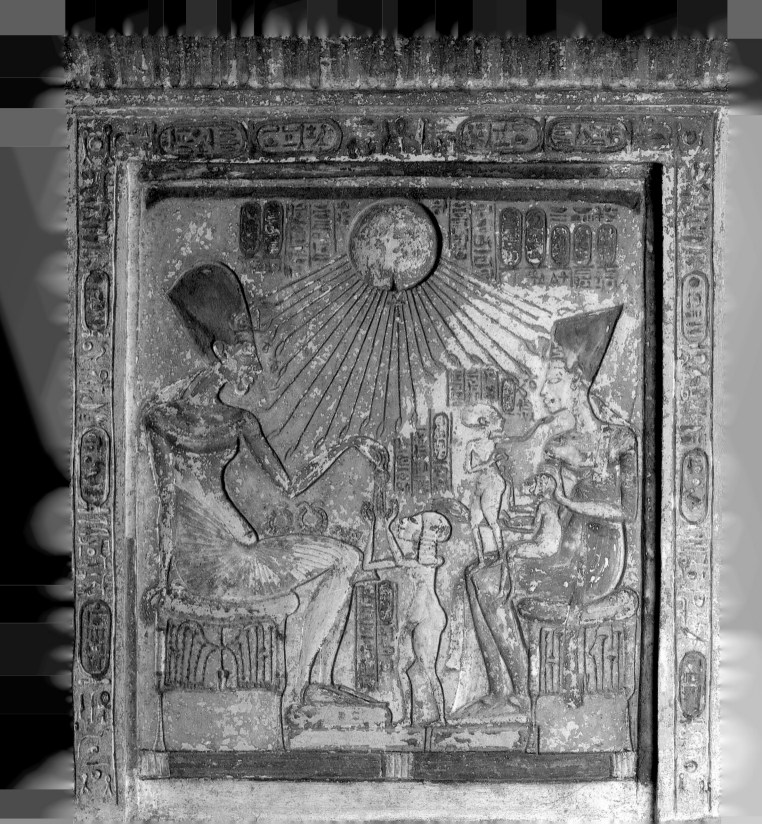

122. Stela of the royal family

Painted limestone; Tell el-Amarna; H. 44 cm, W. 39 cm;
18th Dynasty, reign of Akhenaten, 1372 - 1355 BC;
Ground floor, room 3; JE 44865;

Found in one of the houses at Tell el-Amarna, this stela was set as a private shrine for the family inhabiting the house. It was protected by wooden shutters, whose hinges were fitted into pivots that are still visible at the corners of the stela. At times of worship the shutters were opened.

The scene is shown as a whole unit, thereby breaking the traditional rule of ancient art, in which the scene was divided in registers. The god Aten is the dominant figure, shown in a relief cut more deeply than the other figures, in order to emphasise his importance. As in all the Amarna scenes, Aten is shown as a solar disc, depicted with a royal cobra, which distinguished him as 'the king of gods'. The rays end with human hands, transmitting Aten's force to the royal family, as well as the ankh sign of life and the was sign of prosperity.

King Akhenaten is seated on his cushioned seat, which is decorated with lotus and papyrus designs, symbolising the unification of the country He is wearing the *khepresh* blue crown, a large collar necklace and a pleated kilt. His face and body have those peculiar characteristics of Amarna art: the long face and chin, thin neck, fat stomach and heavy buttocks. He has two necklaces over his lap and is presenting another piece of jewellery to his daughter Ankhesenpaaten. She is naked, and has the lock of hair, which is the symbol of childhood, on the side of her head. Queen Nefertiti is represented wearing her special high blue crown, sitting on a cushioned chair, which has the same decoration as Akhenaten's, described above. The queen is patting the head of Princess Meketaten, who is sitting on her lap. The third princess Meritaten, who is represented with an elongated head, is standing on her mother's lap, while her mother is touching her chin.

The upper part of the stela is decorated with a cavetto cornice, and a torus roll frames the stela. It is decorated with cartouches containing the names of Akhenaten, Nefertiti, the god Aten, and the three daughters, Ankhesenpaaten, Meketaten and Meritaten.

The people prayed in front of stelae such as this, which were placed in small shrines in homes, and may be compared to the later Christian icons, which resemble them in principal and use. The representation of the domestic life of royalty was an innovation that became another characteristic of Amarna art. Formerly, the human side of the pharaoh was not represented. The scenes of Akhenaten in Amarna art show him as a man with a happy family life, in contrast to the formal postures of former times. This realism aimed to express the royal family's emotions and affections, as Akhenaten always said that he lived in reality.

123. Panel with adoration Scene of Aten

Painted limestone; Tell el-Amarna; H. 53 cm, W. 48 cm;
18th Dynasty, reign of Akhenaten, 1372 - 1355 BC;
Ground floor, room 3, TR 10.11.26.4;

Found in the ruins of the royal tomb at Tell el-Amarna, this panel is probably a model made by Bak, the chief royal artist in the earlier years of Amarna to be used as a guiding piece in the tomb decoration. The red grid lines on the surface of the panel bear out this theory. It depicts a worship scene, where two offering altars with bouquets of lotus flowers, together with various other items, are being presented to the god Aten. According to the new religion, people could only have contact with Aten and worship him through Akhenaten himself. The rays of the sun gave the king and the queen, and only them, the life and prosperity of *ankh* and *was*. Akhenaten was the sole intermediary between the people and Aten. His family was included in this privilege. The religious ceremonies involved the presentation of offerings, royal chariot processions and the king's appearing in the Window of Appearance of his palace. It seems that these ceremonies, performed in the sun, were lengthy. One of the Amarna letters, in which the Assyrian king wonders how Akhenaten had obliged the Assyrian ambassador to stand for long hours in the open temple, in the heat of the sun, attests that the ceremonies used to last for a long time.

The panel shows the god Aten dominating the scene, and he is accorded greater importance than the other figures by being carved in a deeper sunken reliefs. Aten is represented as a solar disc, the long rays radiating from it ending with human hands that give the *ankh* sign of life and *was* sign of prosperity in front of the king and

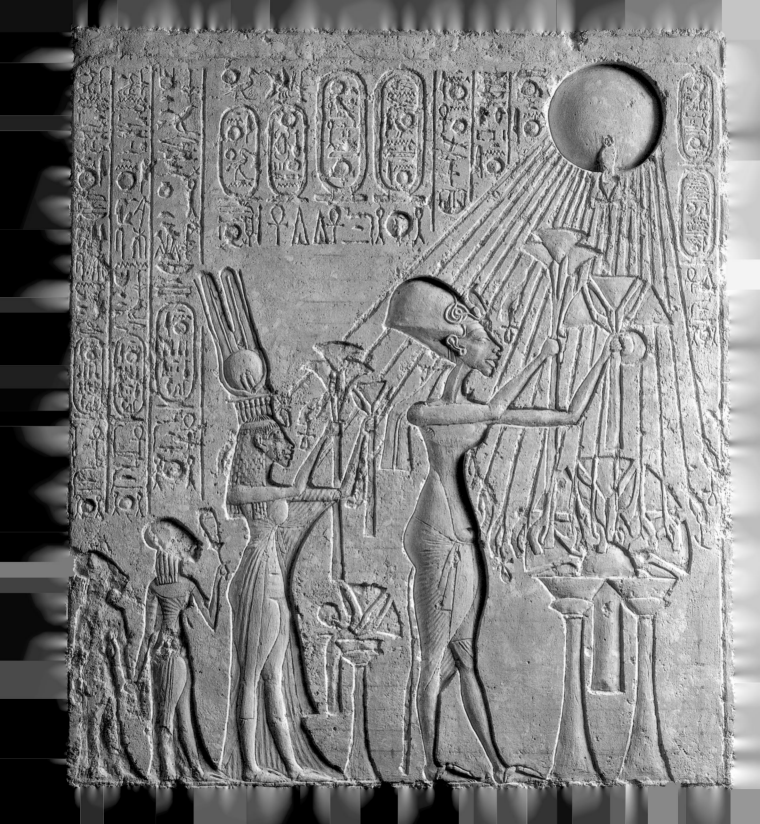

queen. The rays also pass over the offering table, almost covering the items placed on it.

The king is wearing his *kheperesh* blue crown, and a short pleated kilt, to which an ox tail is attached, a remnant of traditional art. The exaggerated bodily features strongly suggest that this panel was made in the earlier years of his reign. Nefertiti is shown with an elongated face like her husband, and a long wig surmounted by a diadem, and topped with two cow horns and a sun disc, in addition to the two feathers signifying the god Shu. This headgear is another indication that the panel dates from early in the reign. She is wearing a transparent dress that reveals the curves of her body. The two daughters Meritaten and Meketaten are represented behind their mother; Meritaten holds a sistrum in one hand, and is holding the hand of her sister with the other.

The royal tomb lay in the valley east of the central part of the city. The burial chamber contains a rare scene of mourners around a corpse on a bed. Another mourning scene also appears in a side chamber of the tomb for one of Akhenaten's daughters, who died during his lifetime. Remains of the royal sarcophagus and a canopic chest were found. At the time when the city was founded, the king announced his plan to use this site as the royal family's future burial place. At the first anniversary of the new city, the king reiterated his intention, but there is no evidence to suggest that Akhenaten or any of his family members were ever buried in that tomb; and the canopic jars were unused.

124. Façade of a shrine

Painted limestone; Tell el-Amarna; H. 98 cm, W. 118 cm;
18th Dynasty, reign of Akhenaten, 1372 - 1355 BC,
Ground floor, room 3, JE 65041;

This shrine-like altar came from the house of Panehsy, the chief of police, whose house is the best preserved of all the nobles' houses in Tell el-Amarna. These houses were relatively large, with several halls and rooms, some within an enclosure as large as 900 square metres, and comprising up to 400 rooms, with gardens, pools and toilets. They were built of gesso-covered mud brick, and probably decorated with scenes from nature, originally.

124

Designed to resemble the pylon or façade of a traditional temple, the altar featured two wings linked by a terrace, which was called the 'Balcony of Appearance'. The presence of this altar in the house of Panehsy reinforces the idea that the god Aten was worshipped in private homes, through the representations of the royal family seen praying to that god.

The upper part of the altar is decorated with a cavetto cornice and inscribed with cartouches carrying the names of the god Aten, 'the king of gods'. The inscription here reads: 'May Re live, which appears in the horizon of the Aten, as a visible manifestation that lives like Aten.' The external frame is decorated with a torus roll.

On the left wing is a hieroglyphic inscription of the prayer for eternal life, written twice: *di ankh djet neheh* 'to be given life forever and ever'. Akhenaten is represented with a *kheperesh* blue crown, large collar necklace, transparent pleated kilt and characteristic facial features and bodily details. He is libating an offering altar, before the rays that radiate from the Aten disc, which end in life-giving human hands. The queen, wearing her high blue crown, accompanies her husband. She is seen presenting a libation jar and is followed by one of her daughters.

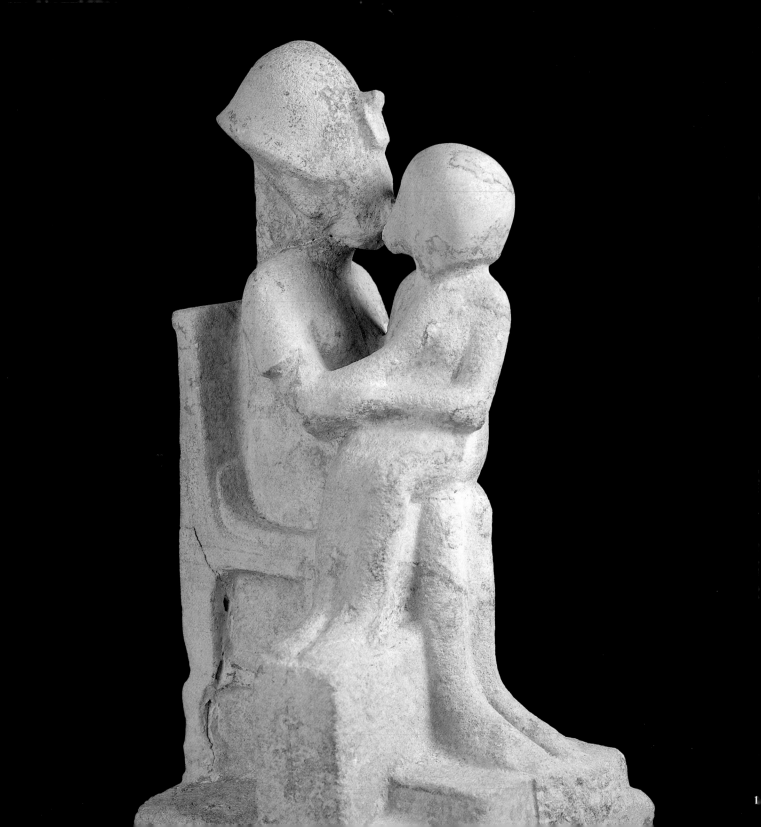

The right wing of the shrine, partly destroyed, shows the same scene: the king stands in front of an offering altar, presenting offerings to Aten, while his wife holds the *kherep* scepter, the symbol of leadership. The figure of the daughter is well preserved. She has a lock of hair on one side of her head, and is holding a sistrum. Works of art such as this enabled the king to enhance the position and status of the royal family, by presenting them as a holy family at the same time as promoting the new god.

Several temples were built for the god Aten: the largest one, which lay in the northern part of the city, measured 800 X 300 meters. It was called *GempaAten*, meaning 'Aten was found'. The name is the same as the one for the temple Akhenaten built for Aten in the east of Karnak, when living in Thebes at the beginning of his reign. This Amarna temple consisted of a series of courtyards leading to an open sanctuary with a huge offering altar; the idea resembling the solar temples of the Fifth Dynasty in Abu-Sir and Abu Ghourab. It was built of a mud-brick enclosure wall, the pylon and columns, of stone. Some 750 stone and brick altars were found in and around the temple at Tell el-Amarna, together with sealed storage jars and bowls with burned incense. Large bakeries, situated to the south of the temple, provided the bread needed for offerings. In addition, 920 altars were found, also in the south of the temple, for the offerings given by the populace, who for the first time in Egyptian history, were able to watch the religious ceremonies as they were performed in the open-air sanctuary.

125. Akhenaten with a female figure on his lap

Limestone; Tell el-Amarna; H. 39.5 cm;
18th Dynasty, reign of Akhenaten, 1372 - 1355 BC;
Ground floor, room 3; JE 44866;

This statue was found in one of the artist's studios at Tell el-Amarna in 1912. It is an unfinished statue without inscriptions, and shows the king, seated on a throne, decorated with lion's legs and paws, wearing the *kheperesh* crown, with the cobra over his forehead, and wearing a short-sleeved indoor gown. The king is kissing the female figure sitting on his lap. As no inscriptions are given here, the identity of the female is uncertain. She could be Akhenaten's wife called Kiya, or his daughter Meritaten or alterna-

tively another one of his six daughters. She is wearing a wig and touching the elbow of the king with her left hand while his hand is placed on her shoulder.

This statue shows the innovative theme of Amarna art, in revealing the domestic life of the king with members of his family. For the first time, the private life of the king was displayed in Amarna art, revealing the intimacy and emotions of the royal couple and their children. Other examples include the scene of Nefertiti sitting on Akhenaten's lap, with their two daughters beside them represented on a stela in the Louvre. Another scene on a stela at the Berlin Museum shows Nefertiti putting a collar necklace around Akhenaten's neck, while the couple exchange affectionate looks. Later, scenes of the kings Ramsses II and Ramsses III with their wives appear as rare cases of royal intimacy.

126. Head of a princess

Quartzite; Tell el-Amarna; H. 21 cm;
18th Dynasty, reign of Akhenaten, 1372 - 1355 BC;
Ground floor, room 3; JE 44869;

Sculpted of brown quartzite, this head was found in 1912, in the workshop of the chief sculptor and overseer of Akhenaten's work, named Tuthmosis. The workshop was adjoined by living quarters and a studio where the sculptor and his staff lived. Two dozen other statues were also discovered in the same place: mainly heads, busts and some complete statues, in a walled-off type of cupboard. This abandoned statutory had been used as models for sculptors. In addition, a large number of other trial pieces were discovered in the ruins of temples and houses. Some lightweight and portable models were taken to the worksites, to serve as guides for royal faces.

This head was part of a composite statue; a tenon under the neck shows that it had been attached to a body. It belongs to one of the six royal daughters, probably Meritaten who was held in high favour by her father. The unusual elongated head and facial features are characteristic of Amarna art. At the same time, the long face, protruding lips, long chin and long pierced ears, together with the long, slim neck, display the elegant sensuality and beauty typical of the later years.

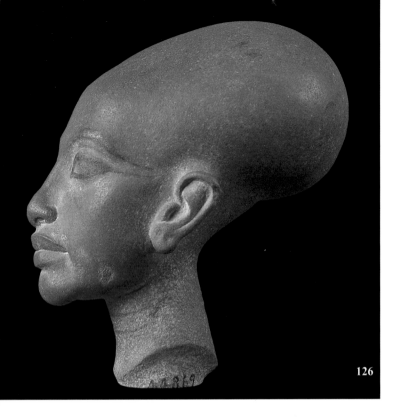

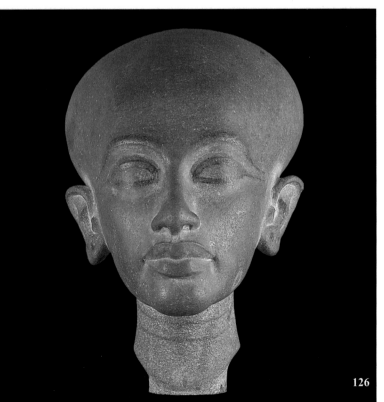

The artist had painted the eyes and eyebrows, which would probably have later been inlaid with lapis lazuli; white quartzite and obsidian for the eyes themselves.

Another sign that this head was probably made during the later period of Amarna art, is that the features are less exaggerated. At first, Egyptologists believed that the odd appearance of Akhenaten was a realistic depiction of pathological deformity. Later, the idea was rejected in favour of the more convincing one that the bodily and facial distortions express a philosophical concept, emphasizing the divine and unique nature of the royal family.

The sculpture in Tuthmosis workshop differs from the sculptor Bak's; as Tuthmosis was the guiding force in the artistic moderation of the later years, according to the instructions of Akhenaten, who wished to abandon earlier eccentricities and for the images to be softened.

126

127 & 128. Fragment of a painted floor

Painted plaster; Tell el-Amarna; H. 101 cm, W. 160 cm;
18th Dynasty, reign of Akhenaten, 1372 - 1355 BC; Ground floor, room 3, JE 33030/1

This painted fragment came from a floor pavement in the southern palace, which was called 'Maru Aten', at Tell el-Amarna. This pavement shows aquatic plants, papyrus, reeds and other floating flowering plants. In addition, wild ducks hover over the scene, the details of which are all represented with great accuracy and talent, and the colours are well preserved. The overall impression is lively and realistic.

The palace enclosures housed altars and shrines as well as pools and gardens. It was one of several palaces that stood in Tell el-Amarna; the most notable among them being, 'The King's House', which was used for formal events and was the place where Akhenaten received his officials. It featured the famous 'Balcony of Appearance', from where Akhenaten and Nefertiti used to greet their subjects, throwing them little gifts of amulets as well as necklaces, armbands, bracelets, rings, vases and goblets. Another palace nearby, which was linked by a bridge to the king's house was called 'The Great Palace'. A third was the northern palace called 'Hat Aten', which, like 'Maru Aten', was decorated with scenes

126

from nature, and was Nefertiti's residence towards the end of the reign.

Nature scenes, such as those on the pavement, were symbolic of the creative power of Aten and for his presence. Contrasting with the old religion, no mythology, sacred animals or human forms were associated with Aten. There were only the hands, which emerged from the life-giving rays, to bring prosperity. Light and nature were the main essences attributed to him. The god Aten encompassed life in all its forms, as the one who gave life to all creatures. The Hymn to Aten was preserved in the tomb intended for Ay the priest, written in 13 lines. Aten was the light and life, his absence was the night and death. Part of the Hymn is present in Psalm 104 of the Hebrew Scriptures, as noted in the research of the Egyptologist James Henry Breasted, and others. This hymn is the origin of that psalm, but how and when it reached the Hebrews is still open to study. It may represent a possible link between Akhenaton and Moses.

The hymn recited by Akhenaten expresses joy in all the creatures and in creation itself as well as in the god who created all life, which is interpreted with the painted scenes over those fragments:

> O living Aten
> > Source of all life!
> You have flooded the world with your beauty
> > Trees and vegetation grow green
> Birds start from their nests,
> > Wings wide spread to worship your person
> Once you rose into shining, they lived;
> When you sink to rest, they shall die.

127

129. Stela of Any

Painted limestone; Tell el-Amarna;
18th Dynasty, reign of Akhenaten, 1372 - 1355 BC;
Ground floor, room 3, CG 34177, JE 29748;

Discovered in Tell el-Amarna, this stela of Any bears inscriptions of the titles of this influential noble man: *Imy-r pr,* 'Overseer of the House'; sesh nsw, 'Royal Scribe'; and *sesh wdjeh n nb tawy*, 'Scribe of the Offering Table of the Lord of the Two Lands'. The name and titles of the charioteer Tjay are inscribed as well. This vo-

128

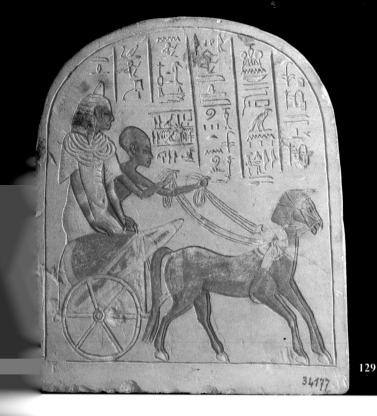

34177

129

tive stela is one of six that were placed in three niches, in Any's tomb; dedicated to him by his brother, the charioteer Tjay, and other family members.

The round-topped stela shows Any wearing a straight wig that reaches down to his shoulders and is surmounted by a cone representing the type often worn, which were made of perfumed wax that would melt in the heat, moistening the hair with a beautifully scented oil. He wears an innovative multi-tiered collar necklace called the shebyu, which appeared during the reign of Tuthmosis IV as well as in the tombs of Khaemhat (TT 57) and Ramose (TT 55) in Qurnah during the reign of Amenhotep III. The *shebyu* consisted of a series of necklaces formed by threaded gold-disc beads, and was a special royal gift to grandees and people of distinction with exceptional qualities. Any is dressed in a transparent gown with pleated sleeves, as was the fashion in the Amarna period. His full belly is typical of Amarna art. The charioteer Tjay is represented with an elongated head, slanted eyes, and long ears, also typical of the Amarna style. The chariot is drawn by one horse, and the line surrounding it is thought to represent the movement of the galloping horse. Alternatively, the line may suggest a second horse, represented with a flat perspective. Attached to the chariot, is a quiver of arrows.

The reign of Akhenaten saw a new development in the language, known as the late Egyptian stage, which was used in business documents and letters as well as in literary composition until the Twenty fourth Dynasty.

Any, along with the other trusted officials and nobles at Tell el-Amarna cut out their tombs in the mountains surrounding the city at two different sites. The northern site contains 17 tombs, the most important among them belonging to the Overseer of the Royal Harem, Huwa; Meryre the High Priest, and Meryre another royal scribe; Pentu the Chief Physician; and Panehsy, the Chief of Police. The southern site contains 27 tombs, including the tombs of Mahu, the Chief of Police and Ay the prominent noble man who later became King Ay. These tombs show a mixture of the new Amarna art alongside the traditional style.

130

130. Princess nibbling a roasted duck

Limestone, Tell el-Amarna; H. 27 cm, W. 16.5 cm;
18th Dynasty, reign of Akhenaten, 1372 - 1355 BC;
Ground floor, room 3; JE 48035;

This plaque was found, broken in two, near the northern palace in Tell el- Amarna, which was probably inhabited by Nefertiti during the later Amarna period. It shows an artist's sketch, probably made to practice the new artistic mode of the period. It is unfinished, as only the lower half of the plaque was carved in relief; and so contributes to the knowledge of the stages these artists followed in order to produce such a piece.

The scene shows one of the six royal daughters, wearing a transparent cloak that reveals her body, and seated on a cushion. She is represented with the artistic characteristics of Amarna, having an elongated head, large stomach and slim neck and arms. She also has a heavy lock of hair on one side of her head, symbolising childhood and adolescence. She extends one of her hands towards a table, laden with various fruits and vegetables as well as bread; and is about to devour the duck in her other hand.

This scene adds to the variety of new scenes the artists freely represented, especially in from the royal family's domestic life. It carries the spirit of Atonism, that is, realism, as the king often repeated that he lived in reality.

131. Meryre and his wife Iniuia

Painted limestone; Saqqara;
18th Dynasty, reign of Akhenaten, 1372 - 1355 BC;
Ground floor, room 3; JE 99076;

This dyad was discovered in Saqqara and belongs to Meryre, who was a royal scribe in the Temple of Aten at Tell el-Amarna and later at Memphis, together with his wife, Iniuia, a noble lady bearing the title 'Favourite of the Lady of the Palace'.

Private statuary in this period was very rare, so this statue is considered especially valuable. The couple sits in a high-backed chair decorated with feline legs, and Iniuia's arm is placed affectionately around her husband's waist in a manner reminiscent of the statue of Queen Tiye and King Amenhotep III. Meryre wears a

131

132

shoulder-length curly layered wig, a short-sleeved tunic with pleats on the ends of the sleeves and the front of the skirt; and is holding a folded cloth in a noble manner. His names and titles are inscribed on the skirt, giving the names of the two cities where he was posted: Akhetaten, which is Tell el-Amarna; and Memphis, also attesting to the presence of the cult of Aten in the temple at Memphis. Meryre wears a *shebyu*, consisting of a two-tiered necklace, formed by threaded gold disc beads, a special royal gift for distinction; presented together with the armbands he is also wearing.

His wife wears a long wavy wig covering her shoulders, the locks of hair ending in short braids. Her long dress, which almost covers her feet, has pleated sleeves and the left side is also pleated. Like her husband, she is holding a folded cloth in her left hand.

Meryre's tomb, in the northern part of Akhetaten, contains a unique scene of Akhenaten and Nefertiti with their six daughters. It records the arrival of foreign emissaries to pay tribute to the king, a major event during the reign that took place in the king's twelfth regnal year.

Many officials from this period are well known, like Ramose the vizier who lived with the king when he was in Thebes, and cut out his own tomb in Qurnah (TT 100) before moving with Akhenaten to Amarna. In addition, Parennefer the royal butler, who had tombs in Amarna and in Thebes. Ay, who later became pharaoh, having been a great support to the royal family; built a tomb in Thebes after the abandonment of Tell el-Amarna during the reign of Tutankhamun.

132. Thot and a Scribe

Steatite, Tell el-Amarna; H. 14 cm, W. 6.8 cm, D. 11.2cm;
18th Dynasty, Reign of Akhenaten, 1372 - 1355 BC;
Ground floor, room 3; JE 59291;

This steatite statue, which was discovered in a house at Tell el-Amarna, comprises a scribe and a baboon. No inscriptions remain on the statue to reveal the identity of the scribe, who is sitting cross-legged, wearing a layered wig, a necklace with a heart scarab amulet, and a short-sleeved tunic covering his legs. He is looking down at the papyrus scroll on his lap.

The baboon represents the god Thot, the god with a wide range of associations; to wisdom, writing, medicine, science and cosmology, as well as mathematics, accounting, and astronomy. The Greeks associated him with the god Hermes. The cult centres of Thot were present in various places throughout the country. He is represented either as a squatting baboon or as an ibis or ibis-headed man holding the papyrus and scribal pen. His headdress features both the full moon and crescent moon. In this sculpture he is shown overseeing and protecting the scribe.

He is depicted in the scene of divine judgment in the vignette, accompanying chapter 125 of the 'Book of the Coming Forth by Day' ('Book of the Dead'), as an ibis-headed man recording the event, or as a baboon sitting on top of the scales of justice.

Thot's principal cult centre was at Hermopolis, the ancient Egyptian Khemenu, known today as el-Ashmoneen, near Minya in Middle Egypt. There, Amenhotep III dedicated two colossal granite statues of baboons representing that god, each weighing 30-tons. Near el-Ashmoneen, in Tuna el-Gebel, there is a massive cemetery for baboons and ibises, the animals sacred to Thot. In Sakkara, another cemetery contained tens of thousands of these two mummified animals.

Thot was the head of the Ogdood (eight gods) of Ashmoneen, who was credited there with world creation. As 'Lord of the Sacred Word', he personified sacred speech; and was closely related to Seshat, the goddess of writing and literature. In addition, Thot was connected with Maat, who personified rightness and the cosmic order.

The presence of this statue in Tell el-Amarna, as well as the fact that many amulets of the goddess Tawert and the god Bes, who were associated with childbirth, were found in the ruins of houses there, suggests belief in other gods apart from Aten. The monotheism of the period is therefore open to question. The acknowledgement of other gods also calls into doubt whether Akhenaten's religion was true monotheism in favour of the god Aten, or if Aten was merely the dominant god and other gods co-existed with him, either in secret or in public. It may well have been a belief in one god as the creator god, without denying the existence of other gods. In other words, some other popular gods were tolerated, but probably only worshiped by the populace. Amen, however, was anathema.

133. Canopic jar

Alabaster; Valley of the Kings (KV 55), Thebes; H. 38.5 cm;
18th Dynasty, reign of Akhenaten, 1372 - 1355 BC,
Ground floor, room 3; JE 39637;

133

This canopic jar is one of the four discovered at the Valley of the Kings in the unfinished tomb (KV 55). It had been brought, along with other funerary objects, from Amarna, following the return to Thebes and the subsequent re-establishment of the Amen religion, and of Thebes as the capital of Egypt. Three of these jars are now in the Egyptian Museum here, and the fourth is in the Metropolitan Museum of Art, New York. The jar is sculpted of calcite, or Egyptian alabaster. It features a stopper in the form of a female royal head, wearing a curly wig and a broad multi-tiered pectoral. The royal cobra that would have rested over the forehead, is now lost. The earliest example of such a human-headed lid on a canopic jar dates to the First Intermediate Period, when it replaced the domed or flat lid.

The canopic jars contained the internal organs that were removed from the body during the mummification process; that is, the liver, intestines, stomach and lungs. They were associated with the deities, the Sons of Horus, who were Dwamutef, Qebehsenuef, Imsety and Hapy. These four were under the protection of the goddesses, Isis, Nephthys, Neith and Selket.

The facial features on the head show the grace and delicacy of the later part of the Amarna period, when exaggeration in art was abandoned in favour of naturalism and beauty. The eyebrows are inlaid with blue paste imitating lapis lazuli, and the eyes are inlaid with white quartz and obsidian.

It is difficult to determine with certainty the owner of these four jars, as the inscription giving the names and titles were obliterated. Some Egyptologists ascribe it to Kiya, the minor wife of Akhenaten; others have thought it belongs to Meritaten, his daughter. The organs inside the jars, which were found in the same tomb as his mummy, are believed to belong to Semenekhkare, Akhenaten's son and successor, whose mummy was found inside its gilded coffin, where the cartouches were also obliterated.

133

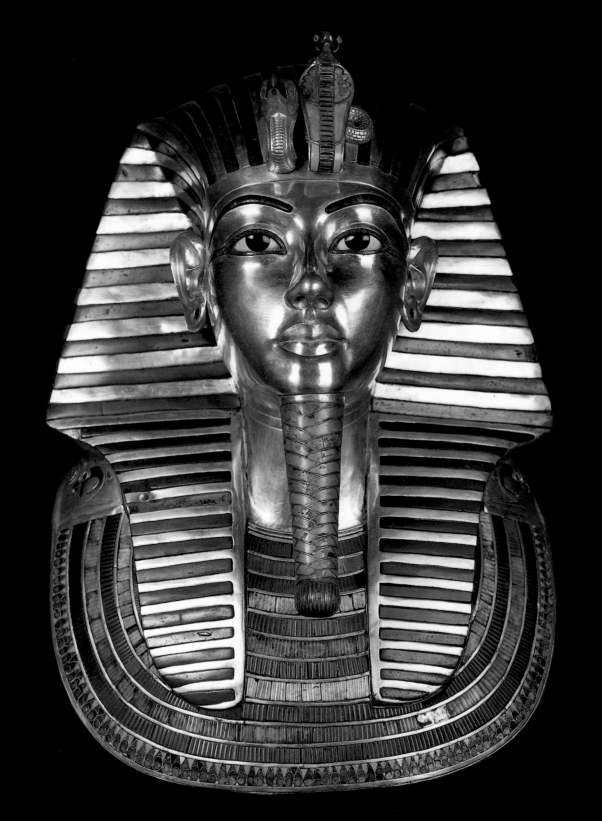

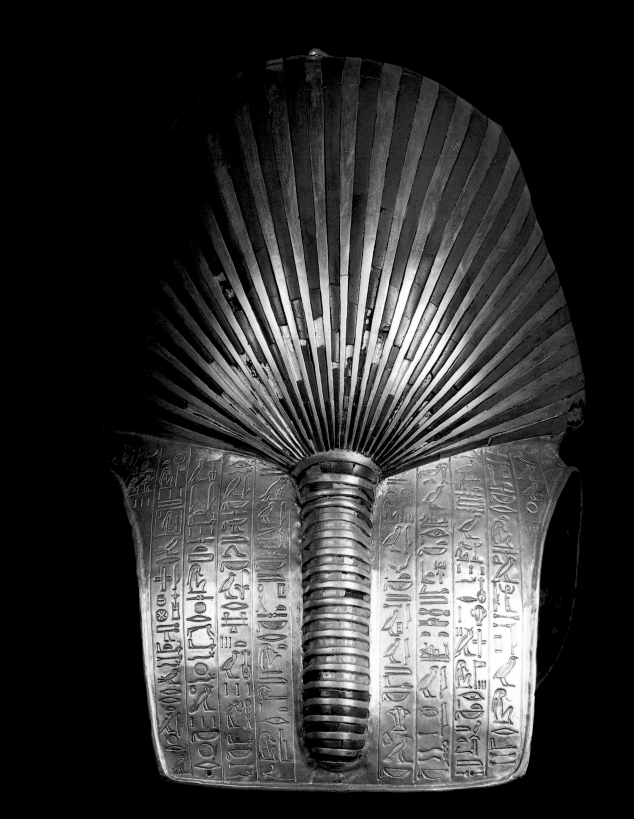

134. Gold mask of Tutankhamun

Gold, Semi-Precious Stone, Glass Paste; Valley of the Kings;
H. 54 cm; Upper floor, room 3; JE 60672;

This stupendous mask of King Tutankhamun is made of solid gold, and ornamented with lapis lazuli, turquoise, carnelian and coloured-glass paste. It is a masterpiece indeed, and one of the highlights among the treasures. The mask was found covering the mummy's head and shoulders, and weighs 11 kilos, it shows the king, as a young man in his teens. He is wearing the *nemes* royal headdress, with a cobra and a vulture over the forehead, symbols of the unification of Upper and Lower Egypt.

The eyebrows and eye lines are inlaid with lapis lazuli, and the eyes themselves are inlaid with obsidian and white quartz. The red dot at the corner of each eye adds a touch of realism to the mask. The king is wearing a false funerary beard with a curved end, which is again inlaid with lapis lazuli. The chest is covered with a large usekh multi-tiered pectoral, also inlaid with lapis lazuli as well as turquoise and carnelian, and culminating at the sides with falcon heads.

The elongated face, arched eyebrows, large pierced ears, and lines on the neck are all traces of Akhenaten's Amarna art, wrought here with great realism and beauty.

The rear side of the mask reveals the *nemes* headdress, gathered in a braid on the shoulder; and the hieroglyphic inscription bears texts explaining the religious significance of the mask. The gold and lapis lazuli associated the deceased with the god Re, whose flesh is of gold, and hair of lapis lazuli. The facial features of the mask are identified with divinities mentioned in Spell 151b of the 'Book of the Coming Forth by Day' ('The Book of the Dead'), to enable the deceased a safe passage to the realm of Osiris in the hereafter. The protection of the head of the deceased was one of the important concerns in ancient Egypt; the mask provided a permanent substitute for the head in case of damage.

In the Old Kingdom, facial features were painted on top of the mummy bandages that covered the faces. The earliest masks, dating from the First Intermediate Period, are hollow masks carved of wood, made of two pieces that are held together with pegs. Some are of 'cartonnage', modelled over a wooden core. The masks of the New Kingdom Period are more sophisticated and elaborate than before, and by this time, the making of permanent face coverings ran parallel to the mummification process. Finally, in Roman times, the masks evolved into flat portraits covering the faces of mummies.

The semi-precious stones used in this mask, and elsewhere, were symbolic. In ancient times, every stone was believed to possess certain magical powers, lapis lazuli, or *khesbed* in ancient Egyptian, considered to be the most precious, after gold and silver, because of its special blue like the colour of the heavens. It was imported from Syria and Palestine, and was used right from the beginning of Egyptian history. The red of carnelian represented dynamism and power, and the blue-green colour of turquoise symbolised growth.

Gold was used to attain immortality because of its sun-like brilliance and its resistance to corrosion. It could be hammered and melted into thin sheets to cover the body like skin. Gold was related to the afterlife, and intended as a means of acquiring the flesh of the gods.

In his Amarna letter, the King of Mittani, Tushrata, describes the gold of Egypt 'as abundant as the dust on the ground'. The ancient Egyptians first found gold in Coptos, 35 km north of Luxor. It was described as 'the gold of Coptos' and quarried from a site near Wadi Hammamat and Wadi Abbad.

Nubia, whose name may have been derived from the word for gold *nbw*, was the best source of this precious metal. In Lower Nubia, called *wawaat*, gold was present at Wadi Alaki. In Upper Nubia, then called Kush, it was found at Soleb and Semnah. There were fortresses in Nubia to control the commerce of the gold, which was presented as a tribute to Egypt.

In preparing the raw material, fire was used to crack the quartzite stone, which was then pounded, and later washed over a sloping table in order to separate the metal from the quartz. Finally, the gold was melted and formed into ingots.

Some occupational titles were connected with gold production, from 'The Gold Washer', 'Scribe Reckoner of Gold', to more elevated titles like 'Overseer of the Gold Lands' and 'Overseer of the Treasury'.

The metal was worked in workshops that were attached to royal palaces or temples. One of the goldsmith's techniques was 'cold-hammering', which was used for the preparation of gold sheets. It was also worked hot, the molten gold poured into molds of

various shapes. The 'lost-wax' method was also used. Here, the desired shape was formed from wax, which was encased with clay and then heated, to melt the wax; leaving a hollow to be filled with molten gold. Later, the clay would be removed and the gold item, finished and polished.

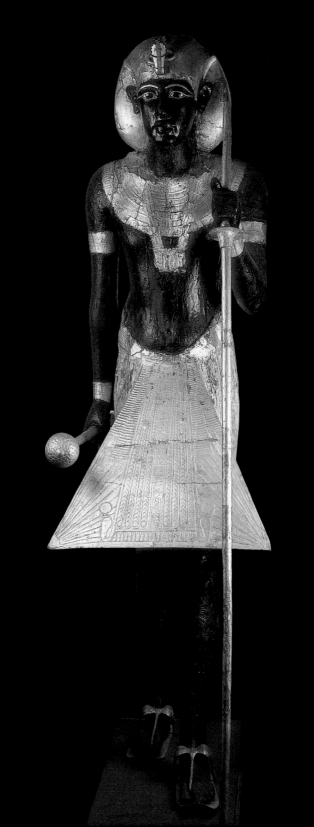

135. Ka statue of Tutankhamun

Wood coated with bitumen; H.198 cm, W. 53 cm;
Upper floor, gallery 45, JE 6070;

Carved of wood, this life-size statue is partly gilded, and is one of two statues that stood at the entrance of the burial chamber, as though guarding it. The entrance was blocked by a stone wall, which ancient robbers broke through, entering the chamber, and stealing some of the treasures. They were later caught, however, and the stone wall was restored by funerary priests, who put their seals on the wall. The pair of statues depicts the king and his *ka*, or double, which was thought to represent the attributes that designate character and temperament. The king is shown with his *khat* headdress, which signified both rejuvenation, and the nocturnal side of the solar cycle. The headdress reveals the ears, which are shown pierced, as in Amarna art. The other *ka* statue shows the king wearing the *nemes* headdress.

A gilded bronze royal cobra lies over the forehead for protection. The eye lines and brows are inlaid with gilded bronze; and the eyes themselves, with white quartz and obsidian. The king wears a large pectoral and a pendant necklace. Bracelets and armbands of gold leaf also adorn the wooden statue.

In one hand the king is holding the *hedge* mace, as the traditional weapon of a victorious king; and in the other, a staff in the form of a papyrus plant, which symbolises youth and freshness. He wears the starched, pleated kilt that was the fashion of the period. The buckle on his belt displays Tutankhamun's cartouche, and contains the title *neb kheprw re,* 'the lord of existence of the god Re'. The cartouche on the other statue contains the name *Tut ankh Amen,* 'the living image of the god Amen'.

Wearing gilded bronze sandals, the king is standing in the traditional posture with the left foot advancing, as though striding forward.

The king is shown here with black skin, the colour having been achieved by coating the wood with bitumen. Also, as the colour of the Nile mud that flooded the land and gave it fertility every year, black signified resurrection and the continuity of life. In addition, this colour was associated with the underworld, and sometimes the skin of Osiris was represented as black, emphasising the belief that, after death, the king would personify Osiris, god of the hereafter.

Black skin, moreover, recalled the Nubian guardians, who were known to be powerful, shrewd and fierce; and would therefore frighten any intruder in the tomb, giving added protection to the funerary treasures.

Egyptologists initially believed that Tutankhamun was either poisoned or died of tuberculosis. An x-ray of the mummy, however, made in Liverpool in 1969, showed a wound beneath the left ear, suggesting that probably a brain haemorrhage, resulting from this wound, had led to the king's death. However, whether he was murdered or was the victim of an accident has not been determined with certainty.

Shortly after the burial, robbers broke into the tomb and took with them some of the light, but valuable objects, leaving the tomb in disorder. Officials and priests later tidied up the antechamber.

The death of Lord Carnarvon in 1923, shortly after the discovery of the treasure-filled tomb, caused speculations about 'the curse of the pharaohs'.

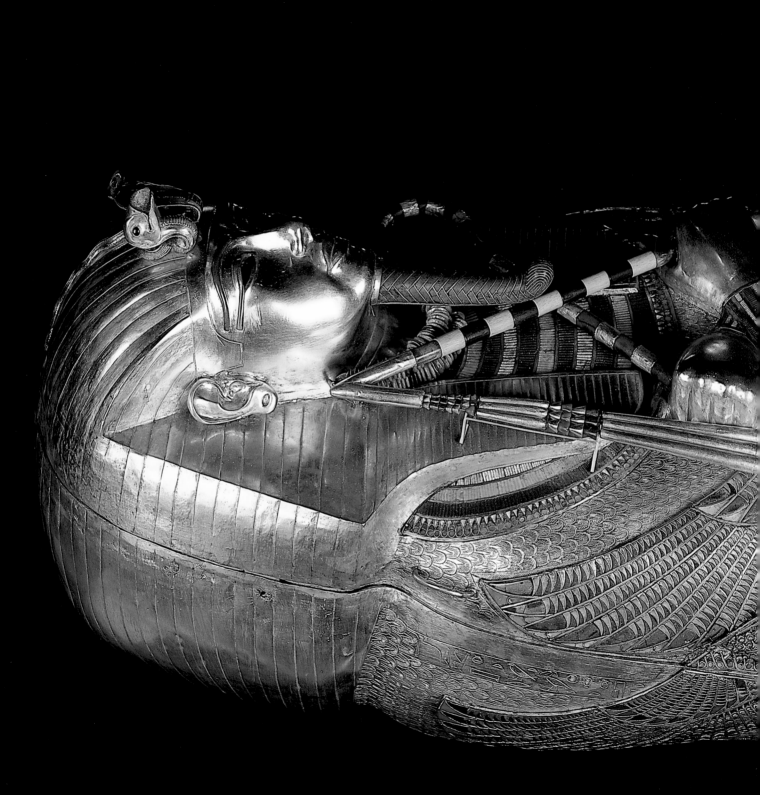

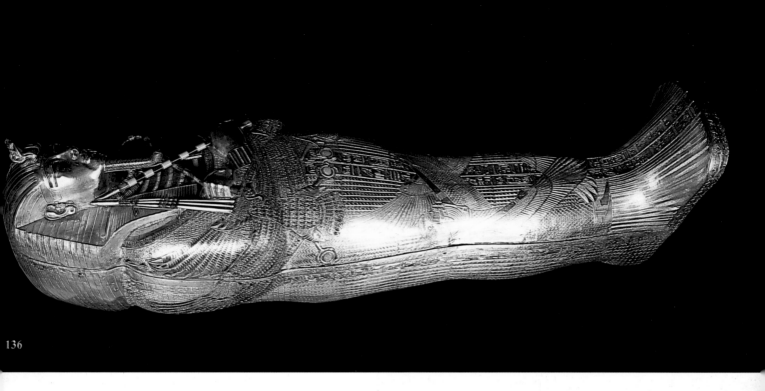

136. Inner gold coffin of Tutankhamun

Gold, Semi-Precious Stone; L. 187.5 cm, weight 110.4 kg; 18th Dynasty, reign of Tutankhamun 1356 - 1346 BC; Upper floor, room 3; JE 60671;

This anthropoid coffin was the innermost of three coffins, which were placed one inside the other, then placed in turn within a larger rectangular quartzite sarcophagus with a granite lid. This coffin is made of solid gold and weighs 110 kg, while the other two coffins are made of gilded wood. The second one is displayed alongside this, the innermost coffin. The third and largest coffin now contains the mummy and is inside its sarcophagus in Tutankhamun's tomb in the Valley of the Kings at Luxor.

When discovered, the coffins rested inside each other so tightly that it was impossible to insert one's little finger between them. Moreover, the funeral libation poured over the coffins, during the funerary rites, had stiffened and solidified, like cement. Freeing them, therefore, caused damage to much of the decorative and inlay work, although this was later restored.

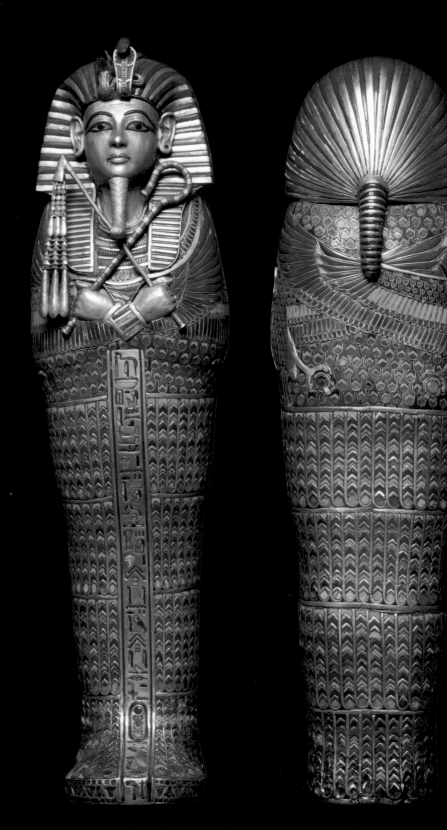

The coffin shows the king wearing the *nemes* royal headdress, and the cobra and vultures over the forehead personify the two protective deities of the unified Upper and Lower Egypt. The portrait of the young king here, with features showing the influence of Amarna art, resembles the mask. The eyebrows and eye lines are inlaid with lapis lazuli, but the eyes are missing. The king wears his funerary curved false beard, also inlaid with lapis lazuli. Around his neck is a double-tiered *shebyu* necklace, formed by threaded gold discs, a special item of royal jewellery, signifying the exceptional qualities of the wearer. A multi-tiered *usekh* pectoral covers his chest, and is inlaid again with lapis lazuli, carnelian, turquoise and coloured-glass paste. The king is shown in the Osiride pose, with arms crossed over the chest. He is holding the *heka* crook, symbol of power; and the *nekhekh* flail, symbol of authority. Wide bracelets adorn the wrists.

The cobra and vulture spread their wings to protect the king's body, holding the *shen* amulet as a symbol of continuity and infinity.

The goddesses Isis and Nephthys are represented in the form of the *djerty*, two women with outspread wings, offering protection to the deceased. As sisters of Osiris, and his two main mourners; they perform the same service for the deceased king, who is associated with Osiris. The two goddesses also make up two of the four protectors of the canopic chests, which contain the canopic jars with the internal organs of the deceased inside. The wings of the two goddesses are extended over the coffin between the hieroglyphic funerary texts inscribed on its surface.

Beneath the king's feet is a representation of Isis, who kneels over the sign *nbw,* the sign for gold and, is once again, seen spreading her wings to protect the king.

A look at Tutankhamun's breathtaking treasures gives an idea of the lost treasures of the great kings of Egypt, and begs the question of what might be found if the graves of Ramsses II, Amenhotep III or Tuthmosis III were discovered intact.

137. Coffin of Tutankhamun's internal organs

Gold, semi-precious stone; H. 39 cm, W. 12 cm, D. 12 cm; 18th Dynasty, reign of Tutankhamun 1356 - 1346 BC; Upper floor, room 3; JE 60688;

This miniature anthropoid coffin is one of four, which contained the internal organs of the king: the stomach, intestines, lungs and liver that were removed from the body at the time of mummification. These organs were embalmed and wrapped in linen, then placed in the four miniature coffins, that then went into the alabaster, canopic jars. On the lids of these jars are images of the king's head. Particular care was taken with the organs, as these jars were in turn placed in an alabaster canopic chest, which was found in the gilded wooden chest in the treasury of the tomb, adjacent to the burial chamber.

The king is shown in the traditional manner, wearing the *nemes* royal headdress, with a cobra and vulture, the protective deities of unified Upper and Lower Egypt, on the forehead. The eyebrows and eye lines are inlaid with lapis lazuli; and the eyes themselves are inlaid with white quartz and obsidian. A curved false beard is attached to the chin. He wears two small *shebyu* necklaces, and a large *usekh* pectoral. The king is represented in the Osiride form, with arms crossed over the chest, and holding the *heka* crook, symbol of power, as well as the *nekhekh* flail, symbol of authority. He is also wearing wide gold bracelets.

Two wings envelope the torso and the entire coffin is inlaid with semi-precious stones such as lapis lazuli, carnelian and turquoise as well as with coloured-glass paste in a *rishi,* or feathered design.

The hieroglyphic column in the middle shows the prayers of the goddess Nephthys and the god Hapy, who was the protector of the lungs, one of the Four Sons of Horus protecting the jars containing the viscera, together with the other three deities Dwamutef, Qebehsnuef, and Imsety.

The back of the coffin shows the *nemes* gathered in a braid; and underneath, the claws of the vultures are holding the *shen* amulet, which is a symbol of everlasting continuity and infinity.

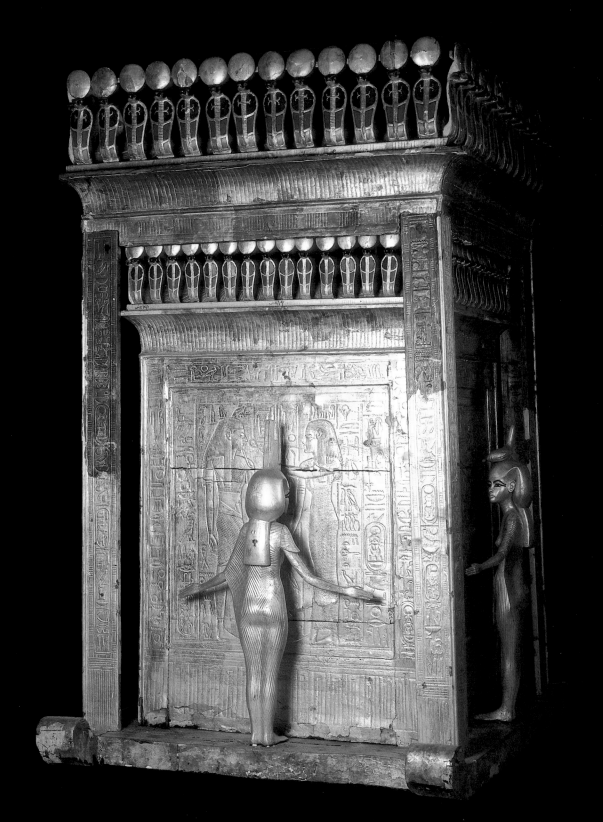

One of the other three coffins shows that the cartouches were altered, indicating that these miniature coffins were made for another person; but due to Tutankhamun's premature death, the names were altered and used to store his organs.

138. Canopic shrine

Gold and wood; H. 198 cm, L. 153 cm, W. 122 cm;
18th Dynasty, reign of Tutankhamun 1356 - 1346 BC; Upper floor, gallery 9; JE 60686;

Found in the treasure room of Tutankhamun's tomb, this gilded wooden shrine stood against the east wall, facing the door of the burial chamber. It contained a smaller alabaster canopic chest that in turn housed the four canopic jars, containing the viscera. Inside these jars were the four miniature coffins with the internal organs of the king.

The shrine is placed over a sledge, and surrounded by a canopy formed of four pillars that support the roof, which features a cavetto cornice. The upper part of the roof is decorated with protective cobras, inlaid with coloured-glass paste, and their heads are surmounted with solar discs.

Four goddesses surround the shrine, spreading their arms in a protective manner. The head of one is turned, showing alertness and a readiness to attack any intruder, as an added measure for the safety and protection of the chest. The turned head breaks the tradition of frontal poses seen in the older statuary, due to the influence of Amarna art, which is also evident in the representation of slim necks and naturalistic bodies. The goddesses wear headdresses from which their hair descends; and their identities are revealed in the hieroglyphic inscriptions on the heads. They are the goddess Isis, who carries a throne on her head; the goddess Nephthys with a house and a basket on hers; the goddess Selket, identified with the burning heat of the sun, bears the scorpion on her head; and the goddess Neith of the city Sais in the north-west Delta has two bows on her head. These four goddesses were associated with the Four Sons of Horus, and together the eight formed a protective group to guard the internal organs of the deceased. In addition, these eight deities are mentioned in protective religious formulas on this shrine, which also bears the king's cartouches. The roof of the shrine features a

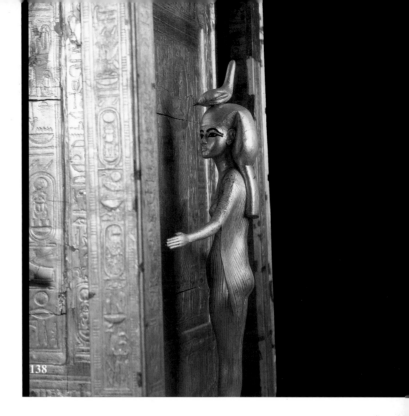

138

cavetto cornice, and the upper part is decorated with protective cobras inlaid with coloured-glass paste, their heads surmounted by solar discs.

The goddesses are wearing close-fitting dresses, and the naturalistic style of their bodies, again shows the influence Amarna art.

The goddess Selket, who personified the scorpion, was worshipped, in order to prevent its fatal stings. She is the protector of the god Qebehsenuef, the hawk-headed Son of Horus. Her cult existed as early as the First Dynasty.

Another deity associated with the scorpion was the goddess *Shed,* described as 'the saviour, who bestowed protection against the scorpion stings'. *Shed* was depicted on stelae at a chapel in the workmen's village in Tell el-Amarna. In addition, seven scorpions protected Isis from her enemies.

The title *sa srkt,* the Guardian of Selket, was one of the titles given to the funerary priests, present in the scenes of funeral processions depicted on the walls of the Theban nobles tombs. Examples include the Tomb of Amenemhat at Gournah (TT 82) and Montuherkhopshef at Draa Abu el-Naga (TT20).

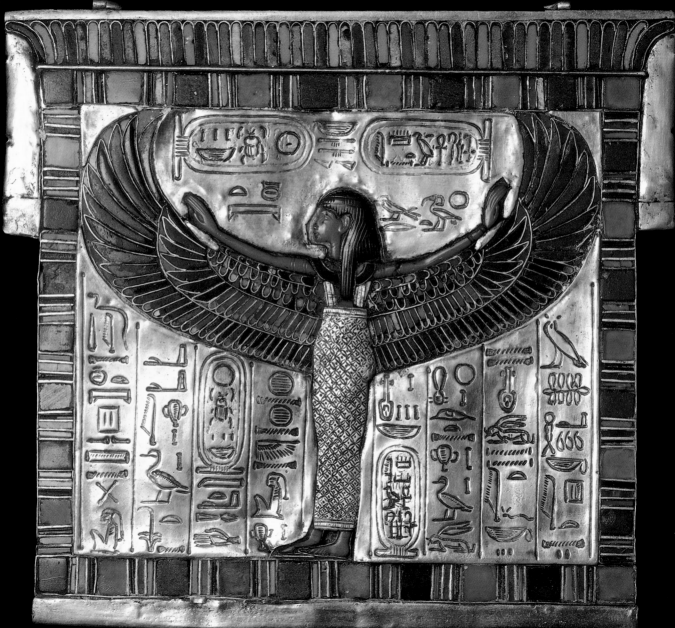

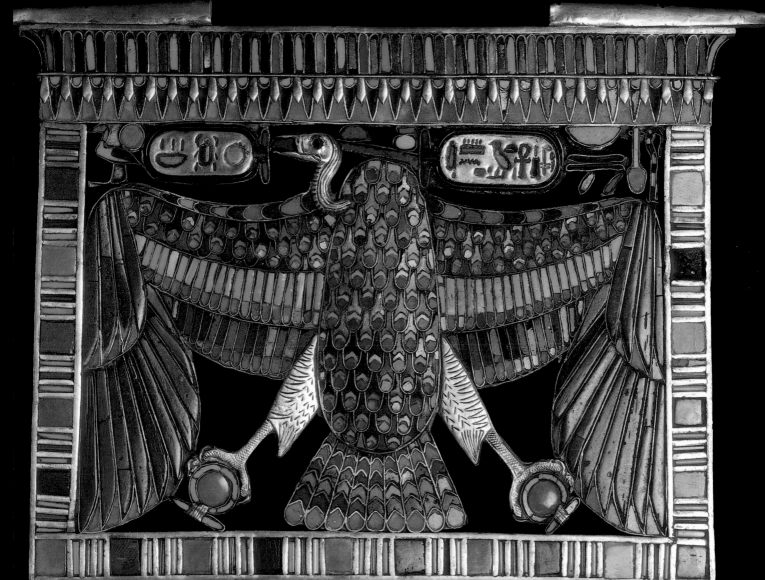

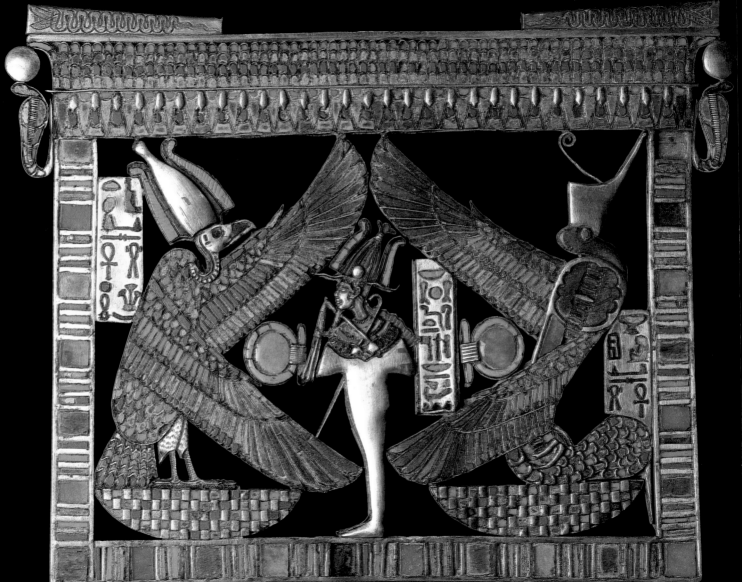

The sledge on which the shrine rested was meant to facilitate its movement. It also had a religious significance as a symbolic connection to the sun god Atum and the Four Sons of Horus, who were believed to raise the deceased to heaven on a sledge.

139. Pectoral of the sky goddess Nut

Gold, semi-precious stone; H. 12.6 cm, W. 14.3 cm;
Upper floor, room 3; JE 61944;

This shrine-shaped pectoral shows the goddess Nut with outstretched arms and wings. The upper part is surmounted with a cavetto cornice. The cartouches give the names of King Tutankhamun, but show some alteration and modification, having probably belonged to another king and reused for king Tutankhamun. On the other hand, the alteration may be the correction of a mistake.

Every evening, Nut was believed to swallow the setting sun and then give birth to it every morning. These acts are depicted on the ceilings of several tombs in the Kings Valley and in many temples. The fact that the sun made another journey through the underworld was not contradictory to that belief, as Nut's body was the route of the stars, and she was one of the funerary deities referred to in the Pyramid Texts. In the New Kingdom Period, representations of the deceased were shown under Nut's protection, assuring his rebirth, just as the sun was newly born each day. Nut afforded protection among the imperishable stars in her body, and as such, was depicted on the underside of many coffin lids to give such assistance to the deceased.

A member of the Heliopolitan Ennead, Nut is mentioned in Spell 548 of the Pyramid Texts as the celestial cow who suckles the king and takes him to herself in the sky. The goddess is, in fact, often represented as a woman, whose naked body is arched over the earth. In addition, in Spell 306 of the Coffin Texts, she performs the swallowing of the deceased, who is identified with Re.

The deceased sought magical protection for his soul by the use of amulets and jewellery, just as he sought physical protection through mummification. The most typical funerary jewellery was an attempt to gain help and influence by magical means.

140. Pectoral of the sky goddess Nut as a vulture

Gold, semi-precious stone; H. 12 cm, W. 17 cm;
Upper floor, room 3; JE 61943;

Some 143 pieces of jewellery were found in Tutankhamun's treasures, and the whole collection amounts to 3,500 pieces. Some of the jewellery was found on the mummy, and other pieces were found inside the various chests and boxes placed inside the tomb. This pectoral was found in a chest, surmounted by the god Anubis in the tomb treasury, adjacent to the burial chamber.

The hieroglyphic signs on the rear side of this pectoral associate the vulture here with the sky goddess Nut, who is in turn associated with 'Isis that protects Osiris and Horus and accordingly will protect the mummy', as indicated in Chapter 157 of the 'Book of the Dead'.

Another vulture goddess called *Nekhbet*, is often related to kings and kingship. One of her earliest appearances holding the shen sign was on the Second Dynasty stone vase of Khasekhemwy from Hierakonpolis, which was the cult center of that goddess. Other goddesses are also represented as vultures like the goddess Mut, wife of the god Amen and a member of the divine Theban triad.

141. Pectoral of Osiris, Isis and Nephthys

Gold, semi-precious stone; Upper floor, room 3; JE 61946;

Tutankhamun's treasures include 26 pectorals and those worn during his life show signs of wear. This pectoral, which appears to have been worn was also found in the Anubis chest in the tomb treasury. It is shaped like a shrine, featuring a cavetto corniche at the top and surmounted by two cobras with vultures' wings. Under the cornice, is a frieze of lotus flowers with a cobra wearing the solar disc at both sides.

At the right side of the pectoral is a cobra wearing the Red Crown of Lower Egypt, and two wings framing a *shen* sign. It lies on a basket with a checker design. Although this cobra represents the goddess Wadjet, the protective deity of Lower Egypt; the text

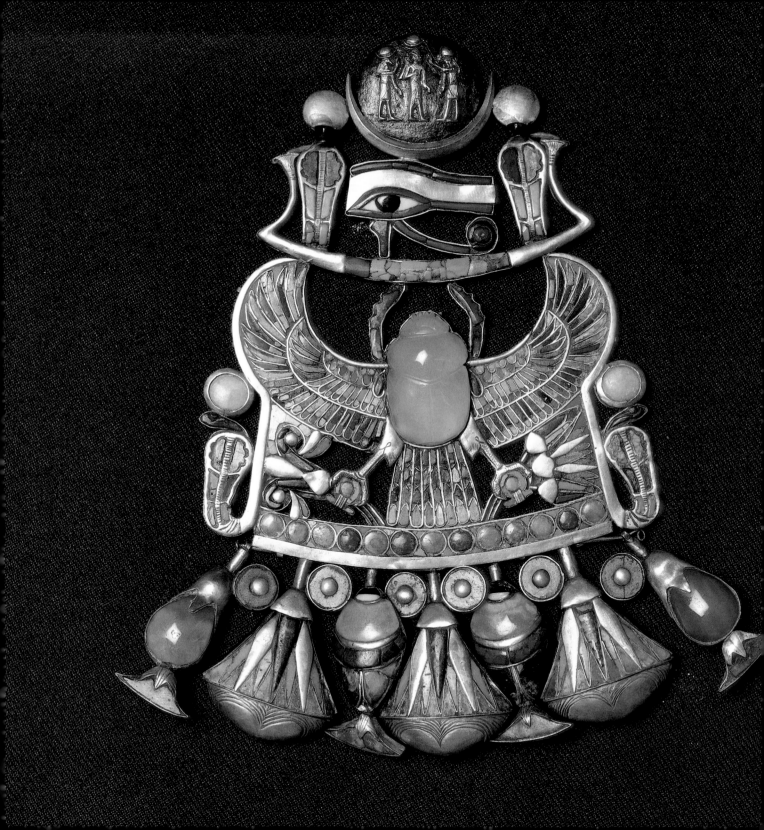

beside it gives the name of the goddess Nephthys. The left side of the pectoral features a vulture wearing White Crown, which is flanked by two feathers, recalling the *atef* crown. It stretches its wings to protect the shen sign, and is resting on a basket similar to the one on the right side. Here too is the vulture goddess Nekhbet, the deity of Upper Egypt, and an accompanying text mentions the name of Isis.

In the centre, Osiris is shown in mummy form, wearing the atef crown and a large pectoral; holding the *heka* and *nekhekh* scepters. Osiris here represents the king himself, who would be associated with Osiris after death and resurrected in his realm in the hereafter. The text beside runs: *nb neheh, heka djet, neter nefer, nb ta djeser*, 'The lord of eternity, ruler of everlasting, the good god, lord of the holy land'.

142. Pectoral with a winged scarab

Gold, silver, silica glass; H. 15 cm, W. 15 cm; Upper floor, room 3; JE 61884;

Comprised of composite motifs, the upper part of this pectoral shows the figure of the king, accompanied by the falcon-god Reherakhty, whose head is surmounted by a solar disc. In addition, there is the ibis-headed god Thot, whose head is surmounted by both the crescent moon and the full moon.

Inside a solar barque is the left *udjat* eye of Horus, flanked by two cobras, each wearing a solar disc on its head. The *udjat* is the eye of the falcon god Horus with its characteristic marking beneath. The word *udjat* means 'the perfect' it belongs to Herwer, who was worshipped at Kom Ombo. An early creator god, 'his right eye was the sun and his left eye was the moon'. During the mythical struggle between the god Horus and his enemy Seth, the left eye of Horus was plucked out, but later restored by the god of wisdom Thot. Horus, the son of Osiris, later brought his father back to life by giving him this eye. This offering of the eye was an alternative to food offerings, and the lunar and solar *udjat* are mentioned in Chapters 140 and 167 of the 'Book of the Dead.' The *udjat* eye pendant contained great protective power, imbuing the bearer with particular protective qualities.

The barque represented the nocturnal journey of the sun. It is shown here carried by a winged scarab, which holds the *shen* sign of eternity. Scarab beetle is the *scarabaeus sacer*. It became a symbol of new life and rebirth because the beetle lays eggs in a ball of dung. The ancient Egyptians equated the hatching of the eggs with the rise of the 'newly born' sun.

The scarab god Kheperi was a creator god, sometimes represented as a man with a scarab head or as a scarab in a boat held by Nun, god of the primeval ocean. The scarab, which emerged from balls of dung, was associated with creation. In the Pyramid Texts, Kheperi was referred to as a sun god, 'he who is coming into being'.

143. Earrings with duck heads

Gold, glass; L. 10.9cm; Upper floor, room 3; JE 61969;

This pair of earrings is the most beautiful of the four pairs discovered in Tutankhamun's treasures. The ducks with outstretched wings form a circle and their feet hold the *shen* sign. The head is made of translucent blue glass and the wings are fashioned in cloisonné. Under the duck hang gold and blue glass beads with five cobra heads. These earrings show a great aesthetic sensibility, and ducks held a specific erotic symbolism. The statues of the king never showed him wearing such earrings, however.

Earrings were worn in Mesopotamia and Nubia earlier than in Egypt where they started to appear at the end of the Second Intermediate Period, at the end of the 17th Dynasty. During the New Kingdom Period, earrings became common, and were worn by both sexes although women are more frequently shown wearing them. Kings were never represented with earrings although the statues and some of the mummies show pierced ears.

143

144. Collar of the Two Ladies

Gold, semi-precious stones, coloured glass; Upper floor, room 3;

Discovered between the bandages on the chest of Tutankhamun's mummy, this piece is called the *nebty* collar or the Collar of Two Ladies.

It shows a cobra flanking a vulture with outstretched wings. The piece and its counterpoise were made using the cloisonné technique, inlaid with hundreds of pieces of semi-precious stones and coloured-glass. Glass and faience possessed magical properties for the ancient Egyptians as they could be transformed from a dull white substance or silica, lime, alkali into a glimmering material. The *nebty* was a royal title as early as the fourth king of the First Dynasty King Djet, and signifies the cobra and vulture as the two protective deities of Upper and Lower Egypt. The cobra is a protective deity called Wadjet, who represented Lower Egypt in the kings' titles. She was described as the *wrt hekaw* 'the great of magic'. She was also associated with the eye of Re, protecting the sun god. In addition, she was represented guarding the gates that divided the hours of the underworld.

The vulture is Nekhbet, is goddess of el-Kab, in Upper Egypt. One of her feet ends with the *shen* sign of infinity. *Shen* means to encircle, to last forever; and the cartouche is a modification of this sign.

145. Necklace with a pectoral in the form of a solar boat

Gold, silver, semi-precious stone and glass paste; Overall Length 44 cm, W. 11.5 cm, H. 6.3 cm; Upper floor, room 3; JE 61885;

This outstanding pectoral came from a wooden box in Tutankhamun's tomb treasury. Suspended from a necklace, it features the scarab god Kheper inlaid with lapis lazuli, and holding a solar disc with his front legs and the *shen* symbol with his back legs. Two squatting baboons are also represented at the top of the two shrines represented here. The baboon heads are surmounted with the lunar crescent and lunar disc. This animal was sometimes used to represent Thot, the god of writing and wisdom, who had a lunar

144

aspect. The baboon was also used in sun symbology. At sunrise, these animals greet the sun with high screams, and by stretching their bodies. They are seen here in a solar boat sailing on the waters of Nun, the primeval ocean, represented as series of zigzag lines inlaid with blue lapis lazuli.

The sides of the pectoral are framed by the *was* sign, indicating prosperity, while on the top is the sign *pt*, hieroglyph for the sky, which is adorned with stars and inlaid with gold and lapis lazuli.

The necklace from which this pectoral hangs shows images of the god Heh, the god of eternity, and over them is the sign signifying the *sed* festival. The necklace also comprises gold and glass beads.

Clearly, jewellery was not only used to signify rank, wealth or social status, as the symbolism it contained had amuletic use. Certain chapters of the 'Book of the Dead' required the provision of amulets as part of the funerary accoutrements. Scarabs, made of various materials, were often used as amulets in jewellery, either strung in bead-form as necklaces, or scattered loose among the bandages. The various types of funerary scarabs also include the winged scarab for protection and the heart scarab, understood to be 'begging the heart not to be a witness against the deceased on the Day of Judgment'. The heart scarab was especially significant as a funerary amulet, in accordance with Chapters 26 - 30 of the 'Book of the Dead'.

146. Cosmetic box

Gold, silver, semi-precious stones; H. 16 cm, W. 8.8 cm, D. 4.3 cm; Upper floor, room 3; JE 61496;

This double cartouche-shaped box was used as a container for cosmetics or ointments. The face on the box shows Tutankhamun as a child, indicated by the lock of hair at the side of his head. The cobra over the forehead, signifies royalty. The hands are placed over the chest, and the king is holding the royal insignia the *heka* crook and *nekhekh flail*.

On his head is the solar disc representing god Ra, flanked by two cobras, with *ankh* signs hanging from each; the king is squatting over a sign symbolising the *heb* feast. Another solar disc, on top of the lid, is flanked by two feathers.

145

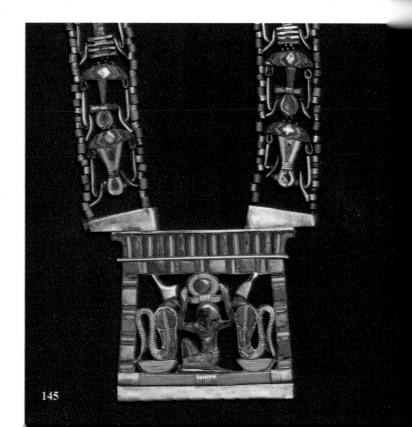

145

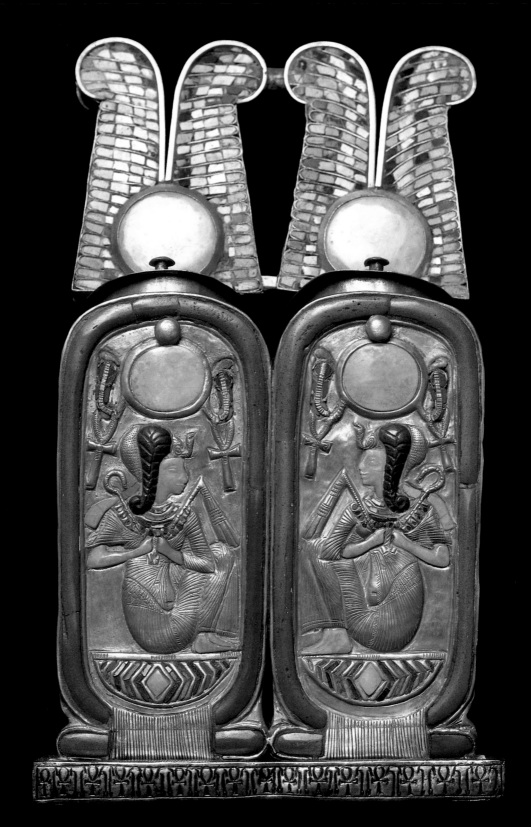

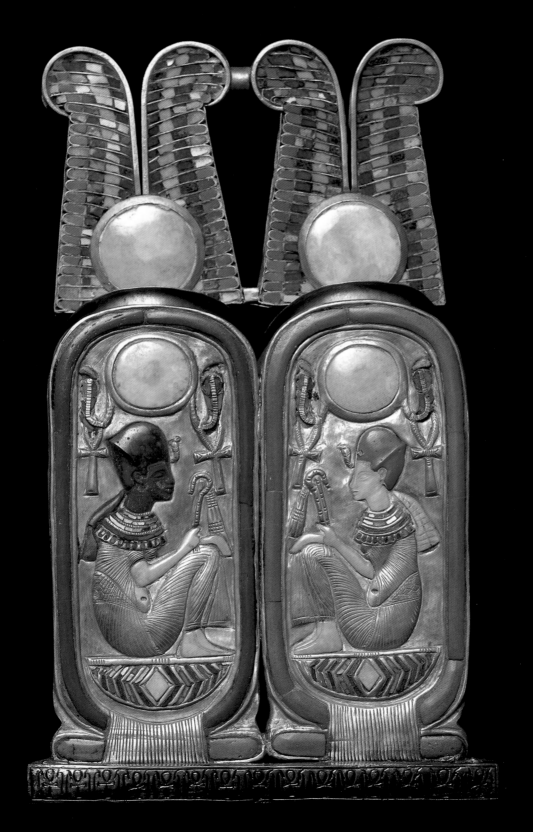

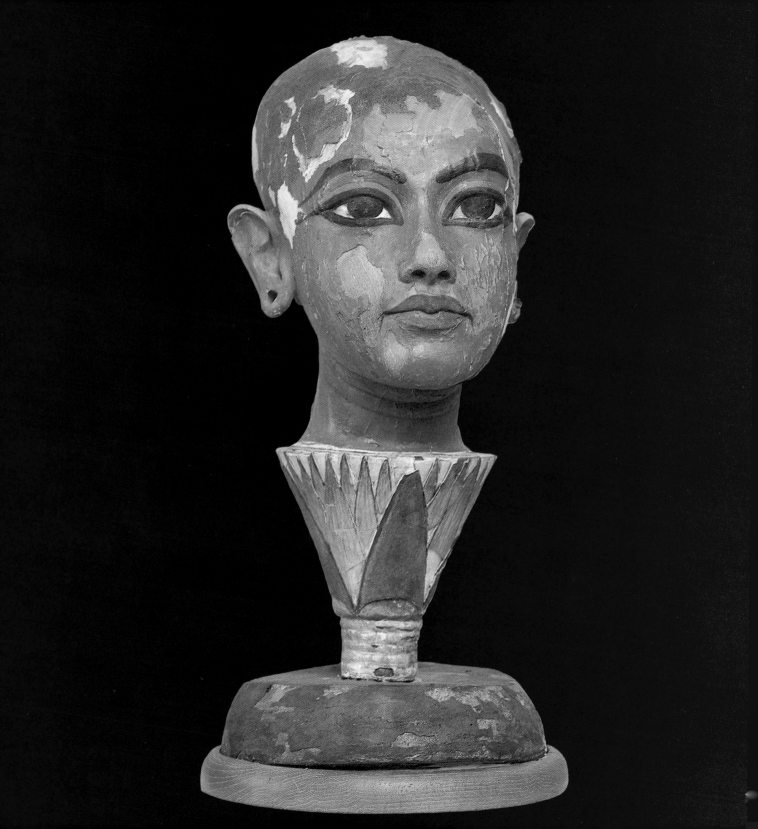

The other sides of the box show the king variously wearing the Blue Crown; again squatting over the *heb* sign, holding the *heka* and *nekhekh* scepters in one hand, and resting the other hand on his knee. Similar solar discs having the above-described decoration as its counter part on the other side exist over his head.

One of the king's faces is black, symbolising the underworld as well as the resurrection and continuity of life, black being the colour of the Nile mud that flooded the land and gave it fertility every year. Moreover, black is one of the colours associated with Osiris, who is sometimes seen with black skin, therefore, emphasising the belief that the king, after his death would personify Osiris, the god of the hereafter.

A representation of Heh, the god of eternity, is seen on the third side of the box. Like the king, he is squatting over the *heb* feast sign and holding two palm fronds, which represent the promise for a million years of life for the king, whose cartouches are represented beside him. Over his head, we see the name *neb kheperw re* enclosed by palm fronds.

The box's base is made of silver, and decorated with the *ankh* and *was* symbols of life and prosperity.

Indeed, the box shows great elegance, refinement and a fine artistic sense, as well as a high standard of skills that involved casting and hammering techniques.

147. Head of Tutankhamun emerging from the lotus flower

Painted wood; H. 30 cm; Upper floor, gallery 20; JE 60723;

Carved of wood that is covered with gesso and painted, this piece shows the king's head emerging from a lotus flower. The head is elongated, and this feature, together with the arched eyebrows, slanted eyes and large pierced ears, as well as the lines on the neck, are all characteristics of Amarna art. The lotus flower is depicted on a bluish-green base that represents the water of the Nile where lotus flowers usually profilerated.

The lotus was highly symbolic in Egyptian art and religious beliefs, appearing as one of the two heraldic symbols, the lotus and the papyrus, signifying Upper and Lower Egypt. In this piece, the lotus flower indicates the rejuvenation and the resurrection of the king. According to the Hermopolis theory of the creation of the world, the newly born sun was created from a lotus flower that emerged from the primeval ocean Nun. The lotus, which opened its petals and emerged from the Nile every day symbolised the daily rebirth of the sun. The deceased expected to be reincarnated in different forms in order to circulate the realm of the underworld; taking the form of the lotus flower would guarantee his rebirth as the newly risen sun.

For this reason, scenes of noblemen and women, carrying or smelling the lotus, frequently occur in the mural decorations in tombs. Because it opened under the rays of the sun, the lotus defeated darkness and death.

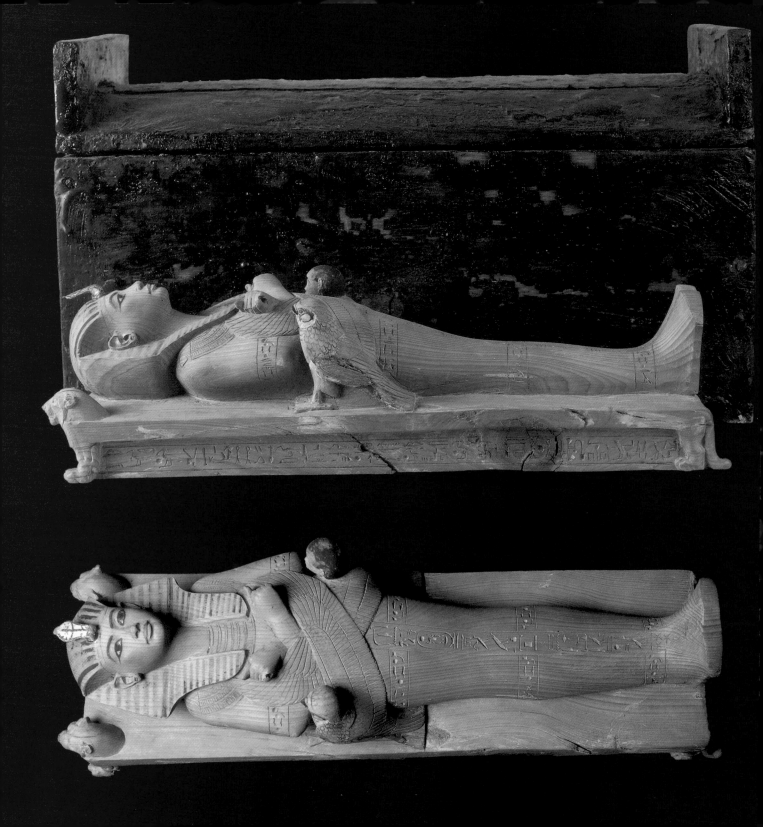

148. Miniature effigy of the pharaoh

Wood; L. 42 cm, H. 4.3 cm, W. 12 cm; Upper floor, gallery 25;
JE 60720;

This effigy came from a black rectangular chest in the treasury room, and according to the inscriptions on its sides, was dedicated to Tutankhamun by the scribe and treasury superintendent, Maya. It was wrapped in linen sheets, alongside miniature agricultural tools that were made for the *ushabti*, the symbolic answerers who were to serve the king in the afterlife. It shows the king lying on a funerary bed that looks like the mummification table, which is decorated with two lion heads as well as paws and tails. The king is represented wearing the *nemes* royal headdress with the royal cobra over his forehead. His eyes and eyebrows are outlined in black paint and the whites of the eyes are painted in. He is wearing a multi-tiered pectoral, and his arms are crossed in the Osiride posture. His body is wrapped in linen bandages like the mummy shape of the god Osiris. Beside the king are two birds: the *ba* bird with a human head and the falcon, representing the god Horus. The outspread wings of both birds cover the chest of the king.

The symbolism in this piece is very prominent, linking the king with the theme of resurrection and rejuvenation. The two lion gods, called Aker, are identified with the eastern and western horizons. Between them they support the rise of the sun, representing the sun of 'yesterday and tomorrow' and thereby, symbolising eternity.

The *ba* is one of the elements forming the human individual, which is considered as the soul or spirit. The *ba* was thought to return to the mummy and hover over it, reuniting every night with Osiris, who was embodied in the mummy itself. This union enabled the *ba* to be reborn each day among the living. The piece, in fact, symbolises the union of Ra and Osiris in the underworld, where, it was believed, they met in the depths of the darkness each night; and Ra received the power of rebirth from Osiris. At the same time, Osiris was resurrected in the form of Ra.

According to the same theme, Horus, the son of Osiris, became the son of the king, insofar as he had become Osiris. The son would assure a proper funeral procession and burial for the king, protecting him against any enemies that might hinder him in his path. Spell No. 60 of the Coffin Texts refers to the journey made by the deceased, who had become Osiris, and who had to be protected against foes, especially Seth. 'The god is in his shrine, he makes a journey by boat before going down into the necropolis; the boat is pulled straight towards the necropolis; the son whom he loves that is his pious heir, the *sm* priest, the lector priest and the embalmer, act for him; he receives food offerings; he ends in a columned shrine, which is to serve as his protection'.

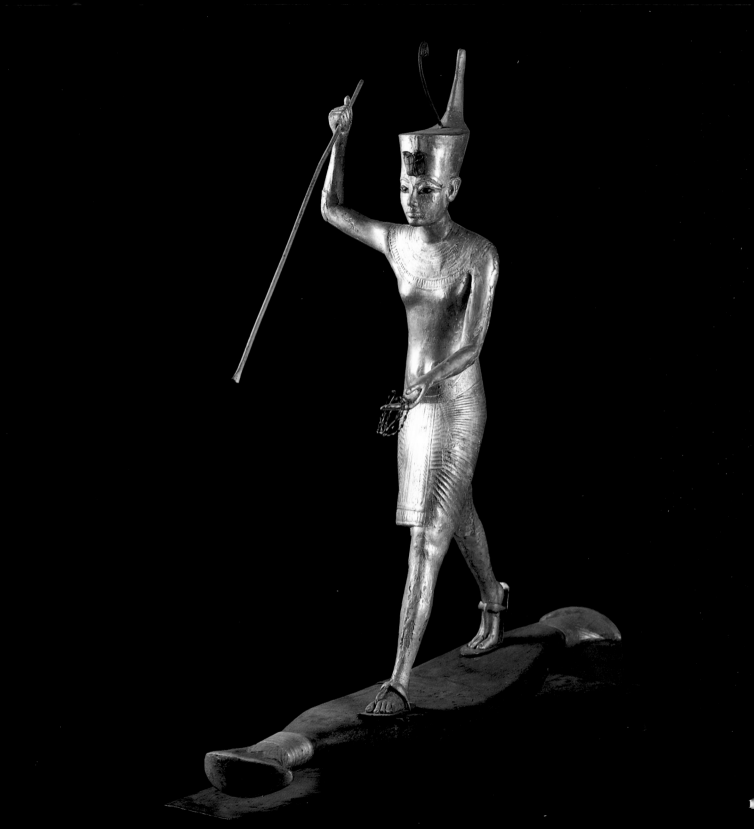

149. Tutankhamun on a papyrus raft

Stuccoed and gilded wood, bronze; H. 69.5 cm, W. 18.5 cm, L. 70.5 cm; Upper floor, gallery 45; JE 60709;

In another piece from the treasury room in the tomb of King Tutankhamun, the king is here seen standing on a flat papyrus boat that is painted green and partially gilded. The prow and stern are both decorated with papyrus flowers.

The king is represented wearing the *deshert* Red Crown of Lower Egypt, with the royal cobra over his forehead. His eyebrows and eyes are outlined in black; he wears a multi-tiered *usekh* pectoral, and is seen striding forward, holding a harpoon to hunt in the Nile. In his other hand, he holds a cord made of bronze to tie up his prey, creatures like the hippopotamus and crocodile. He wears a short pleated kilt and sandals. While the king may have wished to enjoy such a hunting trip in the Delta marshes in the afterlife, the scene bore a religious significance. It symbolised the victory of the king over the evil forces that would cause cosmic disorder. Moreover, it associated the king with Horus, who had spent 82 years fighting Seth, to avenge the murder of his father Osiris. Horus finally won victory over Seth, who had assumed the form of a hippopotamus. The harpooning scenes are also interpreted as a conflict between the fertile valley and the barren desert that threatens to overcome it. Success in the hunt then, meant the victory of the fertile valley over the desert.

The dynamic posture of the statue is such that was rarely seen before the Amarna period. Other influences from Amarna art are the naturalism of the king's face, together with the fleshy breast and abdomen; the slim arms and legs.

This statue was found together with six other royal statues and a group of 27 statues of divinities inside several black wooden chests. All were wrapped in sheets of linen as if mummified, and only the heads were visible. A date mentioning the third year of Akhenaten's reign was recorded on the linen sheets, indicating that those linen sheets had either originally belonged to Akhenaten, or that the statues themselves had belonged to Akhenaten, but had been usurped and modified to be reused for Tutankhamun.

150. Tutankhamun on the back of a leopard

Gilded and painted wood; H. 85.6 cm; Upper Floor, gallery 45; JE 60714;

One of an identical pair, this statue was found in the treasury room of Tutankhamun's tomb, in a black wooden chest containing another 33 statues of the king and of various divinities. The piece is carved of wood and covered by a layer of stucco, before being gilded. It shows the king wearing the *hedjet* White Crown, with the royal cobra over his forehead, his eyebrows and eyes outlined in black. He wears a multi-tiered *usekh* pectoral, a pleated short kilt and sandals. In his right hand, he is holding the *nekhekh* scepter, symbol of authority and a long staff in his left. He is standing on a rectangular pedestal that rests on the back of a leopard.

What appears simply as a hunting scene also had a religious significance, identifying the golden-skinned king as the sun god Re. The black leopard represents the night sky. The sky swallows the sun, in order to be reborn every morning, out of the body of the sky. The king on the leopard's back shows his domination of the situation, and emphasises his rebirth and resurrection. He is like the sun reborn every day.

Tutankhamun's calm face reveals his confidence in the triumph over death. Meanwhile, the panther is represented with a fierce naturalistic face that adds an air of liveliness and realism.

The influence of Amarna art is again apparent in the naturalism of the king's face as well as in the fleshy breast and abdomen, and the thin arms and legs.

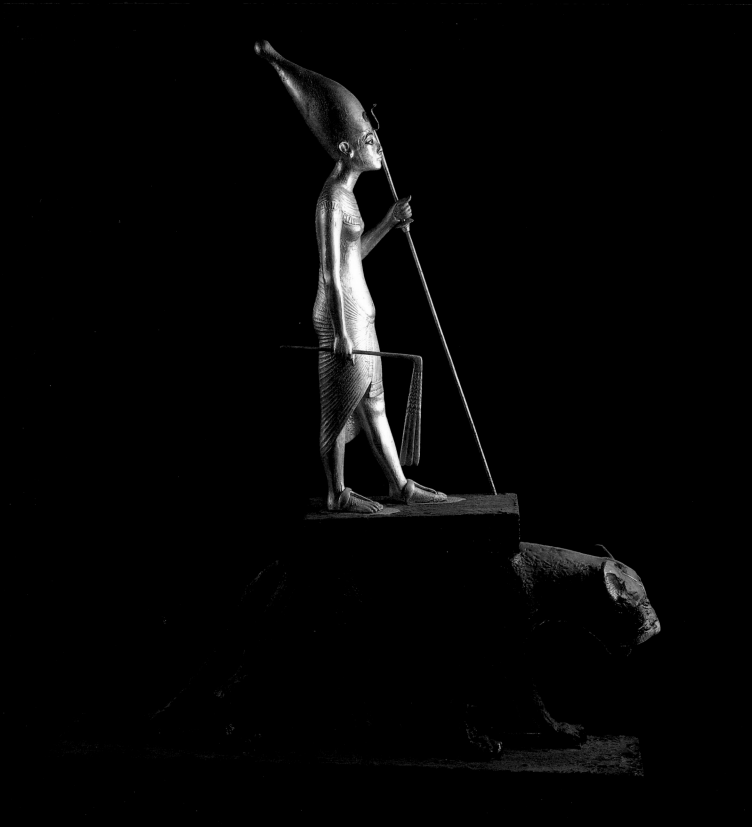

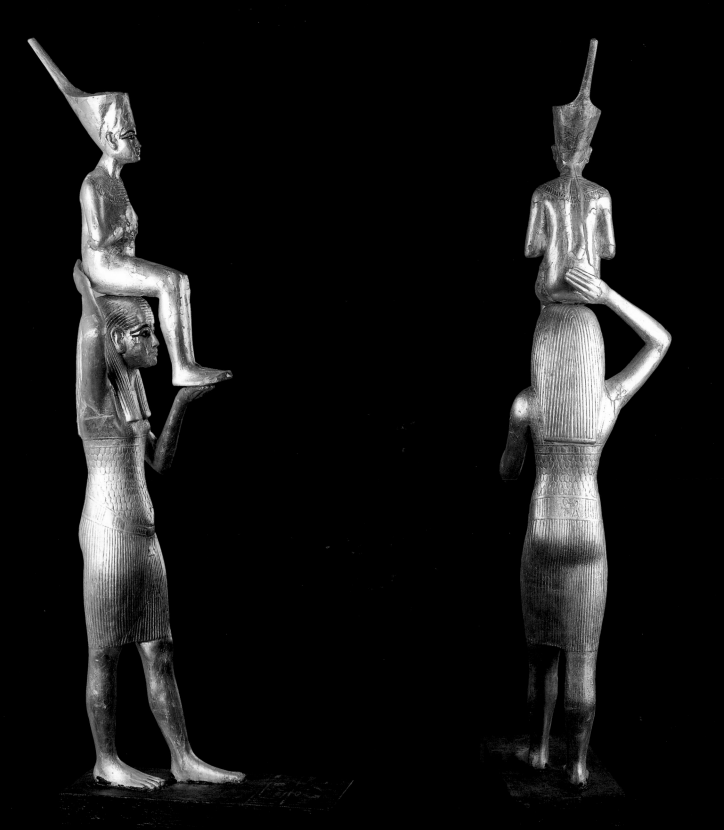

151

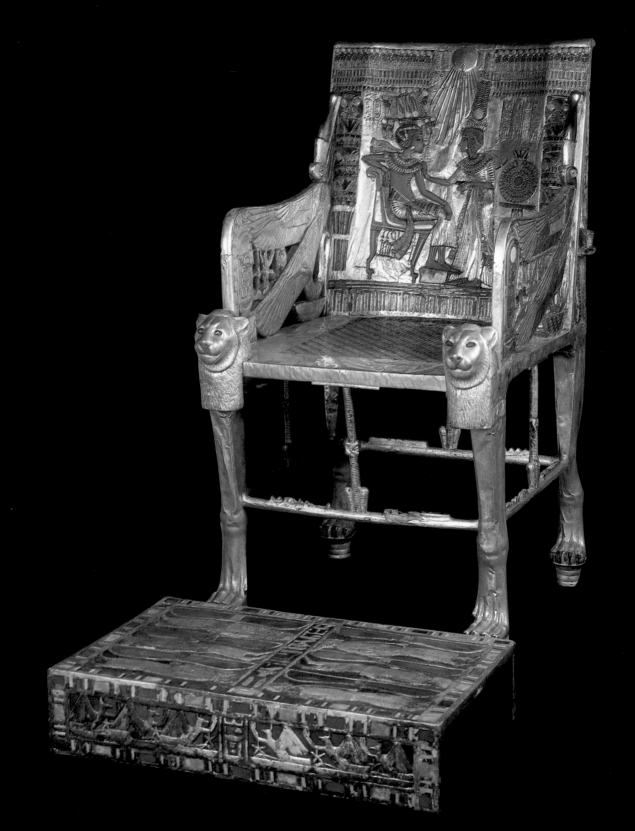

151. A goddess carrying the king

Gilded and painted wood; Upper floor, gallery 45;

Carved of wood and covered by a layer of stucco, this gilded statue was found in the treasury room of the tomb of King Tutankhamun. It shows the king wearing the *deshret* Red Crown, with the royal cobra over his forehead, his eyebrows and eyes framed in black. He wears a multi-tiered *usekh* pectoral and his body is shown covered in bandages, recalling those of the god Osiris. It shows the king carried by the goddess Menkart, who would help facilitate his journey through the underworld. She is wearing a long straight wig, and a tight pleated dress with geometric motifs. The buckle of her belt shows the *tit* symbol, which is the knotted girdle of the goddess Isis. Described in Chapter 156 of the Book of the Dead as 'red as the blood of Isis, this sign signifies the protection that Isis provided for the mummy. On the statue's rear side is the *ankh* sign of life and the *sa* sign of protection.

Like the previous two statues, this one also shows the Amarna influence in the naturalistic renderings of the two figures.

152. Throne of Tutankhamun

Wood, gold leaf, silver, semi-precious stones; H. 100 cm, W. 54 cm, D. 60 cm; Upper floor, gallery 35; JE 62028;

Another of the masterpieces in the Egyptian Museum, this throne was found under the funerary beds in the antechamber of the tomb. It is made of wood and covered with gold leaf, which is inlaid with silver and semi-precious stones like lapis lazuli, carnelian and turquoise, as well as coloured-glass paste. The piece shows great artistry and technical skills. The legs of the throne are in the form of lion's paws, inlaid with lapis lazuli claws. The front legs are surmounted with lion's heads, the eyes inlaid with white quartz and crystal. Originally, a filigree decoration forming the *sematawy* scene of the lotus and papyrus plants, was present between the legs of the throne, symbolising the unity between the north and the south.

The arms of the throne bear other symbols of unification as well as of protection, which is signified in the head of the cobra with the wings of the vulture; the two protective goddesses of Upper and Lower Egypt. The *sekhmety* Double Crown on the cobra head shows the unity of the country: the White Crown is made of silver and the Red Crown, of gold. The wings of the vulture enclose the *shen* sign of infinity; and the king's cartouches as well as the *nsw-biti*, one of his titles as King of Upper and Lower Egypt. In addition, the title on the right of the throne shows the king's original name of Tutankhaten. The name, meaning 'the living image of Aten' was replaced by 'the living image of Amen' following the abandonment of Tell el-Amarna and the return to Thebes, where the cult of Amen and the pantheon of other divinities was restored. The throne, therefore, dates from the earlier years of Tutankhamun's reign when he was still living in Tell el-Amarna.

The footstool, also carved of wood, stuccoed and gilded, features six bows that represent the foes of Egypt, shown as three Asiatic and three Nubian enemies, all under the complete control of the king who would trample over them. The hieroglyphic text includes the phrase *taw khaswt wrw n rtnw kher tbay.k* 'All the great foreign lands of the Retenw (Asiatics) are under your sandals.' The sides of the stool show the bird *rekhyt*, which symbolises the Egyptian populace, together with the sign *nb*, meaning 'all', alongside a star, which means 'to adore'. Together, these words mean that 'the king is adored by all the populace'.

The back of the throne shows one of the intimate royal scenes, popular in Amarna art, the artist representing intimacy between the royal couple. The king is represented wearing a composite crown over his short curly wig, together with large pectorals and bracelets. He also wears his informal, long, pleated kilt, which is inlaid with silver and adorned by a belt inlaid with semi-precious stones. The abdomen reveals a strong Amarna influence, and the god Aten, moreover, dominates the scene. The sun disc extends its life-giving rays to the royal couple. Tutankhamun is sitting on a cushioned throne decorated with various symbols, his feet resting on a cushioned *sematawy* footstool. His queen, Ankhesenpaamen, is holding a cup of perfumed oil, and lovingly rubbing his body. She is wearing a crown, composed of two horns that enclose a solar disc and two feathers, as well as a multi-tiered *usekh* pectoral and an informal pleated transparent dress inlaid with silver. The hieroglyphic inscription behind the couple shows her earlier name of Ankhesenpaaten, 'the one who lives for Aten'. Each of the sandals is either partially damaged or lost.

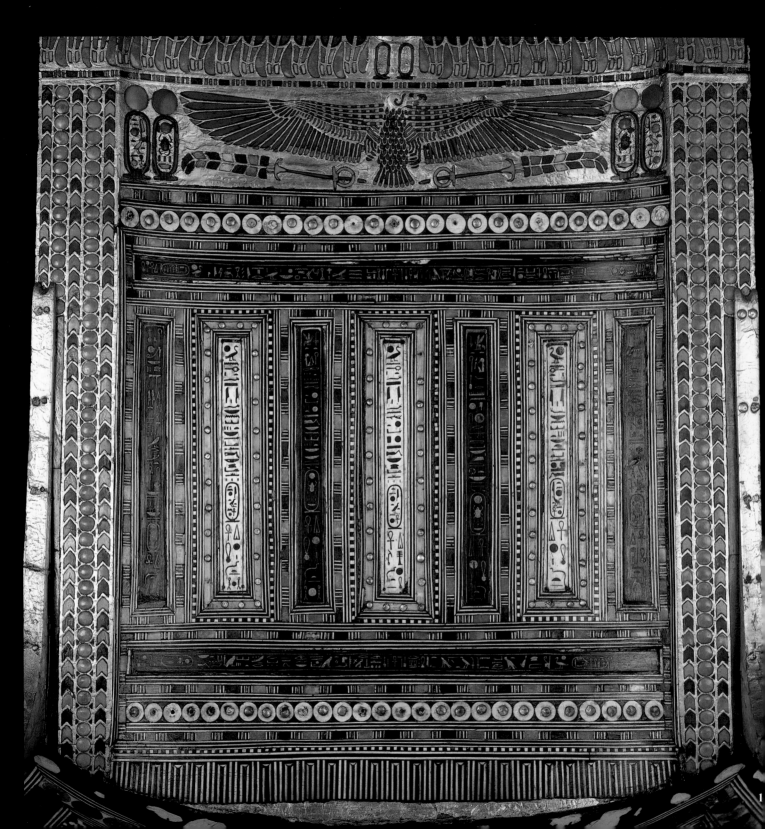

Beside the couple is a peculiar representation of a tall stand, the top of which is represented in a vertical manner. Bouquets of flowers decorate the right and left sides of the scene, while a frieze of protective royal cobras surmounted by solar discs are shown at the top.

153. Ceremonial chair

Ebony, ivory, gold leaf, stone, faience;
H. 102 cm, W. 70 cm, D. 44 cm; Upper floor, gallery 25; JE 62030;

This wooden chair was found in the annex of the tomb's antechamber. Inlaid with ebony, ivory and semi-precious stones, the stool is also partly gilded. As a folding stool that, supplied with a back, doubles as a chair; it is a fine example of folding furniture.

The feet of the throne are decorated with ducks heads inlaid with ivory as well as the *sematawy* sign, which is partly damaged.

Chairs were status symbol in ancient Egypt. Some are cushioned and there are stools with concave seats of latticework. Others have slanted or curved backrests, and yet others have straight, flat backrests. The legs are usually of feline design. The seats themselves are, most often, a mesh of linen cords, or woven rush. Some stools have crossed legs and deeply curved seats and others are three-legged.

The upper part of the chair back is decorated with a frieze of royal protective cobras surmounted by a solar disc. In the middle of the frieze is the disc of the god Aten, which is placed above two cartouches that bear the names of that god. A vulture goddess is represented, spreading her wings to protect the king, who would sit on the chair. Under the goddess is a representation of two feathers, together with the *shen* symbol of eternity and infinity. At the extreme right and left, we see the names of the king in his cartouches as Twt ankhaten and Nebkheprwre. The vertical hieroglyphic inscriptions underneath, giving the titles and new name of the king as Tutankhamun, were added later.

This footstool represents the nine enemies of Egypt as individuals; the enemies here replaced the traditional metaphor of the nine bows. They are depicted with the naturalism that is characteristic of Amarna art. Their facial features reveal their origin as either Asiatics or Africans. One is represented in old age, which is apparent by the wrinkles on his neck.

153

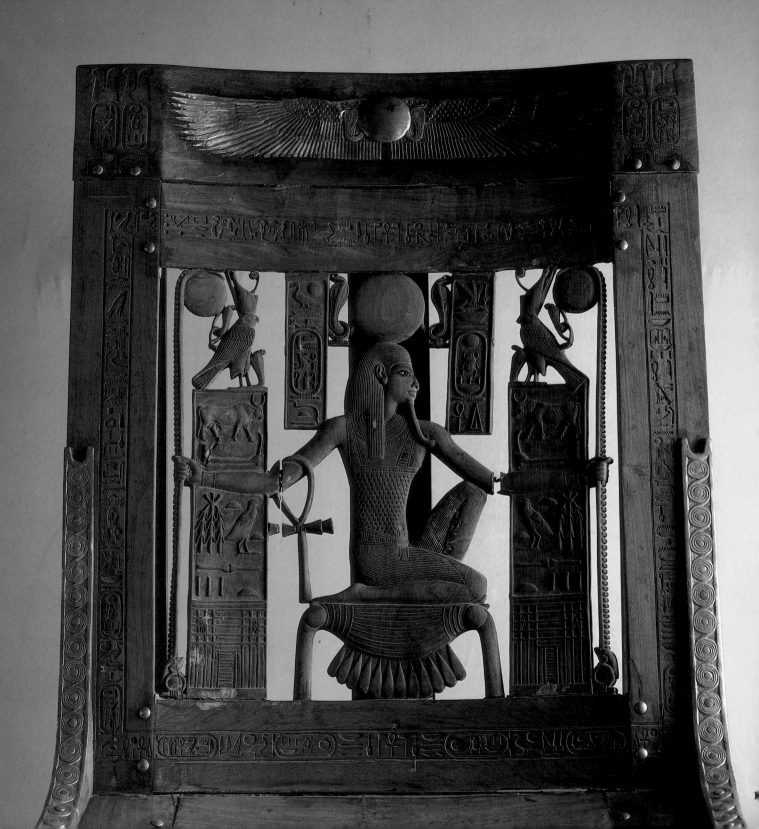

When the king sat on the chair, he placed his feet on the footstool, signifying that all his foreign foes were under his feet, and, therefore, subject to his authority. The accompanying text here reads as follows: 'All the great foreign lands of the Retenw (Asia) are like one thing under your sandals forever and ever like Re'.

154. Chair with god Heh

Wood, gold leaf; H. 96 cm, W. 47.6 cm, D. 90.8 cm;
Upper floor, gallery 25; JE 62029;

Found in the antechamber, this chair is carved from cedar wood and partially gilded. The upper part shows a winged solar disc that is adorned by two cobras in gold leaf, which are fixed to the wood. On the sides are the king's cartouches. The main theme here is the god Heh, who is shown seated on the *nbw* sign of gold. He is holding two palm ribs and an *ankh* sign hangs from his arm. Over his head, is a solar disc flanked by two cobras.

The chair legs are of feline design with gilded claws, and typical of chairs in the New Kingdom Period. Between the legs, was a gilded *sematawy* symbol, representing the unity of Upper and Lower Egypt, which is now destroyed.

Heh was the god of infinity, who is represented as a kneeling man holding a palm rib, or alternatively, sometimes with a palm rib on his head. The palm rib is called *rnpt,* which means 'a year'. The word Heh means a million; he was the god of eternal life. Eternity was symbolised by the word *djet* as well; *djet* was static eternity, while Heh was dynamic eternity. Heh belonged to the Ogdood pantheon of Hermopolis, according to that theory of creation. Sometimes, he is represented holding a solar barque, lifting it to heaven at the end of its journey through the underworld.

Both sides of the chair show falcons, wearing the double crown of Upper and Lower Egypt, and representing the king himself.

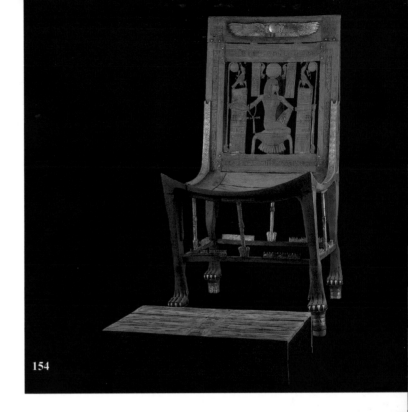

154

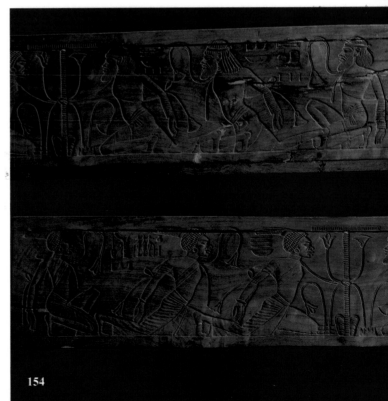

154

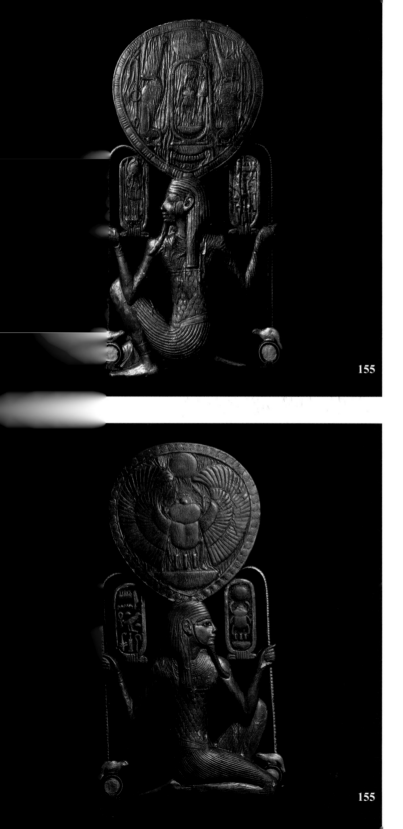

155

155

155. Mirror box with god Heh

Wood, gold leaf; H. 26 cm, W. 14 cm;
Upper floor, room 3; JE 62348;

This refined mirror case shows the god Heh as the main motif. He is represented in the above-mentioned pose, a kneeling man holding a palm rib and flanked by two cartouches giving the names of the king. Above his head, is the name *Neb kheperw re*, which is enclosed in an ornamented frame.

The mirror itself, probably made of silver, is now lost. It is thought to have been taken by tomb robbers, who broke into the tomb to pilfer gold and other valuables. Theban priests subsequently resealed the tomb.

156. Painted chest

Stuccoed and painted wood; H. 44 cm, L. 61 cm, W. 43 cm;
Upper floor, gallery 20; JE 61467;

This superb wooden chest, which was discovered in the antechamber of the tomb, is in an excellent state of preservation. It was one of the chests used to store luxury items and the personal belongings of the deceased, such as papyrus sandals, a gilded headrest, ritual robes, scarves, belts and necklaces. Many other boxes and chests were found in the tomb, some were shrine-shaped, others had flat lids or double-pitched gable lids. The lid on this chest is secured with cords wound around large knobs.

The scenes on the sides are also framed by geometric motifs. Cartouches of the king are surmounted by two feathers and a solar disc; and the cartouches rest over the hieroglyph *nbw*, meaning gold. Also on the sides are symmetrical representations of the king as a sphinx, trampling over his enemies, which here include the Nubians and Asiatics, whom he crushes under his paws.

On the side of the lid is Tutankhamun's cartouche, which is protected by the solar disc, two cobra heads and two wings of vultures at the sides.

The front and rear sides of the chest are decorated with a battle scene showing the king's victories over his enemies. The scene on the front is surrounded by geometric and floral motifs. The king appears here on a much larger scale, dominating the scene; and is

shown wearing the *kheperesh* Blue Crown, and riding in his chariot with horses, galloping. Holding the bow, he shoots arrows at his Asiatic enemies, who fall on the ground in confusion and disorder. Two fan bearers are shown walking behind him, and chariots of the army supporting the king follow close behind, represented with great discipline and order. Two protective vultures are hovering over the head of the king holding the *shen* sign of eternity and infinity; between them we see a solar disc with two heads of protective cobras. On the uppermost part of the chest, above the king himelf, is the sign *pt*, which means 'the sky', to show that the heavens are watching over the king. The rear side of the chest shows a similar battle scene against the Nubians.

Such battle scene postures had become the traditional theme for a victorious king since the time of Tuthmosis IV, and later found their place on the pylons and walls of temples, such as the battles of Ramsses II and Ramsses III.

The lid shows a hunting scene, which symbolises the victory of the king over the evil that would cause cosmic disorder. At the same time, hunting in the desert may well have been one of the royal hobbies that the king enjoyed in his free time.

In the hunting scene on the lid itself, the king and his companion are hunting with bows and arrows in their chariots. The king is shooting animals like gazelles, hyenas, ostriches and lions, which flee from him in confusion.

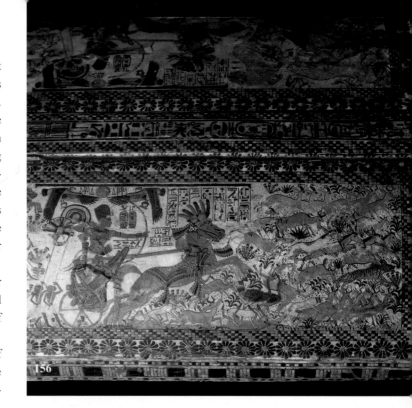

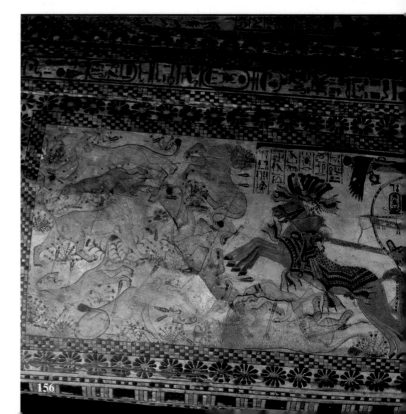

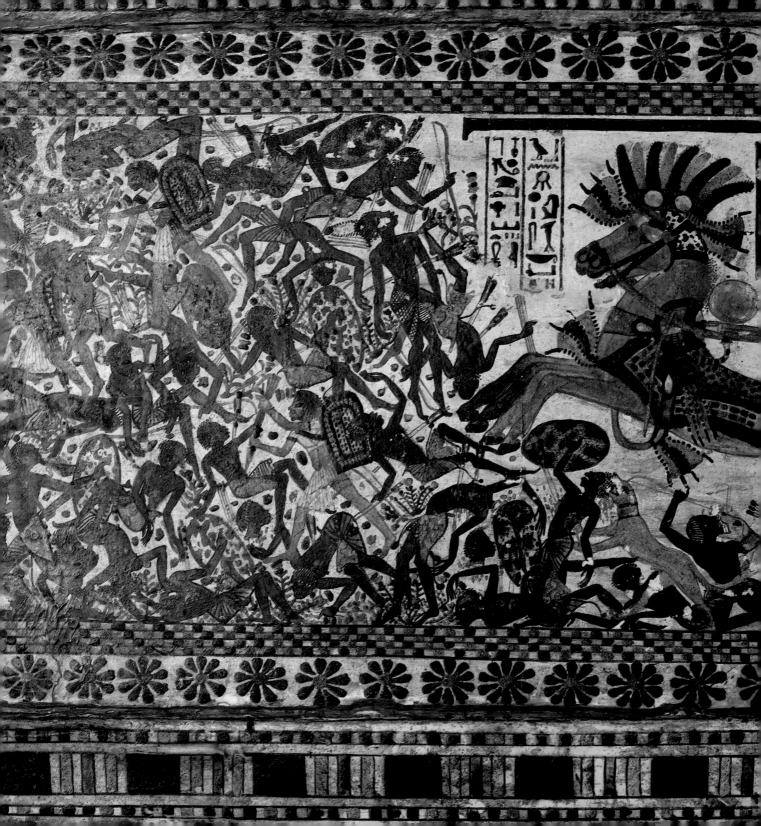

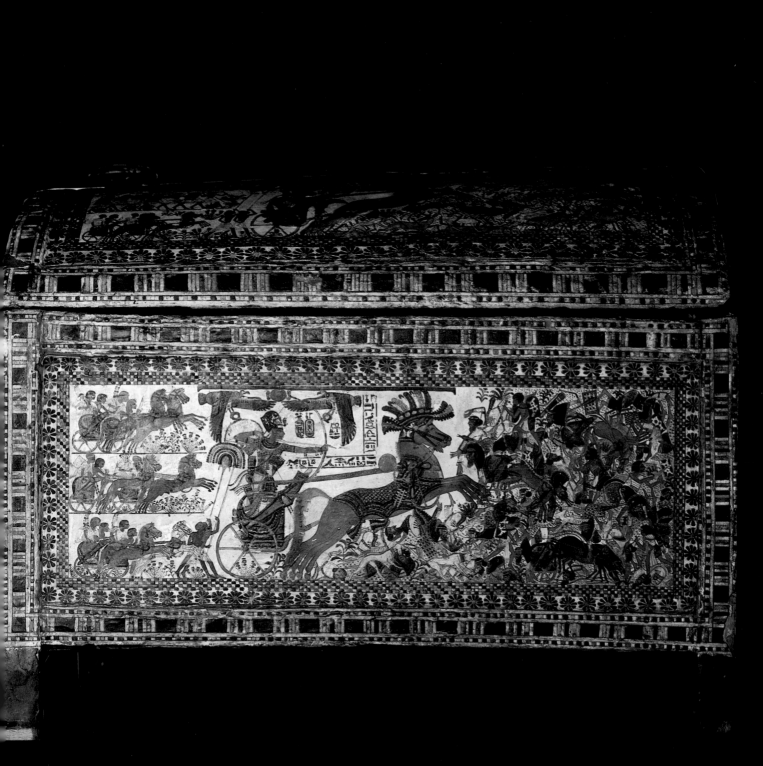

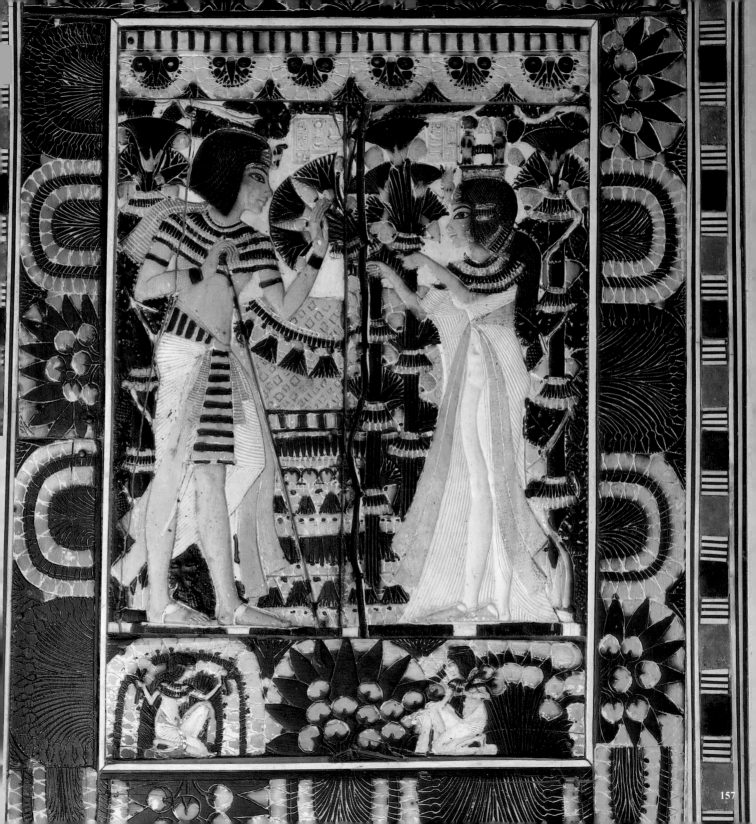

157. Ornamented chest

Wood, ebony; H. 48.5 cm, L. 72 cm, W. 53cm;
Upper floor, gallery 25; JE 61477;

This outstanding shrine-shaped box is made of wood inlaid with ivory and ebony, lapis lazuli and carnelian. Ivory tusks had been split to make thin panels on the box. The lid design is framed by geometric patterns inlaid with lapis lazuli and carnelian, surrounding another frame of floral motifs, also inlaid with ivory and ebony, showing cornflowers and mandrakes as well as pomegranates. The side shows a desert hunting scene, where trained dogs, lions, and leopards attack antelopes, bulls and calves.

The lid on this chest shows the royal couple in a scene revealing intimacy and affection. The queen is represented in a wig that is surmounted by a perfumed wax cone, with two cobras at the sides, and a large pectoral. Her transparent, pleated, fluffy dress reveals details of her body. She is holding a bouquet of lotus flowers, papyrus stems and mandrakes, ready to present to the king, who is shown wearing a layered curly wig, a large pectoral covering his shoulders, as well as a short pleated kilt. His body is inclining forward as though he is talking to her and about to accept the bouquet she is holding. The scene is lifelike and naturalistic. Beneath it, servants are seen picking the flowers for the bouquet.

On the sides of the chest, another scene of the royal couple shows them sitting in a garden, in which there is a pond filled with fish. The king sits on a cushioned chair and his wife is sitting at his feet. Holding a bow and arrow to shoot birds, the queen is holding another arrow ready to hand to him, and a servant is carrying a bird and a fish that he has shot. The scene not only records one of the king's hobbies reveals the intimacy between the royal couple, but also signifies the king's triumph over the evils that would cause cosmic disorder.

158. Ivory headrest with Shu

Ivory; H. 17.5 cm, W. 29.2 cm; Upper floor, gallery 9; JE 62020;

This *wrs* headrest was sculpted out of solid ivory, and consists of three parts: the curved neckpiece, the column and the base. Originally it was also provided with a cushion. Not only was such a headrest used during sleep, but also had a religious significance in the burial.

The column here is in the form of the god Shu, the god of air who would carry the king's head and raise it to heaven, as the one who had raised the goddess Nut to the sky, away from Geb the god of earth. Shu is shown as a man, wearing a straight wig and a pleated kilt. The two lion gods at the right and left sides are together the god Akr, who is identified with the eastern and western horizons. They support the rise of the sun between them, representing the sun of 'yesterday and tomorrow', thereby symbolising eternity. This imagery signifies that the deceased king would be raised to the heavens, to be reborn and rejuvenated, like the sun that rises in the eastern horizon each day. In addition, the scene indicates that the head of the deceased would remain raised, as the sun rises eternally. At the same time, the head would not be separated from the mummy, as mentioned in Chapter 166 of the 'Book of the Dead'.

Several other headrests were found in the Tomb of Tutankhamun, made of faience or ivory in the form of a folding stool.

Headrests had been buried in tombs since the Old Kingdom period, and the ancient Egyptians sometimes made small models of them, to use as protective amulets. The actual headrests were made of various materials such as wood, granite or alabaster as well as ivory. Funerary amulets were made of hematite.

159. Lion unguent container

Alabaster, gold and ivory; H. 60 cm, W. 19.8 cm;
Upper floor, gallery 20; JE 62114;

This perfume container is sculpted in the form of a standing lion, which raises one leg as though greeting the viewer, and is placing the paw of another leg on the sign sa, which was one of the protective amulets. A lotus flower graces the top of the piece, as one of the symbols of rebirth and resurrection. The eyes of the lion are covered with gold leaf, and the tongue and teeth are carved of ivory, and inlaid. On the lion's chest are the cartouches of the king and queen. The base of the container is formed like a lattice type stand.

The lion is sometimes represented as the god Re himself, as in Chapter 62 of the 'Book of the Dead', which says 'I am he who

crosses the sky, I am the lion of Re'. The two lion gods called Akr appear again here.

Perfume and unguent containers and jars were among the customary funerary equipment to be supplied for the dead as part of a proper burial, and to assure his well being in the afterlife. The preparation of unguents and perfumes was performed under the supervision of the *imy-is* or the *imy-khnet* priest.

Seven kinds of oils were placed in vases to go into the tombs. Some of the vases were amphora shaped, and others had a piriform body and a flat cylindrical mouth, or were cylindrical with splayed foot and conical mouth. In addition, some took on the form of a pitcher with one handle.

As well as vases containing perfume, slabs of alabaster were also used as receptacles. Measuring about 5.5 by 2.5 inches, they comprise seven circular hollows into which drops of perfume were poured. The names of the seven oils were inscribed on these slabs.

The perfume deity was the god Nefertum, son of the god Ptah, the god of Memphis. He was known as 'the lord of perfumes'.

158

160. Calcite boat in a tank

Alabaster, gold, H. 37 cm, W. 58 cm;
Upper floor, gallery 20; JE 62120;

This impressive artefact was sculpted of translucent alabaster stone, and found in the annex of the tomb. It was probably a decorative piece, a case of 'art for the art itself', as its function has not been determined with any certainty. The boat is decorated with the heads of gazelles, which were supplied with real horns. Their necks are adorned with gilded collars. Two female dwarves are sailing the boat, one sitting at the prow, holding a lotus flower, and the other standing on the stern. The object she formerly held is now lost. Both dwarves are represented with curly wigs, and are naked, except for their bracelets and armbands. The one on the prow is wearing a gold earring. The boat has a central cabin, surrounded by four columns that support a canopy. Both cabin and canopy are ornamented with cavetto cornices; and the columns boast papyrus capitals, which emerge from lotus flowers. Partially, painted and gilded, the boat rests on a pedestal in the middle of a basin. The basin's outer surface is decorated by floral and geometric motifs.

159

160

161

161. Calcite ibex vase

Alabaster; H. 27.5, L. 38.5, W. 18.5 cm;

Upper floor, gallery 20; JE 62122;

This alabaster vase, discovered in the tomb annex, is one of the innovative forms of perfume and unguent containers in the collection of Tutankhamun's funerary equipage. The ibex horn is actual, adding life and an air of realism to the piece. Originally, there were two horns, but one is lost. The facial features and the eyes are painted black, and the eyes themselves are inlaid with translucent rock crystal. The tongue of the ibex is carved of ivory, stained red and inlaid over the alabaster. The cartouche on the body of the ibex, contains the name Nebkheperwre, which is one of Tutankhamun's names, and this is surmounted by a solar disc flanked by two feathers.

162. Alabaster perfume vessel

Alabaster; H. 70.5 cm, W. 36 cm; Upper floor, gallery 20, JE 62114;

This remarkable alabaster perfume vessel was found in the burial chamber between the first and second shrines that housed the king's sarcophagus and the royal anthropoid coffins. Sculpted of four alabaster pieces that were fixed together, it features the *sematawy* sign. This sign, which indicates the unification of the two lands, that is, the north and south of Egypt, appears frequently on the sides of royal thrones throughout Egyptian history.

The two figures flanking the container, represent the god of the Nile, who ties the papyrus plant, signifying the north, and the lotus plant, symbolising the south of the country. During the months of the year when there was no inundation, the Egyptians called the Nile *itrw*. During the inundation season, they called it Hapy, who was deified and represented as a man with pendulous breasts and a prominent belly. In some representations, the body is covered with wavy blue lines, representing water.

The cartouches of the king and queen are inscribed on the container, and the upper part shows two cobras. The one on the right is wearing the *hedjet* White Crown of Upper Egypt and the other wears the *desheret* Red Crown of Lower Egypt. The flat rim of the

container is surmounted by a vulture, which spreads its wings in a protective manner to guard the figure of the king that, most likely, formed the stopper on the rim.

The cartouches of the king appear again on the base that supports the container. Two falcons with outspread wings surround the cartouches. Above them are solar discs and the sign *nbw*, meaning 'gold'. This scene signifies the mythical victory of god Horus over his enemy Seth, who, as the god of the city Ombos, is identified as the sign of gold.

163. Ceremonial chariot

Wood, gold Leaf, semi-precious stones and glass;
H. 118 cm, L. 250 cm; Upper floor, gallery 13; JE 61989;

This chariot is one of four that were found dismantled in the antechamber of the tomb. They were probably dismantled to allow them to pass through the tomb's narrow entrance, and most likely remained in pieces due to a lack of space inside. Chariots were sometimes taken into the tomb intact during funerals or were first dismantled then taken to the tomb in pieces. The dismantled chariot, moreover, represented death, due to its lack of dynamism.

The pieces were heaped up in confusion, as tomb robbers had broken into the tomb to steal gold. Theban priests subsequently resealed the tomb, however. Once reassembled, the chariots proved to be in an excellent state of preservation. They are made of wood covered with gold.

As Tutankhamun's reign was a peaceful one, and he was not one of the warrior kings, his chariots were used in civil life: for hunting, parades and rides. However, his military general Horemheb, who later became king, did lead a campaign in Asia in order to regain territory overrun by the Hittites. These adventures are illustrated alongside the royal cartouches, and the king, in sphinx form, tramples over the two rows of Negroes alternating with Asiatic enemies, who are tied together with a rope. The falcon standing over the figure of an enemy, is a symbolic representation of the king's victory.

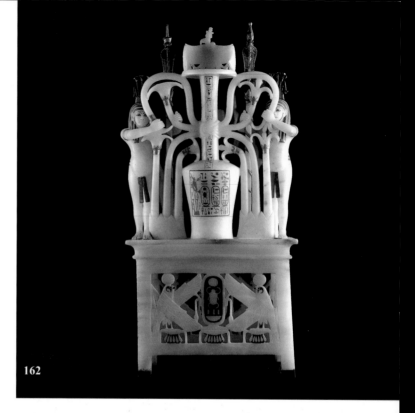

162

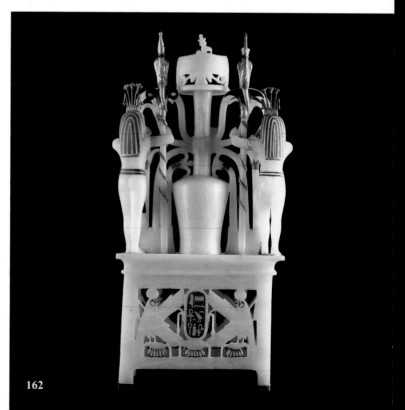

162

163

164 & 165. Accessories of the cermonial chariot

Wood, gold Leaf, semi-precious stones and glass;
Upper floor, gallery 13;

These accessories of the chariots were the stirrups, spindles and the saddle, as well as the blinders that were used to cover the eyes of horses for high jumps. War chariots, in addition, had quivers attached to the sides, for holding bows and arrows. The blinders of the ceremonial chariot of the king feature the *udjat* eye of Horus and lotus flower. The decoration also shows two heads of Bes, a deity who protected against terror and snakebites as well as scorpions. In addition it was his role to watch over childbirth.

In the New Kingdom Period, the scene of the king riding his chariot, poised with bow and arrow ready to attack his enemies, became the conventional scene for a king victorious over the real enemy, which was the evil causing cosmic chaos, represented here by the animals.

Chariots had arrived in Egypt by the time of the Hyksos domination, but their origin is difficult to determine with certainty. A considerable number were imported from Northern Syria and Mesopotamia. They were made of wood, ornamented with gold and silver. The chariots are constructed of a light, wooden semicircular and open-backed framework, furnished with an axle and a pair of either four or six-spoke wheels. A long pole attached to the axle by leather straps enabled the chariot to be drawn by a pair of horses, or alternatively, oxen or mules.

166. Game boards

Wood, ivory, bronze; H. 48 cm, L. 72 cm, W. 53 cm;
Upper floor, gallery 35; JE 61477;

Manufactured of wood and ivory, these game boards were discovered in the annex to the antechamber. The largest one is placed on feline legs and fixed to a sledge. The variety of the boards and their differing sizes indicate that this was the king's favourite game. There is even a pocket sized one for him to take along on trips and outings.

164

This game is called *senet*, which means passing. The gaming board consists of thirty squares divided into three rows of ten. The players threw little sticks or dice to take their moves. By blocking or removing the opponent's pieces, a player aimed to remove all his pieces from the board first. The *senet* game was one of the symbolic requirements of the funerary equipment for tombs.

In Chapter 17 of the 'Book of the Coming Forth by Day' ('The Book of the Dead'), the deceased is demanded to play this game against an invisible opponent, which could be fate or death itself. Winning assured success in overcoming any obstacles that might hinder his way towards resurrection and immortality. The game appeared as early as the Archaic Period and appears in the mural scenes on the 'mastabas' in Giza and Sakkara from the Old Kingdom Period.

In addition, one of the most famous and best preserved scenes in the Tomb of Queen Nefertary, wife of Ramsess II, in the Valley of the Queens in Thebes, shows the queen playing the *senet* game. It was a scene that reappeared at various times throughout Egyptian history, for example, in the Tomb of Padiwsir (Petosiris) in Tuna el Gebel near Minya, which dates from the third century BC.

The ancient Egyptians had other board games, such as the *men,* which means the endurance game. This one required two players and involved a long, narrow board that was divided into thirteen sections. In addition, there was the *mehen* game, which means 'serpent', and was played on a round slotted board in the form of a coiled snake. This game could be played by up to six people.

167. Boat with a sail

Wood, linen; Upper floor, gallery 20; JE 61239;

One of thirty five models of boats discovered in the treasury and the annex to the antechamber, this one is carved of solid wood, covered with gesso and painted. It has a central cabin, with a stair for access. The kiosks on the stern and prow, consist of an open canopy carried by four columns. The one on the right is decorated by a bull, and the other features a walking sphinx. The sail and cords are made of linen and there are two oars. Models of boats were believed to provide the deceased with a means of transport in the Nile of the hereafter. Two kinds were usually placed in the tomb, one intended

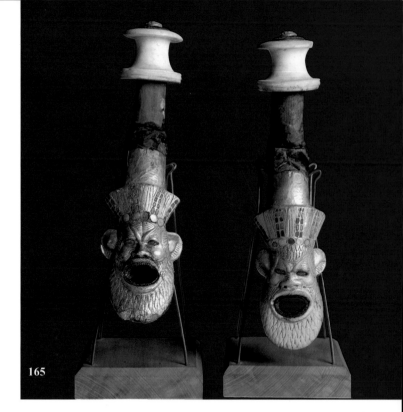

165

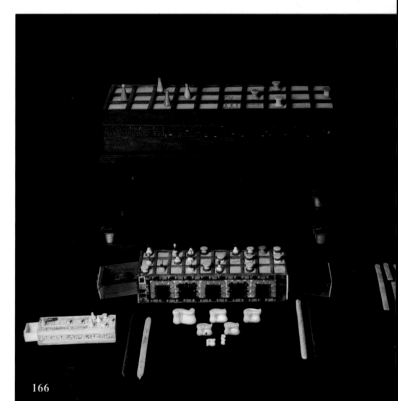

166

167

for sailing south with the prevailing wind, and the other for rowing downstream with the water current, to the north.

Actual funerary boats were used to cross from the east to the west of the Nile, either heading to the embalmment house, or for burial in the necropolis. These boats were used to transport the deceased, as the Nile provided the easiest and the most direct route.

Boats were also used for pilgrimages to religious sites like Abydos and Busiris. The several types included the *neshmt,* used for pilgrimage, and the simple papyrus skiffs.

168. A barge

Wood, gold leaf; Upper floor, gallery 20; JE 61330;

Carved of wood, covered with gesso and painted, this transport barge was discovered in Tutankhamun's tomb treasury. It has two steering oars but no sail. Steps lead to the central cabin, and the boat has kiosks on the stern and prow like the one above. Each kiosk consists of an open canopy supported by four columns. The one on the right is decorated with a bull, and the other features a walking sphinx.

Several boats were used together for funerals and sometimes a procession of boats crossed the Nile to go to the necropolis. Probably, there was a ready to go-fleet in Thebes that was rented for both funerals and pilgrimages.

169. Tutankhamen as god Khonsu

Granite; H. 152 cm; Groound floor, room 12; CG 39488;

This granite statue of King Tutankhamun was sculpted of granite and found in Karnak. It shows the king with a lock of hair at the side of his head, and a cobra over his forehead. He is holding the *djed* pillar, the *nekhekh* flail and the *heka* crook; and wearing the large pectoral and its counterpoise, all these emblems signify god Khonsu. As member of the Theban Triad worshipped at Karnak, Khonsu was the son of the god Amun and the goddess Mut. Khonsu was a moon god whose name means 'the wanderer'.

In addition, he was worshipped as the son of Sobek and Hathor at Kom Ombo, where he was associated with Horus, and called Khonsu-Hor.

170. A king with the Osirian Triad

Granite; Abydos; H. 139 cm; W. 116 cm;
18th Dynasty, Ground floor, gallery 9; JE 49537;

This granite statue of a king, accompanied by the Osirian triad, came from Abydos. Although it bears no inscription, it is known to date from the 18th Dynasty, due to the characteristic style of the facial features, showing full cheeks and prominent eyes.

Isis is represented wearing a tight dress and straight wig, surmounted by cow horns that frame a solar disc and with a cobra over her forehead. Osiris is shown in his traditional posture wearing the *atef* crown, and is crossing his arms over his chest. He is holding the *heka* crook, symbol of power and the *nekhekh* flail, emblem of authority. His body is enveloped in mummy shrouds.

The king is represented wearing the royal *nemes* headdress, with a cobra over the forehead, and is wearing the traditional pleated kilt. The head of the fourth figure is lost, and is thought to have been the head of the falcon god Horus, as the third member of the Osirian Triad. The arms of the figure surround the shoulders and sides of each other creating a strong harmony in the statue.

The deceased was equated with Osiris, the ruler of the realm of the dead. Indeed, the king's survival in the hereafter depended on his becoming as Osiris. The name of Osiris was mentioned in the funerary offering formulas; and in the judgment of the dead, he was the supreme arbiter.

Represented as a woman, sometimes with long elegant wings, or as a bird; the goddess Isis, on the other hand, embodied the virtues of the Egyptian mother and wife. She was the devoted sister-wife of Osiris, who searched for his body after his murder by Seth, beating her wings to infuse him with life. She also hovered over him as a kite, to conceive her son Horus. Isis was always regarded as the mother of each king, as the king was seen as the manifestation of Horus. The emblem on her head is a throne, and her name probably means a seat. Isis was closely connected to the cow goddess Hathor, which is why she is seen on some occasions with cow horns. Isis, moreover, was believed to possess great magical powers.

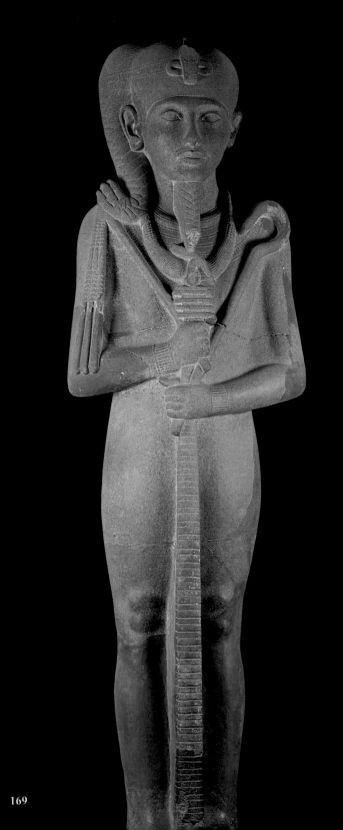

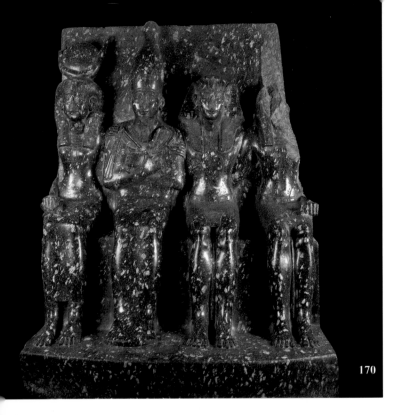

170

171

171. Coffin of Seti I

Wood, Western Thebes;
19th Dynasty, reign of Seti I 1314 - 1304 BC;
Upper floor, gallery 46;

This wood coffin belonging to King Seti I was among the cachette of mummies at Deir al-Bahari. The kings of the 21st Dynasty had gathered numerous mummies and coffins of former kings, and placed them in a secret hiding place to protect them from further robbery.

The lid shows the king in the Osirian position, his arms placed over his chest. The scepters he once held: the *heka* crook, symbol of power and the *nekhekh* flagellum, insignia of authority, are now lost. The coffin is covered with a thin layer of white stucco; and a cobra is painted over the forehead. A hole in the forehead suggests the former presence of another cobra, probably made of gold. The hole in the chin also indicates that a false beard had most likely been attached, also, likely to have been gold.

Several lines of the cursive hieratic script on the lid include two cartouches of Seti I, which are above the sign *nbw,* meaning gold. The script also reveals that the tomb of Seti I was restored during the sixth year of the reign of King Herihor, in the 21st Dynasty. In the 16th regnal year of the same king, the mummy of Seti I was first moved to the tomb of a princess, before being transported by King Panedem I to the tomb of Amenhotep II. Finally it became part of the cachette of Deir al-Bahri.

The mummy of Seti I, now in the Egyptian Museum, is one of the best-preserved royal mummies of the New Kingdom Period, due to the exemplary embalming techniques of the period.

Seti I, the second king of the 19th Dynasty was a great warrior king as well as an intrepid builder. In his third regnal year, he defeated the Libyans invading the west of the country. In the battle scenes shown on the outer northern wall of the Hypostyle Hall at Karnak, the king recorded his victories in Asia as well as in Nubia, where he crushed a rebellion in his eighth regnal year.

Seti I, who constructed magnificent monuments for the state gods, like Amen-Re, Ptah and Osiris; also boasts the largest and most beautiful of all the New Kingdom tombs in the Valley of the Kings (KV 17). In addition, he erected a splendid sandstone temple at the northern side of the necropolis in Qurna, to serve as a resting

place and a way station for the god Amen when he came in procession from Karnak during the Festival of the Valley. It is one of the temples to the west of Thebes, which bore the designation as the House of Millions of Years, in the hope that it would last forever.

At Abydos, Seti I constructed a magnificent temple for the god Osiris, together with a cenotaph tomb called the Osirion. He left a rich and flourishing empire to his son Ramsses II.

172. Ramsses II smiting his enemies

Painted limestone; Memphis; H. 99cm, W. 50 cm;
19th Dynasty, reign of Ramsses II 1304 - 1237 BC,
Ground floor, gallery 10; JE 46189;

This painted limestone block, showing Ramsses II smiting his enemies, came from Memphis. The king is wearing the Blue Crown and a cobra rests over his forehead. He also wears a large pectoral and a long, transparent kilt with a belt. Holding the enemies by their hair, the king is ready to smite them with his axe. The enemies' faces reveal a Libyan, a Nubian and a Syrian, and one is represented with a frontal view, thereby breaking the traditional rule of showing faces in profile. As early as the Old Kingdom, this pose of the king smiting his enemies was the traditional posture of the victorious king, and symbolised his victory over both the enemies of the country and the evil powers that would cause cosmic disorder in the world.

In the fifth year of his reign, the king waged war against the Hittite king Muwatallis and his allies. Intending to attack the Hittites, who were garrisoned in a fortress in the city of Kadesh in Syria, the king divided one army into four groups, which travelled through the desert towards the Dead Sea, and a second army sailed to the north of Byblos, in Lebanon. The four groups of the first army marched 10 km apart, so there was no communication between them. When Ramsses crossed the river, only one group crossed with him while the other three were still on the other side of the river.

The Hittites sent two spies, who misinformed the king, telling him that the Hittites had withdrawn in fear of the Egyptian army. The king mistakenly believed them and advanced in confidence. Suddenly, a thousand Hittite charioteers attacked.

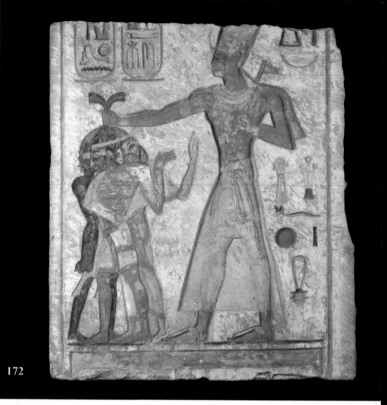

172

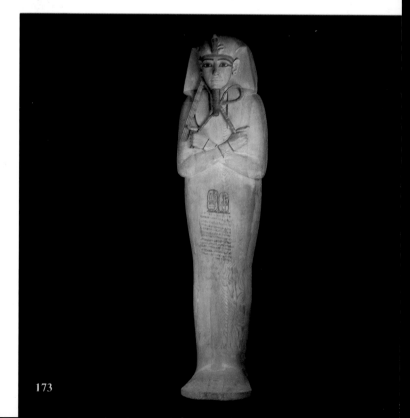

173

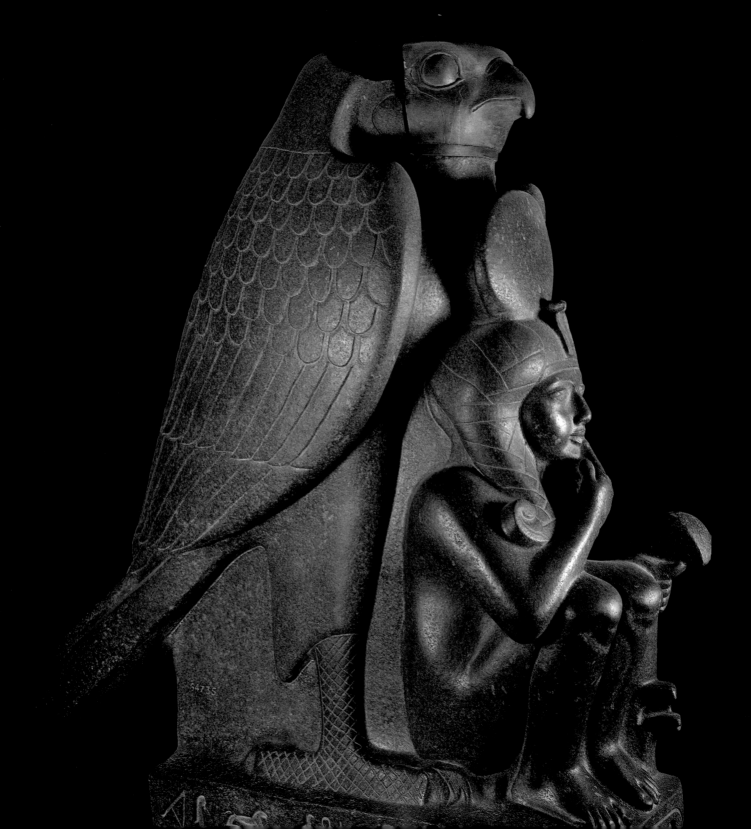

Ramsses managed to withstand the situation, and after claiming victory on the first day of the battle, retreated to a higher spot and erected a fortified camp, receiving the second army that had travelled by boat.

The Hittites then retreated in the direction of Kadesh, and thanks to their ill-disciplined army, the king was able to return to Egypt with his troops, announcing his victory. He later recorded the scenes of this battle on walls of temples, erected during his reign. Accounts of this battle were also given on papyrus. Mistaken as poetry at first, the whole text is preserved on the papyrus 'Chester Beatty III', and another version exists on the papyrus 'Raife and Sallier III'.

Later, as both sides realised that a complete military victory could not be achieved, they signed a peace treaty that ended hostilities between them

173. Coffin of Ramsses II

Wood; Western Thebes; L. 206 cm; 19th Dynasty, reign of Ramsses II 1304 - 1237 BC; Upper floor, gallery 49; JE 26214;

This coffin of Ramsses II, carved of cedar wood, was among the cachette of mummies in Deir al-Bahari. As there were several instances of major robberies, reflecting the corruption and the economic crisis at the end of the 21th Dynasty, the Thebes populace suffered from starvation and threats from Libyan tribes, in addition to public disorder. The kings of the 21st Dynasty, deciding that the safety of the royal tombs could no longer be guaranteed, began to move the royal mummies from their tombs in the Valleys of the Kings and the Queens for reburial in cachettes. Probably a removal of all the valuables from the tombs followed shortly after.

In the 19th century, the royal mummies cachette in Deir al-Bahari was discovered by a family, living in the village of Qurna, called Abd el-Rasool. They kept the discovery secret until it was finally revealed to the authorities and the Egyptologist Maspero by one of the brothers, following a dispute between the family members. As a result, Maspero transported the coffins and the mummies to Cairo in 1881. The lid shows the king represented in the Osirian position, placing his arms over his chest and holding the *heka* crook, the symbol of power and the *nekhekh* flagellum, emblem of

authority. His mummy, which was brought to Paris in 1976 for precise investigation and conservation, is now in the Egyptian Museum. Three lines written in the cursive hieratic script on the lid, include the two cartouches of Ramsses II, and also tell how Ramsses II's mummy was first moved to the tomb of Seti I before being taken to the cachette at Deir al-Bahari. King Ramsses II cut out his own tomb (KV 7), and made tunnels for tombs and burial chambers for his sons (KV 5) near to his in the Valley of the Kings, so that his sons would be buried beside him and resurrected with him in the realm of the hereafter. This king's magnificent rule lasted for 67 years, and was a reign marked by great political events and enduring monuments. His monumental temple at Abu Simbel is one of the great highlights of ancient Egyptian architecture today.

On the west bank of the Nile, Ramsses constructed his memorial temple, the Ramesseum, as well as building a shrine for the Queen Mother Tuya. In addition, he built several tombs for his wives in the Valley of the Queens.

174. Statue of Ramsses II as a child and god Horun

Granite; Tanis; H. 231cm; 19th Dynasty, reign of Ramsses II 1304 - 1237 BC, Ground floor, gallery 10; JE 64735;

This granite statue of Ramsses II was discovered in Tanis near the Great Temple of Amen. The site was probably a sculptor's workshop, as the limestone falcon head was found near the statue; suggesting that the statue was undergoing restoration there. It shows the king as a naked child with the signs of childhood seen in the lock of hair at the side of his head, and the finger in the mouth. A royal cobra lies over his forehead and the solar disc is on his head. He is holding the *sw* reed plant. These sculptural elements are thought to signify the name Ramsses or *Ra ms sw,* 'the begotten of the god Ra', as *Ra* is the solar disc, *ms* means 'the child' and *sw*, 'the plant'.

The huge falcon protecting the child signifies the Canaanite god Horun. This god was integrated into the Egyptian pantheon, and associated with the god Heremakhet Horus of the Horizon, who was manifested in the form of the Sphinx at Giza. The base of the statue

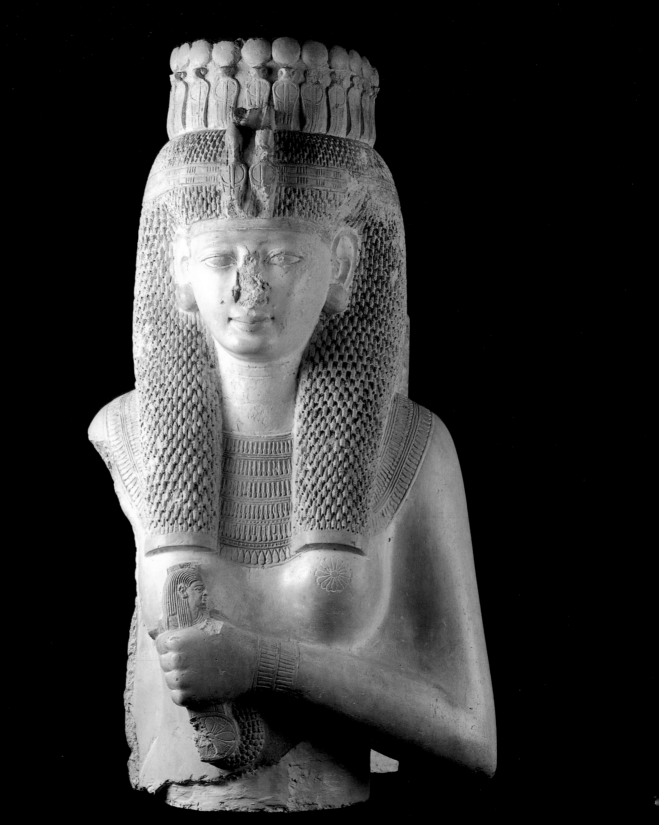

shows the names and titles of the king in his cartouches, and the name of the god Horun.

As the most celebrated and mightiest king of the Ramesside era, Ramsses II is often referred to as Ramsses the Great. He had two principal queens, Nefertary and Isetnofret. In addition, he married three of his daughters and two Hittite princesses. In all, he had about fifty sons and fifty four daughters. Many of his sons had military, civil administration or priestly careers.

175. Bust of Queen Merit-Amun

Painted limestone; Western Thebes; H. 75 cm, W. 44 cm;
19th Dynasty, reign of Ramsses II 1304 - 1237 BC,
Ground floor, gallery 15; JE 31413;

This well preserved limestone bust of Queen Merit-Amun was found in the Ramesseum in Western Thebes. She was one of Ramsses's II daughters, whom he married after the death of Queen Nefertary.

It shows the queen with a youthful face and almond-shaped eyes with two incised lines on her neck. She is wearing a three-part wig on which a diadem is decorated by two cobras : one wearing the Crown of Upper Egypt and the other, the Crown of Lower Egypt. Another diadem consists of cobras carrying solar discs. On her shoulders is a large pectoral consisting of beads, which form the word *nfr,* meaning beautiful. Her close-fitting dress is decorated with rosettes that are probably of gold. In her hand, we see the counterpoint of the *menat* beaded necklace, which is the symbol of Hathor, the goddess of music, love and beauty. She is wearing round earrings, and a double bracelet adorns her arms.

The queen's titles are inscribed on the dorsal pillar of the statue, which also shows her as the player of Hathor's sistrum and the player of the *menat* necklace as well as a dancer of Hathor. The queen's name is no longer apparent on the dorsal pillar, but the statue was dated with certainty after the discovery of an identical statue of Merit-Amun in Akhmim, on the east side of the Nile, north of Abydos. The Akhmim statue is colossal, the largest free standing statue of a queen ever discovered in Egypt.

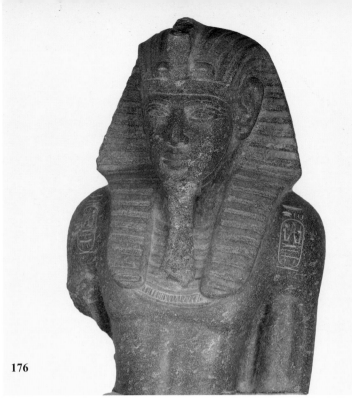

176

177

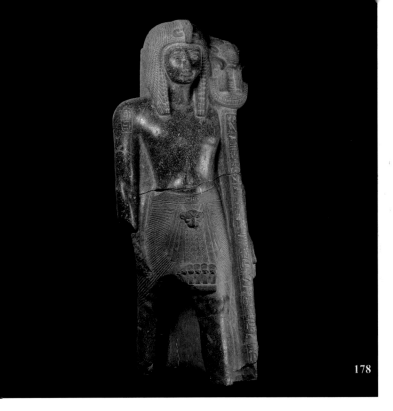

178

176. Bust of Merenptah

Granite; Western Thebes; H. 91 cm, W. 58 cm;
19th Dynasty, reign of Merenptah 1237 - 1226 BC;
Ground floor, gallery 13; JE 31414;

This granite bust of King Merenptah, which came from his temple in Western Thebes, shows him as a man in the prime of life, wearing the *nemes* crown and with the royal cobra on his forehead. His facial features comprise narrow eyes, a thin nose, wide lips and relatively large pierced ears. His false beard is now destroyed. Traces of paint still exist on the bust.

He wears a broad pectoral, and his titles and cartouches are inscribed on the shoulders. On the right side is his title *neb khaw*, 'Lord of the Crowns, and his name Merenptah hetep her Maat. The left side shows his other titles as *neb tawy*, 'Lord of the Two Lands (Upper and Lower Egypt) and his name as Mry-ra Ba-n-Imn.

The piece is an idealised and stylised representation of the king shown as a young man, although he was about fifty-years-old when he ascended the throne, following the death of his father Ramsses II, who reigned for 67 years.

The fourth king of the 19th Dynasty, Merenptah, reigned for about ten years. He cut out his tomb in the Valley of the Kings (KV 8) where his beautifully made sarcophagus was discovered. His mummy was found in the tomb of Amenhotep II, which was the place of another cachette of royal mummies, like the one in Deir al-Bahari, mentioned previously.

177. Victory stela of Merenptah

Granite; Western Thebes; H. 318 cm, W. 163 cm;
19th Dynasty, reign of Merenptah 1237 - 1226 BC;
Ground floor, gallery 13; JE 31408;

This granite stela came from the temple of Merenptah in Western Thebes, where it was placed in the king's fifth regnal year, to commemorate his victory over the Libyan and Proto-Hellenic invaders, whom the ancient Egyptians called 'sea people'.

The lunette at the top of the stela features sunken reliefs of the winged-solar disc, which symbolises victory. Below, the king is represented with the Theban Triad: the god Amen, who is present-

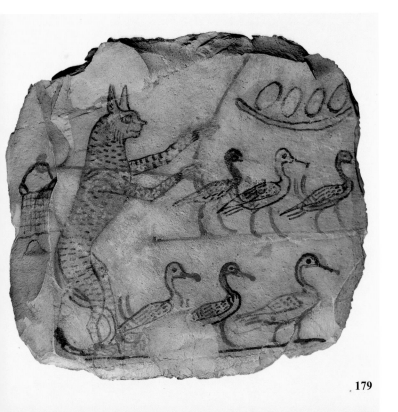

179

ing the sickle of victory to the king; the goddess Mut and the god Khonsw. Traces of yellow and blue are still visible on the reliefs. The accompanying text of 28 lines gives details of the victorious king's military success. It mentions his battles with the Libyans and sea people, and the 6,000 defeated or killed, in addition to 9,000 captured. Although the Libyan chief fled, his family members were captured, and the Egyptians, moreover, took a handsome booty.

After the account of the Libyan defeat on the stela, the king recorded the capture of the Palestinian cities: Canaan, Ashkalon, Gezar, and Yenoam. In the penultimate line, the king declares his victory over the people called 'Israel'. It reads, 'Israel is laid waste, its seed exists no more'. Here, Israel is not a country, but a tribe, as the word *rmt* contains the determinative of a man and woman, signifying 'people'; instead of the determinative *niwt,* which is a circle representing a city. The only ancient Egyptian monument mentioning the name Israel, this stela is also known as the Israeli stela.

Merenptah had reused this stela, which was originally situated in the nearby temple of Amenhotep III; the other side shows King Amenhotep III making offerings to god Amen.

178. Statue of Ramsses III as a standard bearer of Amen

Granite; Karnak; H. 140 cm;
20th Dynasty, reign of Ramsses III 1198 - 1166 BC;
Ground floor, gallery 15; JE 38682;

Found in the Karnak cachette, this granite statue of Ramsses III shows the king in the traditional stance, advancing his left leg forward. He carries a standard surmounted by a ram head, representing the animal sacred to the god Amen. Such standards were carried in temples and at festivals by the king, when he participated in celebrations, honouring the gods.

The statue has a delicate face and shows the king wearing a short wig, with a cobra on the forehead, and a pleated kilt, typical of the New Kingdom Period, which is decorated with a panther head and several cobras. The king's cartouches are inscribed on the shoulder and on the buckle of the belt, as well as on the standard he carries.

Commencing building operations at the magnificent temple of Medinet Habu in the peaceful, early years of his reign, the king then shifted his attention to matters of defence. From the regnal years five to eleven, he fought off three attempted invasions of Egypt, battling against the Libyans in year five; the Proto-Hellenic 'sea-people' in year eight, winning great victory over them; then he warded off a second Libyan attack in year 11.

The 'sea people' advanced into Egypt by both land and sea, and the subsequent battles are illustrated in reliefs on the walls of Ramsses III temple in Medinet Habu. The sea people were properly named the 'Sekelesh', and are thought to have come from the island of Sicily; the Peleset from Palestine; the Denyen from Danaoi or mainland Greece, and the Sherden from Sardinia. The scenes show the Egyptian king with his army and navy, winning an overwhelming victory. Some of the prisoners were women and children, and are shown in chariots, signifying that they had intended to settle in Egypt.

In his 20th regnal year, Merenptah sent one expedition to Punt (Somalia), for myrrh and incense, and another expedition to quarry turquoise from Serabit el-Khadim in Sinai.

179. Decorated ostrakon

Limestone; Deir al-Medineh; H. 11cm;
Ramesside period 1315 - 1081 BC; Upper floor, room 24; JE 63801;

This limestone ostrakon was found in the workers and artisans village at Deir al-Medinah in Western Thebes. It is a painted scene with a graceful cat standing on its back legs, carrying a bag on its back and holding a stick in its paws. The cat is herding six geese, which are represented in two registers. The upper part shows a nest with four eggs inside.

This is one of the figural ostraca that illustrate fable-like situations, in which humans are combined with animals in unusual forms. These so-called caricatures, or satirical drawings, are representations of myths and stories that are now rather obscure, so it is not easy to understand their true significance. The origin of the word 'ostracon' is Greek, which means a potsherd. In Egyptology,

1

the word ostracon, plural ostraca, refers not only to potsherds but also to chips of limestone that were used to write on. Papyrus was expensive, and ostraca was cheaper and more easily accessible, as well as more resistant to damage. This medium was used for writing and painting with a reed pen, using a red ochre base or carbon based colours.

Numbering around a thousand, the ostraca that have been found have enriched the knowledge of Egyptologists about various aspects of ancient Egyptian life.

'Harem Conspiracy', and documented on the 'Harris Papyrus', this affair shed light on the country's internal affairs at that time.

Ramsses III was buried in a magnificent tomb in the Valley of the Kings (KV11); though his mummy was later transferred to the royal mummy cachette in Deir al-Bahri. This monarch is considered the last significant king of the New Kingdom Period.

180. Statue of Ramsses III crowned

Granite; Western Thebes;
20th Dynasty, reign of Ramsses III 1198 - 1166 BC; Ground floor, room 14;

This granite statue was found in Medinet Habu Temple in Western Thebes. King Ramsses III is standing in the traditional manner, advancing his left leg forward. Wearing the White Crown of Upper Egypt, with the royal cobra over his forehead, he also wears the false beard and pleated, royal kilt. In one hand, he is holding the *ankh* sign of life, and in the other, his royal seal. He is joined by the gods Seth and Horus, who are crowning him; and both gods are holding the *ankh*.

Seth, on the right of the king, and Horus, on the left, were the mythological representations of the two powers in the country that had settled their dispute. Now reunited and reconciled, they are crowning the king. Seen together, they were understood to unite the two lands of Upper and Lower Egypt, thereby allowing the king to rule over an orderly and peaceful country. By crowning the king, they symbolically gave him the two halves of their world.

The statue demonstrates the advanced techniques of the sculptor, who mastered the carving of a hard stone like granite; and brought out its durability, particularly in the gaps between the three figures.

At the end of his reign, certain officials conspired with one of the king's wives, Queen Tiye, to deprive the legitimate heir of the crown and to favour instead, her son Pentawere. The plot failed, however, and the officials were caught and tried. Known as the

The Third Intermediate Period and the Late Period

The Third Intermediate Period covers the 21st to the 25th Dynasties (1081 - 656 BC), which was a period of decentralization when rulers of foreign origins appeared. The 21st Dynasty (1081 - 931 BC) saw two ruling parties: the family of Semendes I in the north, which ruled from Tanis (San el-Haggar) in the east Delta; and the second family was the priestly military regime of Panedjem in the south, which ruled from Thebes.

The kings of the 22nd to the 24th Dynasties were the Meshwesh tribe of Libyan origin, which stayed for generations in Bubastis in the east of the Delta. The first king of the 22nd Dynasty, Sheshonq, is the best known of these kings. Staging a campaign against Palestine, the king commemorated the event on the walls of Karnak temple, together with a list of the towns he attacked. This campaign was mentioned in the Old Testament in 'The First Book of the Kings' as taking place in the fifth regnal year of the Judean king, Rehoboam. It is described as an attack of Jerusalem by king 'Shishak'.

The 23rd Dynasty ran parallel with the 22nd Dynasty. The 24th Dynasty was based in Sais in the west of the Delta, and comprised two kings. One of them was Baccoris, who was remembered for issuing a series of laws.

The 25th Dynasty kings were descendants of a family that established itself in the land of Kush in Upper Nubia after the end of the New Kingdom Period and the loss of the Egyptian power there. They were centred in Napata in Upper Nubia, but soon extended their power to Thebes. This rule ended with the Assyrian invasion of Egypt and the looting and plunder of Thebes by the Assyrians.

The throne of Egypt then passed to Psametik I, who had been a governor of Sais in the western Delta, and was a vassal of the Assyrians. He became the founder of the 26th Dynasty (664 - 525 BC), which is regarded as the beginning of the Late Period.

Psametik I (664 - 610 BC) united the cities of the Delta and Middle Egypt and with the help of the powerful Theban called Montuemhat, sent his daughter Nitokris to Thebes to become the wife of the god Amun. Her position of authority, and highly important priestly functions, rewarded her with great income and prestige in Upper Egypt. Accordingly after nine years, Psametik was in full control of the country.

The king hired Greek mercenaries to form a strong army, and wide cultural interaction existed between the Greeks and Egyptians. During Psametik's reign, a sizeable Jewish community was founded on Elephantine Island on the Nile at Aswan.

Psametik I's son Neko II (610 - 595 BC) formed a strong fleet and began digging a canal between the Red Sea and the Nile. He was thought of as sending a voyage to go around Africa as well.

In addition, the *demotic* script, a more rapid and flexible system of writing, became popular at this time. This widespread adoption of the new script was the mainly the result of the successful unification of the country by Psametik I, after the *demotic* script was developed in the north; probably in Sais itself.

Moreover, there was a great revival of ancient art and architecture, known as 'archaism'. The sculptors of the Saite period looked back to the Old Kingdom Period for examples of statuary and carved reliefs, and copied them. In the south, the nobles copied from the old Theban nobles' tombs of the same period. Also, the cults of dead kings were revived.

King Psametik II (595 - 589 BC) conducted a campaign in Nubia against the Kushite kings of Napata, and succeeded in subduing them.

King Apreis (589 - 570 BC) was the fourth king of the 26th Dynasty. After a rebellion and civil war during his reign, he fled to Babylonia. Subsequently, the Chaldean King of Babylonia, Nebuchadnezzar II, invaded Egypt in 567 BC and intended to re-establish Apreis on the Egyptian throne. They were defeated, however, and Apreis was drowned and buried in the royal cemetery at Sais.

The fifth king was Amasis (569 - 526 BC), an army general who was chosen by the Egyptian army to replace Apreis. His reign was marked by a high level of welfare in the country together with ambitious building projects. He made an extension to the temple of Neith in Sais, and founded temples in the Oases of Baharyia and Siwa in the Western Desert. He also built a temple for the goddess Isis on Philae Island.

The 26th Dynasty ended with the reign of King Psametik III (526 - 525 BC), who was the son of King Amasis.

The Persians, led by Cambyses, conquered Egypt in the year 525 BC, marking the beginning of the 27th Dynasty (525 - 405 BC). This leader, who occupied Memphis, executed numerous Egyptians, and was known for his cruelty. Later he became reconciled with the Egyptians, in order to regain their recognition.

His successor, Darius I, completed the canal that had been started during the reign of King Neko II. He also constructed several temples in the oases.

Memphis had become the most dominant city once more, and the Greek historian Herodotus visited Egypt in 450 BC, leaving his accounts in his 'Histories', Book II.

Rebellions raged against the Persian rule, and King Amyrtaeos established himself on the throne, forming the 28th Dynasty (405 - 399 BC), only to be deposed by the founder of the 29th Dynasty, King Nepherites I from Mendes in the Delta. This king sent grain to Sparta to support the country in its conflict with the Persians.

Nepherites was succeeded by King Hakoris, who was an ally of Athens and Cyprus against the Persians. Egyptian coins were minted for the first time, in order to pay the Greek mercenaries. This king was able to repel a Persian attack in 385 BC. However, the 29th Dynasty (399 - 380 BC) ended in confusion; the last king was deposed by Nectanebo, the governor of the city called Sebenetus in the central Delta, who and became the new king.

King Nectanebo I, who founded the 30th Dynasty (380 - 343 BC), was an active builder of temples throughout the country. During his reign, the Persians tried to invade the country once again, but were routed by the flood. Nectanebo I believed that his piety had saved the country, and his successor, King Nektanebo II continued the temple building activities.

The Persians finally met success when King Artaxerxes III invaded Egypt, establishing the 31st Dynasty (343 - 332 BC), which lasted until the conquest of Egypt by Alexander the Great. Artaxerxes was known for his acts of brutality and cruelty. He sacked the temples and killed many sacred animals like the Apis bull and the ram of Mendes, which were sacred to the ancient Egyptians.

In 332 BC, the Macedonian king, Alexander the Great, invaded Egypt during the reign of the Persian king Darius III. After the fall of the Persians, following the battle of Issus, Egypt became part of Alexander's empire. He met no opposition from the Egyptians, who had been very hostile to the Persian occupation. He was crowned in Memphis and recognized as a divine pharaoh. Proceeding to Siwa Oasis, Alexander was supposedly accepted as the son of Amen by the oracle in the temple. He founded the port city of Alexandria on the site of an ancient Egyptian village called Rachotis. So began the Ptolemaic period of Hellenistic Egypt, which lasted until the Roman conquest in 30 BC.

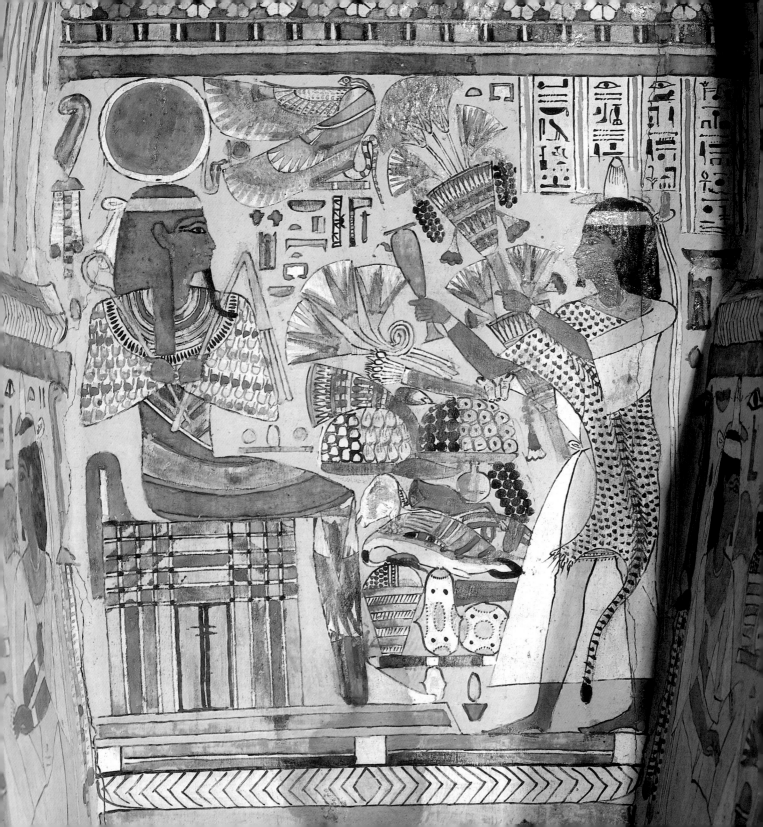

181. Anthropoid coffin of Ankhefenkhonsu

Wood; Western Thebes;
21st Dynasty, 1081 - 931 BC; Upper floor, room 27;

This multicoloured coffin of the scribe Ankhefenkhonsu was found in his tomb in Qurna, Western Thebes. Its owner was a scribe of the treasury of Amen during the 21st Dynasty. The wooden coffin is decorated with exquisite paintings on the inside as well as the outside. These paintings were thought to replace the former paintings on the tomb walls. Being even closer to the mummy, they were believed to have a better protective function.

The scene is divided into registers, showing funerary and ritual themes and deities, as well as representations of sacred symbols and amulets. The upper part is covered with geometrical designs, floral motifs, and representations of the protective *udjat* eyes, together with solar discs.

The main scene involves the presentation of offerings. We see Ankhefenkhonsu standing wearing a leopard skin, indicating his priestly function and career, with a perfumed wax cone on his head. He is holding a bouquet of flowers in one hand and a *kbh* libation jar in the other. He has placed a huge amount of offerings on an altar, including bread, poultry, vegetables and fruits. Facing him is a seated god with a solar disc on his head, and arms crossed over his chest. Behind this god is the word *imntt,* which means the west.

The next register shows a row of alternating sacred symbols, the *djed* and the *tit.* The *djed* was originally one of the attributes of the god Sokar, then of Ptah, and eventually, it came to symbolise the backbone of Osiris. Chapter 155 of the 'Book of the Dead' states the importance of the *djed* for the stability of the mummy on the day of burial. The *tit* is the knotted girdle of the goddess Isis, which is described in Chapter 156 of the 'Book of the Dead', as being as red as the blood of Isis; and it represented the protection that Isis provided for the mummy.

The lower part of the coffin shows a solar disc, flanked by two *udjat* eyes and two representations of the jackal-headed god Anubis, one of the most important funerary gods. He belonged to the mythical Osirian cycle. The black colour, moreover, was associated with the fertile black soil of the Nile valley that was linked with the concept of rebirth. Anubis was the protector god of the necropolis, a guide for the dead, who also kept watch over the ceme-

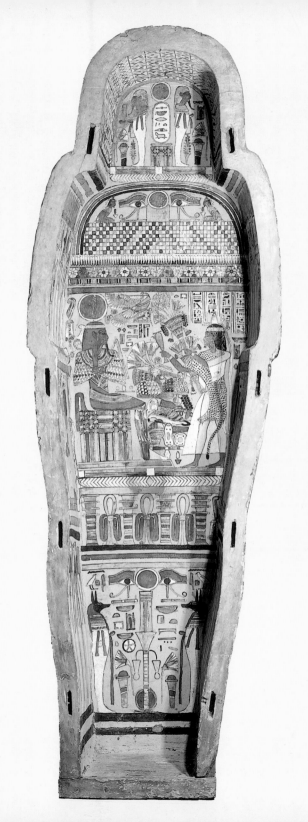

182

183

tery. His cult was assimilated with Osiris, as the one that wrapped the body of Osiris. Anubis, therefore, was closely connected to the mummification process. The epithets representing his funerary role were many: 'The Great God', 'The Foremost of the Westerners', 'The Foremost of the Divine Booth', 'He Who is Upon His Mountain', 'The Lord of the Sacred Land', 'The Master of the Necropolis', 'He Who is in the Mummy Wrapping', 'The Undertaker', 'He Who is in the Place of Embalmment'.

182. Alabaster Statue of Nakhet-Muti

Alabaster; Karnak;
22nd Dynasty, 931 - 925 BC; Ground floor, room 24;

This statue was found in the Karnak cachette, and Nakhet-Muti was the fourth prophet of Amen during the reign of King Osorkon II in the 22nd Dynasty. It shows Nakhet-Muti wearing a straight wig, and a pleated dress over which is a leopard skin, conforming to his priestly career. He is kneeling and presenting a round-topped stela. This pose became popular during the Third Intermediate Period and the Late Period.

The kneeling pose for private statues existed as early as the 3rd Dynasty, as in the statue of Hetepdief. From the New Kingdom Period onwards, the kneeling pose either imitated the simplicity of the earlier statuary, or incorporated other elements, such as the presentation of a naos or a stela. The statues shown presenting a stela are known as stelophorous statues.

The prophet, or the *hm-ntr* priest, was associated primarily with temple activities, rather than funerary cults. He officiated at the divine rituals, prepared the offerings, and shared in the economic affairs of the temple and its estates. The prophets had access to the inner parts of the temple and the first prophet was permitted to enter the sanctuary of the gods itself; to come face to face with and touch the image of the god in his naos in the temple sanctuary or the holy of holies.

The *hm-ntr* priest or prophet was assisted by the *wab* purification priest during the divine rites. 336

183. Harpist stela

Wood, Qurnah; 25th Dynasty, *c.* 850 BC;

Upper floor, room 22; JE 65756;

This votive stela shows a harpist called Senw playing to the god Rahorakhty. Discovered in Qurna in Western Thebes, the stela is carved of wood, covered with stucco and painted. The lunette shows a representation of the winged solar disc, representing defence and protection. The harpist is bald, signifying his constant purity, and wears a large, white, priestly garment and sandals. He is seated on a stool, holding his ladle-shaped harp. Running his fingers over the strings, he plays in front of the god Rahorakhty, who stands, holding the *was* scepter of prosperity and the *ankh* sign of life. In front of the god, we see an offering altar supporting the *kbh* jar, which was used in funerary ceremonies and libation rites.

Several gods and goddesses were concerned with music. While Hathor was the most prominent, Meret was the goddess of the vocal apparatus. The god Bes is often represented playing music, and the blind Horus khentyenerty was the harp god and the patron of harp players.

Many representations of temple musicians exist on private monuments as an act of worship or devotion to a god. The theme of a single harper playing to a god is frequently represented in New Kingdom art. In many such scenes, the harpist is singing one of the songs concerned with life and death.

The ancient Egyptian harps, known as *bnt* or *djadjat* in ancient Egyptian, are divided into two groups: arched and angular. The arched harp was a native instrument known as early as the 4th Dynasty, and appeared in banquet scenes in Old Kingdom mastaba tombs at Sakkara and Giza. The type used in that period is referred to as the shovel-shaped harp, which describes the appearance of its wooden body. This shape disappeared from the representations of scenes by the end of the Middle Kingdom Period, but reappeared in the New Kingdom Period.

In the Middle Kingdom Period, the ladle-shaped harp came into being, as seen in the tombs of Meir in Middle Egypt. This type became common in the New Kingdom Period. At the same time, a new kind of a boat-shaped portable harp appeared in the tombs of Beni Hassan in the Middle Kingdom Period, which became popular during the New Kingdom Period.

184

In the New Kingdom Period, a new type of an angular-shaped harp also appeared. In addition, the boat-shaped harp reached large dimensions, becoming as tall as the player, and the ladle-shaped harp diversified into several varieties.

184. The stela of Ankhefenkhonsu

Wood, gold leaf; Qurnah;

26th Dynasty, *c.* 664 - 525 BC; Upper floor, room 22;

This votive stela, discovered in Qurna, is carved of wood that is covered with stucco and painted. It shows a scene of personal worship before two gods. The lunette of the stela shows the winged-solar disc, beneath which are two cobra heads, symbolising protection and defence.

The main scene is a mirror image scene. On the right side, the funerary priest Ankhefenkhonsu places a perfumed wax cone on his head. Wearing a long kilt and sandals, he is worshipping the falcon-headed god Rahorakhty. The god is seen holding the *was* scepter of prosperity and the *ankh* sign of life; and is wearing a short kilt

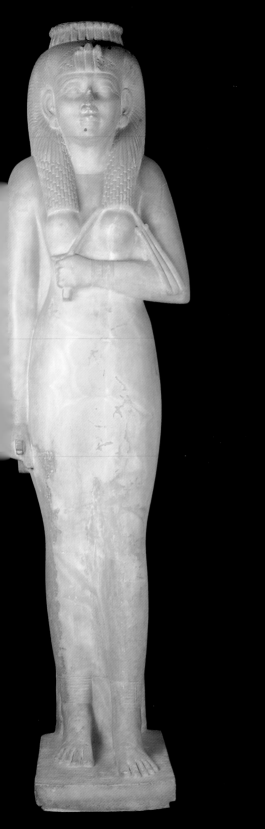

with the tail of an ox attached. In front of the god is an offering table supporting a large amount of offerings, including bread and poultry. On top of the offerings is a bouquet of lotus flowers. Beneath the altar, are two jars for libations that would have been wine, beer, water or milk.

The left side shows an identical scene of worship in front of the god Montu, who is represented as a man wearing the Double Crown. The scene is innovative, being depicted on a black background with the figures covered in gold leaf.

185. Statue of Amenirdis

Alabaster, basalt; Karnak; H. 170 cm, W. 44 cm;
25th Dynasty, reign of Shabaka, 712 - 698 BC;
Ground floor, gallery 30; JE 3420;

Carved of alabaster with a basalt base, this statue was found in Karnak in a chapel dedicated to Osiris in his form as Osiris Neb-Ankh, 'the Lord of Life', which is situated in the enclosure wall of Montu temple, north of Karnak. The piece is in an excellent state of preservation and shows consummate workmanship.

Princess Amenirdis was the daughter of King Kashta and sister of King Shabaka of the 25th Nubian Dynasty. She reigned from 755-656 B.C., holding the title of the God's Wife, *hmt-ntr* and the Divine Adoratrix, *dwat-ntr*. This priestly and political title indicates that she was the principal priestess of the cult of Amun, which rewarded her with high political and economic authority in Thebes.

Amenirdis stands here, wearing a long close-fitting dress and a long wig, covered by the wings of a vulture. Over her forehead, is a cobra and a vulture head, and on the wig, a diadem of cobras.

In one hand, she holds a *menat* beaded necklace whose counterpoise bears the image of Hathor, and in the other, a flagellum, bent to resemble a lily. Her bracelets and anklets are incised on the statue.

Discovered by the French Egyptologist Marriette; the statue inspired him when he was writing the story for Verdi's Opera Aida, giving the princess in the leading role, the name Ameniris.

186. Statue of goddess Taweret

Schist; Karnak; H. 96 cm, W. 26 cm;
26th Dynasty, reign of Psametik, I 664 - 610 BC; Ground floor, room 24; CG 39194;

This schist statue of the goddess Taweret was found in a limestone shrine to the north of the temple of Amun in Karnak. The shrine was used by the populace for prayer and the presentation of offerings to Taweret.

The goddess is represented with a hippopotamus head, human arms, the pendulous breasts of a nursing woman, the round belly of a pregnant woman and lion's paws. She is placing her front paws on the *sa* sign of protection. She wears a straight wig, with the base of a crown resting on it, although the crown itself is now lost. She also has a crocodile tail.

The name Taweret means 'The Great One'. She was a protective deity for pregnant and nursing women, driving evil spirits away from the infants. A popular domestic goddess, Taweret was continually worshipped throughout all ancient Egyptian ages. Even in the Amarna period, numerous amulets were found in the ruins of Tell el Amarna houses, testifying to her popularity. The goddess assumed an additional role as a healing deity, and her image appears on beds, stools and headrests.

Other deities took similar forms of a hippopotamus woman and these were also concerned with pregnancy and protection, such as the goddess Raret, whose name is included in the inscriptions on this statue. Other such goddesses were Ipet and Hedjet.

The inscription on the statue mentions that Pabsa, the steward of Nitokris, who was the daughter of King Psametik I, and had a political and a priestly career as the God's Wife of Amun; dedicated this statue to the goddess Taweret. Pabsa prayed to Taweret, pleading for the protection of Nitokris.

The statue is in an excellent state of preservation and shows fine workmanship and a high artistic sense. Indeed, the proportions and finish are remarkable.

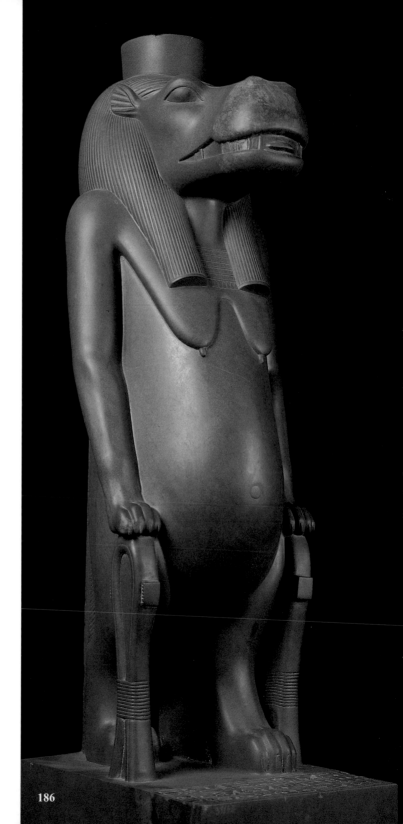

186

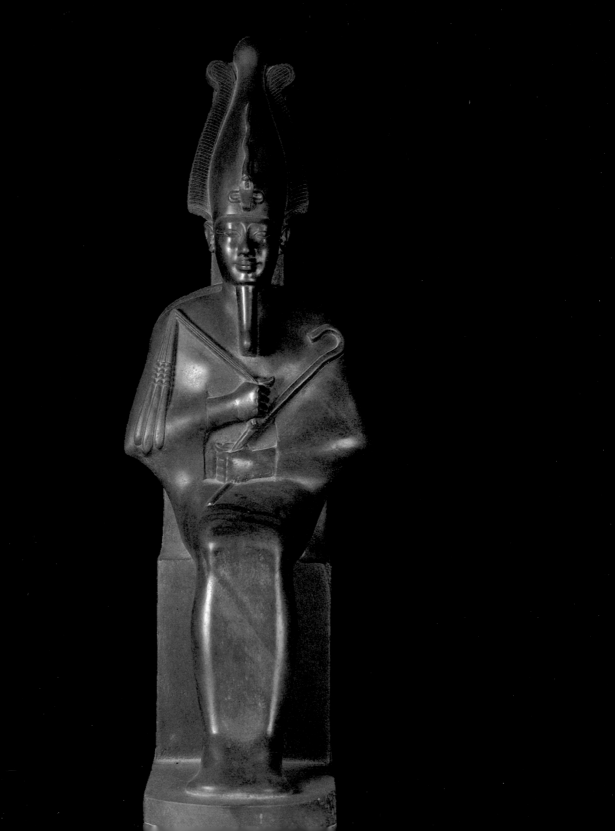

187. Statue of Osiris

Schist; Karnak; H. 89.5 cm, W. 28 cm;
End of the 26th Dynasty, *c.* 530 BC;
Ground floor, room 24; CG 38358;

Sculpted of schist, this statue was found at Saqqara, in one of the pits in the tomb of the chief scribe Psametik, a noble with the impressive titles of 'Overseer of the Seal', and 'Governor of the Palace'.

It shows the god Osiris seated and wearing the *atef* crown, with a cobra over the forehead as well as a false beard. He is in his traditional position, with the arms over the chest, and is holding the *heka* and *nekhekh*. His body is enveloped in mummy shrouds.

Osiris was one of the earliest Egyptian gods. Associated with death, his flesh was sometimes shown white like a mummy, or at other times, black, to resemble the fertile Nile mud. This aspect of fertility, coupled with Osiris' funerary role, gave him the qualities of the god of resurrection; hence his flesh was also shown as green, to signify rebirth. Many cult centres were devoted to Osiris, the chief among them being at Abydos, which became an important place of pilgrimage.

Osiris numerous epithets include: 'The One Who is Eternally Good', 'The Chief of the Westerners', 'The Lord of Abydos', 'The Lord of Busiris', 'The Lord of the Occident', 'The Good God', 'The King of Eternity', 'The Lord of the Sacred Land', 'The Lord of Eternity', 'The Lord of the Living People', 'The Opener of the Gates', and 'The Master of Immortality'.

The statue is another testimony to the excellent workmanship and high artistic qualities of Late Period statuary.

188. Statue of Hathor with Psametik

Schist; Saqqara; H. 96 cm, W. 29 cm;End of the 26th Dynasty, *c.* 530 BC; Ground floor, room 24; CG 784;

This schist statue was found along with the previous statue of the god Osiris, in one of the pits in the tomb of the chief scribe Psametik at Saqqara. Psametik is represented standing under the head of the goddess Hathor. A headdress covers his hair, and he wears a starched kilt. His hands are in the prayer pose.

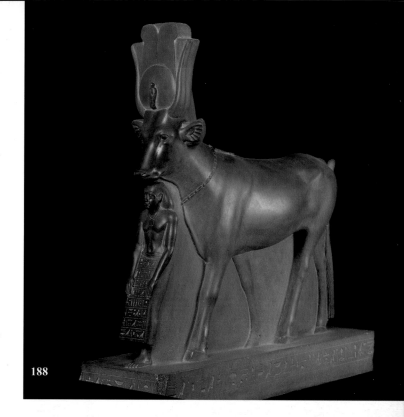

188

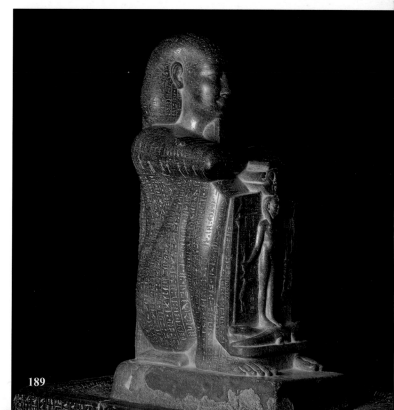

189

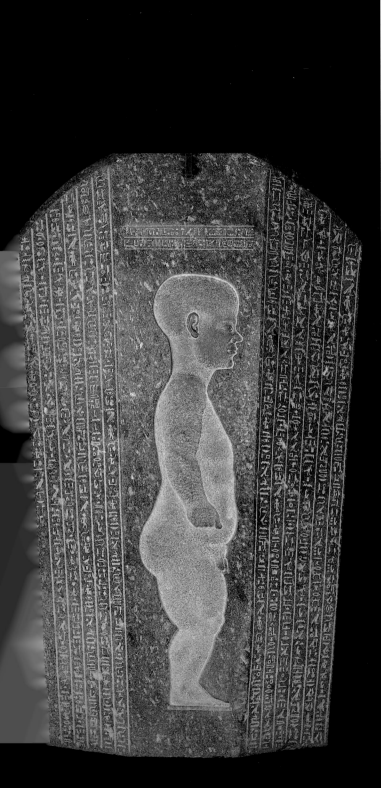

Hathor was the goddess of love, sexuality, beauty, joy, music and dance. She was worshipped in three forms: as a woman with the ears of a cow, a real cow, and as a woman wearing a headdress consisting of a wig, horns and a sun disc. She was regarded as the royal mother, who suckled the king. In her vengeful aspect, she shared the leonine form of the goddess Sekhmet. In her funerary role, she was a goddess of amiable character. She was believed to receive the setting sun and swallow it at the end of the day; protecting it by night, and to watch over its birth, next morning. The deceased, therefore, wished to have the same care from Hathor, in order to be resurrected. She was worshipped in the form of the seven Hathor goddesses who determined the destiny of a child at birth. Her cult centers were as numerous as they were diverse: Memphis, Sinai and especially Dendara were major sites for her cult. At Dendara, Hathor was also invested with healing properties.

Her funerary epithets were: 'The Lady of *deshret*', 'The Lady of the Necropolis', 'The Lady of Thebes', 'The Lady Living in Western Thebes', 'The Lady of the West', and 'The Lady of the Desert'. Hathor's additional epithets were: 'The Lady of the Turquoise, 'The Lady of the Sycamore', 'The Lady of the Faience, and 'The Lady of Byblos'.

The pose seen here recalls the former statues of kings, placed under the protection of gods, that had appeared from the Old Kingdom Period onwards, such as the Statue of King Chephren and that of King Neferefre, both represented with the falcon god Horus. In the New Kingdom Period, King Amenhotep II was represented with the cobra goddess Mrytsegret. Another statue of the same king with the goddess Hathor is also kept in the Museum.

This exemplary piece of Egyptian statuary expresses the idealism of the period together with the characteristic beauty of surface, grace of form and smiling face.

189. Magical statue of Djed Hor

Basalt; Tell Atrib; H. 78 cm; W. 35 cm;
Ptolemaic Dynasty, 305 - 31 BC, First floor gallery 13; JE 46341;

Sculpted of black basalt, this statue was found at Tell Atrib in the Delta, near Banha, north of Cairo, and is one of the statues made in the cube form, known as 'block statues', which were popular from the Middle Kingdom Period on.

It shows Djed Hor with his legs raised to his chest and his arms resting over his knees. Such a pose gives a large surface for lengthy inscriptions, and texts cover the entire statue here, including the headdress. Djed Hor's headdress covers his hair, leaving his ears exposed, and he has a short false beard,

This statue is one of the so-called healing statues. Attached to the front of the figure is a magical stela known also as the *cippi* or Horus stone. It shows the god *Hor pa ghered,* 'Horus the Child', represented as a naked boy with a lock of hair on the side of his head and a cobra over his forehead. The head of the god Bes surmounts the head of the god Horus, the child. In his left hand, Horus holds a lion and two serpents; and in his right hand, he holds a scorpion and an oryx. Standing on two crocodiles, Horus, in addition, is flanked by sacred emblems: the lotus of the god Nefertum on the right and a papyrus stem surmounted by a falcon on the left.

The texts on the statue refer to the myth of Isis and Osiris, when Seth plotted the murder of his brother Osiris and usurped the throne. Accordingly, Isis hid Horus the child in the marshes at the Delta, protecting him evil until he became a young man. Horus was then able to gain victory over Seth; thereby avenging the murder of his father Osiris, and regaining the throne of Egypt. This myth also became a symbol of the victory of good over evil and over the chaos that would cause cosmic disorder.

This stela, therefore, contains the idea of protection against evils and dangers, which also included bites and stings, and was thought to have healing properties in itself. Indeed, magic, prayer and medicine complemented one another in ancient Egypt, and needy people, suffering from danger, evil or sickness would pray in front of such stelae. Moreover, when water was poured over the stela, the sufferer drank it, in order to benefit from the magic represented in the texts inscribed, which would protect and heal him. The basin in front of this stela served to collect the sacred water, ready to be drunk.

190. Lid of a sarcophagus of a dwarf

Granite; Late Period; Ground floor gallery 49;

This lid of this sarcophagus, sculpted of black granite, shows the dwarf Dje Her, naked. The vertical columns of hieroglyphic writing on both sides are excerpts from the 'Book of the Going Forth by Day', and were intended to facilitate the deceased's reception in the realm of the hereafter, of the god Osiris.

Starting from the Late Period, figural representations became rare, although the scene on the lid here is dominated by the figure of the owner. Dje Her clearly suffered from a pathological deformity, which is depicted in the large head and torso and very short arms and legs. Representing deformity, however, was usual in ancient Egyptian art. A deformed man wished to be represented with all his defects, so that his *ka* would recognise his coffin in the afterlife. Showing nudity in adults was less usual though, but was probably done here to ensure the restoration of all vital functions in the afterlife.

191. Mummy cover of a young lady

Linen and stucco with polychrome decoration; Saqqara; H; 158 cm; Roman Period, 325 - 350 AD, Upper floor gallery 47; CG 33281;

This cover, placed over the mummy of a young lady, was discovered in Saqqara. Fixed on top of the mummy bandages, the cover is made of cartonnage, which is a material consisting of layers of linen or papyrus that were stiffened with plaster. Finally, it was painted, using the tempera technique, which involved the mixing of pigments with a binder that was soluble in water.

It shows the portrait of a young lady with large black eyes and thick curved eyebrows, a thin, sharp nose and a small mouth. Her hair is tied in a chignon, held by a pin. The young face wears an expression of quietude, and the head is slightly raised as though the deceased woman were looking and watching the world.

The young lady is represented wearing her exquisite jewellery of pendant earrings and three necklaces, as well as bracelets, rings and anklets. In addition, the space on her body is divided into squares, incorporating amulets. She is also seen wearing her Roman-style sandals.

A splendid example of the naturalistic portraits of the Roman Period, this portrait depicts the woman's facial features with realism. In addition, the social and economic standing of the deceased is apparent by her jewellery and clothing.

Illustrated Guide of the Egyptian Museum

This book is arranged in a chronological order and consequently provides limited guidance to the visitor. This section is intended to assist the visitor making a quick tour through the museum.

Ground Floor. Start with *Gallery 43* which is dedicated to the Predynastic and Archaic Periods. The most important pieces are the Narmer palette, the Libyan palette and various bowls. Proceed to *Gallery 48* which is dedicated to both the Archaic Period and the Old Kingdom. Here the statues of kings Khasekhem and Djoser as well as the base of Djoser's statue are exhibited. Continue towards *Gallery 47,* which contains Old Kingdom artifacts exclusively. Here the visitor will discover Fifi and his family, the servant statues, the statue of Hetepdief, the wood panels of Hesire, the Triads of Mycerinus, the statues of Neferefre, the head of Userkaf and a libation altar. *Gallery 46* is also dedicated to the Old Kingdom and houses the statue of a servant carrying two bags, the reserve head, the double statue of Nimaatsed, the scribe and a second colossal version of the head of Userkaf. Proceed to *Room 42* where the visitor will encounter another set of magnificent statues of the Old Kingdom. Start with the diorite statue of Chephren, then the seated scribe and the seated man, the wooden statue of Ka-aper or Sheikh el-Balad, the wooden bust of Ka-aper and his wife, the false door of Ika as well as the false door of the Mastaba of Nikaure. In *Gallery 41* observe the reliefs with paste inlays from the tomb of Nefer-Maat and the relief from the Mastaba of Kaemrehu in addition to the alabaster statue of Mycerinus. In *Gallery 36* observe the relief showing the name of Khasekhemwy, and in *Gallery 31* the reliefs of Snefru from Wadi Maghara.

Room 32 contains a collection of magnificent pieces of the Old Kingdom. Visit the ivory statue of Cheops, the furniture of Queen Hetepheres, the statue of Sneferu and then proceed towards the painted limestone statues of Ra-Hotep and Nofert. Do not miss the dwarf Seneb and his family, the painted relief of boatmen in a sporting competition.

Gallery 26 is dedicated to the Middle Kingdom. First, you will encounter the founder of the Middle Kingdom King Mentuhotep II, and the seated statue of Queen Nefert. As you enter *Gallery 21* you will encounter the statue of Senusert III and the funerary stela of Amenemhat. In *Room 22* ten limestone seated statues of Senusert I, the wooden statue of Senusert I, and the granite head of a Sphinx of Senusert I. *Gallery 16* contains the Double statue of Amenemhat III as a Nile god, the Sphinxes of Amenemhat III and the statue of Amenemhat III.

In *Gallery 11 the* visitor will encounter the last statue of the Middle Kingdom representing King Hor Auibre. The latter is followed by the head of Queen Hatshepsut that marks the beginning of the New Kingdom, the limestone sphinx of Hatshepsut and the newly discovered statue of a nurse and four princes and princesses.

At this point enter *Room 12* which houses the statues of Egypt's Imperial Age, namely the 18th Dynasty. The visitor will come upon the stela of King Ahmose, the standing statue of Hatshepsut, the reliefs showing the expedition of Punt, statues of Amenhotep II, various statues of Tuthmosis III including the white marble statue of Tuthmosis III kneeling, the Victory stela of Tuthmosis III and the Chapel of the cow goddess. This room is con-nected to *Gallery 6* where the seated statue of goddess Sekhmet stands. Here the visitor may chose to go upstairs or continue towards *Gallery 7.* The latter contains the two granite statues of Hatshepsut: a sphinx and a kneeling statue. Towards *Gallery 8* the Akhenaten era begins; a statue of Akhenaten making an offering, the Head of Akhenaten, the stela of Akhenaten's royal family and a sculptor's model of two royal portraits. *Room 3* houses many of Akhenaten's monuments such as the colossal statues of Akhenaten, the unfinished head of Nefertity, etc.

In *Gallery 13* the Victory stela of Merenptah and in *Gallery 10* the bust of Merenptah and the stela of Ramses II smiting his enemies and the statue of Ramses II as a child with god Horun are equally important artifacts. At this point the visitor either walks up the stairs to the treasures of Tutankhamun or continues visiting the last dynasties of the New Kingdom, the Late Period and the Greco-Roman Period on the ground floor. Here *Gallery 15* offers the bust of Queen Merit Amun and Ramses III crowned in *Room 14*. In *Room 26* the statues of the Late Period stand, and in *Gallery 30* the statue of Amenirdis stands.

Upper Floor. The upper floor at *Gallery 50* offers three options :
First: a ticket to enter the Mummies Room.
Second: entrance to the realm of Tutankhamun. Starting with *Gallery 45* that contains the two Ka statues proceed to *Room 3* where the Gold mask of Tutankhamun, the Inner and Outer coffins and the collection of Royal Jewellery are exhibited.

Third: a visit to the other sections of the upper floor ending with a visit to the Tutankhamun collection (starting from *Room 3* and walking till *Gallery 45*).

Galleries 48 & 43, house the funerary collection of Yuya and the faience of Djoser. The coffin of Ramses II rests in *Gallery 48*. *Gallery 54* houses the Bird stela, and *Room 53* the mumyfied animals and the Wall painting from tomb no.100 at Hieracompolis. The coffins of Seti I, the Anthropoid coffin of Queen Ahhotep and the Anthropoid coffin of Queen Ahmose Merit Amun rest in *Gallery 46*.

In *Room 37* the troops of pikemen and Nubian archers from the Middle Kingdom are particularly beautiful as well as the models of Meket Ra also from the same era exhibited in *Room 27*.

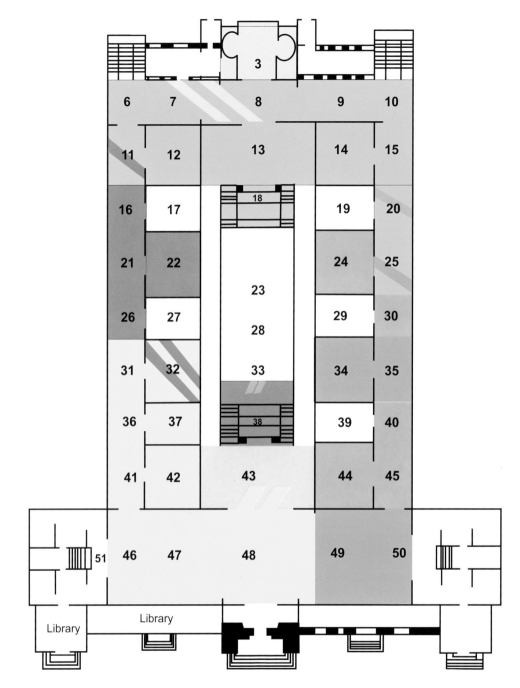

GROUND FLOOR

Archaic Period 3200 - 2700 BC

Old Kingdom 2686 - 2184 BC

Middle Kingdom 2040 - 1782 BC

New Kingdom 1570 - 1070 BC

Reign of Akhenaten, 18th Dynasty, 1350 - 1334 BC

Third Intermediate Period, 1069 - 525 BC

Late Period 525 - 332 BC

Greek Roman Period 332 - 30 BC

Yuya and Tuya's collection
Mummified Animals
Lunette
Sarcaphaguses
Items from tombs
Tutankhamun's collection
Treasures of Tanis
Jewelery
Portraits of Fayum
Deities
Ostraka and Papyrus
Daily Life
Mummies

UPPER FLOOR

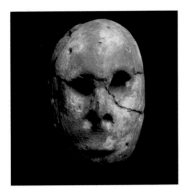

1. Human male head,
Ground floor, gallery 43;

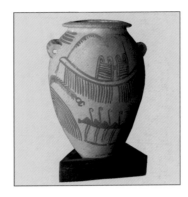

3. Vase with painted decoration,
Ground floor, gallery 43;

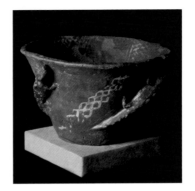

2. Vase with crocodiles,
Ground floor, gallery 43;

7. Antelope vessel,
Ground floor, gallery 43;

8. Cosmetic palette,
Ground floor, gallery 43;

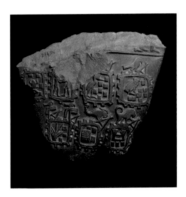

9. The Libyan palette,
Ground floor, gallery 43;

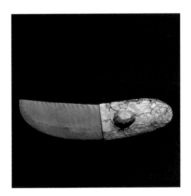

5. Flint knife with a gold handle,
Ground floor, gallery 43;

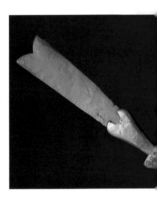

4. Flint knife with a fish-tail
shaped blade, Ground floor, ga
43;

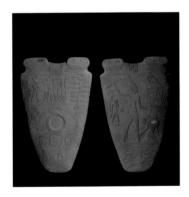

10. The Narmer palette,
Ground floor, gallery 43;

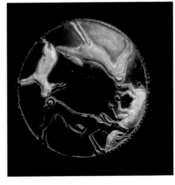

11. Disc from the tomb of Hemaka,
Ground floor, gallery 43;

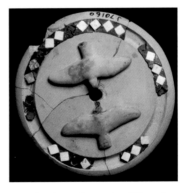

12. Disc from the tomb of Hemaka,
Ground floor, gallery 43;

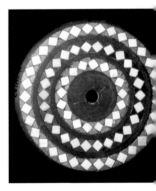

13. Disc from the tomb of Hen
Ground floor, gallery 43;

Ground Floor, Gallery 43

NB. Boldface numbers refer to pictures in the book.

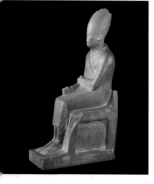

King Khasekhem,
~~und~~ floor, gallery 48;

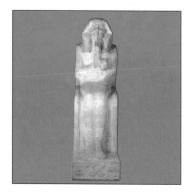

16. King Djoser,
Ground floor, gallery 48;

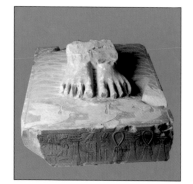

17. Statue base of King Djoser;
Ground floor, gallery 48;

37. Panels of Hesire,
Ground floor, gallery 47;

~~P~~anels of Hesire,
~~und~~ floor, gallery 47;

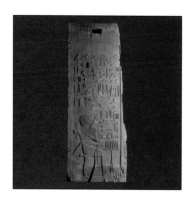

39. Panels of Hesire,
Ground floor, gallery 47;

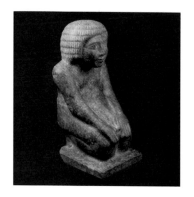

40. Hetepdief,
Ground floor, gallery 47;

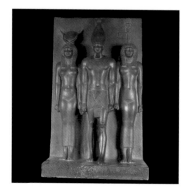

28. Triad of King Menkaura,
Ground floor, gallery 47;

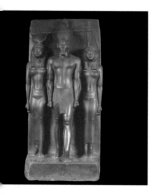

~~T~~riad of King Menkaura,
~~und~~ floor, gallery 47;

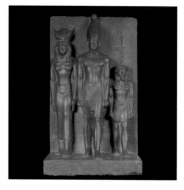

30. Triad of King Menkaura,
Ground floor, gallery 47;

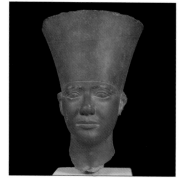

31. Head of King Userkaf,
Ground floor, gallery 47;

33. King Neferefre,
Ground floor, gallery 47;

Ground Floor, Galleries 47 & 48

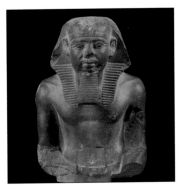

34. Bust of Neferefre,
Ground floor, gallery 47;

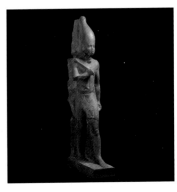

35. Schist statue of Neferefre,
Ground floor, gallery 47;

55. Family of Neferherenptah,
called Fifi, Ground floor, gallery
47;

63. Servant plucking a goose,
Ground floor, gallery 47;

62. Sandal bearer,
Ground floor, gallery 47;

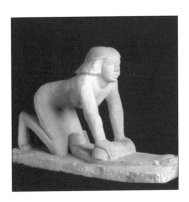

64. Woman grinding corn,
Ground floor, gallery 47;

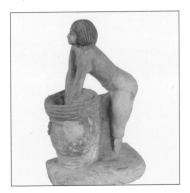

60. A female brewer;
Ground floor, gallery 47;

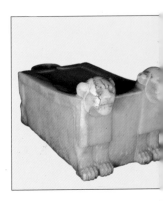

36. A sacrificial or libation alta
Ground floor, gallery 47;

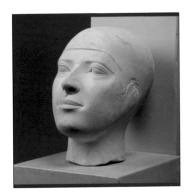

43. Reserve head,
Ground floor, gallery 46;

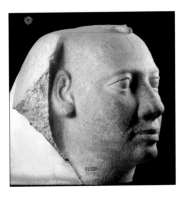

32. Colossal head of Userkaf,
Ground floor, gallery 46;

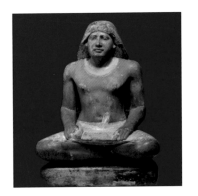

51. The scribe,
Ground floor, gallery 46;

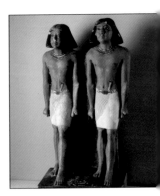

54. Double statue of Nimaatse
Ground floor, gallery 46;

Ground Floor, Gallery 46 & 47

NB. Boldface numbers refer to pictures in the book.

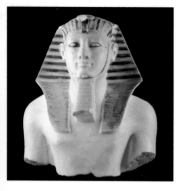

103. Bust of Tuthmosis III,
Ground floor, room 12;

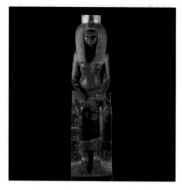

104. Queen Isis,
Ground floor, room 12;

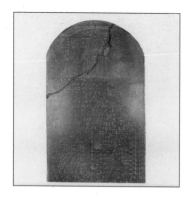

105. Victory stela of Tuthmosis III,
Ground floor, room 12;

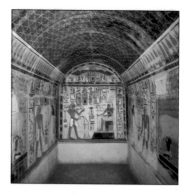

106. Chapel with cow goddess,
Ground floor, room 12;

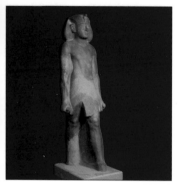

108. Statue of King Amenhotep II,
Ground floor, room 12;

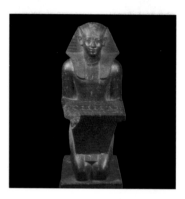

107. Statue of Amenhotep II carry-
ing an offering table, Ground floor,
room 12;

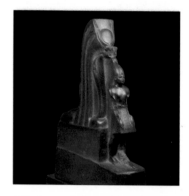

109. Statue of Amenhotep II with
Mrytsgr, Ground floor, room 12;

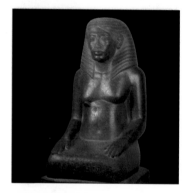

113. Amenhotep son of Habu,
Ground floor, room 12;

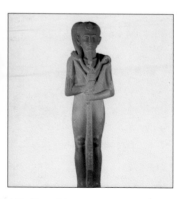

169. Tutankhamun as god Khonsu,
Ground floor, room 12;

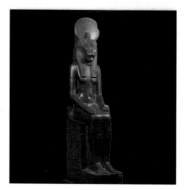

114. Goddess Sekhmet,
Ground floor, gallery 6;

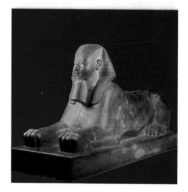

94. Granite sphinx of Hatshepsut,
Ground floor, gallery 7;

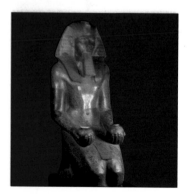

95. Kneeling statue of Hatshepsut,
Ground floor, gallery 7;

Ground Floor, Galleries 6, 7 & Room 12

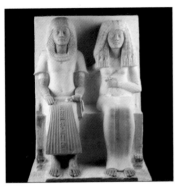

131. Meryre and his wife Iniuia, Ground floor, gallery 7;

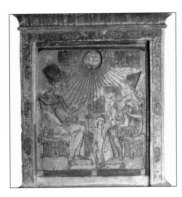

122. Stela of the royal family, Ground floor, gallery 8;

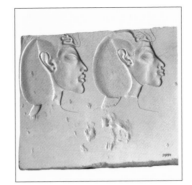

120. Sculptor's model with two royal portraits, Ground floor, gallery 8;

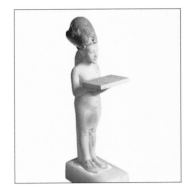

118. Akhenaten making an offering, Ground floor, gallery 8;

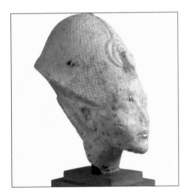

119. Head of Akhenaten, Ground floor, gallery 8;

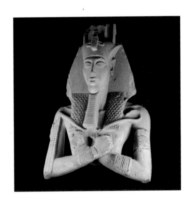

117. Bust of Akhenaten, Ground floor, room 3;

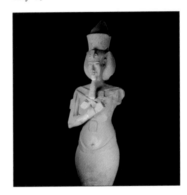

116. Colossal statue of Akhenaten, Ground floor, room 3;

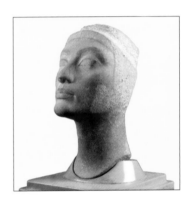

121. Unfinished head of Nefertiti, Ground floor, room 3;

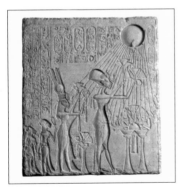

123. Panel with adoration scene of Aten, Ground floor, room 3;

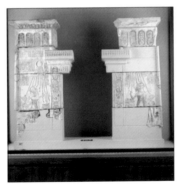

124. Façade of a shrine, Ground floor, room 3;

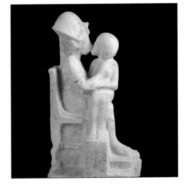

125. Akhenaten with a female figure on his lap, Ground floor, room 3;

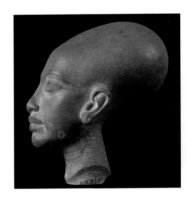

126. Head of a princess, Ground floor, room 3;

Ground Floor, Galleries 7, 8 & Room 3

NB. Boldface numbers refer to pictures in the book.

130. Princess nibbling a roasted duck, Ground floor, room 3;

128. Fragment of a painted floor, Ground floor, room 3;

127. Fragment of a painted floor, Ground floor, room 3;

129. Stela of Any, Ground floor, room 3;

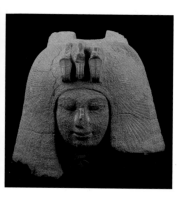

112. Head of Queen Tiye, Ground floor, room 3;

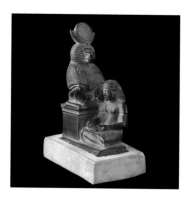

132. Thot and a scribe, Ground floor, room 3;

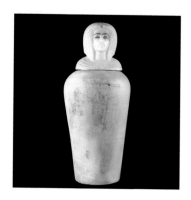

133. Canopic jar, Ground floor, room 3;

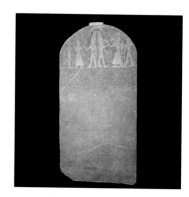

177. Victory stela of Merenptah, Ground floor, gallery 13;

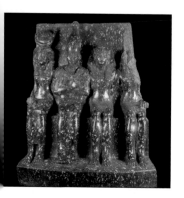

170. A king with the Osirian Triad, Ground floor, gallery 9;

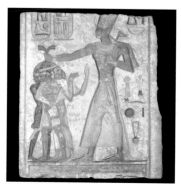

172. Ramsses II Smiting his enemies, Ground floor, gallery 10;

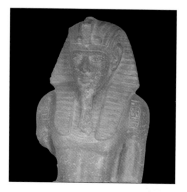

176. Bust of Merenptah, Ground floor, gallery 10;

174. Statue of Ramsses II as a Child and god Horun, Ground floor, gallery 10;

Ground Floor, Galleries 9, 10, 13 & Room 3

178. Statue of Ramsses III as a standard bearer of Amen, Ground floor, gallery 15;

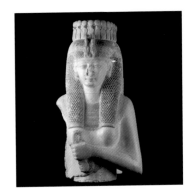

175. Bust of Queen Merit-Amun, Ground floor, gallery 15;

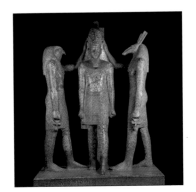

180. Statue of Ramsses III crowned, Ground floor, room 14;

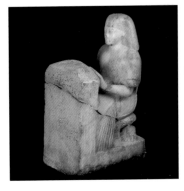

182. Alabaster Statue of Nakhet-Muti, Ground floor, room 24;

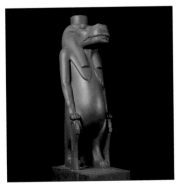

186. Statue of goddess Taweret, Ground floor, room 24;

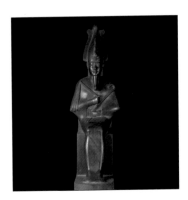

187. Statue of Osiris, Ground floor, room 24;

188. Statue of Hathor with Psametik, Ground floor, room 24;

185. Statue of Amenirdis, Ground floor, gallery 30;

190. Lid of a sarcophagus of a dwarf, Ground floor, gallery 49;

75. The pyramidion of Amenemhet III, Ground floor, gallery 33;

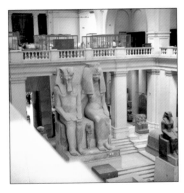

111. Colossal group statue of King Amenhotep III, Queen Tiye and their daughters, Ground floor, gallery 13;

41. Birds in the Delta marshes; Upper floor, gallery 54;

Ground Floor, Galleries & Rooms 13, 14, 15, 24, 30, 33, 49 & Upper Floor Gallery 54

6. Wall painting in Tomb no.100 at Hieraconpolis; Upper floor, gallery 54;

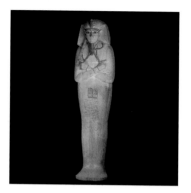

173. Coffin of Ramses II; Upper floor, gallery 48;

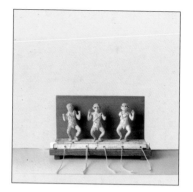

87. Statuette of a hippopotamus; Upper floor, gallery 48;

88. Game with Three Pygmies; Upper floor, gallery 48;

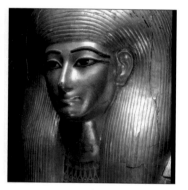

110. Coffin of Yuya, Upper floor, gallery 43;

18. Curtain-like faience panel; Upper floor, gallery 42;

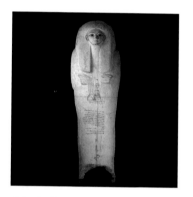

171. Coffin of Seti I; Upper floor, gallery 46;

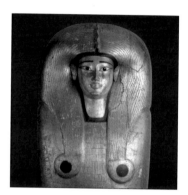

89. Anthropoid coffin of Queen Ahhotep; Upper floor, gallery 46;

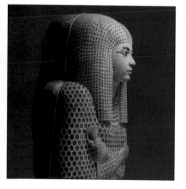

92. Anthropoid coffin of Queen Ahmose Merit Amun, Upper floor, gallery 46;

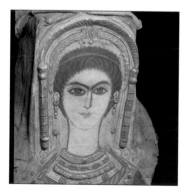

191. Mummy cover of a young Lady, Upper floor gallery 47;

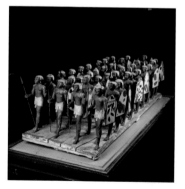

77. Troop of pike men, Upper floor, room 37;

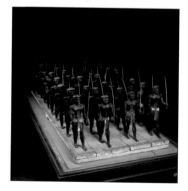

78. Troop of Nubian archers, Upper floor, room 37;

Upper Floor, Galleries 42, 43, 46, 47, 48, 54 & Room 37

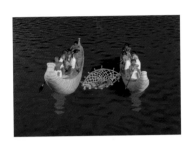

79. Model of a fishing scene, Upper floor, room 27;

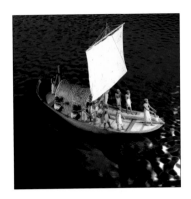

80. Model of a sailing boat, Upper floor, room 27;

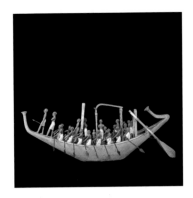

81. Row boat of Meket-re; Upper floor, room 27;

82. Statue of an offering bearer, Upper floor, room 27;

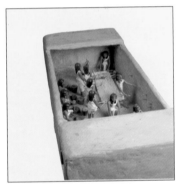

84. Model of a weaving workshop, Upper floor, room 27;

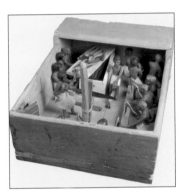

83. Model of a carpentry workshop, Upper floor, room 27;

85. Model depicting the counting of cattle, Upper floor, room 27;

181. Anthropoid coffin of Ankhefenkhonsu, Upper floor, room 27;

183. Harpist stela, Upper floor, room 22;

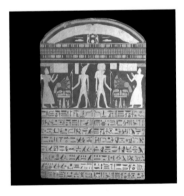

184. The stela of Ankhefenkhonsu, Upper floor, room 22;

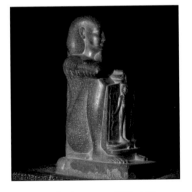

189. Magical statue of Djed Hor; Upper floor gallery 18;

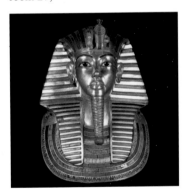

134. Gold mask of Tutankhamun, Upper floor, room 3;

NB. **Boldface numbers refer to pictures in the book.**

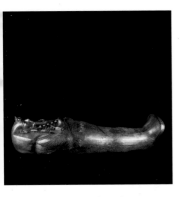

136. Inner gold coffin of Tutankhamun, Upper floor, room 3;

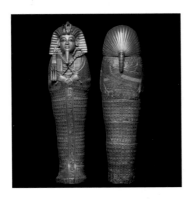

137. Coffin of Tutankhamun's internal organs, Upper floor, room 3;

143. Earrings with duck heads, Upper floor, room 3;

144. Collar of the Two Ladies, Upper floor, room 3;

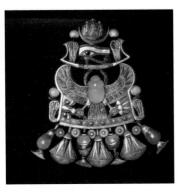

142. Pectoral with a winged scarab, Upper floor, room 3;

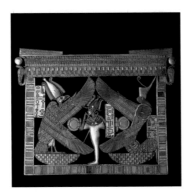

141. Pectoral of Osiris, Isis and Nephthys, Upper floor, room 3;

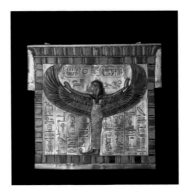

139. Pectoral of the sky goddess Nut, Upper floor, room 3;

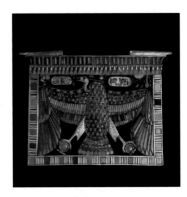

Pectoral of the sky goddess Nut as a vulture, Upper floor, room 3;

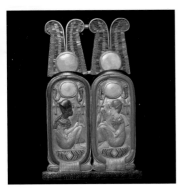

146. Cosmetic box, Upper floor, room 3;

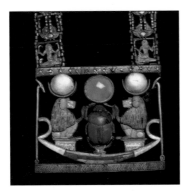

145. Necklace with a pectoral in the form of a solar boat, Upper floor, room 3;

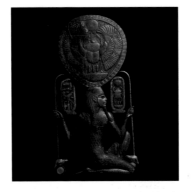

155. Mirror box with god Heh, Upper floor, room 3;

163. Ceremonial chariot, Upper floor, gallery 13;

164. Accessories of the cermonial chariot, Upper floor, gallery 13;

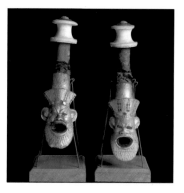
165. Accessories of the Cermonial Chariot, Upper floor, gallery 13;

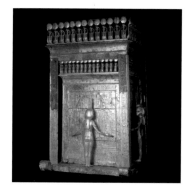
138. Canopic shrine, Upper floor, gallery 9;

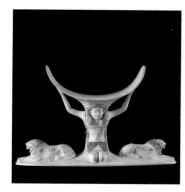
158. Ivory headrest with Shu, Upper floor, gallery 9;

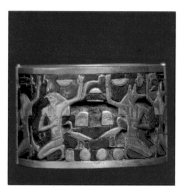
90. Bracelet of Queen Ahhotep; Upper floor, room 4;

156. Painted chest, Upper floor, gallery 20;

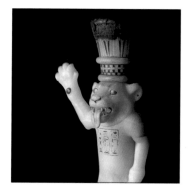
159. Lion unguent container, Upper floor, gallery 20;

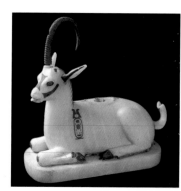
161. Calcite ibex vase, Upper floor, gallery 20;

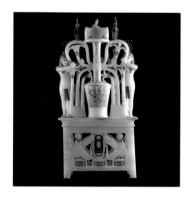
162. Alabaster perfume vessel, Upper floor, gallery 20;

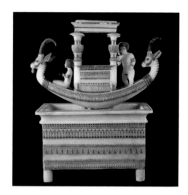
160. Calcite boat in a tank, Upper floor, gallery 20;

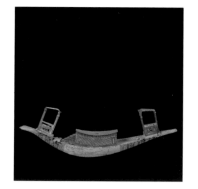
168. A barge, Upper floor, gallery 20;

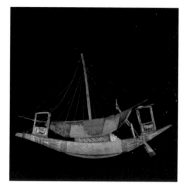
Boat with a sail, Upper floor, gallery 20;

Upper Floor, Galleries 9, 13, 20 & Room 4

NB. Boldface numbers refer to pictures in the book.

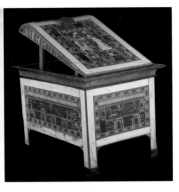

157. Ornamented chest, Upper floor, gallery 20;

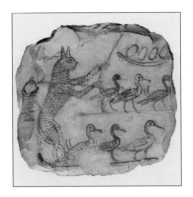

179. Decorated ostrakon, Upper floor, room 24;

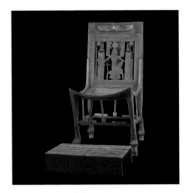

154. Chair with god Heh, Upper floor, gallery 25;

153. Ceremonial chair, Upper floor, gallery 25;

148. Miniature Effigy of the Pharaoh, Upper floor, gallery 25;

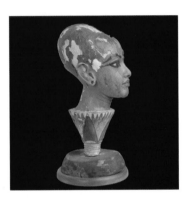

147. Head of Tutankhamun emerging from the lotus flower, Upper floor, gallery 30;

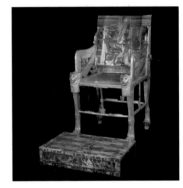

152. Throne of Tutankhamun, Upper floor, gallery 35;

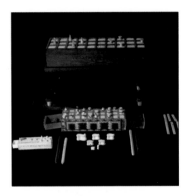

166. Game board of Tutankhamun, Upper floor, gallery 35;

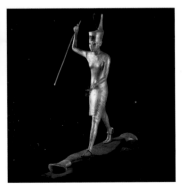

149. Tutankhamun on a papyrus raft, Upper floor, gallery 45;

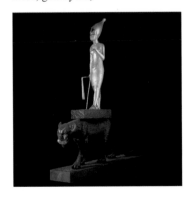

150. Tutankhamun on the back of a leopard, Upper floor, gallery 45;

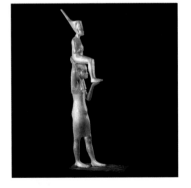

151. A goddess carrying the king, Upper floor, gallery 45;

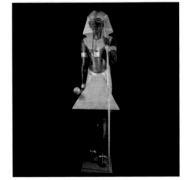

135. Ka statue of Tutankhamun, Upper floor, gallery 45;

Upper Floor, Galleries 20, 25, 30, 35, 45 & Room 24

Glossary of the Ancient Egyptian Words

Akh one of the elements of the person, representing his light.

Ankh sign of life.

Akhet horizon.

Atef crown of the god Osiris flanked by two feathers.

Ba one of the elements of a person, representing his soul, depicted as a human-headed bird.

Bekhen schist stone.

Bnbn the primeval mountain, the first to emerge from the ocean at the creation of the world by the god Atum.

Bnt harp.

Deshret the red crown of Lower Egypt.

Djed a pillar, symbol of stability.

Djadjat harp.

Ds flint stone.

Heb-sed jubilee festival during which the king's power and kingship were confirmed and renewed.

Hedj royal mace scepter.

Hedjet white crown of Upper Egypt

Heka a scepter in the form of a crook, symbol of power.

Hetep-di-nsw offering formula recited at the presentation of offerings ceremony and written over the walls of the tombs.

Ib one of the elements of a person representing his heart, center of wisdom and thinking.

Ikm shield

Inb-hedj wall, one of the names of the city Memphis.

Inr-hedj limestone.

Irp wine

Isr tamarisk tree

Ka one of the elements of a person, representing his double or the vital force, depicted as two upraised arms.

Ka-nkht a strong bull.

Kbh libation vase

Khat a royal head dress.

khekeru frame, representing the tied reeds, which used to form enclosure walls around primitive buildings or was woven over mud brick buildings.

Kheperesh the blue crown, often called the war crown.

Kherep scepter of authority.

Khet one of the elements of a person, representing his body.

Mdw-wr divine words.

Menat beaded necklace whose counterpoise bears the image of Hathor.

Mn-nfr stable and beautiful, originally, the name of the pyramid of King Pepi I in Saqqara, later used as the name of the city Memphis.

Nbty the two ladies, Wadjet and Nekhbet, goddesses of Upper and *bty* Lower Egypt, one of the royal titles.

Nekhekh the flagellum scepter, symbol of authority.

Nemes royal headdress.

Nht sycamore tree.

Nsw-biti king of Upper and Lower Egypt, one of the royal titles.

Pr-aa the great house, also used as one of the secondary royal titles starting . from the New Kingdom.

Pr- hedjet treasury of Upper Egypt.

Pr-deshret treasury of Lower Egypt.

Prt winter season.

Pseshkef a fish tailed knife used in the opening of the mouth rite.

Rekhyt birds, symbolizing subjects.

Rn one of the elements of the person, representing his name.

Sa protective amulet

Sekhem a scepter, symbolizing power.

Sekhmty double crown of Upper and Lower Egypt.

Sema-tawy unification of the two lands.

Senet a board game, the name means passing game.

Serekh palace façade.

Seshen lotus.

Shemw summer or low water season.

Shen circular amulet, representing infinity and duration.

Shendyt royal pleated kilt.

Sw reed plant

Tit the knotted girdle of the goddess Isis.

Udjat a protective amulet representing the eye of the god Horus.

Usekh broad beads collar.

Wadj Papyrus.

Was scepter with canine head, symbolizing prosperity.

Wrs head rest

Index

Bibliography

1. Aldred, C., *Old Kingdom art in Ancient Egypt*, London, 1949.

2. Aldred, C., *Egypt till the end of the Old Kingdom*, London, 1978.

3. Aldred, C., *Middle Kingdom art in Ancient Egypt*, London, 1950.

4. Aldred, C., *New Kingdom Art in Ancient Egypt during the Eighteenth Dynasty*, London, 1961.

5. Aldred, C., *Akhenaten, King of Egypt*, London, 1988.

6. Aldred, C., *Egyptian Art*, London, 1980.

7. Andrews, C., *Egyptian Mummies*, London, 1994.

8. Andrews, C., *Ancient Egyptian jewelry*, London, 1990.

9. Andrews, C., *Amulets of ancient Egypt*, London, 1994.

10. Baines, J., and Malek, J., *Atlas of Ancient Egypt*, Oxford and N.Y., 1980.

11. Baker, H., *Furniture in the ancient world*, London, 1966.

12. Barucq, A., *Religions de l'Egypte*, Lille, 1947.

13. Budge, W., *The mummy, a handbook of Egyptian funerary archaeology*, London, 1987.

14. Bongioanni, A. & Corse, M. S., *The illustrated guide to the Egyptian Museum in Cairo*, Cairo, 2001.

15. Brayan, B., in *The Oxford encyclopedia of ancient Egypt*, Cairo, 2001, vol. 1, p. 60-65, s. v. Amarna, Tell el-.

16. Brewer, D., in *The Oxford encyclopedia of ancient Egypt*, Cairo, 2001, vol. 1, p. 89-94, s. v. Animal husbandry.

17. Cailliaud, F., *Recherche sur les arts et sur les métiers*. Les usages des anciens peuples d'Égypte, de la Nubie et de l'Éthiopie, Paris, 1831.

18. Capart, J., *Documents pour servir a l'étude de l'art Egyptien*, vol. I, Paris, 1927.

19. D'Auria, S., Lacovara, P. & Roehrig, C., *Mummies and magic. The funerary arts of ancient Egypt*, Boston, 1990.

20. David, A. R., *The ancient Egyptians religious beliefs and practices*, London, 1982.

21. Davies, Jon, *Death, burial & rebirth in the religions of antiquities*, London, 1999.

22. Davies, N. de G., *The tomb of Rekhmire at Thebes*, N. Y., 1943, 2 vols.

23. Davies, N. de G., *The tomb of 2 sculptors at Thebes*, N. Y., 1925.

24. Davies, N. de G., *The tomb of Antefoker*, London, 1926.

25. Desroches- Noble court, C., *Les religions Égyptiennes, L'histoire générale des religions*, Paris, 1949.

26. Dodson, A., in *The Oxford encyclopedia of ancient Egypt*, Cairo, 2001, vol. 1, p. 231-235, s. v. Canopic jars and chests.

27. Doxey, D., in The Oxford encyclopedia of Ancient Egypt, Cairo, 2001, vol. 1, p. 97-98, s. v. Anubis.

28. Eaton-Krauss, M., in The Oxford encyclopedia of ancient Egypt, Cairo, 2001, vol. 1, p. 48-51, s. v. Akhenaten.

29. Edwards, E., S., The pyramids of Egypt, Harmondsworth, 1995.

30. Erman, A., Life in Ancient Egypt, N. Y., 1971.

31. Faulkner, R. O., The ancient Egyptian Pyramid texts, Oxford, 1969.

32. Faulkner, R. O., The Ancient Egyptian Coffin Texts I-III, Warminister, 1973-80.

33. Faulkner, R. O., The Ancient Egyptian Book of the Dead, London, 1985.

34. Freed, R, Markowitz, Y. & D'Auria, S., Pharaohs of the sun Akhenaton-Nefertiti-Tutankhamen, London, 1999.

35. Gardiner, A. & Davies, N. de G., The tomb of Amenemhat, London, 1915.

36. Gardiner, A., Egyptian grammar, Oxford, 1978.

37. Garstang, J., Burial customs of ancient Egypt, London, 1907.

38. Goyen, J. C., Rituels funéraires de l'ancienne Égypte, Paris, 1972.

39. Grimal, N., A History of Ancient Egypt, translated by Ian Shaw, Oxford, 1992.

40. Gutgesell, M., «The Military», in R., Scultz & M., Seidel (ed.), Egypt, The world of the pharaohs, Cairo, 2001, p. 365-369.

41. Hart, G., A dictionary of Egyptian gods and goddesses, London, 1986.

42. Hickmann, Hans, « Terminologie musicale de l'Égypte ancienne », BIE XXXVI, Le Caire, 1955, p. 583-618.

43. Hickmann, Ellen, « La musique magique rituelle, et cultuelle des Égyptiens pharaoniques », Encyclopédie de musique sacrée, Paris, 1968. vol. I, p. 310-19.

44. Hoffmeier, J., in The Oxford encyclopedia of ancient Egypt, Cairo, 2001, vol. 2, p. 406- 412, s. v. Military: Materiel.

45. Hornung, E., Idea into image. Essays on ancient Egyptian thoughts, N.Y., 1992.

46. James, T., G., H., Tutankhamun, Cairo, 2000.

47. James, T., G., H., Egyptian Painting, British Museum, London, 1985.

48. James, T., G., H., Egyptian sculpture, British museum, London, 1983.

49. Kendall, T., in The Oxford encyclopedia of ancient Egypt, Cairo, 2001, vol. 2, p. 1-3, s. v. Games.

50. Kessler, D., «Tanis and Thebes-The political history of the Twenty First to Thirtieth Dynasties », in R., Scultz & M., Seidel (ed.), Egypt, the world of the pharaohs, Cairo, 2001, p. 271-275.

51. Kitchen, K. A., The Third Intermediate Period, 2nd edition, Warminister, 1986.

52. Lapp, G. & Niwinski, A., in the Oxford encyclopedia of ancient Egypt, Cairo, 2001, vol. I, p. 279-286, s. v. Coffins, sarcophagi and cartonnage.

53. Leahy, A. in The Oxford encyclopedia of ancient Egypt, Cairo, 2001, vol. 3, p. 257-260, s. v. Sea Peoples.

54. Lesko, B., The great goddesses of Egypt, Oklahoma, 1999.

55. Manniche, L., Music and musicians in ancient Egypt, London, 1991.

56. Markowitz, Y., in The Oxford encyclopedia of ancient Egypt, Cairo, 2001, vol. 2, p. 201-207, s. v. Jewelry.

57. Markowitz, Y. & Lacovara, P. in The Oxford encyclopedia of ancient Egypt, Cairo, 2001, vol. 2, p. 34-38, s. v. Gold.

58. Moran, W., in The Oxford encyclopedia of ancient Egypt, Cairo, 2001, vol. 1, p. 65-66, s. v. Amarna letters.

59. Peck, W. in The Oxford encyclopedia of ancient Egypt, Cairo, 2001, vol. 2, p. 621-622, s. v Ostraca.

60. Petrie, F., The funeral furniture of Egypt, London, 1937.

61. Pinch, G., « Red things: the symbolism of color in magic », in W. V., Davies (ed.), Color and painting in ancient Egypt, London, 2001, p. 182-188.

62. Posner, G., Sauneron, S. & Yoyotte, J., Dictionary of Egyptian civilization, London, 1962.

63. Ranke, H., Masterpieces of Egyptian art, London, 1951.

64. Ranke, H., The art of ancient Egypt, Vienna, 1936.

65. Ray, J., in The Oxford encyclopedia of ancient Egypt, Cairo, 2001, vol. 2, p. 267-271, s. v. Late period.

66. Robins, G., in The Oxford encyclopedia of ancient Egypt, Cairo, 2001, vol. 1, p. 291-294, s. v. Color symbolism.

67. Romer, J., The Valley of the Kings, London, 1981.

68. Roth, A. M., in The Oxford encyclopedia of ancient Egypt, Cairo, 2001, vol. 1, p. 575-580, s. v. Funerary rituals.

69. Saleh, M & Sourouzian, H., The Egyptian Museum Cairo Official Catalogue, Cairo, 1987.

70. Schlogl, H., in The Oxford encyclopedia of ancient Egypt, Cairo, 2001, vol. 1, p. 156-158, s. v. Aten.

71. Shaw, I. & Nicholson, P., British museum dictionary of ancient Egypt, Cairo, 1995.

72. Smith, W. S., History of Egyptian sculpture and paintings in the Old Kingdom, Boston, 1949.

73. Spencer, A., Death in ancient Egypt, Harmondsworth, 1982.

74. Strouhal, E., Life in Ancient Egypt, Cambridge and Norman, 1992.

75. Taylor, J., Death and the afterlife in ancient Egypt, London, 2001.

76. Tiradritti, F., The treasures of the Egyptian Museum, Cairo, 1999.

77. Tirard, H., The book of the dead, London, 1910.

78. Vandier, J., Manuel d'archéologie Égyptienne, Tome II, Paris, 1954; Tome IV, 1964; Tome V, 1969.

79. Vandier, J., La religion Égyptienne, Paris, 1949.

80. Vogel Sang- Eastwood, G., Pharaonic Egyptian clothing, Leiden & N.Y., 1993.

81. Winlock, H. E., Models of Daily life in Ancient Egypt, N.Y., 1955.

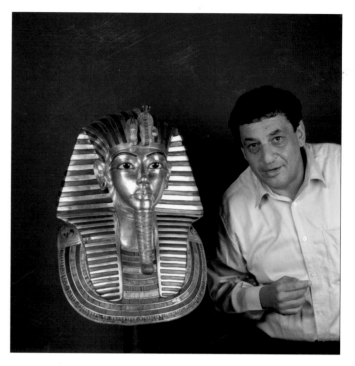

Abeer el Shahawy, M.A., is an Egyptian Egyptologist, who obtained her B.A and M.A. from Helwan University, Cairo. Her main achievement is her iconographic study of the funeral procession scenes in the New Kingdom Theban Tombs.

In this Egyptian Museum book, the writer has contributed detailed and informative descriptions as well as comprehensive explanations on many of the fine objects and masterpieces to be found in the Egyptian Museum.

Writer, photographer and publisher Farid Atiya is the author of many books on the Red Sea, Sinai and the monuments of Egypt, including the acclaimed "The Red Sea in Egypt, I and II", "The Best Diving Sites in the Red Sea", "Red Sea Panorama", "The Brother Islands", "Cheops's Solar Boat", "The Silent Desert, I Bahariya and Farafra" and "Pyramids of the Fourth Dynasty".

Front cover : Ka-aper, called Sheikh al-Balad, 5th Dynasty *c.* 2500 BC.

Back cover : Panel with adoration scene of Aten, reign of Akhenaten 1372 - 1355 BC.